CREATIVITY AND BEYOND

CREATIVITY BEYOND

Cultures, Values, and Change

ROBERT PAUL WEINER

STATE UNIVERSITY OF NEW YORK PRESS

San Francisco Museum of Modern Art, Albert M. Bender Collection, San Francisco California, for reproduction of Jackson Pollack's *Guardians of the Secret*, 1943.

Stanley Bailis, editor, *Issues in Integrative Studies*, for use of the author's article, "Western and Contemporary Global Conceptions of Creativity in Relief against Approaches from So-called 'Traditional' Cultures," in *Issues*, no. 15, (1995): 1–48.

Bayerische Staatsgemaldesammlung, Munchen, Alte Pinakothek, for reproduction of Albrecht Dürer's *Selbstbildnis im Pelzrock*, 1500.

Barry Martin, for use of his photograph of the Eiffel Tower, 1998.

Liz Leger, for reproduction of her drawing, *Despina*, from *Fragments* series, 1997. Collection of the Palace of Legion of Honor, Fine Arts Museums of San Francisco.

David and Barbara Moser, for use of David's photograph of Barbara at the Great Wall of China, 1998.

Ken Light, for use of his photograph, *Convict With Homemade Last Supper Clock, Administrative Segregation Cell Block*, 1994, printed in Ken Light and Suzanne Donovan, *Texas Death Row*, Singapore: University of Mississipi Press, 1997.

Susan Light, for use of her photographs, *Women's Gamelan Orchestra*, 1990, The *Temple of Athena Nike*, 1981, and *Roman Coliseum, Verona*, 1987.

Galleria de l'Accademia, for use of the author's photograph of Michelangelo's *Prisoner* or *Waking Slave*, 1995.

Published by

State University of New York Press, Albany

© 2000 State University of New York

For information, address State University of New York Press,
State University Plaza, Albany, NY 12246

Production, Laurie Searl
Marketing, Fran Keneston

Library of Congress Cataloging-in-Publication Data

Weiner, Robert, 1950–
Creativity and beyond : cultures, values, and change / Robert Paul Weiner.
p. cm.
Includes bibliographical references and index.
ISBN 0-7914-4477-5 (alk. paper) — ISBN 0-7914-4478-3 (pbk. : alk. paper)
1. Creative thinking. 2. Creative ability. I. Title.

BF408.W384 2000
153.3'5—dc21 99-052763

10 9 8 7 6 5 4 3 2 1

I dedicate this book to

Susan, Sophia, and David,

and to all those who love and create—or who long to.

CONTENTS

PART THREE

CREATIVITY IN PRACTICE

ILLUSTRATIONS

PREFACE

This book attempts to say something creative about creativity.

I have loved working on the book. Since I began a decade ago, almost everything I've studied and experienced, almost everyone I've spoken with, has turned out to have some connection to the subject of creativity, and this has provided me with continuous intellectual stimulation. The process of writing has been a wonderful voyage of discovery as well.

Many people are creative, but I am not sure if anyone is a "specialist" in creativity. I have been able to approach this broad topic because of my unusually interdisciplinary background and interests. Still, I had not focused my attention on this subject until Cynthia Campbell spontaneously asked me to teach her required humanities creativity course at Contra Costa College when she went on sabbatical. I barely knew Cynthia and found her trust in me startling but wonderful. When I asked her what I should do for the course, she simply said, "be creative." In the following years, I lost contact with Cynthia, but continued to teach workshops and courses on creativity and invention. I then began to collaborate with Lou Miller from California State University, Sonoma on a book of "creativity exercises." The book was well underway when I drafted an introduction focused on the question, "why do people in our society care about creativity?" It was Lou who encouraged me to turn those ten pages into the far more involved book before you.

In all truth, this book has been an extremely collective effort—my immediate and extended family have been wonderfully supportive, providing ideas, criticism, love, and inspiration. I have received a tremendous amount of help and goodwill from friends and colleagues, some of whom have given a great deal of time and thought to this book. In addition to Lou Miller, special thanks go to my sister, Diane Weiner (University of California, Los Angeles); Paul Giurlanda (Saint Mary's College of California); and my wife, Susan Light (University of California, Berkeley). These individuals helped throughout this project.

Because the book deals with content from such a wide range of academic fields as well as politics, the arts, business, and everyday life, I have gotten ideas from very many people, including some colleagues, students, and casual acquaintances from museums, cafes, and elsewhere, whose names I cannot recall. The people named below are ones who gave me more sustained and specific help. From Saint

Mary's College: Paola Sensi-Isolani, Brother Charles Hilken, Carl Guarneri, Mike Reilly, Joseph Lanigan, Chris Miller, Sandy Grayson, Mary McCall, Brother Ken Cardwell, Carol Beran, Brother Camillus Chavez, Bob Gorsch, Diana Wu, Frank Murray, Dan Cawthon, Steve Cortright, Dean of Science Keith Devlin, and Academic Vice President Bill Hynes; from California State University, Sonoma: Les Adler, Nelson "Buzz" Kellog, and Richard Zimmer; from John F. Kennedy University: Barry Martin, Marjorie Schwarzer, Suzanne West, Leanna James, and Barbara Fisher; from California Institute of Integral Studies, President Joseph Subbiondo.

Additional thanks go to the following artists, musicians, journalists, businesspeople, psychologists, computer experts, producers, and performers: Jim Rosenthal, Liz Leger, Joe Saah, Michelle Metz, Seth Mausner, Paul Feinberg, Jan Weiner, Ken Light, Steve Alpert, Rick Shapiro—all of whom helped directly with sections of the book. Further thanks to: Lil, Sophia, David, Melanie, Joan, Joel, Babs, Ed, Lei Ching, Judy, Lee, Scott, Savage, John, Carlos, Sheila, Dawn, Stan, Tex, Lisa, Jeff, Lael, Harvey, and the "Cinque Familie," Alison, Edgardo, Catherine, Steve, Nick, Ellen, Shary, and Joe, all of whom discussed ideas with me which worked their way into this book.

Also, thanks to Stan Bailis, editor of *Issues in Integrative Studies*, and especially James Peltz and Laurie Searl, editors at the State University of New York Press, and copyeditor Lani Blackman. Valuable word processing, editing, and proofreading help came from Angela Carden, Miranda Kentfield, Susan Parr, Norm Andreasen, Ann Thatcher, Leigh McDougall, Karen O'Brien, Trish Bracelin, and Janet Sarico. I also received considerable help from the librarians of John F. Kennedy University, Yale University, California State University Sonoma, and especially Saint Mary's College of California and the University of California Berkeley. And thanks to the Saint Mary's College and John F. Kennedy University faculty development funds. Finally, because some of the ideas in this book derive from my former teachers and friends, I'd like to acknowledge Richard Macksey of Johns Hopkins, Wilfrid Desan of Georgetown, Louis Dupre of Yale, and Ernst Vollrath and Klaus Ertel of Cologne.

This book is filled to overflowing with thinking about creativity, but it could easily be twice as long. It is also as good as I can make it as of today, but I'm sure that tommorow I'll want to change things. Frankly, creativity is too big a subject for me or anyone else to master. I am sure that if you are an attentive reader, you'll have valuable suggestions for revisions and additions, and I solicit those suggestions from you—in fact, I hope you will become a collaborator in this respect. A book like this cannot be complete—it will always be a work in progress.

INTRODUCTION

Creativity, understood as bringing something new into being, is a major value in our society. It may not be articulated as such in our major political or religious documents, but it is something that most Americans,[1] and many other people around the world care about deeply. As Silvano Arieti has written, "creativity stands out as an activity to be studied, cherished, and cultivated" (1976, ix). But why is this so? Does everyone agree on the meaning of creativity? Are there limits to creativity? Does valuing it actually make us more creative?

Surely, creativity as we generally define it is something which has taken place throughout history and all around the world . . . to a considerable extent, world history *is* the history of creativity. But our common modern conception of creativity is itself a new creation. Most people in the past, and many still today might have difficulty comprehending it and probably would not value it as we do, even if they did understand. Indeed, the word "creativity" did not exist before 1870 and was not widely used until about 1950. The concept, and the positive value we attach to it, might in fact be seen as hallmarks of our modern, secular, democratic, capitalistic society. And as our postmodern global culture expands, more and more people are adopting this conception as theirs, but even as they do, what we mean by creativity seems to be shifting.

The primary task of this book is to examine the cross-cultural differences and continuing historical evolution of our society's conception of creativity. The second goal of the book is to examine a variety of ideas about and expressions of creativity as well as the many ways in which creativity may be limited by material conditions or opposing values. I believe this examination is not merely of academic interest. The way conservatives and liberals, right and left relate; what we think of other cultures; the laws and policies we seek or confront, may all be affected by posing serious questions about such a key cultural value.

But before we even start with such questions, you might well deny my premise about the value of creativity in our society. And truthfully, when I first conceived this book, I approached a number of artists, writers, and musicians to ask them if creativity is highly valued in the United States—and the answer I received was a unanimous "No!" Even those individuals fortunate enough to make a living in the archetypically creative fields of the arts maintain that the governments of

other countries are much more supportive and that most people working in the arts barely survive economically unless they "prostitute" themselves to "uncreative" forms of employment. If, furthermore, they try to follow their unique, creative paths, they tend to be viewed as bohemian, asocial misfits.

Likewise, the scientists I've asked frequently maintain that their ideal of "pure science" is a luxury rarely supported by the society, and that those who pursue it are often viewed as "nerds" or even as "mad." The only way these researchers can get to do what they really want is to convince the corporate world or the government that their work is of commercial or political value. Scientists and academics repeatedly write and speak of their frustrations with a society which, they say, gives lip service to their work and generally prefers reruns of old television sitcoms to any "genuine" creativity.

And to my surprise, most of the business people I've asked have agreed with the artists and scientists that creativity is not valued: the competition of the market is ruthless, and often enough, creative enterprises must be abandoned before their potential can be developed. What's more, government regulations and bureaucracy stall corporate growth and suffocate entrepreneurship; and large corporations routinely ignore or even repress individual initiative.

These complaints are significant . . . not in the least because they underscore the fact that many individuals expect their creative efforts to be appreciated. Many agree that "to be called 'creative' is a special form of praise" (Hartshorn, 1985, 3), and that those who are creative deserve corresponding financial and social reward.[2]

THE CELEBRATION OF CREATIVITY
IN AMERICA AND THE WORLD TODAY

This expectation would make no sense if it weren't the case that our society does, in fact, proclaim the importance of creativity. Frustration is common and deep because the ideal is so widely and fervently believed. Not merely artists, scientists, and business managers, but also cowboy poets, cooks, homemakers, and ghetto rappers—people from all walks of life and all economic classes—seem to want to be viewed as "creative" in some respect. That is why books and courses on creativity (and innovation and invention, which are often used interchangeably with it) have been so popular in the United States and elsewhere during the last few decades. Millions want to "discover that creative spark within" or "develop the creative abilities" they believe they already possess. That is also why we are routinely told by educators, art directors, the media, civic leaders, and business executives that creativity is good for the individual, the nation, and the planet.

Cultural historian Jacques Barzun is perhaps right then, when he says, ". . . in contemporary culture, no idea is so appealing, no word put to more frequent and varied use, than 'creativity' " (in Wilmer, 1991, 4). But can the word be at once a

form of praise and at the same time so common? Yes, that is precisely the democratic dream, where everyone can be president, or as Andy Warhol mused, where everyone can have his or her fifteen minutes of fame. Each of us can and should create him- or herself; or, as popularized American psychology might have it, each should become "self-actualized."[3]

In many respects, since the Renaissance, our society's paradigm for such creative fulfillment has been art. And this persists despite the commercialization and entertainment aspects of much art today. A great deal of music is played publicly, art works displayed, dance and theater performed, and books published because producers, editors, curators, and their audiences believe that creativity is being expressed and that these expressions are enjoyable and or important. We revere creative "genius" and hope to participate in it—and not just as spectators. Following the call of artists from Rodin to Beuys for "everyone to become an artist," millions are actively engaged in the arts avocationally.[4]

But all we need do is look at the telephone listings of any large American city to see that the arts are just a fraction of the spheres in which various groups, corporate and nonprofit alike, have decided to label their activities or products "creative": there are such strikingly named operations as Creative Property Management, Creative Parenting, and Creative Leisure. And, of course, the advertizing media constantly markets all manner of what they call "creative new" things.

In many respects, the rewards system of our society seems to require creativity. For example, doctoral degrees, grants, and fellowships are usually awarded only for projects judged to be creative. Job announcements for managers and professionals in many fields routinely describe the company as "innovative" and call for applicants who are creative. In the United States and elsewhere, candidates for political office generally must appear to have creative solutions to public problems.

No wonder, then, that there are a host of organizations and works dedicated to analyzing and encouraging creativity in our society. Most obvious perhaps are the hundreds of art and technology museums around the country which display, educate about, and advocate creativity. Almost all universities and centers for advanced research perceive themselves as "advancing the frontiers of the known" and fostering creativity and discovery; some universities have specific interdisciplinary programs on creativity.[5] Interestingly, while one can search high and low for a category called "creativity" in grant listings, many foundations, like the Carnegie, Ford, Rockefeller, MacArthur, and Lemelson, are committed to supporting creativity in various guises. And there are countless workshops and courses on: creative writing, creative cooking, creative management, creativity in your relationship, and creativity pure and simple.

Less well known are the hundreds of creativity consultants, companies like Creative Think in Palo Alto California and Creativity for Kids in Cleveland Ohio; organizations like the National Collegiate Inventors and Innovators Alliance; institutes such the Center for Applied Creativity in London, the Creative Education

Foundation in Buffalo, the Dow Creativity Center in Midland, Michigan—which takes as its "responsibility to make available to every individual the opportunities for constructive growth,"—and the Center For Creative Leadership in Greensboro, North Carolina, which serves business, government, and even sports teams.

The American media also thrive on the subject. Public Broadcasting presented a television series, *Creativity with Bill Moyers*. Such diverse, general interest magazines as *Omni, Psychology Today, Discover, Working Woman,* and *Dun's Review* have had cover stories dedicated to Creativity. The daily newspaper is filled with articles about the latest creations not only from the world of art in the culture section, but also about scientific and technological breakthroughs, new programs introduced in the schools, new weapons in the military, environmental advances, new businesses, and solutions to problems in politics and society.

Many, perhaps all governments around the world directly support some activities we would call "creative." In the United States, the Poet Laureate publicly encourages literary and artistic creativity; the Smithsonian Institutions celebrate and further artistic and technological creativity; the federal government gives financial support (though for how long we cannot be sure) to particularly creative artists, writers, scientists, and institutions, through the National Endowment for the Arts, National Endowment for the Humanities, National Institutes of Health, and National Science Foundation. More significantly, the government gives tax benefits to individuals and corporations involved in researching a creative project and to those who fund such efforts. The government gives huge sums for creative research in weaponry through the Defense Department, and supports entrepreneurship through the Small Business Administration, Commerce Department assistance, and tax allowances. The United States copyright and patent laws, designed for the protection of original work, are among the world's strongest. This government support does not guarantee creativity, but it is intended to foster and protect it.

It is obvious, then, that creativity is a value not only in the ultimate, ideal, and emotional sense, but also in the commercial sense. However, there is obviously no direct correlation between the two forms of value. Many people shake their heads in amazement at the prices paid for creations they consider irrelevant or stupid. At the same time, many talented creators are never honored for their work, and however much personal satisfaction they may find through their creative activity, they would probably like social respect and economic reward as well. In fact, the intensity of the societal celebration of creativity as an ultimate value probably exacerbates the frustration felt when corresponding opportunities for commercial valuation and social recognition are missing.[6] Even so, this disparity between ideal and real rarely deters those who feel most passionately committed to their particular creative paths, because they generally enjoy what they are doing and hold the ideal value so firmly.

And if the United States is an especially strong example of a culture which adheres to this value, the belief in creativity as a primary value is almost as securely entrenched in Western Europe, Canada, Australia, and Japan. Indeed, it is a cornerstone of what is coming to be viewed as "global culture." No one seems particularly startled when a business-person from Thailand speaks of innovation and "self-actualization," or when an Inuit (Eskimo) artist discusses his "creative" process and intentions, or when Nelson Mandela speaks out for "social and political creativity" in South Africa.

Whether or not the people of the world are any more creative than in the past, there is widespread talk of "creativity," "innovation," etc.—and this talk borders on reverence. As one reviewer recently said of several different books on creativity, regardless of their approaches, "all hail it" (Dembart, 1990, 16).

This positive attitude toward creativity is so widespread that we tend to take it for granted as normal (as we do many other values). That is why a cultural analysis of the phenomenon is important. Creativity is not an eternal or universal concept—even translating the term into other languages is not a simple matter. In fact, though enthusiasm for what we call "creativity" had been developing for a long time in Western history, the celebration of it emerged with full force only in the second half of the twentieth century.

THE CREATIVITY MOVEMENT

The fact that the word "creativity" became common only after World War II, reflects major historical cultural changes in the United States and beyond. As Frank Barron has written, the American government's cold war political and military concerns, the business community's belief that innovation would lead to profit, student centered educational reforms, and psychologists' turning away from a focus on neurosis and disease toward a picture of mental health all contributed powerfully to the intellectual interest in creativity at midcentury.[7] This intellectual interest in the subject, coupled with the broader economic, political, and cultural forces have shaped how most of us now view creativity.

Already in 1937 the first "creativity training" programs were introduced by General Electric Corporation, and by the mid-1940s, "creativity" could be found in most English language dictionaries. In 1948, businessman Alex F. Osborn's popular *Your Creative Power* was published, and "creative problem-solving" emerged as a common expression. About the same time, the University of California's Institute of Personality Assessment found creativity to be an important component of "healthy personalities"; in 1950, the President of the American Psychological Association, J. P. Guilford, delivered a keynote address which noted the paucity of studies on creativity and called for concerted research on the phenomenon; then, in 1954,

Guilford, Henry A. Murray, and John C. Flanagan carried out studies for the United States Air Force which revealed creativity to be an important quality for leadership. At the same time, researchers Calvin Taylor and Ann Roe focused attention on scientific creativity. Researchers in education, too, followed up on Lewis Terman's earlier studies of "the gifted," exploring the connections between creativity and intelligence, and E. Paul Torrance examined classroom conditions which foster or deter creativity. In the 1950s, as well, groups like the Society for the Philosophy of Creativity were formed; Jennie Graham introduced annual Creative Problem Solving Institutes at the State University of New York, Buffalo; and Sidney J. Parnes and others founded the Creative Education Foundation in Buffalo as well (see F. Barron, 1968, 1–8).

In 1956, Michigan State University was host to a major interdisciplinary conference on creativity: its ability to gather prominent intellectual figures from across the society, like Margaret Mead, Erich Fromm, J. P. Guilford, and others shows how the subject's appeal had broadened. Indeed, Harold Anderson, who edited the papers presented at the conference, expressed the historical role of the interdisciplinary discussion clearly:

> What is new in creativity is the growing realization, the emerging discovery, of the tremendous unsuspected potentialities in the creativity of man, in the nature of human resources, in the meaning of respect for the individual. Such a discovery, which has been taking on meaning since the Renaissance and which is still in process, may prove as significant as Darwinian evolution or the discovery of atomic energy (1959, preface).

Meanwhile, a number of educators sought to bring greater creativity into the classroom. In 1970, for example, the Purdue Creativity Training Program for schools was introduced. About this time as well, universities began to offer courses on creativity and even creativity studies. Interest grew in Europe as well. In 1966 the Jungian-oriented Eranos Center in Switzerland hosted an interdisciplinary international conference on *Schopfung und Gestaltung* (Creation and Formation). By 1990, at the International Conference of Creativity in Buffalo, "creatology" was proclaimed a unique discipline by Istvan Magyari Beck.

The business world, keenly interested in the creative process, brought its forces to bear to support some of these academic studies—as early as 1952, the Industrial Research Institute had held a conference on "the Nature of Creative Thinking." More importantly, the business world has come to trumpet creativity and innovation widely. Today, almost every advertisement and corporate annual report speaks of "innovation," "entrepreneurship," and "creative problem solving." The high tech industry in general, and Silicon Valley in particular, have preached the gospel of creativity and innovation ceaselessly. No wonder economic theorists like Julian Simon and Peter Drucker have called innovation the single most important economic resource.

Today, creativity analysts, teachers, consultants, workshops, books, and Internet web sites abound, and a thriving creativity industry now markets itself to corporations and individuals. Collectively, these developments reinforce the public desire for creative fulfillment. They address, but also exacerbate the frustrations of those who do not find this fulfillment. We do not have to attend a workshop or read a book about creativity to feel the impact of this phenomenon, because it has permeated business, education, and the media, which have regaled us with creative developments of every shape and kind.

In 1980, Barron and Harrington reported that the number of works written on creativity had grown during the previous thirty years from one hundred eighty-six to about seven thousand. Twenty years later, that number has almost certainly doubled. The quantity of works on the subject alone expresses the importance of creativity in our culture. As Lynn White has stated, "the analysis of the nature of creativity is one of the chief intellectual commitments of our age" (1963, 273).

But the character of these writings tells us more. The vast majority of these works presume a common definition of creativity, and this definition has involved a common evaluation as well. Whether the primary focus of these books is art, business, engineering, education, or psychology, *they almost universally advocate creativity*. Virtually every work is as normative as it is descriptive. Every writer seems to view "creativity" as a good, and the types of person and product described as creative are, with few exceptions, recommended to be emulated.

This advocacy is so strong that few have stopped to ask what this says about our society. As we will see more clearly, the concept of creativity is inherently interdisciplinary or transdisciplinary (see Rhodes 1961, 21, Gardner, 1993), and while the books on creativity range from art, literature, and music, to business, education, and psychology, only a handful of writings[8] have considered the subject philosophically, politically, historically, sociologically, or anthropologically. None yet has attempted to do all of this at once. Hardly any has tried to connect theories of creativity with concrete policy issues. And none has attempted the obviously difficult task of carrying out a wide-ranging cultural analysis of the meaning and role of "creativity" in our culture.

This is the goal of my book. It explores creativity from both an historical and a cross-cultural perspective, asking how different cultures have defined and valued what we call "creativity," how social norms and values express creativity, and how creativity competes with other values.[9] To say this makes it sound as if things like "our culture," "creativity," and so on are easily identifiable entities. In truth, even a detailed analysis of society and creativity will necessarily be filled with sweeping generalizations and miss a number of significant elements, because it requires such a broad view of human history. But the broad view is what I intend to offer as a way of going beyond present thinking about creativity.

WHAT IS CREATIVITY?

If I were to try to give a single, precise definition of creativity now, it would be to jump the gun, because investigating ideas about creativity and how they are changing is what this entire book is about. And this investigation is significant precisely because one of the striking things about the advocacy of creativity in American society today is the seeming self-evidence of the word's meaning and importance.

The dictionaries tell us that "creativity" comes from the English word, "create," which derives from the hypothesized Indo-European root, *ker*, *kere* (to grow), via the Latin, *creatio* or *creatus* (to make or grow). The word, "create," ultimately came to mean "bring something new into being." As explained in part one of this book, which details the evolution of the concept, the noun, "creativity," was invented in the late nineteenth century when it seemed to many people that there was something analogous in the work of those in the arts and sciences; the word is an abstraction which presumes that there is some kind of quality which transcends disciplines. Thus, whether we are speaking of the creative "person," "process," or "product," we generally assume a common, interdisciplinary meaning to be expressed.[10]

But is creativity really a single phenomenon? When we use the word, we seem to be intending precisely that. Creativity defines something that the much older words, "create," "creation," and "creative" never did: a special phenomenon that can be abstracted from any particular product or activity and somehow relates all products or activities of a certain kind to each other. Not only does creativeness—whatever it is—seem to be visible in many forms, but also, as Donald MacKinnon has pointed out, "there is remarkable agreement among creative individuals and psychologists as to how the process of creativity is to be described" (1968, 436).

Thus, numerous authors have agreed that there are a few basic components to the creative process. With slight word changes and sometimes with additional stages, analysts of creativity frequently speak of the stages as follows: preparation, incubation, illumination, and elaboration. As Lois Robbins, who adds "frustration" and "communication" to this list says, "it is generally acknowledged . . . that the stages must be gone through every time something is created" (1985, 19-20).

Furthermore, regarding the "creative personality," Barron and Harrington conclude from their lengthy bibliographic review that:

> In general, a fairly stable set of core characteristics (e.g. high valuation of aesthetic qualities in experience, broad interests, attraction to complexity, high energy, independence of judgment, autonomy, intuition, self confidence, ability to resolve antinomies or to accommodate apparently opposite or conflicting traits in one's self concept, and finally, a firm sense of self as "creative") continued to emerge as correlates of creative achievement and activity in many domains (1981, 453).

This consensus about the nature of the creative process and the characteristics of the creative person points to the fact that there is an operating definition of creativity in our culture that rarely seems to require elaboration. In the writings on creativity and in everyday speech, the dominant view of creativity seems to express the following salient features:

1. It involves bringing something new into being.

2. It is possible in virtually any domain of human activity.

3. It is potentially achievable by anyone, anywhere.

Furthermore, this definition implies an evaluation:

4. Creativity is good.

5. Individuals who are creative are open, flexible, willing to take risks.

6. Freedom, democracy, and tolerance encourage greater creativity, and creativity strengthens society.

These notions are so common for many of us as to be obvious, which makes sense if, as I maintain, creativity is an important social value. Nonetheless, a sense of history and of cultural diversity should lead us to understand that this definition is not universally valid, and even among those who adhere to this definition, there is a range of perspectives on it. Creativity is many faced.

This is apparent as soon as we examine the great variety of writings which discuss the subject of creativity. These works range across the following general categories:

• creativity in the arts and literature
• empirical psychological analyses of creativity
• humanistic or transpersonal psychological works on creativity
• creativity exercise books and computer software
• creativity games for children
• how to foster economic innovation
• New Age self-help books
• philosophical-metaphysical essays on creativity
• social psychologies of creativity
• anthropological views of creativity
• how to increase or manage creativity in the workplace
• creativity in the classroom for the gifted and others
• technological invention and scientific discovery
• accounts of the creative process among great "creators"[11]

Finally, in 1999, there appeared an extraordinary *Encyclopedia of Creativity*, which provided articles relating to most of these categories. It is clear from this list

that while creativity in general is assumed to be "the same thing regardless of task or person" (Webb 1987, 20), it is also always creativity in some particular realm of human activity (Gardner, 1993, xiii; 7). Even those who write about creativity in general invariably cite examples from the histories of specific fields, and the broad abstraction implied by creativity may not be too visible. Certainly, creativity in science, art, business, and other realms like parenting or cooking all seems quite different.

There are some other complications as well. Some of us unhesitatingly extend the word, "creativity" to the doings of nature, while others insist that creativity refers only to products of human free will and intention and shall not be confused with evolution.[12] Some forms of creativity seem more playful, some more purposeful, some more spontaneous, and some more methodical. Usually we think of "self-expression" when we think of the arts, and of creative problem-solving when we think of business and science.

In conjunction with this, some authors distinguish between "extrinsically" or "intrinsically" motivated (Amabile), "pure" and "applied" (Scott, 1995), or "expressive" versus "productive" forms of creativity. However, each individual creator may have a number of different, perhaps even conflicting motivations for creating. As John Haggart has said of "innovation," it "has always been stimulated by problems to be overcome, the search for novelty for its own sake, the personal satisfaction of the innovator, and the hope of financial gain" (1983, 179).

Furthermore, one could take either a very broad, inclusive view of creativity, or a much narrower one, targeting only the most outstanding, exemplary cases of accomplishment. There are clearly differences of quality or degree of creativity. Creativity could be a matter of tinkering with something, revising something, reinterpreting something, maintaining something against challenges or breakdown, introducing a new dimension to a field, changing a dominant paradigm in a field, or introducing a whole new realm of human endeavor.

To distinguish between a child's interesting play with the kitchen mop and the invention of the cyclotron, Arieti speaks of "ordinary" versus "great" creativity (1976, 10), and authors like Maslow, Rogers, and Fromm have spoken about a "creative attitude" as opposed to "special talent" creativity. Other theorists, like Hausman, Barzun, and Gardner, have pointed out that the truly outstanding cases of creativity in art and science provide the models by which we understand any other activity as "creative."[13]

In general, whether we're talking about literature, cooking, or computers, we praise as creative that which is new, different, and unique, and generally that which is to some degree good, meaningful, exciting, interesting, helpful, appealing, and/ or technically refined. Calling something "creative" means attributing value to it, and this attribution requires judgment and standards.

In truth, we can barely conceive of creativity except against the background of what it is not. Usually, we distinguish creativity from that which is common,

routine, habitual, repetitive, mass-produced, traditional, and normal. But this usual distinction is itself a habit of our society. The "common," "traditional," and "normal" may be very different from mass-produced and routine . . . in fact, we may see everyday life filled with creative moments and therefore define creativity in the most inclusive terms possible. While some might want to see creativity solely as the work of a handful of extraordinary geniuses, others might say that everyone has creative abilities in some respect. But that is precisely when creativity seems to lose its significance.[14] Where and how are standards to be applied? asks one group in our society. Who are you to judge? asks the other; and the debate goes on. There certainly seems to be some kind of tension between how extraordinary the creative person or thing is and how common we want creativity to be.

Undoubtedly, every definition of "creativity" must proceed from the understanding that the uses of the term are hardly identical but rather, to use William James' and Ludwig Wittgenstein's terms, express "family resemblances" and "overlapping meanings."[15] As this book aims to show, every definition implies a valuation, and every valuation implies a definition. While we might make such a claim about every definition and evaluation, the subject of creativity expresses this in an exceptional way, if we take seriously the notion that it refers to "bringing something new into being"—for every new thing stretches our definitions and the structures within which and against which we evaluate that thing. To be creative, something must be familiar enough to us that we can comprehend and classify it to some degree, but also new enough that we can recognize it as original (Hausman, F. Barron, 1969).

But whether or not we decide to call something creative, it is always important, as many authors have said, to consider the "appropriateness"[16] of the creative act or product, that is, to what extent the novelty represented is useful, desirable, or even comprehensible within a context. Some creations seem stupid or tasteless, some even seem horrific. The desirability of a particular form of originality may be limited to the individual creator or may be shared with millions; it may exist for an hour, or thousands of years; it may work in a comedy but not in politics, in the space shuttle, but not at home. The question is how much people value the work. This evaluation takes place in many ways: personal taste, expert judgments, public opinion, educational curricular decisions, marketplace decisions or government legislation. Of course, the assessment of a creative work's value may change radically between different cultural groups and over time; even within a group, disagreements are common, and individuals change their minds as well—measuring the significance or appropriateness of a creative effort may be very difficult.[17] However, to the extent that people view novelty as appropriate or important to any degree is to attribute *value* to it.

That is why there are nearly endless possibilities for tension and conflict here. Most obviously, the decision whether or not a particular creation is tolerable, let

alone desirable, is subject to much debate. People argue about what is creative and whether one's preferred form of creativity is appropriately valued by society. Things judged to be creative masterpieces by some—a particular painting, a newly patented gene—may provoke outrage in others, and government support, tolerance, or restriction of these creations is a recurrent subject of intense political debate in Iran, France, and China, just as it is in the United States. Despite the considerable differences in these countries' tolerance for different forms of creativity, debate rages in each society about the line to be drawn against the unacceptable and about the amount and direction of government aid to creative projects. Even in the West, the characteristics associated with the creative personality have often been associated with "rebellion" and sometimes "deviance." Other cultures that espouse more collective or traditional values might tolerate such characteristics even less. If "creativity implies radical novelty" as Frank Barron claims (*Creative Person and Process*, 12), this may be very disturbing.

In fact, creativity and tradition seem to be in perpetual conflict—one represents a commitment to the past; the other a push toward the future. All of us inherit the customs and beliefs of our families and societies; we also develop habits and tend to value what is familiar and fear or disdain what is foreign or new (Allport, 1954, 29).[18] In fact, cultural identity and social stability require continuity. At the same time, need, curiosity, imagination, and enthusiasm drive us to invent, explore, and express ourselves in ever new ways.

The preservation of the familiar and the creation of the new thus appear to be powerful, mutually exclusive values. However, fear of the new is probably as common as desire for it; frustration with the status quo as widespread as comfort with the familiar. What is more, no culture ever conforms to an ideal "type," and each is constantly subject to change. As global culture expands, the variations diminish, not only because the Western conception of creativity becomes increasingly dominant, but also because this development has prompted many individuals to seek creative ways of integrating the new *and* the traditional.

The debates go on, but the debate is *not* about the goodness of creativity itself. Despite the conceptual tensions and political differences, most people in Western society and increasing numbers around the world seem to hold creativity as one of their primary values. Our norms of approval, institutional structures, language, and behavior all express the high esteem in which we hold creativity.

At the end of the twentieth century, this enthusiasm for creativity has become part of our familiar social context—but the familiar is the context against which novelty is understood as novelty, and creativity is a social construct. We must understand our context in order to judge something as "creative," and our creativity is every minute changing the context within which we live.[19] The changes are material and attitudinal. Today, in art, science, economics, and other fields, the context is global and rapidly changing. But as the global culture grows, we are entering unfamiliar territory. We know this but can barely begin to describe it.

SOME ASSUMPTIONS IN THIS BOOK'S APPROACH TO CREATIVITY

Difficult as it is to grasp the changes of the present, it is, of course, even harder to envision what will happen in the future. However, our culture's definition of creativity is all about going beyond the present, by imagining, by constructing the future. This is something almost all of us intend to do. I, for one, hope to say something creative about creativity in this book and thereby help some of us approach the future with new perspective.

In order to proceed toward the future, it is important, I believe, to retrace the familiar ground of Western history to see how the concept of "creativity" has evolved and how the ideal of creativity is currently evolving in our global culture. This examination constitutes part one of this book. Part two looks at some divergent cultural approaches toward creativity by examining China, the United States, and some so-called traditional cultures. Part three examines the range of concrete problems which arise when people attempt to practice creativity and how this finds its way into public policy debates. Finally, the conclusion considers how our conception of creativity is changing and encourages a particular understanding of creativity for the future.

Before carrying out this analysis of creativity, I want to acknowledge a number of key assumptions:

1. Since the goal of the historical and cross-cultural sections is to consider how people have conceptualized creativity, I will be looking at what seem to be dominant tendencies of thought. Breaking down thousands of years of the histories of numerous ethnic, religious, racial, linguistic, and national groupings into general categories like, the Renaissance, China, and so on is a convenience and is not to be taken rigidly. In fact, this book emphasizes the commonalities as well as the differences in cultural conceptions of creativity.

2. In making generalizations about what others mean or have meant, I intend this whole book to be understood in terms of "it seems to me." I am keenly aware of the difficulties of a book like this. Not only am I presenting views from the past and their subsequent interpretations, but I am also trying to infer attitudes about creativity from other cultures, even though few of them have had a word which directly translates as "creativity."

3. In looking at how people have valued creativity, I understand that values can be of many kinds: moral, aesthetic, intellectual, economic, physical, spiritual— yet all express measure, hierarchy, or significance, and in a sense, they are all therefore moral valuations, indicating what is most important to people.[20]

4. I accept the common anthropological notions that what people say and do are not necessarily consistent and that to understand or evaluate such a thing as a culture's conception of creativity, we should try to look both at its "high culture,"

and the complex cultural whole, including the people's daily practice, customs, language, technologies, and institutions.

5. Because creativity today is applied to such a wide range of human activities, and because cultural analysis involves the whole of the culture, I have found it essential to proceed in as interdisciplinary a manner as possible. In this book, therefore, I will be studying things from the arts, history, literature, politics, law, psychology, business and economics, science and technology, anthropology, and philosophy. I am an expert in none of these fields; my expertise, such as it is, lies in connecting these diverse subjects. I have asked friends who are more knowledgeable in these fields to help me make sure that my generalizations about their subjects are reasonably accurate. Some details may still be incorrect, but I am trying to paint a big picture here. So, if one corner is a bit fuzzy, please look at the rest.

In a sense, each chapter is written so as to stand alone. As a result, you could probably skip ahead to any chapter in the book and not be confused, though, of course, I believe you will find that the whole of the book is far greater than the sum of the parts. Only by looking at the multiple dimensions of this subject can we assess how creativity has been defined and valued in different cultures, and how this is changing in the crucible of our rapidly growing global culture.

PART ONE

*The Formulation of
the Concept of "Creativity"
in Western History*

CREATIVITY, THE WEST, AND HISTORY

All around us are structural, technological, institutional, artistic, economic, and social creations of the past. From the Brandenburg Concertos to computers, to agriculture, to a custom like shaking hands, forms of life have been invented which have had so much staying power that we take them for granted. It is obvious that they influence who we are and how we create. We have also been shaped by our predecessors' ideas about these changes, and their support or repression of creativity. In other words, despite the focus on "newness" in our current definition of creativity, what we create is against the backdrop of the creations we've inherited, for what we understand creativity to mean has itself evolved through a long tradition.

While all of human history might be viewed as the history of creativity, it is nonetheless probable that neither any past society nor the traditional ones existing today would recognize our concept of "creativity." Examples of early human creativity, which have endured and influenced civilization, such as the invention of the wheel, music, agriculture, writing, and ceramics, were manifestly valued by vast numbers of people in countless generations, but more than that, we cannot always say, because few written records are available to us. How many times did the secrets die with the discoverers before they were preserved? Was there initial societal resistance? Were the inventions immediately attributed to the gods?[1] What did it mean to introduce something "new"?[2]

While we cannot know the answers from the preliterary past, these kinds of questions are what I intend to analyze in this sweeping review of Western history of the past three thousand years. Specific creations will, of course, be mentioned in the following, but only inasmuch as we can infer differences in attitudes or perspectives on creativity expressed in these works.

In many ways, these inferences are a matter of guess work; this is true even when we find explicit statements about creativity, because the views publicly expressed may stand only in loose relation to the actual creativity of a given society. For one thing, the lag time between the introduction of a new idea and its acceptance may have been anywhere from a few days to a few centuries, and once introduced,

techniques and inventions have tended to spread more easily and widely than the scientific or conceptual reasons which had originally led to their development (Needham 1954–1985, I:238-39). Furthermore, the elite literary and philosophical minds of an era (the ones whose views about creativity have been passed down to us) may have had diverse motivations (conscious and unconscious) for what they said. They may or may not have been well acquainted with creators in fields other than their own, and they may have been blinded by a number of prejudices or assumptions.[3] And, of course, their ideas usually determined the community's evaluation of creativity only to the extent that those in power tolerated or encouraged those ideas. Many creators produced brilliant works but never passed on thoughts about creativity or its relative importance in society. According to Socrates, the poets could barely speak intelligently about their own work (Plato, *Apology*, VII: 22). History is filled with examples of powerful groups conquering and subjugating other peoples, destroying or simply disregarding their creations. Thus, for example, it took Europeans four hundred years to begin viewing African sculpture as "art," and even though Spanish invaders were fascinated by the rubber balls used by the Mayans, Europeans took credit for the invention of rubber three hundred years later. Slaves and "free" women as well certainly created beautiful, useful, and important things, but they generally had little opportunity to publicly express themselves. Indeed, the areas of creativity which were valued throughout much of history were areas of activity usually restricted to particular classes of men.

Over and above these complications, the whole idea of writing a history of anything might well be suspect—only a willingness to bracket out vast parts of reality and accept the limitations of one's own placement in history allows one to plunge ahead. And such a plunge is good to take, I think, as long as we recognize its limitations. Whatever else might be the case, it seems indubitable that our concept of creativity has been greatly influenced by the works viewed in past epochs of Western history as unique and also by what was said about those works.

THE WEST

Most people have a pretty clear idea what we mean when we speak of "the West" or "Western culture": the culture of Europe, particularly western Europe, North America, particularly Canada and the United States; Australia and New Zealand also belong to it. This sweeping generalization must be taken with many grains of salt, however. Countries which experienced long-term political-cultural dominance or influence by Europeans (Brazil, South Africa, Israel, perhaps India) might be counted as part of Western culture. For that matter, European influence has been great throughout the world for some centuries. Is Japan's participation in the Organization for Economic Cooperation and Development (OECD) a sign that Japan should be counted as "Western?" Are the poorest and least democratic countries of

Greco - Roman
Judeo - Christian
influences

eastern Europe part of the West simply because they are geographically in Europe and have linguistic and religious links to other European countries? Are all the inhabitants of the unambiguously Western countries (France, Germany, the United States, for example) Western in their attitudes and behavior, despite their diverse class positions, ethnicities and religions?

We do not need to resolve these questions. But most of us today understand "the West" to be both a geographic term and a cultural-political-economic one as well.[4] As I hope to make clear, moreover, our concept of creativity is intimately bound to the West's definition of itself, vague as that definition is.

In this book, I use the expression, "the West," as shorthand to refer to a wide range of phenomena in the realms of art, economics, religion, politics, technology, philosophy, psychology, science, and society which people around the world refer to as Western. One of the distinguishing features of the West is its two thousand year long sense of cultural continuity with ancient Israel and Greece. Following from this bond are ideas of Christianity, capitalism, the scientific method, representative democracy, and historical change which have made Western culture somewhat different from the cultures of China or the Aztecs. *2000 yrs*

To a certain extent, this difference might be thought of as an emphasis on "creativity"—in our contemporary sense of the term. Another distinguishing feature of the West has been its relative economic-military-scientific-technological power for the past few hundred years, which has allowed the West to dominate other cultures.

The history of the West has included a long-standing belief that it is very different from the rest of the world. This difference was usually exaggerated and was often coupled with condescension and hostility. It ignored the debt the West had to other cultures and the degree to which the West was not monolithic, but itself, quite multicultural. Today, many might wonder if the West even exists as a separate reality of any kind. The South Korean business-person and the Ecuadoran concert violinist may carry with them far more of the ideas we associate with the West than does that American truck driver who just went by . . . but if that truck driver also happens to study Chinese martial arts or African drumming on the weekend, then he or she, like the Korean and Ecuadoran, might actually be viewed as a member of the "global culture"[5]—which the West has brought about and continues to dominate.

Part of the history of the West is also, therefore, its key role in transforming the whole world through trade, war, missionizing, tourism, telecommunications, and so on. The result is that we live in an increasingly global society, where the West is, to some degree, everywhere but nowhere. Fifty years from now, one hundred, at the most, I believe, the term, "the West," will have mainly historical reference. For now, the term is helpful in explaining the past and pointing to important current tendencies within the global culture.

In a perhaps less helpful way, "the West" is commonly used by those who feel concerned about the dilution of separate cultures and the rise of a global one. For many nationalists outside of Europe and America, the West is the frightening bogeyman who is corrupting their countries' way of life. For some nationalists in Europe and America, fears of multiculturalism and internationalism have prompted efforts to reassert "traditional (Western) values." It is my contention that these reactions are not only about political and economic power and cultural identity, but also about conceptions of creativity. The Western definition of "creativity" as bringing something new into being and the West's valuation of creativity as "good" have become key elements in the emerging global culture. Resistance to this dominant conception has come from many directions—for example, fear, the desire of locals to retain power, thoughtful concern about tradition and cultural identity. These efforts have, in their way, also helped to modify this dominant conception, even as the world tends more and more to adopt what seems to be a global ideology of creativity.

Therefore, if I devote many pages to the West, it is not necessarily because I consider all the works of the West more creative—who could possibly say that Chartres Cathedral is "more creative" than Ankgor Wat? Rather, it is because my focus is on conceptions of creativity, and it seems to me that it has been the West which has given birth to the term, most debated its meaning, most expanded the opportunities for people to be creative, and most successfully disseminated its conceptions throughout the world. Furthermore, it seems to me that when we speak of "global culture" today, our reference to its multi-sidedness and cultural diversity is an acknowledgement of thousands of cultures in our world, while our reference to the common characteristics of global culture is an acknowledgement, of what the West has influenced or imposed on others. Therefore, while different conceptions of creativity from around the world are noted throughout this book and highlighted in part two, "Cross-cultural Variables," the dominance of Western ideas of creativity in today's global culture means that the evolution of the concept in the West is worthy of special attention.

HISTORICAL ORIGINS OF WESTERN CULTURE

If defining "the West" is difficult, tracing its history is even more so. Western civilization might be said to go back twenty thousand years to the caves at Lascaux, France, or those in the Coa River Valley, Portugal, where stone tools have been found and extraordinary paintings cover the walls, telling us of animals, the hunt, death, and probably religious and sexual matters. Or we might look at Çatal Hüyük in Turkey, or the Divje Babe site in Slovenia, where a bone flute and other artifacts dating back forty-five thousand years were recently discovered. Further back still, the most basic tools, methods of social organization, customs of parenting and

eating, language, strategies for hunting, and so on were developed and passed down throughout prehistoric times, perhaps dating even from early, common, African ancestors.

It is hard to say much about the prehistoric conceptions of creativity beyond the obvious facts that many new things were brought into being and that some human beings considered some creations valuable enough to pass on to following generations. However, numerous myths and legends have been passed down as well, and some of the most important of these myths tell us of how certain things originated. The creation of the cosmos, of humans and animals, of various arts and institutions, have been explained by Germanic, Celtic, Slavic, Etruscan, and other early European peoples in different ways, and these myths have worked their way to some extent into Western culture. This is obvious in the survival of Christmas trees, Easter eggs, the Maypole, and other traditions. It is also visible in certain legal structures, artistic motifs and place names. Remains like Celtic carvings, Scandanavian runes, and Gothic jewelry reveal obvious artisitic creativity, however, it is less obvious how we might decipher conceptions of creativity in the cultures which produced these works.

In truth, the Western cultural inheritance has been strongly influenced by the written word, and the largely oral European cultures were ultimately pushed aside by the literary cultures of ancient Greece and Israel—primarily because of the military power of the Roman Empire and Christianity's successful repression of the indigenous European religions. The glories of Greece, Rome, Israel, and Christianity became the cultural "stuff" of the West and propelled the distinctive Western notions of creativity.

For their part, the Greek and Israelite conceptions of creativity were strongly influenced by traditions from other cultures of the ancient Near East, especially the powerful and literate ones of ancient Egypt and Mesopotamia. These peoples created great empires, invented cuneiform and hieroglyphic writing, made great advances in mathematics and astronomy, invented glass, produced magnificent statues, ceramics, gold work, monuments, cities, systems of irrigation, and much more.[6] Furthermore, the Mesopotamians and Egyptians had many direct interactions with the Greeks and Jews whose writings preserved and passed on these cultures to the West.[7] Indeed, the inhabitants of Europe were long more familiar with the cultures of the ancient Near East than they were with the cultures of the early inhabitants of their own neighborhoods.

If we try to determine some of the most influential of the Mesopotamian and Egyptian ideas about creativity, we should note to begin with that many of the artistic creations of these cultures were painstakenly preserved, given as gifts, pillaged, and/or carefully laid to rest with the dead, and this clearly shows that they were valued. Still, it is difficult to say that these works were valued as "creations." For the most part, they seem to have represented wealth, power, status, or religious

significance. Meanwhile, the status of the creators of these works was relatively low. In Mesopotamia, there were apparently no words for artist or for inventor, and the social status of artisans was, for the most part, just one step above that of slaves. In Mari, for example, the term, *mar ummenim*, referred to "singers, doorkeepers, brewers, scribes, and animal fatteners, as well as various craftsmen"—all the people who had some kind of "skill" regardless of what kind (Mathews, 1995, 455).

In Egypt, artisans had the creator god, Ptah, as their patron, and the status of the human creators may have been somewhat higher. Still, "in pharaonic Egypt, there was no concept of individual creativity marked by the stamp of an 'artist's' unmistakable personality. Instead, other qualities were valued, such as mastery of traditional rules and their correct application and a knowledge of craft techniques that was handed down from generation to generation" (Drenkhahn 1995, 339). Indeed, by 2500 B.C.E. the social structures were "codified" and the artistic canons "set" for the next two thousand years (Schiff 1999, 110–116). In both Egypt and Mesopotamia, of course, the idols of the gods had to be made according to strict formulas, and the creator was understood to be a servant of the divine. Regardless of the subject matter, virtually all paintings and sculptures were anomymous, and except for a few names, we hardly know of any artists, architects, or craftspeople at all. To serve the wishes of the patron, especially a royal one, was apparently a creator's greatest achievement.[8]

Without a doubt, the most important people in the society were the rulers, and the significance attributed to founding a city and establishing laws was great. While this might correspond to our ideas about innovation, it seems that the main point was that the act of establishing or founding something indicated the power of the doer.

This emphasis corresponds to the ancient creation myths of the Sumerians and Akkadians, which tell of the beginnings of the world, and which had a major, though indirect influence on the West, primarily through the ways in which the Hebrew Bible adopted them.[9] In the *Enuma Elish*, the young God, Marduk, defeats Tiamat, the Goddess of watery Chaos; the other gods view Marduk as their savior; dry land and civilization arise. Marduk "fashions artful works": he "creates . . . savage man" to serve the gods; order is established (Speiser 1958, 31–39). This mythical structuring of the cosmos parallels Hammurabi's great historical initiative of codifying the laws, through which the order of society is given (very explicit punishments are prescribed for different classes of people and for particular wrongs). The myth also parallels the achievement of irrigating the area of the Tigris and Euphrates Rivers: stability and solidity replace flooding and arbitrariness. (This order/chaos dualism evolved in late sixth century B.C.E. Persian and Babylonian thought—especially in Zoroastrianism—toward ideas of light and life versus death and darkness and heaven versus hell, notions which carried over into the Bible and beyond.)

Probably the most significant creation from our perspective (for it demarcates prehistory from history), was that of writing (ca. 3200 B.C.E.). According to one Sumerian text, the king of Kullaba (Uruk) was the first to set words on clay tablets. Previously, writing had not existed, "But now, as the sun rose, so it was!" (in Wilford 1999, D2). While it is puzzling how the king wrote without anyone able to read, these lines show that the ancient Mesopotamians, too, recognized the significance of this invention—in fact, the "so it was" echoes descriptions of divine creation. But even if kings could create like gods, that hardly meant that other mortals could do so.

Among the most lasting of Babylonian inventions were astronomy and astrology, the former having considerable influence on Western history, the latter holding great and ongoing appeal despite rejection from Western religious and scientific communities. Astrology might be seen to express a significant feature of the Mesopotamian understanding of creativity: what we humans do is "written in the stars," not invented by us. If our lives are so determined, then we have no responsibility for our actions, and "creativity" in the modern sense of the word would seem to be a near impossibility. Nonetheless, even if many people of this area did feel this way, it did not prevent some of them from creating great works of art, engineering, and statecraft . . . they may have done so in the belief that they were acting in accordance with transcendent forces expressed in the stars.

The Egyptian belief in *matt*, however, meant that one was responsible for one's actions—in fact, it would determine one's rebirth. Indeed, the pyramids were created because rulers took this responsibility so seriously. In general, ideas of creation in Egyptian religion seem to have been directly tied to ideas of death and rebirth; and although ancient Egypt boasted magnificent temples and other monumental work, much of it was dedicated to sheltering royalty in the afterlife (and honoring the gods). The pyramids and the artwork in them (for example, the famed tomb of Tutankhamen), are extremely impressive, and they tell us that the Monarchs who commissioned these works hoped to live in the afterlife surrounded by creations at least as magnificent as the ones they had known in this life. Material beauty and comfort were important; the uniqueness and splendor of the artifacts also seem to have mattered greatly, as in our society. However, since most of the pyramids were in the desert, and since their artistic contents were locked and sealed, it is clear that there was no thought of a popular audience for these creations: they were made for the dead and for the gods only.

The Egyptian dream of rebirth and recreation gave rise to the image of the Phoenix, and this has held great symbolic power for Western culture as well. Indeed, the idea of birth, death, and rebirth seems to be quite a universal one, and myths and rituals about this were common throughout the ancient Near East and Europe as well. Many of these myths and rituals were tied to fertility cults and the planting and

harvest seasons. Ancient sculptures and small carvings from throughout Europe present what probably were "mother goddess" symbols. Creation, in this culture, seems to have meant primarily seasonal fertility, so that the modern sense of creation as bringing something new into being, once and for all, hardly seems present.

These ideas, so briefly noted here, were transmitted to the West and contributed in some major and some minor ways to the Western conception of creativity. Nonetheless, the manner in which Egyptian and Mesopotamian conceptions of creativity were handed on to Europe was scattered and diluted. One reason was that the sole means of translating ancient Egyptian hieroglyphs, the Greek *Rosetta Stone*, was lost and not deciphered until 1822 C.E. For the classical Greeks, the Persian invasion of their country seems to have led them (and subsequently, the Romans) to view the people of Mesopotamia as powerful enemies who had to be resisted, then conquered, rather than as a source of cultural inspiration. While Herodotus expressed admiration for the inventors and creators of ancient Egypt, his historical works received a mixed reception from Greek readers. And the magnificent civilization in Egypt, which awed the Romans in the age of Cleopatra, was sufficiently Hellenized, that Romans continued to honor the Greeks, rather than the Egyptians, as their teachers. In the Bible, moreover, a negative bias against ancient Egypt coexisted with respect for its power, for Jewish abstract monotheism defined itself in sharp opposition to the polytheistic idol worship of Egypt, and the emancipation from slavery celebrated in the Book of Exodus resonated as a distancing from Egypt in almost every way. The same was true regarding the Mesopotamians. What the West initially inherited were these biblical, Greek, and Roman attitudes; then, with the rise of Christianity, many of the beliefs derived from ancient Mesopotamia and Egypt, which smacked of "paganism," were consciously excised from Western culture.

THE BIBLE

THE HEBREW BIBLE: GOD THE CREATOR AND HUMAN DOING

As powerful, long-lasting, and impressive as the Egyptian and Mesopotamian cultures were, their influence on subsequent Western culture was slight compared to that of the numerically, politically, and materially much weaker Jews. This is because Christianity's success in Europe meant that the major creation and focal point of Jewish culture, the Hebrew "Bible,"[1] came to be treated in the West not simply, as it might have been, as a group of odd writings created by a small Near Eastern group, but as Holy Script, inspired or even written by God for all of humanity. The result is that the Hebrew Bible has given the West many of its fundamental ideas about the cosmos, monotheism, justice, love, righteousness, history, salvation, and creativity. This is indicated most strikingly in the Bible's very first sentence, "In the beginning God created heaven and earth," which gave the first book its name: B'reshith (Hebrew, for in the beginning) or Genesis (Greek, for origins). There is probably no other sentence as familiar to so many people as this one, and the impact of these words on Western culture is incalculably great.

According to the Book of Genesis, the Earth was "tohu ve vohu" [usually translated as unformed and void]; God speaks, and the void is transformed. This is presented as a virtually effortless work (like that of Egyptian God, Ptah's creation, but as opposed to the energy expended by the Babylonian God, Marduk, who had to struggle with Tiamat in order to bring order to the earth). The God of the Hebrew Bible is portrayed as speaking, thereby bringing things into being, finding it good, and subsequently giving those things names. After creating "swarms of living creatures," he blesses them, saying, "Be fruitful and multiply." He similarly blesses humans, whom he "creates in his own image." Finally, God looks at all He has made and finds it very good, then rests and blesses the day of resting from creating (Gen. 1:2–4).[2]

Among the notions the West has inherited from this biblical creation story are the following: (1) reverence for the creator, (2) the goodness of the creation,

(3) the idea of creation from void or nothingness (*ex nihilo*), (4) the power of the word to create, (5) the idea that humans are made in the image of God, the creator; (6) and the notion that humans are blessed with the commandment to be fruitful and multiply. Throughout Western history these different but related ideas have been emphasized to greater or lesser degrees and reinterpreted in countless, diverse ways, but the overriding notion that God created the world and that human creativity derives from God have been consistent.

Despite the biblical call for the Jews to be "a nation of priests," there were farmers, shepherds, soldiers, prostitutes, merchants—people from all walks of life—whose concern with creativity probably had most to do with daily survival and whose understanding of Jewish theology was probably quite unsophisticated. Furthermore, it is clear from the archeological sources, Josephus, and the Bible itself, that biblical culture reflects a long, one-thousand-plus-year historical development and that throughout this time, social and political disagreement was common. No doubt Caananite, Phoenician, Babylonian, and Egyptian influences on everyday life and ideas were widespread; the Bible tells of countless instances in which large numbers of Jews were not following the dominant ideology but were instead focused on common local fertility cults and or materialism. Combating these ideas was a key dimension of Biblical theology, which directed attention primarily to morality and monotheism.

Even today, for those who truly believe in the biblical creator God, all human "creation" is, in a sense, derivative: it is only because we are God's creatures that we can create anything at all, and all our creations simply rework the stuff of the original creation within the limits God has established. While justice and mercy have been main attributes of God for Jews, Moslems, and Christians, the overriding reverence for the creator god is a distinguishing feature of the West relative to India, China, Africa, or the Americas.[3]

The earliest biblical perspective on human creativity seems simple: man is made in God's image, and just as He created, humans should procreate. Thus, the primary blessing God gives Abraham is to be "fruitful and multiply," and the sign of the Covenant between God and Abraham is that all the males of the clan be circumcised (Gen. 17).[4] It would seem, then, that our word "creativity," if applied to the world of the Bible, would first and foremost relate to God's creation of the material world, and second, as in many of the other cultures of the ancient Near East, to the biological fertility of that world, including human fertility.[5]

The sacrifice of circumcision is, however, paralleled by a more profoundly theological theme: despite the promise that he will "be fruitful and multiply," Abraham must prove his faith by being willing to sacrifice his dearest creation, Isaac (Gen. 22). Because of this radical act of obedience, Abraham has been viewed by Jews, Christians, and Moslems alike as the "model of faith." Perhaps the point is that, no matter how much we love our own creations, the creative power itself is

more important; since all human fertility or creativity comes from God, we must be ready to sacrifice our creations to serve the Creator God, Himself.

Indeed, all of existence derives from God, and even though humans are "made in His image," the Hebrew Bible makes plain how different human and divine creation are: the word, *bara* (to shape or create) is used almost exclusively in regard to divine activity; when humans are depicted as making something, other verbs are usually used (Eerdmans 1977, 219; Brown, 1979, 135). (This important distinction was maintained for more than two thousand years of Western history.)

It is not merely the case that human power is viewed as more limited than God's, but especially that human creativity *should* be limited—God imposes moral prohibitions on human creativity. The most explicit case is the second commandment (Ex. 20:1–6):

> Thou shalt not make unto thee a graven image, nor any manner of likeness of anything that is in heaven above, or that is in the earth beneath, or that is in the water under the earth; thou shalt not bow down to them or serve them.

This commandment reverberates throughout the Bible. Habakkuk emphasizes that however much gold and silver may cover a "dumb idol," it will have no "breath of spirit" in it (2:18–20); Isaiah says that no matter how beautiful, "graven images . . . profit nothing," and no matter how skilled the craftsman, he must learn "fear and shame" (44:9–11).

The fact that this second commandment was issued while the people were creating the golden calf shows that there was hardly consensus about creation among the Jews as they wandered between Egyptian bondage and the "land of milk and honey." Nor did the tension between doctrine and practice subside: the prophets repeatedly railed against those who created and revered, either literally or figuratively, such idols. When King Ahab and Queen Jezebel turned Israel toward the worship of the Phoenician fertility god, Baal, the Prophet Elijah led the massacre of thousands of apostates.

The second commandment has led to a general, though not continuous or universal taboo against visual images of humans and animals in Judaism, Islam, and some Protestant Christian denominations and to occasional iconoclastic movements in Catholicism and Eastern Orthodox Christianity, but it is not clear that the people of ancient Israel always understood the commandment in this way. Not only do the friezes in the Roman-era synagogue at Dura-Europus attempt to portray biblical history in pictorial form, but Moses creates bronze "seraph" serpents (Num. 21:8–9), and the Ark of the Covenant, itself, was commanded to have sculpted gold cherubim with outspread wings (Ex. 25:18–20). There are, however, extremely few surviving examples of pictorial art from ancient Israel, and it seems clear that the commandment had a dampening effect on creativity in this realm. Indeed, Hezekiah later is depicted as destroying the seraph serpent, called Nehustain, for it was idolized by the people and given offerings (2 Kings 18:4).

In the Tower of Babel story, moreover, God is portrayed as jealous and concerned that humans might create structures of their own design; He does not want them to "reach up to heaven and make a name for themselves" (Gen. 11).[6] This particular passage is quite extraordinary: human power to create is seen as so limitless, that God seems to fear it. At the very least, unbridled human creativity is seen as a cause for concern and something to prevent. While this concern is similar to that expressed when God expels Adam and Eve from the Garden of Eden so that they don't also eat of the Tree of Life (Gen. 3:22–24), the Bible more commonly portrays human ability as far less potent than this passage implies. In Job 38:4, for example, God demands, "Where were you when I laid the foundation of the earth?"

The first important constructions mentioned positively in the Bible—Noah's Ark (Gen. 6:14–21) and the Ark of the Covenant (Ex. 25–26)—are made by humans according to precise divine instructions. Bazalel and Oholiab are singled out as superb craftsmen, but the Torah makes plain that the "wise-hearted" make things as God commands (Ex. 35:30) . . . after all, God made the earth, so He knows best.

Indeed, throughout the Bible God is portrayed as the great architect or builder. Therefore, when humans build, they are to follow God's instructions and "walk in His ways," so that He will help them. Psalm 127:1, for example, warns that "unless the Lord builds the house, those who would build it labor in vain." When Solomon builds the Temple, it is thanks to the "wisdom and exceeding understanding" given him by God (1 Kings 6:12).[7]

> As magnificent as the Temple itself is, the physical structure alone will not guarantee God's presence: As for this house which you are building, if you will walk in my statutes, and execute my ordinances, and keep all my commandments to walk in them, then I will establish my word with you. . . . (I Kings 6:11ff)

And Jeremiah 22:13 warns those who fail to follow this path in all walks of life: "Woe to him that builds his house by unrighteousness." That is why Wisdom, conceived as both human wisdom and a divine, creative force, is called "the first work of God's creation" (Pr. 8:22–25).

In general, "creativity" in the Bible is important only when it is used to serve God, as in the building of the Temple. Thus, when Moses and Miriam lead the people in song during the Exodus (15), or when David plays the lyre and sings in the Psalms, or when the Levitical singers and musicians celebrate (2 Chr. 5:12), the lyrics are always dedicated to God. The songs seem to be new compositions, but their themes are not. The sufferings of the people or of the individual; their alienation; their prayers for God's aid; God's victories over Pharoah's soldiers and over the serpent, Leviathan; God's saving of the people; and their thankfulness, echo throughout the Bible and in many instances closely parallel other ancient Near Eastern songs and prayers. The Exodus escape from the pursuing Egyptian armies was a unique

historical event, so dramatic that the people afterward gathered in mass celebration. They danced and sang God's praises in words that directly address the event but that are also formulaic and traditional: "Sing to the Lord, for he has triumphed gloriously: the horse and the rider he has thrown into the sea" (Ex. 15).

Creativity as we use the word—coming up with an original idea and bringing something new into being—is mentioned in the biblical tradition but rarely. When it is, it is of minimal importance, unless it is a specific creation glorifying God or done according to his commandments. In any case, it is not conceived of as "new." This is because throughout the Bible, it is God who is "the Creator." This Creator God explicitly gives humans the freedom to choose, but he also tells them that their fruitfulness is entirely dependent upon choosing to follow His ways (Deut. 30:15–19).

While generations of Jews and Christians have been convinced of the consistent, unified message of the Bible, they have also given voice to innumerable interpretations of it; the different books of the Hebrew Bible and Christian New Testament express diverse ideas, and even within individual books, multiple perspectives on creativity often seem to coexist. For example, Ecclesiastes (or Koholeth) describes a man's "great works"—the houses he built, the gardens he planted—and states clearly that "there is nothing better than that man should rejoice in his works," for to do so is "a gift of God" (2:4–5, 3:22, 5–19). In fact, he says, one should enjoy life fully (9:9-10). While this seems as affirmative of life and of human creativity as possible, Ecclesiastes also insists that there is no end to creating—"of making many books there is no end"—and that all human striving is "vanity, nothing but vanity" (12:12, 12, 8). Ultimately, there is "nothing new under the sun" (1:9).

> Then I looked on all the works that my hands had wrought, and on the labor that I had labored to do, and behold, all was vanity and a striving after wind, and there was no profit under the sun (2:11).

Interestingly, too, one passage of the Song of Songs likens God to a fine craftsman, who has fashioned "the roundings of thy thighs like jewels" (7:2). This book of the Bible, which apparently caused theological discomfort to centuries of Jews and Christians alike, is so sensuous that according to the Talmud, only the advanced students would be able to see that it is about reverence for God and not about reverence for his creatures. Indeed, for the craftsman to be the model, and for God to be likened to him, reverses what has been called the "Divine Analogy," the model which otherwise completely dominates the biblical view of creation and creativity: that we are made in His image. This is not exactly a reversal, however, since God is repeatedly anthropomorphized in the Bible, and humans have His image. Indeed, in one line of Talmudic interpretation, truly righteous human beings are capable of creating new creatures (*golem*) and even a new world (Yezirah, Sanh. 65b). While this idea, which provided inspiration for a whole genre of later Western film and

literature, seems even more audacious than building the Tower of Babel, the point is clearly that humans are capable of creating great works only in extreme piety and righteousness.

But again, this dramatic creation is possible only for those who follow God's ways. Indeed, the great creativity expressed in the thousands of pages of Mishnah, Midrash, and Talmud is focused entirely on interpreting and reinterpreting the content of the Bible and attempting to apply the commandments and ideals to the changed social-historical circumstances in which Jews found themselves. This kind of creativity was displayed dramatically in the ability of Rabbi Yochanan ben Zakkai and others to restructure Judaism in Yavneh, after the destruction of the Temple, providing a model for the continuity of the religion throughout the Diaspora (Neusner, 1975; Kamenetz 1994, 107).[8]

THE CHRISTIAN NEW TESTAMENT

As the Biblical prophets repeatedly emphasized, however, genuine righteousness is hard to find; indeed, humankind has sullied its divine image, and God will need to restore balance. In Isaiah 66:22–23, in fact, God is "about to create new heavens and a new earth . . . about to create Jerusalem as a joy, and its people as a delight." Here is one of the earliest and clearest examples of a figurative understanding of creativity.

In the New Testament, these ideas are carried further. Human degradation is nearly absolute, for we have all "fallen" on account of "Adam's sin" (Romans 5:14, 1 Corinthians 15:21–22). However, just as Abraham was willing to sacrifice his first-born son in order to obey God, God is portrayed as willing to sacrifice "his only begotten son," Jesus, because He loves us and will have us to return to Him. Through the Crucifixion of Jesus, we are cleansed of our sins and the world is restored; through his death, we are recreated and eternal life will be ours.

Indeed, in the Gospel of John, Jesus is the eternal word through whom God first created.

> In the beginning was the Word, and the Word was with God, and the Word was God. He was in the beginning with God; all things were made through him, and without him was not anything made that was made. In him was life, and life was the light of men (John 1:1–4).

Here, creating, the Word, light, life, God, and Jesus are merged. Historical time collapses, as the saving grace of Jesus' life and the original creation of the world are united. The creation is not merely a physical one, but a spiritual one: "the true light that enlightens every man was coming into the world" (John 1:9).

In the Gospels, Jesus Christ is "the New Creation," and anyone who is "in Christ" is, through mystical participation, "a new creature, the old things are passed away, and all things are made new" (2 Cor. 5:17). Jesus is "the way, the truth, and the light" (John 14:6), and we are recreated through him, and thereby reconnected

with God. That alone is important. Aside from the prologue to the Gospel of John, God's original creation is presented as incomplete, and in a sense, inadequate, for human sin has managed to spoil it. But "new things" will replace the old, says Paul, and "the creation itself will be set free from its bondage to decay" (2 Cor. 5:16–18; Rom. 8:21). Following Isaiah, the Book of Revelations revises the original Creation portrayed in Genesis. Revelations envisions the old world as having passed away, and in its place "a new heaven and a new earth" are brought into being. In this new creation, no new temple will be built, for God is the temple and will dwell directly with men (Rev. 21:22). Here the common Near Eastern (and practically universal) idea of birth-death-rebirth is adapted but transformed: the rebirth is primarily spiritual, not biological, and once it occurs, it is complete and forever.

Throughout the New Testament and certainly in this prophecy of the future kingdom, human "creativity," in the sense of multiplying the generations, let alone bringing about anything new in the realms of art, literature, technology, or politics, seems to have no place whatsoever. Repeatedly, Jesus calls on his listeners to give up their possessions and lose their lives, and to seek their treasures not on Earth, but in Heaven. We should not "toil and spin" but be like the lilies of the field. Human creations which receive attention in the New Testament are often blasphemous ones, like the idol of Artemis, which Paul denounces, or the books of magic which converts burn (Acts 19:11–26). In an important sense, too, the Original Sin of Adam and Eve is viewed not just as their wilful disobedience of God's command, but also as their submission to the lure of curiosity. The task for humans is not to succumb to curiosity, not to make new things, not to try to be creative in the modern sense of the word, but to believe and obey, to have faith in God and the recreation of existence through Christ.

And there have been millions throughout Western history who have had this kind of faith, and this has determined how they have conceived of creativity. Those who have believed in this way have probably been the strongest opponents within the West of the otherwise dominant ideology of creativity.

For the believer, even a contemporary one, prophets like Isaiah are seldom viewed as "creative"; rather, they are held to be the mouthpiece of God. The Psalms, directly attributed to David, and the letters of the New Testament attributed to Paul might be viewed as creative. Paul in fact says that he may be "like a master builder," but he insists that the work he does is entirely "according to the commission God has given" him . . . " we are fellow workers for God" (1 Cor. 3:9–10). Understandably then, many "believers" would not be willing to call Moses, Jesus, or the Bible itself creative. Nor would many such believers aspire to be "creative." Instead, their ideal would be to follow as obediently as possible what they understand to be the teachings of the "Holy Bible." While critics might view these people as exercising their own interpretive powers, some fundamentalist Christians claim to adhere to the literal word of God.

On the other hand, millions of other Christians have found the words of the New Testament to be an inspiration toward creativity and freedom. Saint Paul's

repeated claim that Jesus "frees us from the constraint of the law to follow the ways of the spirit" has often been interpreted as a key to liberation. According to Paul, in fact, "in Christ Jesus you are all children of God through faith"; indeed, women as well as men, people of all classes and all nationalities are now equally children of God (Gal. 3:26–28). We will no longer be slaves to sin or to the flesh or even to the law (which we have needed because of our sin), but will be free in faith and grace in Christ. Although Paul repeatedly warns about misconstruing this freedom as license, his words have clearly led many to a sense of spiritual emancipation and even to theologies of social-political liberation. Certainly, the whole idea of resurrection has given hope to millions.[9]

Indeed, this message of hope might be seen to permeate the Bible: the slaves shall be freed; those wandering in the desert will find the land of milk and honey; the humble shall inherit the earth; the righteous shall be redeemed; and paradise shall be regained. Such hope, extended to all who are righteous, faithful, chosen, or simply human, might provide a far greater impetus to creativity than a belief in fate, eternal return of the same, fixed class distinctions, and so on. Nonetheless, the biblical message of hope is generally reserved for those who obey God, fear Him, or are united with Him in Christ, thereby circumscribing the manner and scope of creativity.

For those who consider the books of the Bible the fruit of human creativity, the whole text might appear as fantastic nonsense, or on the other hand, as an extraordinarily great work. In truth, the Bible not only overshadows every other creative effort of the ancient society that produced it, but has also spurred all manner of creativity in the subsequent evolution of the West.

It is impossible to think of the creations of Western culture without their biblical influences. This is true not only for all the art, literature, and thought directly focused on biblical subject matter, but also for the deep and lasting impressions of the core ideas of the importance of the creator, the power of the word, the progress of history, and the bringing of something new into being.

Furthermore, works like Isaiah and the Book of Revelations seem to be exceptionally imaginative. They are filled with metaphors and symbols, sometimes so cryptic, that the most creative skills of interpretation are called for to understand them. In point of fact, one invaluable influence on later creativity was the biblical use of analogy (Song of Songs, the Prophets, Psalms), and parables (the Gospels). These examples of divergent and associative thinking[10] allowed Talmudic scholars, Philo Judaeus of Alexandria and then Islamic scholars to accept the idea of multiple possible interpretations of revered texts. Jesus' (and Jeremiah's) words calling us to focus on the "spirit," rather than the "letter" of the law, also stimulated the interpretive efforts of the church fathers, and later Christian thinkers distinguished several ways to read a holy text: the literal, the analogical, and the spiritual.

CHAPTER THREE

ANCIENT GREECE AND ROME

Since the Renaissance, Western culture has looked upon ancient Greece as a singularly creative society, responsible for inventing or significantly shaping our understanding of the sciences, politics, philosophy, drama, poetry, sculpture. And some ancient Greek thinkers seem to have thought of their culture in a similar light. Pericles, for example, is quoted by Thucydides as praising the Athenians for being brave, independent, politically aware, friendly, and creative. They love what is beautiful, love the things of the mind, know how to take risks, and can judge what they are doing. "Taking everything together, then," Pericles says, "I declare that our city is an education to Greece . . . " (1954, 147). And for two thousand years, great creators of this culture, such as Aristotle, Plato, Sophocles have played a major role in educating the West and shaping our ideas of creativity.

Nonetheless, we should be clear that Greek culture was never homogeneous and that the dramatic flourishing of Athenian art and philosophy lasted only a few generations. Furthermore, however creative Athenians and other Greeks may have been, they did not have an overarching concept of creativity in the sense that we do.[1] While the Greeks invented a great deal, Greek ideals generally called for people to follow tradition and the gods, not to invent something new. Even if it is true, as M. L. West has said, that Hesiod and others consciously invented some of the Greek gods—including the goddesses of invention, the Muses—it is still the case that Greek drama and poetry, and no doubt popular life, as well, were filled with the belief that the gods intervened in and controlled human destinies. This surely implies a limited view of what and how humans could create. Still, the matter is complex: the Greek classics have managed to provide fodder for countless debates among generations of Western readers who have tried to figure out to what extent the heroes of epics or tragedies were responsible for their actions and to what extent they were tools of the gods.

And this has direct bearing on Greek ideas about creativity. Homer, for example, says "all men owe honor to the poets," because they are "dearest to the muse" (*Odyssey* 8: 478), and he attributes his own poetry to the divine in his frequent

appeals to the Muse to inspire him. Those of us who no longer believe in the Greek gods are inclined to view Homer (or those we call Homer) as personally responsible for his poems and therefore as creative—but he seems to say that the goddess is the creative one, not he; his claim to fame is only that he is "dear to the muse."[2]

Interestingly, while Homer seems to minimize his own creativity, he calls Odysseus the "master of invention" (358), a great strategist, and a superb weaver of stories (239); Homer also presents Odysseus as conceiving and crafting, without the help of the gods, the magnificent bed he and Penelope share. However, the gods seem to determine, or at least guide, almost all of the human action in both the *Iliad* and the *Odyssey*. In the *Iliad*, moreover, the most important material creation, the glorious shield of Akhilleus, is crafted directly by Hephaestus, the god of the smithy. The shield is decorated with images of all of human life—birth, death, crafts, love, and so on. The images seem to say: "This is how it is, how it has been, and how it will always be"—a sense of fated, eternal return, which is also indicated by the larger stories of both the *Iliad* and the *Odyssey*. Odysseus himself says, "Our lot from youth to old age was given us by Zeus: danger and war to wind upon the spindle of our years until we die to the last man" (Bk XIV: 89ff). In this world view, bringing something new into being does not seem particularly important . . . after all the fighting in the *Iliad* and all the wandering in the *Odyssey*, Odysseus' return home is what matters.

The later "invention" of philosophy and science by Greek thinkers might be viewed as breaking with this cyclical perspective. The new way of theorizing consisted in asking about the causes or first principles of things and coming up with natural, materialist, or abstract answers, as opposed to anthropomorphic, mythological ones. For these thinkers, air, earth, fire, and water were at least as significant forces in the world as any gods. Both the questioning approach and the concern with origins relate to creativity. For Thales and others, however, the cosmos is eternal, and "nothing is either generated or annihilated." Parmenides also believed that all was one and eternal; he did, however, say that Love was the first God and created male and female and that fire and earth are causes as well (Aristotle, *Metaphysics* 1.3; 983b7; Hippolytus, *Phil.* 11, Dox 564 in Nahm 1967, 118, 120, 61, etc.). Heraclitus perhaps contributed the most to modern cosmological views with his belief that all is continuously changing, becoming, and dying. Creative generation and destruction are eternal (Nahm, 1967, 89–97).[3]

To a great extent, however, the Greek ideas which later merged with biblical ones and thereby helped to shape subsequent western thinking on creativity came chiefly from Plato and Aristotle. Unlike the portrayal of God in the Hebrew Bible, Plato's creator of the cosmos is described as a "demiurge" who works upon preexisting material and *makes* (*techne*) the world according to the eternal ideas. According to Plato, only by making something following eternal, unchanging models will anyone accomplish something good and beautiful (*Timeus*, 28.a–c).

In the *Symposium*, Plato follows Parmenides and attributes all begetting and bringing forth to the creative power of the god of Love (or Beauty), and says that "in every art and craft the artist and craftsman who work under the direction of this same god achieve the brightest fame . . ." (197a, 178b, 206b). This implies conscious intention, at least, but elsewhere, Plato insists that the great works of the poets are entirely the inventions of the divine Muses. They possess the poets, leaving them bereft of reason, but inspiring them to make things they otherwise could not through mere human skill (*Ion*, 534; cf. also *Laws*, 719). The poets therefore bear limited responsibility for their work.

Moreover, according to Plato, all the arts (painting, poetry, music, dancing, and sculpture) are imitations of nature (or life), as if in a mirror (*mimesis*). Since nature, crafted by the demiurge, is already an imitation of the eternal ideas, the arts are merely imitations of the imitation, and therefore "far removed from the truth" (*Republic* X: 597–98).

For Plato, philosophical reasoning toward Truth is unquestionably superior to being possessed by the gods or being immersed in baser, material things. While in the *Symposium* he seems to say that one can rise up through successive appearances of beauty to behold the eternal (211), he says in the *Republic* that the imitative artist produces without thought of good or bad, distorts the truth, and can easily lead people astray by stirring their emotions. In fact, poets must therefore be excluded from the state (X: 602, 606–07)! In other words, to the extent that an artist makes up something new, he is potentially dangerous to society, or immoral. Whether the artist knows it or not, he is simply imitating the semblance of the eternal idea. "If he had genuine knowledge of the things he imitates, he would far rather devote himself to the real things . . . and would endeavor to leave after him many noble deeds and works . . ." (X: 599).

The value Plato puts on deeds and works is a slight variation on the praise of "words and deeds" in Homer and Pericles (Homer IX:39; Thucydides, II:40), and the goal of leaving a record of noble deeds seems as if it must have been a major motivation of creativity in Greek culture.[4] However, many things that appear to us to be "creative" would not be called that by Plato. Apparently, when Eudoxus and Archytas developed mechanical engineering, Plato was outraged that the abstract purity of geometry would be turned to such mundane purposes (Plutarch 1952, 99). Furthermore, Plato would almost definitely not have viewed as creative his own elaborately worked out utopian vision of the *Republic* and the allegory of the cave within it. For him, philosophy was a matter of reasoning about and discussing eternal truth, so that to imply that he was "bringing something new into being" probably would have been insulting to him. He did not even claim it as his own creation, but rather put his words in the mouth of Socrates. In a sense, then, Plato's *Republic*, as original as it seems, shares with most of the great works of Homer and others in Greek society an attribution to precedent, or to divine inspiration or

command. Indeed, Plato went so far as to propound the idea that all true knowledge is recollection from previous lives (*Meno*), a doctrine hardly compatible with creating something new. *Teachers only help recall*

On the other hand, neither Plato nor Greek culture in general was so single-minded. In his *Laws*, written at the end of his life, Plato implies that painting, music, medicine, and statecraft are valuable arts (889), and that it is natural for the soul to practice them. In the *Symposium*, the "love of what is lovely"—shown in the creative arts—is called a "blessing" (1976). What is more, throughout his writings he/Socrates asks others to "imagine" and to "envision"; he uses allegory and analogy, and even myths of his own making. This kind of creativity seems self-conscious and intentional.

Aristotle, while adopting Plato's mimetic theory of art, abandoned the notion of Eternal Ideas and therefore valued the artist's and poet's imitation of life or nature much more highly. Aristotle frequently mentions artists and inventors by name and says that "the products of the arts have their goodness in themselves" (*Nic. Ethics* II:4). Tragic drama, in particular, imitates human actions and emotions in a serious light and may provide pleasure by portraying moral purpose of the characters (*Poetics*, 6). Aristotle maintains that imitation, harmony, and rhythm are "natural to us," and that "it is also natural for us to delight in works of imitation," particularly "the most realistic representations" of things, for we learn from them (4). In contrast to Plato's notion of human creations determined by divine inspiration or possession, Aristotle says that "it was through their original aptitude [for imitation and harmony] and by a series of improvements for the most part gradual on their first efforts, that they created poetry out of their improvisations" (4).

However, improvisation is not Aristotle's focus as much as the means of achieving "gradual improvements"; he therefore presents rational "rules" for the construction of drama and epic poetry (*Poetics*; Nahm, 1956, 47).[5] In general, Aristotle was intent upon classifying and categorizing most things in the world, including human activities and ways of knowing. For him, the dramatic and poetic arts hold a special place, but they are still *poetike*—productive activities, like sculpture, but also like any other craft, including shoe making and house building—they all involve *techne*, that is, skills which can be acquired by practice and which can be taught. In fact, Aristotle says of these skills that "once a good outline is made . . . , anyone can fill in the gaps" (*Ethics* I: 7:22.25). While *techne* was later translated as *art* into Latin, our concept of art definitely involves a far stronger sense of spontaneity and bringing something new into being. Because these skills are, for Aristotle, imitative (good drama imitates human action and emotion), they do not, strictly speaking, bring something new into being.[6]

On the other hand, Aristotle sees all of existence as being in motion, always striving to transform potentiality into actuality; all is caused (though not exactly "created") by the "unmoved mover," and, in human beings, all moves toward the

divine realm of thought thinking itself (*Physics* VIII, *Metaphysics* A). Humans have within themselves—in their souls—a principle of origination (*arche*) which allows them to act. An action is not like an art or skill; an action is not something that was there before; it comes into being uniquely on its own and is its own end (*Ethics* IX.9.29, Metap. Theta. 8, 1050a8–11). Therefore, while productive activities work on preexistent material according to systematized rules, activities like political decision making are, according to Aristotle, new and original. So even though Aristotle generalizes about ethical and political activities and advocates ideals of virtue, he emphasizes that he cannot provide an "exact science" in this realm. Following Homer, Plato, and Pericles, Aristotle identifies the realm of action, particularly ethical-political action, as the most creative sphere of human endeavor.

Aristotle's conception of the creative character of political action and ethical decision making has played a key role in later Western thinking about government, and in fact about the entire realm we call "the social sciences." His ideas also fit fairly well with twentieth century notions of creativity and seem extremely insightful in that respect. On the other hand, the dominant Western ideas about creativity from the Renaissance until quite recently largely viewed politics and ethics as realms of power and virtue, while discussion of what we call creativity focused instead on the arts and poetry . . . which Aristotle considered skills. Furthermore, even Aristotle's emphasis on the initiative involved in politics doesn't exactly equate with modern thinking. He assumed that the best actions would fit with custom and tradition and would follow the path of moderation as determined by reason.

Aristotle's belief in rational rules echoed that of Pythagoras, who had taught that all the things of the senses, from musical harmony to the human body, follow arithmetical ratios (Nahm, *Selections*, 68). And this was displayed in Greek architecture and sculpture; Doric and Ionic columns, temple construction, the sculpting of the human figure all followed exact rules of mathematical proportion. The classic Greek architectural orders became "classical" because they were imitated so faithfully well into Roman times; Polyclitus' fifth-century sculpture of a young athlete, Doryphorus, became a model of anatomical proportion for almost all Greek and Roman sculptors (Boorstin 1993, 100).

There are certainly ways in which ancient Greece seemed to honor what we think of as creativity. In addition to Aristotle's emphasis on creative action and Homer's praise of Odysseus' stratagems, many other things might be said to attest to this: the pivotal role of Penelope's weaving and Odysseus' carpentry in the *Odyssey*; the love of metaphor in Homer and of parable in Aesop's fables; the annual celebration and competition of the dramatic arts at the festival of Dionysus in Athens; the myths of Orpheus, the musician; Pericles' speech; appreciation for the innovations in sculpture from the time of Kritios' *boy* to Lysippus' *Apoxyomenos*; great admiration for the paintings of Apelles; the founding of the philosophical Academy by Plato; the first civic painting gallery, the Pinakothekon (dedicated to

the Gods); the careful preservation of the philosophical, poetic, and dramatic writings of the age; the fact that the inventors of various arts or founders of various cities were often described as divine or semidivine.

On the other hand, the creative works of women and slaves were barely recognized as important, and the human activities viewed as most important—philosophy, politics, military and athletic prowess, and religious devotion—were not generally viewed as creative in our sense of the word. Those who produced sculpture, pottery, and many other crafts (techne), were viewed as skilled artisans but not creative and were not given much social status (Herodotus II:167).[7] Most likely, the social stratification of Greek culture was a significant determinant in the culture's understanding of creativity: while nobles could, when they chose, engage in the kind of productive activities that slaves, women, and craftspeople carried out, the male upper class alone, properly speaking, initiated the kinds of "words and deeds" which Homer, Aristotle, and the others so praised. Greece was a limited democracy at best.

Furthermore, however influential Greek philosophy has been in Western cultural history, religious belief was doubtless much more deeply rooted in the general population of ancient Greece. Rituals like the Eleusinian Mysteries were clearly important. Because the initiates into the mysteries were sworn to secrecy, not that much is known about the details, but we do know that the ritual was practiced for about a thousand years and that it became integrated into an annual celebration in Athens which honored the goddesses Demeter and Persephone, agricultural fertility, death, rebirth, and the seasons. Presumably, the initiates imitated Persephone's autumnal descent to the underworld, where she had to stay with Hades. Her mother Demeter mourns during her daughter's winter absence, and therefore, nothing grows. Persephone's ascension and reunification with her mother means springtime fertility and rejoicing. The Eleusinian Mysteries speak of the sacred power of the repetition of the seasons, of sacrifice, of cyclical fertility. No doubt reverence for the traditional gods and a belief that human activity is subject to fate were widespread in ancient Greece.

Certainly, Greek legend strongly emphasized that "pride goes before a fall" and that creativity needs to be limited. Daedalus, portrayed in legend as an ingenious inventor, lost his son, Icarus, because he tried to fly too high. Oedipus, who cleverly solved the riddle of the Sphinx, was nonetheless humbled by the gods. Socrates lost his life because of his inquiries. Pandora even gets blamed for causing all the world's troubles because of her curiosity. In Sophocles' *Antigone*, the chorus sings that of all the "wonders that walk the world . . . none [is a] match for man." But however "ingenious" a person is, he will be "cast out" if he does not follow the laws of the community and the gods (77:406–415). What is more, however much we strive, "fortune lifts and fortune falls the lucky and unlucky every day" (119:1276).

Clearly, a world view as focused on "fate" as the Greek one must have had a very different conception of creativity from ours. Those who create are ordained to; those who fail are similarly ordained. While moderns tend to venerate Antigone as

a rebel (See Jean Anouihl's play of the same name), Greek audiences probably agreed far more with the chorus (Knox 1984, 3). And yet the ancient Greeks awarded prizes and celebrated the creativity of dramatists like Sophocles, despite this belief in fate and despite the fact that he adapted traditional mythic material and dedicated his plays to the god of the festival, Dionysus. Somehow, there was a dissonance between the admiration Greek society felt for creators like Sophocles and the content of their creations, or perhaps the ambivalence is inherent in Greek drama, itself, where characters are portrayed as heroic individuals facing their tragic destinies. If so, their creativity consists in how they deal with their fates.[8]

The one realm in which this mold was intentionally broken was that of comic theater. While the tragic poets "interpreted and embellished" the ancient myths they were handed, the comic playwrights, like Aristophanes, created their own worlds. In fact, a major aspect of Greek comedy was its lampooning of society by turning everything upside-down. That is why Aristophanes' play, *Lysistrata*, is so bawdy, makes a fool of Socrates, and gives women the power to determine politics.[9]

This fantasy was humorous for the Greeks no doubt because it countered their sense of reality. The life of the masses must have been relatively tragic, and it must have been appealing for them to witness the humbling of the nobility in the theater and to believe that this tragedy was fated. At the same time, the Greek tragic dramatists portrayed this so superbly, that their work has been treated for centuries as archetypically creative. Greek dramatic writing conveys exceptional depth and complexity of emotion, and this was apparently perceived by Greeks as the ultimate representation of reality. Following this trend, and in many respects matching it, came the striking Hellenistic sculptures of *The Dying Gaul* and *Laocoon*, and the later Greek and Roman portrait busts of the first and second centuries B.C.[10]

The sense of tragedy, the encounters with other cultures through the Alexandrian Empire, and the overpowering of Greece by Rome all no doubt strengthened the approach to history writing emphasized by Herodotus and Thucydides. While they were far from careful with their sources of information, they surpassed previously recorded royal chronologies by questioning authorities, comparing different accounts of events, and offering what they felt were "probable" assessments of what happened. The ideas of historical change and historical interpretation reinforced attention toward human (as opposed to divine) initiative in shaping human events. This found clear expression in Alexander the Great's creation of a cosmopolitan, multicultural empire and the creation of the first "museum" in Alexandria, Egypt. This institution apparently combined a number of features of what we might consider a museum, library, planetarium, salon, and university in an environment in which the creations and discoveries of the past helped contemporary scholars and poets be more attuned to the Muses.[11]

It makes sense that an era of transition would stimulate a desire to preserve the past and to focus on the future as well. In addition to the rise of Rome, which

came to rule Greece and most of the Mediterranean, and religious ferment within Judaism which would soon give rise to Christianity and the Talmud, several interesting developments occurred which indicate how creativity was consciously valued. First, tourism, which had been a form of activity since before Herodotus, became common among certain Romans; Second, Pausanias and others reported back to Rome about the great significance of Greek culture and what creations were of particular value; third, places like Delphi began to produce souvenir artifacts we might describe as *kitsch*; four, Romans not only took impressive objects from conquered peoples as conquerors had done before, but they also collected artifacts as *creations*, bought, sold them, and copied them. These changes were a matter of degree, not kind, but they clearly show an open-mindedness toward other cultures' creations, even towards ones whose traditions and religions were not necessarily related to those of the Romans. They also show a greater degree of commodification of creations.

ANCIENT ROME

While the Romans quickly identified the Greek gods with their own and incorporated statues of Greek gods as idols in their temples, it is also plain that the Romans appreciated, even revered, the Greek works (and some Egyptian ones) as artistic creations. The first century B.C.E. architect, Vitruvius, in fact, scorned his contemporary Romans' works as vastly inferior to the "true artistic excellence of the Greeks" (Boorstin 1993, 106). Pliny the Elder's *Natural History* singles out such Greek sculptors as Lysippus, Phidias, and Praxiteles as models, and schools of Roman sculptors busied themselves making copies of the Greek originals for avid patrons. However, neither the copyists nor the more original Roman sculptors were viewed as important creators of any kind, and their social status was relatively low. Patrons decided what and how a work should be carried out, and the result often served to gratify the patron's vanity. "Roman art was not art for art's sake" (Kleiner 1992, 6:2–12).

Roman appreciation for creativity in architecture and engineering certainly seems to have been much greater than in sculpture or painting. In his influential *De architectura*, Vitruvius claimed that architecture was the most comprehensive of the liberal arts; he attempted to "disclose all the principles of the art" by showing that the Greek architectural orders revealed perfect proportion and symmetry which expressed the exact measurements of the human body (Boorstin 1993, 101–106). The greatest architectural feats were, therefore, those which imitated nature most exactly.

Architects such as those who designed the huge Domus Aurea with its revolving ceiling and the magnificent Forum of Trajan—Severus, Celer, and Apollodorus of Damascus—were recognized and applauded (Kleiner 1992, 15). Apollodorus was

in fact respected enough that he apparently could insult the Emperor Hadrian's own architectural designs and still be sought out for advice (though later, he was put to death). Hadrian, described by Tertullian as the "explorer of everything interesting," (Boorstin 1993, 120–124) ordered the rebuilding of the extraordinary Pantheon, which was made primarily of concrete, faced with brick and mosaic, and topped by a rotunda about 150 feet in height and diameter.

Most of us would agree with H. W. Janson, when he says, "Roman architecture is a creative feat of such magnitude as to silence all doubt about its originality" (156). Anyone who visits the Forum and the Pantheon cannot help but be awed—just as the ancients were. The Romans were justifiably proud of their engineering achievements. Radiating out from the golden milestone on the Forum were more than fifty thousand miles of Roman roads. Roman bridges and aqueducts impressed contemporaries and continue to impress us today. These accomplishments were bound to modify, somewhat, conceptions of what counted as creative. Thus, Plutarch, the Greek writer who celebrated both Roman and Greek men in his *Parallel Lives*, continues the Greek tradition of praising abstract theorizing but adopts the stronger Roman admiration for practical inventiveness. He devotes several pages to the brilliant military devices created by the otherwise theoretically inclined Archimedes and says that his "inventions had earned him a reputation for almost superhuman intellectual power" among the Romans (102).

We today also greatly admire the organizational talents of the Romans. Applied to warfare, these talents enabled the Romans to conquer parts of three continents. The administrative bureaucracy and laws they developed for their far-flung empire were extraordinary, and the Romans knew it. At the same time, the Romans were even more concerned than the Greeks with origins and the founding of their city. Their arguably greatest written work, Virgil's *Aeneid*, and, of course, the story of Romulus and Remus, show this clearly.

In terms of the Roman conceptualizations of creativity, it is important to recall that the word we use is a Latin one, creation or *creatio* (to make, produce, or grow); but the word was apparently used more for biological fruitfulness than anything else, while *ars, artis* was much more commonly used for human making, whether technical or artistic. The Latin word, *genius* (creator or begetter) was for the Romans the force which allowed procreation and then accompanied a man as his "higher self" throughout his life (women were attended by Iuno); a man worshipped his genius as a household god, and the Genius of the emperor, as well as the Genius of the Roman people itself, were made idols in the Forum and worshipped.[12] Lucretius' *On the Nature of the Universe* presents creativity primarily as the fruitfulness of nature, and he opens his lengthy poem—which is otherwise a materialist manifesto against religious superstition—with homage to Venus as the source of fertility. Cicero, however, shows us a broader conception when he criticizes Lucretius: his poem, Cicero says, was written: "With many highlights of genius, *but* with much art" (in

Lucretius, 1951, 9). Here apparently, creativity is seen as a matter of genius or inspiration, and not one of "art" or technique.[13]

Finally, while Virgil's *Aeneid* opens with the words, "I sing of arms and of a man," the poem is also in certain key respects a celebration of creativity. The overriding theme of the work is the founding of Rome, made possible by Aeneas. When his journeys take him to Carthage, he marvels at the founding of that city by Queen Dido; when he visits the dead in the afterlife, he finds martyrs for the homeland, priests, and also "the pious poets, those whose songs were worthy of Apollo" and "those who had made life more civilized with newfound arts . . . crowned with snow-white garlands" and living euphorically (VI: 874–893).

In many respects, however, Aeneas' founding of Rome is a story of imperialism, and that is why Virgil was so honored by Caesar Augustus. But Augustus did not crown all the poets with garlands: he ordered Ovid's poetry banned for its "immorality." Ovid had felt free to recreate all the old myths and to invent new ones; perhaps this would have been tolerated, but not the great ribaldry and emotional exaggeration, which so excited Roman readers, including Augustus' niece.

For Augustus, creativity was to further the goals of the state: poetry was valuable if it did this, but other, more practical efforts were generally more important. "The glory that was Rome" was to a large extent the creation and long-term maintenance of a far-flung empire. The remains of Roman coliseums and of Roman law, scattered throughout Europe, North Africa, and the Middle East, attest to this creativity. More importantly still, the Roman preservation and transformation of Greek culture, coupled with the claim of inheritance made by the budding Christian community in Rome to the biblical tradition, determined Western culture for centuries after. Not the founding of Rome by the hero Aeneas, but the founding of the Roman Catholic Church by the Apostle Peter, then became the mythic image of origination.

CHAPTER FOUR

TRADITION AND IMITATION
IN THE MEDIEVAL WEST

Following the traditional building imagery of the Hebrew Bible, the New Testament calls Peter the "rock" upon whom Jesus would establish his church, and for the next several centuries, the Church asserted itself against Romans, Jews, and other Christian denominations by claiming direct succession to this founding. A core element of this claim was that Jesus was said to have handed the keys to the Church to Peter, which he in turn, handed down to successive generations of bishops of Rome, the Popes. The Latin word for this handing over was the same as that for transmitting the teachings or doctrine of Christ: *tradition*. The focus on tradition and the dominance of the Church were determining factors in the concepts of creativity which prevailed during the one thousand years of the Western European Middle Ages.

Despite its focus on tradition, there can be no doubt that the early Church was very creative. To some extent, the Church doctrine that the Holy Spirit brings believers new insights and the view of Origen and other church fathers that Christ, the Son of God, is eternally generated by the Father, might indicate that active and continuous creativity could coexist with tradition. In any case, there is no question that the early Church was itself generating doctrine which had never been seen before. Its synthesis of Jewish, Greek, and Roman traditions with the teachings of the New Testament was a significant new step. It was also undoubtedly creative when Theodosius made Christianity the official religion of the Roman Empire in 392 B.C.E. thereby transforming both the state and the religion. Theologically, however, the Council of Nicaea had already exercised extraordinary collaborative creativity in 325 C.E.: the creed they formulated, emphasizing that "God gave his only begotten Son" was certainly consistent with New Testament traditions, and the theology elaborated was but a clear enunciation of doctrine as it had evolved to that point, but the proclamation of the "co-substantiality" (*homoousion*) of Father and Son was an important new addition to Christian doctrine. The specification of doctrine

was intentionally aimed at cutting off other possible interpretations of the divine: those who held those other interpretations, like Arius, were defined as heretics. Thus, the Nicean Council's determination of the doctrine handed down to them was both a creative step and at the same time one made to prevent creativity. However, when the Greek terminology used to explain the biblical relationship between God the Father, the Son, and the Holy Spirit was translated into Latin as "three persons, one substance," many found it confusing, even incomprehensible; its meaning was so debated that it became one of the factors leading to the later split between the Roman Catholic and Greek Orthodox Churches. Still, each claimed to represent the true tradition.

Combining Greek and biblical culture, the fourth century church father, Athanasius, accepted the Platonic-Aristotelian idea that all the arts are an imitation of life or nature, but otherwise rejected "paganism." In his attack on idolatry, he emphasized that the arts were not invented by Zeus or Athena, but by men. Neither those human inventors of the arts, nor the crafters of idols, nor the idols themselves, were divine, Athanasius insisted (Contra Gentiles, 18–9). The mere fact that Athanasius felt compelled to argue so forcefully in this regard shows how much his society venerated creativity and its fruits, but viewed them mythically. Following the biblical distinction between divine and human creativity, Athanasius clarified the issue for subsequent medieval thought:

> For God creates, and to create is also ascribed to men; . . . yet does God create as men do? . . . Perish the thought; we understand the terms in one sense of God, and in another of men. For God creates, in that He calls what is not into being, needing nothing thereunto; but men work some existing material (De Decretis IV: 77) (cf. Nahm 1956, 67).

Nonetheless, Athanasius availed himself of an analogy between human and divine creation when he said we know the sculptor, Phidias, through his works, and God through His creation. (St. Anselm later developed the analogy between the craftsman who first conceives his project in his mind and God's preexisting idea of the Creation, but Anslem then emphasized that the "analogy is very incomplete," for God is the first and sole cause and creates through himself alone, while the artisan follows external models and is not the originator of himself or his works (1903, Chps. IX–XII).)

Of course for all the church fathers, the whole creation was from God, and all human doing was therefore subordinated to God's. Therefore the Vulgate Latin Bible follows the Hebrew Bible's distinction between human and divine creation. This linguistic differentiation seems to have been maintained throughout the European Middle Ages in all the romance languages, and the word "creation" was rarely used except to speak of God (Lewis and Short 1969). Creation therefore generally meant ex nihilo.

Thus, while St. Augustine molded Christian doctrine, exercised great imagination in his City of God, and, through his Confessions, apparently invented the

literary form of autobiography, he also repeatedly condemned himself as a "sinner" and attributed everything good to God. God is the true Creator, says Augustine, and all we have is from Him. Therefore, Augustine's autobiography is hardly a statement of his personal accomplishments, as so many later autobiographies have been, but a statement of his impotence and utter dependence on God: "Can it be that any man has skill to fabricate himself?" (*Confessions* I:6). Indeed, even though we can grow "better in a free spirit of curiosity than under fear and compulsion," God's law justifiably curbs our curiosity by force, says Augustine (I:14). Creativity has its strict limits, and an obstinate refusal to accept doctrine must be punished, "for all must yield to God" (III:8).[1] Following Augustine's view that heretics were a "deadly plague" on the church, some were later condemned to death.

For Saint Thomas Aquinas, humans are made in the image of God, and human will and freedom are so significant, that we can be viewed as coworkers with God. Following both Aristotle and the Bible, Thomas sees God as the "first cause" of all creation and the end towards which all of creation strives, for our goal is nothing short of eternal happiness, and we cannot find happiness without God (*Summa Theologica*, Pt.11, Q2, Art 3; Q5, A5, and Q91, A4).[2] According to Thomas, "sacred doctrine . . . uses the authority of the canonical scriptures as incontrovertible proof . . . ; our faith rests upon the revelation made to the apostles and prophets" (*Summa*, Pt1, Q1, Art 8). Consequently, creativity is legitimate only in so far as it corresponds in some way with this faith.[3]

The unity of faith and knowledge that Aquinas and the Church espoused meant that the study of God's creation was to be best understood as the study of universal essences. Because these universals were also perceived to be eternal, there could hardly be a conception of human creativity as bringing something new into being (despite the fact that Thomas speaks of valuable "additions" to the world, such as clothing, brought about by human invention and despite the fact as well that some of us might consider Aquinas himself quite inventive). The Platonic-Aristotelian notion of imitation dominated. "Invention" was primarily a rhetorical term used in the disputations of the universities. The purpose of rhetoric was to defend the faith. "Art" was *recta ratio factibilium* (right judgment concerning make-able things), and the ideal was "a perfect knowledge of the rules of manufacture" (Eco 1988, 164). While humans could delight in and be inspired religiously by the beauty of God's creation, said Thomas, the purpose of the artwork in the churches was to imitate and reveal the sacred and ideal realms. Mastery of the arts and inspiration were important, but novel interpretations and creative productions were not. Theological "knowledge" was key, and deviance from the "truth"—as defined by the Church—was heresy.[4]

Nonetheless, the Church was surely the premier patron of Western creativity, supporting not only magnificent painting, sculpture, architecture, metalwork, and stained glass, but also great libraries, theological speculation, monastic organizations,

and the universities. The energy poured into these works, and especially into the enduring monuments, such as the great Gothic cathedrals—which required extraordinary social organization, technical ability, and aesthetic awareness—certainly appear to us to be superb expressions of creativity in our sense of the word, whatever the contemporaries claimed.

What concept of creativity is expressed in all this impressive work? On the one hand, that function ought to be enhanced by creations of art and beauty, but on the other hand, that the magnificence of the art has as its primary purpose the glorification of God (or the Church) and, in some cases, the city. Abbot Suger, who directed the building of St. Denis, the first Gothic structure, in the twelfth century, felt that the House of God should be an "image of Heaven"; following the teachings of Dionysos the Areopagite, Suger explained how the adornment of churches with gold, jewels, and sunlight through stained glass windows bespeaks the divine. Gazing at the cathedral, Suger gave thanks that "by the Grace of God, I can be transported from this inferior to that higher world in an analogical manner" (Boorstin 1993, 252). This view was criticized by Bernard of Clairvaux and others, who felt that the temptation of becoming enamored with the beautiful forms instead of the divine presence they bespoke was too great; for Bernard (1090–1153), in fact, these dazzling jewels were "Satanic."[5] This argument replayed the much more intense Iconoclastic Controversy of the eighth century, during which Byzantine Emperors Leo III and Constantine IV carried out widespread destruction of religious images. Motivated in part by political concerns, they based their actions on the doctrine that icons "draw down the spirit of man from the lofty adoration of God to the low and material adoration of the creature" (W. Walker 1970, 149). This doctrine was then repudiated at the Council of Nicaea in 787 under the influence of John of Damascus, and though there were sporadic outbursts of iconoclasm afterwards, religious art flourished throughout the European middle ages. While Moslems and Jews usually interpreted the biblical commandment against "graven images" to preclude human and animal forms, the Church generally considered human creations powerful means of educating the public about the divine creation.

For the most part, however, the names of those who created the icons, the stained glass, the reliquaries, and the sculptures before the late Middle Ages are unknown to us. As beautiful and as unique as some of the works may appear to us, their creators were not singled out. There are a number of reasons for this. First, the point of the work was not to show the human talent of the creators, but to show the Creator's (or Jesus', Mary's, or the saints') majesty. Second, many of the works were collaborative efforts, and singling out one creator over another perhaps would have been difficult. Third, the people who created these works were generally viewed as craftspeople, artisans. Their social status was not one of great prestige.[6]

Certainly, some artists were treated well by their courtly patrons, and some master craftsmen attained status within their towns and in some cases were re-

nowned throughout the region. For the most part, though, mastery of a craft came through guild apprenticeship. One learned sculpture just like shoemaking: through tireless repetition, following the master's instructions and example. Art was still defined as a skill, and imitation was fundamental to it. Thus, while some individual painters' names, like those of Giotto, Cimabue, and Stefan Lochner, have been handed down to us, countless works before 1400 were left anonymous, and many signed creations even three centuries later reveal the name of a master whose apprentice actually did the work.

Many apprentices signed their masters' names, not because of fraud, but in order to honor their master (or because they were obliged to). Imitation—of Christ, of the Saints, of master painters, of guild masters—both in style and subject matter, was proper and good. Thus, even Chaucer, the "father of English Literature," borrowed freely from folk tales, the works of Boccaccio, Petrarch, and Nicholas Trivet. As Donald Howard wrote in his introduction to *The Canterbury Tales*, "originality was not the virtue for medieval poets that it is for us; where we may scorn what is 'derivative' in an author, the medieval would have praised his taste in choosing well" (Chaucer, 1969, vii). As Dante wrote in "Canto XI" of the *Inferno*, "That art, as best it can, doth follow nature, as pupil follows master."[7]

The examples of Chaucer and Boccaccio make clear that medieval creativity, while primarily Christian, was hardly single-mindedly pious. Aside from the construction of castles, armor, and all the institutions and tools of everyday life, ranging from guild organization, to courts, to catapults, there were outrageously bawdy creations, like the sculptures of monks and nuns in obscene poses gracing the tower of the Cologne city hall (1360–1414)—a startling contrast to the sculptures of saints adorning the majestic cathedral, just three blocks away. Clearly, both the stone carvers and the city officials of Cologne were ready to use their (lurid) imaginations to break with some traditions.

Then, too, technological developments from the pistol to the flying buttress indicate that despite the reverence for tradition, society was hardly static. By the twelfth century, the northern Italian city-states were rebuilding urban cultures, the northern European Hanseatic League was formed, and capitalism was beginning. Aquinas articulated a natural law theory which implied the right to rebel against unjust rule, and the Magna Charta, signed by King John of England in 1215, put in writing some of the basic rights and freedoms of citizens. St. Francis of Assisi initiated a reform impulse which inspired a new sense of the importance of the individual as a dignified creature of God.

One of those inspired by Francis was the painter Giotto, whose frescoes of the saint's life helped transform medieval Christian painting by presenting naturalistic action and environment, and above all, dramatic emotion. According to H. W. Janson, the other "epoch-making" innovation of Giotto was to paint his figures so that the viewer could imagine he or she was on the same plane. "Giotto may well

claim to be the first to have established . . . a relationship in space between the beholder and the picture . . ." (1977, 325). This awareness of Giotto's expresses a distance from the sacred subject matter that previous medieval artists had apparently not conceptualized. The realization that the perspective of the viewer could be a factor in determining the character of the composition implied, to later generations at least, the possibility that anything, no matter how sacred, might be subject to interpretation. The image is not delivered from on high but is understood to be structured by the artist for the viewer.

Giotto's advances, together with the new assertiveness of the city-states, allowed Ambrogio Lorenzetti in 1338–1340 to paint one of the first major Western works of art of a completely secular nature (on virtuous and corrupt government) since the Roman era. Lorenzetti's work shows detailed city and country scenes with people working and enjoying their environment. The Sienese Republic was a new patron and allowed new work; Lorenzetti used his commission to change the subject matter of painting and at the same time to advise his patrons to be virtuous governors.[8]

Hand in hand with these artistic developments and the budding of the city-states, the humanistic scholarship of Petrarch, Erasmus, and others helped open Europe to new ideas simply by reviving interest in and awareness of the classical world. While theologians like Albertus Magnus and Thomas Aquinas attempted a synthesis of classical and Biblical ideas, some of the "humanists" focused on ancient Roman and Greek notions as a counterweight to the traditions of the Roman Church. For the humanists, the return to the classics was also a return to a greater degree of individual creativity.

To a large extent, Christian Europeans learned about the ancient Greeks through Jewish and Arabic writers.[9] Because, however, Moslems viewed Jesus as a human prophet and claimed that Mohammed was greater, and because Islam loomed as a significant political-military threat as well, Christians were particularly hostile to Moslems. Dante, in fact, placed Mohammed in one of the deepest circles of Hell (28). Nonetheless, some Christian Europeans must have marveled at the architectural wonders of Islamic Spain in Seville and Cordoba and at the Dome of the Rock in Jerusalem, and European thought was certainly beholden to the teachings of Averroes (Ibn Rushd) and Avicenna (Ibn Sīnā). Indeed, Thomas Aquinas' merging of biblical and Aristotelian thought clearly followed from these Moslem thinkers' earlier efforts to connect Greek thought to Islamic revelation.

While the Koran generally follows the biblical creation portrayed in Genesis, and the arabic *Khalaka* resembles the hebrew *bārā* (Arnaldez, IV:981), Ibn Rushd and others ended up saving a space for creativity by defending the possibility of human free will despite human dependence on God. In effect, they viewed God as directive and explicit in some areas and as allowing multiple interpretations and human initiative in others. Poetry and Quranic interpretation were highly valued as a form of *asalah* or originality (Khaleefa, 1997, 207). This was particularly pro-

nounced in medieval Islam, which generally showed far greater tolerance than did Christianity. Thus,

> Even when a consensus of scholars did sanctify a common tradition which some might have taken as orthodox, differences of opinion were allowed and, in practice, "innovations" occurred frequently with but scant intellectual opposition by the authorities. In fact, it was thought that prophetic agency was at work in the proliferation of Islamic sects. Muhammed was said to have predicted that his community would split into exactly seventy-three divisions (*firaq*) (P. E. Walker, 1985, VI:206).

Judaism was the most open to multiple, creative interpretations of Scripture. This was due in part to the political impotence and wide social dispersal of Jews, who therefore had no central authority to decide on the merits of ideas from different communities. More importantly, however, the Jews had long preserved, in the Babylonian and Palestinian Talmuds, the sometimes quite diverse teachings of generations of rabbis attempting to interpret the Torah. In addition, the Jews had the Kaballah, writings which were said to be based on oral teachings handed down since Moses. The Kabbalists emphasized the mystical steps toward union with God's wisdom. This emphasis involved to a considerable degree esoteric readings of the words and numbers of the Bible. As *Zohar* 2:55b puts it: "there is no word in the Torah that does not contain many secrets, many reasons, many roots, many branches" (Matt. 1995, 135–146; 208–213). Indeed, medieval scribes continued to write the Hebrew Bible with consonants but no vowels, supposedly so that all possible meanings could be read into it (243).[10]

A more striking step toward the modern sense of creativity, perhaps, was the rise of some women to prominence. Hildegaard von Bingen, Catherine of Siena, and later, Teresa of Avila, had considerable influence on Christian teachings. Christine de Pizan[11] wrote numerous works, including *The Book of the City of Ladies*, which argued for the dignity of women. Christine claimed, among other things, that several of the ancient Greek, Egyptian, and Roman goddesses to whom the origins of agriculture, writing, weaving, armor, and so on were attributed, were actually women whose inventive genius was so outstanding, that they were treated as divine.

But Christine went one step further. In an era dedicated to "imitation" and obedience to authority, she asserted that Dame Reason told her: "For it is not such a great feat of mastery to study and learn some field of knowledge already discovered by someone else, as it is to discover by oneself some new and unknown thing" (1982, 71).

Here, along with the other humanistic, artistic, and urban developments, we see a flourishing of the late Middle Ages which are also the beginnings of what we now call "the Renaissance." But Christine could "get away with" saying what she did only by repeatedly citing Scripture and attributing her radical words to imagined

beings such as Lady Reason. In fact, for many people since the Middle Ages, that era seems to have been one when vast numbers of Europeans believed in an entirely imaginary universe, peopled with angels and devils and filled with visions of future heavens and hells to compensate for the burdensome existence to which most humans were subject. From this perspective, the birth of the literary forms of chivalrous romance and adventure as escapes makes complete sense (see Michael Nerlich 1977). Indeed, Marco Polo's account of his travels to China, which clearly influenced later explorers like Christopher Columbus and contributed to the Renaissance spirit of discovery, was initially treated by medieval readers as a marvelous adventure story.

The whole idea of a "knight errant" seems to embody the two-sided attitude of the period, for "errant" means both "traveling in search of adventure" and "gone off-course," and the medieval notions of fantasy and adventure were not meant primarily as excursions into realms of creativity as much as morality tales. Thus, Dante presents himself in his *Inferno* as having lost his way and being in danger of staying lost. Only through the intercession of his beloved and pious Beatrice and the guidance of the ancient poet, Virgil, does Dante find his way through Hell and back up in the direction of Paradise. But in this outstanding example of the creative imagination, Dante makes it clear that even though the poetic art allows men "to grow immortal" (XV:84–48), even Virgil can never reach heaven, because he is a pagan; only those living and creating in faithfulness to the Christian God will truly find their way out of the dark woods. Indeed, Dante's Hell is filled with those who are lost. Among them is Homer's wayward hero, Odysseus, whose guilt derives not only from his clever deception with the Trojan Horse, but also from his "restless itch to rove" and explore the world and especially in urging on his otherwise ordinary men to "follow after knowledge and excellence." Chastened, Odysseus now says, ". . . I curb my talent, that it not run where virtue does not guide" (26:21–122). Creativity, then, must submit to the bounds set by Church doctrine and morality.

With its centralized religious authority, the Roman Catholic Church achieved greater doctrinal clarity than did Judaism or Islam and had far less tolerance for divergent interpretations. Early in the thirteenth century Aristotle's scientific writings were banned by the Church, even though by mid-century, those same works were required reading. Even as ardent an Aristotelian as the "angelic Doctor" of the Church, Saint Thomas, could state emphatically that "Whatsoever is found in any other sciences contrary to any truth in this science [Catholic theology] must be condemned as false." In fact, those who profess Christianity but persist in false doctrine must be excommunicated and put to death (*Summa* 2a 2ae Q11, A3). With such doctrine, the Church established the Office of the Inquisition and frequently denounced those who transgressed the boundaries of acceptable creativity as "heretics."

Since heretical ideas were viewed as the result of human imagination or invention, rather than Divine Revelation, or Church doctrine, we might view most of those called heretics as necessarily "creative" (though the Church might have considered these people to be pawns of Satan). Christopher Marlowe's *Doctor Faustus*, though written in the sixteenth century, was based on material passed on since early Christianity and still exemplifies medieval thinking. In the play, the great Faustus' brilliant and daring creative energies lead him to consort with the devil and then to his own damnation to hell. What we call "creativity," then, was viewed as dangerous. And this was echoed in popular folk belief, which combined Christian and pagan elements and included a strong belief in *the Malocchio* or evil eye. This threatened with all manner of suffering those who would stand out from the community through deviant behavior or creative thinking. Just as the chorus in Sophocles' *Antigone* had sung, those who would transgress the laws of God and community would be cast out. This was a powerful tool for enforcing conformity and dampening creativity (Hauschild).

Then again, probably the most powerful force which smothered creativity in medieval Europe was the Bubonic Plague, which killed perhaps one-third of Europe's population. However, even when nature was less destructive, medieval social structures had a major effect on creativity: the ranks and titles of those in the Church as well as those within the general population expressed clearly defined areas of responsibility and degrees of power. In fact, the relatively fixed and hierarchical roles and status of feudal society indicate to us a very limiting conception of creativity: only certain individuals could create in particular realms and in specified ways. Obedience and loyalty to one's superiors was the highly touted ideal of this culture, where orders came from above. Creativity, therefore, had a very different meaning from today.

THE RENAISSANCE AND THE INVENTION OF THE CREATIVE IDEAL

By 1592, when Sir John Davies wrote, "To create, to God alone pertains," (1967, vii:46),[1] he was fighting what amounted to a rear-guard action against poets, artists, and thinkers of the past century who had begun to apply the word, "create," to human doing. Poetry, art, inventions, and even titles of nobility were now said to be "created." This abandonment of the long held biblical/Latin distinction between divine and human doing is indicative of what we have come to call "the Renaissance." A measure of the radical changes witnessed in this era is the fact that in the fifty years following Gutenberg's 1453 invention of moveable type, an astonishing thirty-five thousand different titles and twenty million individual books were printed (Bunch and Hellemans 1993). Some of these works presented new ideas, and some explicitly celebrated the introduction of new things, whether sanctioned by tradition and authority or not. No wonder the Vatican decided in 1559 to formulate its *Index liberorum prohibitorum,* the list of books forbidden the faithful, and no wonder, too, Protestants and Catholics alike denounced and sometimes executed witches and heretics.

This reaction can be understood as the Church's attempt to halt some of the enormous theological, political, social, economic, and artistic changes we usually term the "Reformation" and the "Renaissance." That this was not an abrupt development is clear from the rise of the city-states, the transformation of art, and the early humanist thinking of Petrarch, Boccacio, and others in the thirteenth and fourteenth centuries. There had been, and continued to be, numerous renaissances. However, these multiple changes seem to have had a cumulative effect that became noticeable to the most progressive historical actors themselves around 1500, which in some respects can be viewed as a turning point in Western history. Indeed, one of the features of this change was that the understanding of history was altered. The humanists' cry of *ad fontes* (back to the sources), was aimed at a revival of many of the great classical models from ancient Greece and Rome—hence the sense of "rebirth" (or renaissance). But this also expressed the fact that the generations of the

Renaissance more clearly understood the past to be past than had previous genera-
tions—and this allowed for a new appreciation of the "new" itself. The era was
characterized, then, by both a looking back and a stepping forward. One of the
things that signals this turn was a change in the Western conception of creativity,
and in many ways, the new ideas about creativity can serve as key to the whole,
broad cultural transformation.

In this respect, Florence was a particular cauldron of creative work and ideas
about creativity: it was the city of Dante, Petrarch, Michelangelo, Galileo, Machiavelli,
and sometimes, Leonardo Da Vinci. These creators were strongly encouraged by the
ruling de Medici family and by the Signoria, the city council. The de Medicis
established a Platonic Academy at their country estate, with the specific intent of
making Florence the inheritor of classical greatness. Marsilio Ficino, the head of the
Academy for a time, wrote the first complete translation of Plato and, based on his
Symposium, initiated what could be called a cult of beauty as the earthly splendor of
God; indeed, Ficino asserted that "the power of the human person almost resembles
that of God's nature." In line with this, the value of art and of the individual creator
was greatly enhanced.[2]

Soon thereafter, Cristoforo Landino, another member of the Academy, wrote
in his 1481 *Commentary on Dante*, repeating Athanasius' distinction between the
divine creation *ex nihilo* and human making, but then claiming that what poets do
is "halfway" between the two. The poet's work, said Landino, "comes very near to
creating. And God is the supreme poet, and the world his poem."[3] Landino's words,
according to M. H. Abrams, indicated a major shift in Western thinking about art.
Soon, Torquato Tasso and Sir Philip Sidney would maintain that poetry could beau-
tify reality and even bring forth new realities, as God had done, and Julius Caesar
Scaliger would intimate that the poet might therefore even be called "another god."[4]
Art continued to be seen as imitation, but not as imitation of an imitation (nature).
These Renaissance thinkers viewed art as the direct imitation of the divine ideas,
and therefore as something that could actually surpass and even transform nature
(Abrams 1953, 42, 273).[5]

While this perspective appeared new at the time, the groundwork for it had
been laid fifteen hundred years before. Plotinus had gone beyond Plato's idea of
imitation and said that artists do not give mere representations of the natural world,
but transcend them by imitating the Eternal Ideas (*Enneads* V:viii.I). More emphati-
cally, Philo of Alexandria, though also a Platonist in many respects, stressed that the
biblical God had created man in His own image, endowing him with "a similar
power of freedom to upset the laws of nature to which he is subject" (Nahm, *Artist*,
1956, 75; cf. Wolfson 1947).[6]

Now these ideas were being revived in the de Medici Court in Florence. But
neither Philo nor the Renaissance poets and philosophers conceived of human cre-

ativity as transcending or transgressing against the divine, eternal forms. Even if poets were "second gods," they were such under the biblical God's purview. Thus, when Pico della Mirandola of the Academy went so far as to speak of man as the center of the world, of human will and judgment as nearly boundless, and of our freedom to create ourselves, he was quickly condemned by the Catholic Church. And, of course, the majority of people in this society did not dare speak of themselves, or of the poets, as "creators" of such scope. In all the European languages, the word "create" was still reserved primarily for God's creating.

While Landino, Tasso, Sidney, and Scaliger had reconsidered the relationship between human making and divine creating, it apparently was not until 1589 that George Puttenham first used the word, "create," in English to denote human activity in analogy to the divine (Abrams 1953, 274). In doing so, he specifically rejected Plato's notion of the demiurge and dismissal of poets and instead emphasized the Biblical notion of the Creator God: "if poets . . . be able to devise and make all these things of themselves, without any subject of verities, then they be (by manner of speech) as creating gods"(4).[7]

As Sidney, focusing on "poetic genius," put it six years later, the artist is capable of creating "forms such as never were in nature," that is, things of the imagination (Puttenham 1936, 25).[8]

Similarly Shakespeare tells us:

> And as imagination bodies forth
> The forms of things unknown, the poet's pen
> Turns them to shapes, and gives to airy nothing
> A local habitation and a name. (Midsummer Night's Dream, 5.1.15–18).

And the characters in Shakespeare's plays exercise their creative imaginations in extraordinary ways as well: in *Hamlet*, for example, Shakespeare writes of, "a dagger of the mind, a false creation" (2.1.38) and says, "This is the very coinage of your brain: this bodiless creation ecstasy is very cunning in you" (3.4.138). The emphasis here was on fantasy and the supernatural, and it could well be that this is what Shakespeare meant by "the forms of things unknown" which the poet imagined and brought forth. Indeed, *The Tempest* was viewed as Shakespeare's most creative work because of the imaginary beings filling that play. In other words, *Hamlet* may not have been viewed as creative, since "it only held up the mirror to nature" (Barzun 1991, 7; Abrams 1953, 274–75 and note 48; Dryden 1984, I:219).[9] Indeed, European literature is filled with talk of "marvels" and "wonders" in the early 1500s, and the Italian critic, Minturno claimed that "No one can be called a poet who does not excel in the power of arousing wonder (Greenblatt 1991, 292).

As much as he was a master at creating such marvels, Shakespeare nonetheless left us with the sober and fatalistic warning that:

Shake spenc

> Life's but a walking shadow, a poor player
> That struts and frets his hour upon the stage
> And then is heard no more: it is a tale
> Told by an idiot, full of sound and fury,
> Signifying nothing. (MacBeth, 5.5.24–28).

Ironically, subsequent generations have rebutted this world view by immortalizing Shakespeare. Significantly, too, the West's later notions of creativity revised Shakespeare's and his early commentators' ideas about what kinds of works were most creative. Already in the Renaissance ideas of creativity went far beyond the production of fanciful images by poets. Whether the word, "create," was used or not, the analogy between human and divine doing took strong hold. In fact, it is likely that the word began to be used so explicitly at the end of the sixteenth century, because of the enormous creative outpouring in the world of art, literature, and science.

Already in 1445, Lorenzo Valla's history of the Kings of Aragon hailed the recent technological advances of the age, and in 1499 Polydore Vergil wrote *De inventoribus rerum*, describing great inventors and their creations. Indeed, engineers began to be recognized for their *ingenio* (natural genius), and the Latin word, *invenire*, (to come upon or discover; to contrive or design), began to be used in increasing frequency at this time. The first significant uses of the word in English were 1475 and 1541, no doubt because of the increasing interest in the new inventions of the era. For a time, "invention" was used for all kinds of novelty in the arts and sciences, in a manner almost comparable to our present-day usage of "creativity."[10]

One invention of significance was that of linear perspective. Following Al-Hasan Ibn al Haytham's geometry and description of the *camera obscurra*[11] (related through Toscanelli), Filippo Brunelleschi discovered the mathematical principles of perspective, demonstrated them to others, and carried them out in his design and construction of the dome of the Florence Cathedral. Leon Battista Alberti then codified the invention in his *On Painting, (Della pittura)*, influencing all subsequent Western artists and the ways in which each of us is taught to see. Not only were painting and architecture revolutionized, but Toscanelli then took the perspective graph form and applied latitude and longitude lines to Ptolemy's map of the world, providing Columbus with a world conception he could follow.

In order to build the cathedral's dome, Brunelleschi designed an extraordinary system of cranes and hoists, and in 1421 he received Florence's first manufacturing monopoly (for a barge outfitted with a large, reversible hoist). Fifty years later, in 1474, the Republic of Venice adopted the first formal patent law. This clearly expressed the importance which the governments of the Italian city-states attached to inventors and their creations.[12] By 1560, the government of Naples opened the first technological research institute, and in 1569, the world's first industrial exposition took place in Nurenberg (Bunch and Hellemans 1993, 132).

It is no wonder, then, that when Leonardo da Vinci sought employment with the Duke of Milan, he listed numerous inventive-engineering talents (mainly military), before mentioning his artistic abilities. Indeed, Leonardo, like the overwhelming majority of artists of his time, did not even sign his works. But this changed drastically and rapidly. Thanks to Leonardo and others who helped raise the status of artists, the Renaissance witnessed not just growing respect for, but even a cult of creative, artistic individuals. Starting around 1500, authorship of creative works has, in the West, been almost always explicit.[13] It comes as no surprise, then, that by 1550 Giorgio Vasari could write *The Lives of the Artists* to celebrate the artist as creator.[14] Indeed, Vasari apparently coined the term, *il Rinascimento*, "the Renaissance."

In this book, Vasari gave greatest reverence to Michelangelo, painter, sculptor, architect, poet, and engineer. In fact, in the first edition of the book, Michelangelo was the only living artist represented. Michelangelo's own creations seem to convey his ideas about the centrality of the creative process. While his 1532 sculptures of the *Prisoners* or *Slaves*, struggling toward liberation might have expressed to contemporaries a Neoplatonic concept of the artist's ability to release the ideal form from dumb material, these works have also seemed since then to express the power of the artist as creator. In the earlier Sistine Chapel ceiling, Michelangelo focuses attention on God's creation of Adam in such a way that the viewer cannot help but anticipate the muscular Adam's own creativity, something reenforced by the words of Michelangelo's poetry: "He can give life to stone, which is beyond craft's power" (*Se ben concetto hala divina parte*, Saslow 1991, 400, #236). As God awakens this life in Adam, and as a love can draw love from the beloved, the artist creates on blank paper or in stone (*S'egli è, donna, che puoi*, Saslow 1991, 245 #111). Human striving can conquer nature, and through beauty, we can ascend from Earth to Heaven. In fact, the artistic striving for perfection draws one toward divinity: "Good painting is nothing else but a copy of the perfections of God and a reminder of His painting" (*Coluiche 'l tutto fé, fece ogni parte*, and note, Saslow 1991, 77).[15]

Earlier, Florentine sculptor, Donatello, had regretted not being able to create life as God had done. But Michelangelo applied Landino's ideas about poetry to the world of sculpture. For his part, Leonardo claimed that painters, like the poets, were "second gods." (Boorstin 1993, 408) For Leonardo, experience was the greatest teacher; the medieval attitude of following traditional authorities was foolish—in fact, "anyone who . . . relies upon authority uses, not his understanding, but rather his memory" (No.1159).[16]

However, "experience" for Leonardo meant in the first place, observation and depiction of nature; for him and for Michelangelo, a strong Neoplatonism was expressed in seeking the divine idea represented in nature and seeing their own work as imitation of these ideas. In Leonardo's painting, and even in his amazing inventions and writings, nature—the ordered creation of God—is viewed as the primary example and key resource for study: Leonardo not only invents wings like

those of birds, tells fables using animals, says an architect is like a doctor, designs hydraulics, conceiving of the Earth as a body, but is also passionately committed to anatomically correct drawing. Indeed, for Leonardo, "experiencing" in art and science first means "knowing how to see," and then reproducing this in a model, machine, painting, building, or sculpture.[17] Still, according to Leonardo, imitating the outward form is only the first step—the real goal is to express the spirit of the subject in the painting and grasp not just order and proportion but especially motion in all things.

Interestingly, while the celebration of inventors and artists kept apace, and while some individuals like Leonardo, Michelangelo, and Brunelleschi, seemed to move easily between the worlds of art, science, and technology—Leonardo's engineering drawings are extraordinary in this respect—conceptions of the pictorial arts definitively parted ways from those of technology and crafts at this time. Until the Renaissance, all that we would associate with the words, "art," "technology," and "craft" was termed *techne* (Greek) or *ars, artis* (Latin); those things were distinguished from poetry and definitely not viewed as originating or creative in the modern sense of the word. But now, with Medieval Aristotelian aesthetics replaced by Florentine Neoplatonic thinking and with artists demanding respect previously denied them as "mere craftsmen," the arts came to be seen by intellectuals as more than and separate from craft or technique.[18] Now painting and sculpture were allied with poetry; poets and artists alike could claim to "create" in analogy to the Divine. No such claims seem to have been made for the mechanical arts, despite their obviously great importance.

Furthermore, the artists' and poets' claim to see divine ideas hiding beneath the surface of nature was followed by the claim that they could see meanings others initially did not. As much as they sought to imitate nature, they also intentionally transformed it through inventive *fantasia*. In Raphael's frescoes at the Vatican, poetry is portrayed as a winged woman, and under her are the words from Virgil, "inspired genius takes flight" (Beck 1993, 38–39). Surely, artists were given greater latitude in their interpretations than before. Thus, while the legend that Michelangelo was told to do as he pleased in the Sistine Chapel is doubtful, he apparently did help decide the arrangement of religious subjects and surely painted them in his own way. The subsequent dispute over the nude figures in his *Last Judgment* shows both Michelangelo's assertiveness and the Church's resistance to his "artistic license." And although Leonardo painted religious subjects, piety and theology played a very minor role in his notebooks. Long gone were the biblical days when human work on sacred objects was supposed to adhere to precise directions from the divine.

Thus, even though few of Leonardo's projects were actually brought to fruition, his notebooks were not published until centuries later, and many of the details of his life were enshrouded in mystery, he achieved considerable fame already during his lifetime. After his death, Vasari and others helped create an image of a man

larger than life: he was known as a transcendent genius, a possessor of secret wisdom, and the greatest inventor of history.

> The most heavenly gifts seem to be showered on certain human beings. Sometimes supernaturally, marvelously, they all congregate in one individual. . . . His talent was so rare that he mastered any subject to which he turned his attention. . . . His gifts were such that his celebrity was world-wide, not only in his day, but even more after his death, and so will continue until the end of time (Burroughs 1946, 187).

But Vasari's effusive praise for Leonardo was surpassed by his description of Michelangelo. In his case, said Vasari, the Almighty

> resolved to send to earth a spirit capable of supreme expression in all the arts, one able to give form to painting, perfection to sculpture, and grandeur to architecture. The Almighty Creator also graciously endowed this chosen one with an understanding of philosophy and with the grace of poetry. . . . so that everyone might admire and follow him as their perfect exemplar in life, work, and behavior, and he would be acclaimed as divine . . . (1946, 258).

And, as if this were not enough, the mythology imbued these great artists with an extraordinary *terribilita'*, the intense and terrible passion which inspired and drove them, and which supposedly could arouse nearly as much concern and awe among us mere mortals as the power of Gods and kings.

While succeeding generations have come close to agreeing with Vasari's extravagant praise and greatly revere Michelangelo, Leonardo, and other great Renaissance artists, we must recall that the patrons who commissioned their works certainly had other values than "art for art's sake" in their minds. The Florentine Republic commissioned the giant sculpture of David to assert its newly won independence and dignity; several of the works commissioned by Pope Julius II, served to enhance the glory of the papacy and feed his own vanity. While Lorenzo de Medici seems to have been genuinely excited by the ideas and artworks of those he gathered to his Florentine court, there can be little doubt that his patronage—like that of the Sforzas in Milan, the Doges in Venice, and the various other Italian city-states or northern European principalities—was given out to painters, architects, engineers, and scientists to enhance the power and majesty of these families and states. There was competition for the finest palaces and public buildings, grandest piazzas, mightiest cathedrals, most beautiful paintings and sculptures, as well as for the most valuable moats and defensive works, ship designs, artillery pieces—and individual creators and inventors of distinction like Leonardo went to the highest bidder, while others went wherever they could find any support at all. Leonardo, for example, was honored by the title, "painter and engineer of the duke," but that honor also reveals Leonardo's dependence on, even subservience to, Duke Ludovico Sforza.

It would, therefore, be foolish to think of Leonardo or Michelangelo as being a match for Pope Julius II or Duke Ludovico, the artists' powerful patrons. In fact, it seems unlikely that these rulers could have cared as much about artistic creativity as about political, economic, and military strategies.[19] To have done so would have doomed them. Interestingly, though, many artists received more acknowledgement from the rulers than did Nicolo Machiavelli, who dedicated his work on politics, *The Prince*, to Lorenzo II of Florence. In this work, Machiavelli emphasizes that successful government is not a question of the constitution or of overwhelming power, but of strategy. Machiavelli says that a prince should "show esteem for talent, actively encouraging able men, and honoring those who excel in their profession" (1951, 123), but the reasons for doing so are that it will help the state prosper, keep citizens happy, and thereby help the ruler maintain power. For staying in power is the prince's overriding goal, and any means at all, no matter how duplicitous or brutal, would be legitimate. According to Machiavelli, the ebb and flow of fortune will sweep us away unless we act creatively to protect ourselves and change its course (chpt. xxv). Machiavelli's belief that we can, in fact, hold our own against fortune, represents a radical shift in thinking from medieval and ancient Greek thought, and shows how the human potential to transform the world had taken hold.

While Machiavelli was denounced by many as "the Devil" for his blunt advocacy of power, the following centuries saw a number of European courts assert a Divine Right of Kings. This doctrine, espoused most strongly by King James I in England and prelate Jacques-Bénigne Bossuet (1627–1704) and King Louis XIV in France, seems to have combined Aristotle's notion that true initiative is found in the political realm, with the medieval view that the temporal ruler serves on Earth parallel to and at the behest of God, who rules in heaven. With the breakup of the Roman Catholic Church hegemony through the Reformation, national monarchs gained far more political power and no longer accepted the medieval religious conditions which limited their reach. The new doctrine therefore served their needs well. In a sense, the doctrine meant that the absolute monarch might be viewed as the sole or primary actor on the earthly stage. Now, in fact, the word, "create," began to be applied to the creation of landed estates and titles of nobility. The ruler was understood to create what was not there before. And, of course, the rulers had the power of life and death over their subjects.

Nonetheless, in the collective memory of the West, the great artists and other creators have managed to at least hold their own, if not far outshine the rulers who, during their lifetimes, patronized and dominated them. This is as true for Galileo Galilei as for Leonardo, Michelangelo, and Machiavelli. The princes who supported Galileo and the pope who demanded that he obey Church teachings are long forgotten by most of us.

When Galileo heard that Hans Lippershey of Holland had invented a telescope and was traveling to Venice to try to sell it to the Doge, Galileo quickly

fashioned his own, superior telescope, raced across northern Italy, and cleverly presented his invention as a gift to the ruler, emphasizing the tool's naval-military advantages. The Doge subsequently established Galileo as "first honorary citizen" in tribute to the value of the inventor to the city-state. A few months later, however, Galileo furtively slipped away to his native Florence, after convincing its governors to support him (Reston 1994). As valuable as the telescope was for military purposes and Galileo's career, it also marked a significant step in Western thinking. Most immediately, the telescope seemed to corroborate Copernicus' claim that the sun was the center of the universe. While this idea was passionately resisted by Church authorities, the ultimate result was the vindication of a new way of examining things and the undermining of papal and Aristotelian authority in the intellectual realm. Indeed, the telescope manifested, in a most tangible way, the professions of the poets and artists to see beyond the surface of things. Through the telescope, stars and planets, which were previously hidden, were suddenly revealed.[20] People's understanding of both distance and vision was radically altered. The awareness that heretofore unknown things might be discoverable was a fundamental impulse to creative efforts and the understanding of creativity. Nature was not so much for imitating as for uncovering. So much new was uncovered, that Galileo could show how the old Aristotelian disciplines were transcended by entitling his work, *Concerning Two New Sciences*.

The new perspective represented what we have come to call "the scientific method." Although Galileo was an extremely important practitioner of this method, perhaps the most significant rationalization of it came from Sir Francis Bacon, whose *Novum Organum* (1620) aimed to replace the superstitious "idols" of the mind with a "new instrument of learning," careful observation, which would "free and cleanse the understanding." While the artists had struggled to free their efforts from the status of "mere craft" and ally themselves more with the "creative" powers of the poets, Bacon saw that whether or not inventors should be called "second gods," Aristotle's separation of scientific theory from practical experimentation and invention was mistaken: reason should be complemented with experimentation, trial and error, to produce useful tools. With science and technique united, the creative power would lead to the "effecting of all things possible." As a model of these possibilities, Bacon wrote a utopian fantasy, *New Atlantis*, where technologies like telephones, airplanes, refrigerators, and so on made life appealing.

Bacon's thoughts of future possibilities were matched by the dramatic discoveries of the great explorers of the era. The famed seafaring discoverers of the fifteenth and sixteenth centuries—Columbus, Magellan, Vespucci, Vasco de Gama—won treasures and glories and were honored to varying degrees by the governments they served, as were their successors on sea and land, Drake, Hudson, Champlain, De Soto, Pizzaro, Balboa. We can see in Gonzalo Fernandez de Oviedo's argument that Columbus had merely "rediscovered" something already known but lost—that it

was of utmost importance whether or not something new was indeed discovered—for the claim had religious, political, legal, and financial consequences (Greenblatt 1991, 276–77).

Destructive as the explorers often were to the other civilizations they encountered in their quest for territory and gold, these men contributed to the Western conception of creativity significantly. As with the telescope and Bacon's view of scientific-technological potential, their discoveries indicated that the heretofore known world was not necessarily all that existed. Exploring, one might find fantastic landscapes and golden cities, incredible wealth, bizarre and exotic social practices. Columbus filled his letters and diaries with what he called "the marvels" he observed. Unable to see the history or value of those they conquered, and convinced that Europe was still the center of the world, these men and their compatriots believed they were exploring the unknown, the uncharted reaches of the world. Their great adventures were matched by a whole literature of romance-adventure writing which captivated Europeans and reenforced the belief in exploring the new (Nerlich 1977).[21]

These explorations, coupled with the move toward a heliocentric view of the universe, the development of perspective in art and architecture, the shift in power away from the Church hierarchy to the individual through Protestantism, and the shifts in resources and social status through capitalism all conspired to relativize previous assumptions, to help some people recognize that there were multiple perspectives. The explorations also represented a willingness, even an eagerness, to go against common beliefs such as the one that the Earth was flat,[22] and in the case of Copernicus, Galileo and others, to try to go against Church authority, which insisted that the Earth was the center of the universe.[23] In each of these cases, experimentation, reason, and exploration were seen as the means toward finding truth, and in each of these cases, independent-minded men and women asserted themselves against authority and the status quo.[24] Staking his claim with faith, Martin Luther (1483–1546), went so far as to denounce a number of common Church practices as blatantly false, and then, standing up against one thousand years of papal authority, said "Here I stand; I can do no other."[25]

In many respects, such individual assertion of rights and powers had been growing for a century or so under the influence of humanism and capitalism. Now, not just priests and aristocrats, but also merchants and bankers, and then others could assert themselves and gain social recognition and power. Neither the de Medicis nor the German financiers, the Fuggers, nor the Dutch Burghers ruled empires, but the portraits of the era reveal their influence; Renaissance art and thought was directly tied to the rise in trade and empowerment of the commercial classes in such places as Florence, Venice, Nurenberg, Bruges, and London.

And the rising cult of the creative individual, the invention of new technologies, and capitalism worked together so that the German painter Albrecht Dürer (1471–1528), the contemporary of Leonardo and Michelangelo, could venture forth

and, with the help of his shrewd wife, Agnes, succeed as an artist-entrepreneur, able
to survive with minimal patronage from the Church or state. Recognizing the mass-
production qualities of woodcuts and engravings, Dürer produced the first works
designed and published solely by an artist and for far broader markets than any had
previously reached. His *Apocalypse, Melancholia,* and other efforts were seen and
prized by people throughout Europe. Dürer was aware of the possibilities inherent
in emerging German capitalism: among the six uses of painting listed in his *Outline
of a General Treatise on Painting* is the contention that it can be a means of attaining
"great wealth and riches. . . ." In fact, says Dürer, "a wonderful artist should charge
highly for his art . . . no money is too much for it" (Rader and Jessup 1976).[26]
 And while the budding capitalists were creating new social relations and
discoverers and scientists were finding new worlds, the claims of Landino and others
that poets, like God the Creator, were able to create new truths, was apparently
taken to heart by the artists and poets. It was but a short step from this conception
to the first artistic self-portraits, starting with Alberti's 1450 profile image in which
he resembles a Roman emperor, to Albrecht Dürer's remarkable self-portrait—in
which the artist resembles Christ and writes A.D. 1500 to indicate both *anno domini*
(the year of our lord) and Dürer's own initials.[27] While some may have seen this as
an expression of piety, most Europeans of previous generations, and no doubt many
of Dürer's contemporaries, must have viewed this work as enormous, even blasphe-
mous egoism. While his older contemporary, Leonardo, still didn't sign his works,
Dürer trumpeted himself as creator. In just a short time, the subject matter of art
had changed in the late Middle Ages from the iconography of Jesus, Mary, and the
saints, to portraits of aristocrats . . . but now the rising bourgeoisie is portrayed as
well, and most startling of all, the artist himself. Here the subject becomes the
object: the artist himself is worthy of attention![28] Soon the medieval *Lives of the
Saints* would be replaced by Vasari's *Lives of the Artists.* Earth and sun switch places:
now interest can revolve around the worldly creators more than around their cre-
ations, the world, or even the divine. Now, in ways never attained before in the
West, individual creators were recognized and revered. The rise of capitalism, the
cult of the individual, and the new sense of the human creator's importance go hand
in hand.
 Of course this approach was bound to provoke a backlash. Columbus' first
voyage coincided with the beginning of the Spanish Inquisition. Luther was de-
nounced and excommunicated by the Roman Catholic Church, and the Counter-
Reformation was initiated. Meanwhile, John Calvin and other Protestant clergymen
forbade the use of art or music in religious services, and in a number of cases destroyed
or defaced works of art and musical instruments.[29] Stephen Gossen warned of the
dangers of art: "From piping to playing, from play to pleasure, from pleasure to sloth,
from sloth to sleep, from sleep to sin, from sin to death, from death to the Devil"
(Rader and Jessup, 222). Italian reformer Savonarola preached against immorality, and

Botticelli and other artists burned their own paintings. Giordano Bruno, advocating the heliocentric view of the universe and the influential role of the human subject, was denounced as a heretic and burned at the stake. Paracelsus burnt his own writings on pharmaceuticals, because his main source of information was denounced as "the sorceress" (Ehrenreich and English 1973, 17); she and countless other "inventive" women were no doubt burnt at the stake. Even Sir Francis Bacon, one of the fathers of modern science, apparently felt no remorse about carrying out legal (Protestant) "inquisitions" against Catholics in Britain, just as the Catholics had been doing with nearly anyone who questioned Church authority.

What is more, the overwhelming majority of Renaissance Europeans were probably oblivious to much of the creative drama of their age: how many of their contemporaries ever saw Leonardo's paintings or even heard of Sir Francis Bacon's name? Peter Breughel the Elder's 1555 painting, *The Fall of Icarus*, reminds us that while a few might have "reached for the sky," most of those around barely noticed the effort or the result; buffeted by centuries of wars, they would have been content to follow the routines of their pastoral lives. Even Leonardo, who attempted to build a flying machine, recalled the myth of Icarus in his frequent comments on human vanity and fallibility (Saslow 1991, *Poems* 1230, 1271, 73, 74, p.),[30] and Michelangelo wrote that the unsung artist might find creative fulfillment only near death, "for at novel and lofty things, one arrives late, and then lasts but a short time" (Saslow 1991, *Poems* 241, 407).

The words we use to describe this era of religious, political, scientific, and artistic transformation all bespeak creativity: the Renaissance, the Reformation, the Age of Discovery. These words also indicate the modern view of that age as one that was still very much dependent upon ancient Greek and biblical beliefs: what was "reborn" was Greek learning; what was reformed was Christianity, brought back to Scripture; what was "discovered," both through scientific investigation and geographic exploration, was the preexisting order of nature and long established societies. John Dryden and Jonathan Swift, creative as they were, still insisted that no modern literature could rival the classics (Bronowski 1958, 89). Leonardo was revered by his contemporaries, but called "the new Apelles," after the famed Greek painter. Cervantes' *Don Quixote* was a visionary adventurer who could not succeed. Copernicus had changed the center of the universe from Earth to the Sun, but the almost circular movements of the heavens were still eternal. Indeed, Kepler's connection of geometry and astronomy led to his description of the elliptical orbits of the planets as the divine harmony. The sense of discovery and creation was coupled with a circular return characteristic of the era: nature was surpassed to reach the eternal ideals.

CHAPTER SIX

THE ENLIGHTENMENT

When Michel de Montaigne said in 1580 that "strangeness and novelty . . . generally give things value" (1958, 137)—an early expression of capitalistic understanding of supply and demand—his distance from the medieval idea that tradition and divine authority determine value was striking. One or two centuries later, in the height of the Enlightenment Age, his words must have seemed commonsensical: in every realm, newness appeared, and it seemed good.

One of the discoveries which introduced all manner of new foods, customs, and ideas to Europe was that of the "new world" of the Americas, and yet, this new world was not conceived of as new, but as old: the land was called the "Indies," the natives were called "Indians," the "Lost Tribes of Israel." America was thought to reflect Europe's childhood: as John Locke said, "In the beginning, all the world was America" (1924, II:5, 49).

Likewise, although Anglo-Americans later referred to the changes of 1776 as a "Revolution," the common meaning of the word at that time was "circular motion." The *Declaration of Independence*, for example, repeats Locke's view that the tyrannical actions of a sovereign make it legitimate to dissolve the government, an action which returns the people to a primary "state of nature," that is, their original condition. As Blaise Pascal said in his *Pensées*, "the art of revolutionizing and overturning states is to undermine the established customs, by going back to their origins . . ." (1961, IV).

While the original inhabitants of the Americas were sometimes viewed by Europeans as noble and free, they were rarely viewed as creative, but rather, as savage or primitive. But when the "civilized" British colonists intentionally dissolved their political contract and returned to "ancient liberties," they did not perceive themselves as having lost their "civilized" qualities: rather, they felt they now had the freedom to create society anew. The *Declaration of Independence* calls for the creation of a new country, and as Thomas Paine wrote in *Common Sense*, the first country with law, instead of a monarch, as the ruler.

Thus, the social contract theories of Hobbes, Locke, and Rousseau seemed to be realized in the founding of the Swiss Federation and the U.S. Constitution, implying that states are intentional creations of the people. For citizens to have the freedom and responsibility to create civil society was a dramatic alternative to perceptions and doctrines which maintained that there was a divine right of kings or eternal order of society. The creative freedom Machiavelli had attributed to the individual prince was now distributed to a broader public. For some, particularly the French Philosophes, this social contact conception entailed a complete denial of any significance to tradition. As Thomas Hobbes said, disapprovingly, "There are many who, supposing themselves wiser than others, endeavor to innovate, and divers innovators innovate divers ways" (1962, *Philosophical Rudiments* V:5, 78). Pro or con, the new theory seems to have convinced many that society was the product of human will and invention.[1]

That, however, was just one element of an Enlightenment view which may be summed up as the belief that human reason and action can transform the world. Largely taken for granted in our society today, this belief represented quite a radical thesis at the time, because despite the advances of the Renaissance, feudal social structures were still widely entrenched, religious dogma was pervasive, and absolute rule was common. It was in the face of this "darkness" that the Enlightenment thinkers sought to shed their "light."

For example, the virtually simultaneous discovery/invention of the calculus by Sir Isaac Newton and Gottfried Leibniz expressed a fundamentally altered perception of the universe. Despite the Renaissance emphasis on proportion and perspective, the Euclidian geometry used by Leonardo and his contemporaries could not be used effectively to conceptualize motion. However, the concern with motion was paramount to the age, and it was clear to Kepler, Galileo, and Newton that the discoveries of astronomy and physics in general could only be articulated through new mathematical forms. Not only the orbits of the planets, but also the great expansion of trade and sea travel and the major demographic changes wrought by capitalism and urbanization meant that "a world in motion" wanted calculation, and the more closely calculated, the more smoothly it seemed to move.

It makes sense that the invention of the calculus occurred in an era when pendulum clocks began to display not only hours, but minutes and seconds, and when their use began to be commonplace throughout Europe. Order, harmony and proportion—measurement of time, weighing of gold—created a structure in which creation takes place.

For Newton and the Deists, God set things in motion, but then, basic natural principles kept everything moving forward and around. Of course, the combination of circular motion and change that epitomizes Enlightenment thinking was strongly influenced by Thomas Aquinas and Aristotle, despite the fact that some of the Enlightenment intentionally distanced itself from those thinkers. The new scientific

approach called for experimentation, but the goal was the discovery of "the natural laws" of the universe. In his *Principles of Mathematical Philosophy*, Newton aspired to explain the relationship of all matter to motion through his three laws of motion and the law of universal gravitation: bodies are propelled by force and attracted to each other by "centripetal force."[2] For Hobbes, Locke, and Rousseau, government emerges out of the state of nature and may return to it. The state of nature is the realm in which individuals exist separately, either in perpetual conflict (Hobbes) or harmony (Rousseau); the needs of the individuals, however, draw them together in civil society. The natural laws of the universe and those of society are similar. Both are comprehensible: God is not busy interfering with either. Tradition, too, has a minimal role, except in that certain traditions might seem to be "natural laws."

Individual human beings, however, have major roles, as capitalism and democracy expand. And the discoverers of these ideas receive special acclaim, as well. Because he "employed . . . his mighty Genius . . . to enlighten our own minds and that of others," Newton was not only knighted Sir Isaac by the British crown, but hailed by Voltaire as a "great man" who had "hardly an equal for the past thousand years" (Voltaire 1968, 65–66, 96–106).

In saying this, Voltaire no doubt consciously meant to elevate Newton over all the statesmen and religious figures of the past millennium. This expressed Voltaire's admiration for reason and democracy over "superstitious" belief and despotic rule. For the French Philosophes in particular, the goal was to fight against and overturn authority and dogma and replace them with the Age of Reason. While the English thinkers professed deism, many of the French espoused secularism, but in either case, the important consequence in terms of creativity was that these thinkers emphasized the individual human's right and power to understand the universe and to direct his own destiny. Ephraim Chambers' *Cyclopaedia* of 1728, Denis Diderot's *Encyclopédie* of 1743, Jacques Buot's of 1761, the *Encyclopedia Britannica* of 1771, and Frederick Brockhaus' *Lexikon* of 1808 all expressed this—as did the pursuit of a new universal language by Descartes, Bacon, John Webster, and John Wilkins (Subbiondo 1996, 129–132).

These new views of the Enlightenment, so removed from most of medieval thought, are clearly evident in European governments' honoring of individual creators and discoverers. Britain, for example, offered prizes for creative solutions to technological problems; the reward it offered for the invention of a sea chronometer in 1714 set off a bevy of competitive efforts.[3] In 1710, Britain granted copyrights to writers as an economic incentive to their creative efforts. As early as the fifteenth century, the English crown had given William Caxton a monopoly to the secret of movable type—an invention he had "borrowed" from Gutenberg. In 1623, the British Statute of Monopolies established a standard for patents which was then followed throughout the world for the next three centuries: ". . . letters patent and grants of privilege for the term of one and twenty years or under, heretofore made,

of the sole working or making of any manner of new manufacture within this Realm, to the first and true inventor or inventors of such manufacturers . . ." (Haggart 1988, 181).

Whether or not patents actually foster greater technological creativity,[4] it is clear that the idea of a patent is direct and strong testimony to the significance of creation in the modern sense of the word: it values innovation, it prohibits imitation, and it gives economic advantage to the recipient. In these ways, it reflected the distance society had moved during the Renaissance away from the Middle Ages: capitalism and creation were now inseparably bound. This development was paralleled by copyright protections given in France, for example, for Jacques Quenci's 1609 engraving of Paris, and ultimately encoded in that country's 1793 "rights of genius" (K. Scott 1998, 27). These efforts expressed both praise and commercial legal privilege.

In a similar vein, the British crown granted knighthood to the discoverer Francis Drake, the scientist Isaac Newton, and the painter Joshua Reynolds for their unique contributions. It is clear from this that "service to the Crown" was understood to encompass a range of activities as wide as that which our present concept of creativity allows. Indeed, we are the inheritors of the Enlightenment belief in "progress"—the steady march forward of reason—which was thought to be expressed in all these honored activities. Such progress seemed undeniable in the scientific and technological realms: each improvement in the development of the telescope, for instance, dovetailed with an advance in pure science, and vice versa (Ziman 1976, 19–23).

These advances had major political and economic value, and that is why Napoleon, still very much an Enlightenment figure, later wrote:

> The sciences that honor the human spirit, the arts that embellish life and transmit great acts to posterity, ought to be especially noted in free governments. All men of genius, all who have attained a distinguished rank in the republic of letters are French, whatever the country that gave them birth . . . (A.R. Turner 1993, 92).

Napoleon's propagandistic efforts are obvious from his implication that his empire was one of those "free governments" and that all creators should feel citizens of it; at the same time, it is also obvious that Napoleon would not have indulged in such propaganda were it not for the fact that he and his contemporaries saw the great merit in the creations of these artists and scientists. Indeed, the revolutionary French government and Napoleon set up the French Society for the Encouragement of Industry, subsidized applied scientific research, awarded prizes for useful inventions, and established the École Polytechnique and École des Arts et Metiers. Nonetheless, social support for invention and entrepreneurship was less, and legal obstacles were greater in France (and the rest of the Continent as well) than in England, which is why the Industrial Revolution was more intense there (Mokyr 1990, 253–261).

Napoleon's view was clearly shaped by the broad currents of Enlightenment thought stretching back more than a century. Already in the seventeenth century, Bacon's *New Atlantis* had come to be understood by some as a model for education based on the scientific method as opposed to the scholastic system of disputation. Unable to change the universities directly, a group of reformers met in John Wilkins' rooms at Oxford to organize what became The Royal Society at London for the Improving of Natural Knowledge (Subbiondo 1996, 131). As Bishop Thomas Sprat described the Royal Society (1667): "their purpose is . . . to restore the Truths that have lain neglected, and to make the way more passable to what remains unrevealed. . . . They have tried to put . . . the Knowledge of Nature . . . into a Condition of perpetual increasing . . ." (Mosse, et al. 1964, 91–93). Or, as the *Encyclopedia Britannica* declared in 1768, to "let knowledge grow from more to more. . . ." Benjamin Franklin relates the founding of the American Philosophical Society similarly:

> . . . I had formed most of my ingenious acquaintance into a club of mutual improvement, which we called the JUNTO; we met on Friday evenings. The rules that I drew up required that every member, in his turn, should produce one or more queries on any point of Morals, Politics, or Natural Philosophy, to be discussed by the company; and once every three months produce and read an essay of his own writing, on any subject he pleased (1932, 54).

This idea of the progress of science was paralleled by the content of the major scientific theories of the era, focusing on motion, acceleration, and dynamism.[6]

Furthermore, the competition which contributed to the "perpetual increase" in the realms of scientific and technological development was matched in the realm of economics, particularly as the Industrial Revolution gathered steam. Leaving behind the feudal view of property as land, inherited or conquered, Locke said that human labor, transforming nature, created property (*Two Treatises* 1924, II:5). Franklin further developed this "labor theory of capital," but also maintained that "money is of the prolific, generating nature. Money can beget money, and its offspring can beget more, and so on" (1924, 219). By 1776, Adam Smith could write about the creative powers of labor and capital in his epoch-making *Inquiry Concerning the Nature and Causes of the Wealth of Nations.* Smith discussed "the Causes of Improvement in the Productive Powers of Labor," "the Natural Progress of Opulence," and the policies which would foster greater economic growth. Not only was labor viewed as creatively altering nature, but there was also an art, Political Economy, which analyzed how labor and capital could be more creative—so that production could be increased, markets expanded, and the accumulation of profit augmented. "The creation of wealth" became a virtue, and the assertion of the bourgeoisie altered the old feudal social structures. What C. B. McPherson has called the "ideology of possessive individualism" was on the rise.

In science and technology, as well as in economics, "progress"—"the perpetual increasing" of knowledge, skill, or wealth—did not result in merely *more* of these things, but also in *new* things. The introductions of the steam engine, coal mining, gas lighting, iron building construction, the railroad, the introduction of large-scale factory manufacturing, all involved technological advances which had mutually reinforcing effects, bringing about what we call "the Machine Age" and the "Industrial Revolution." For example, while the first factory appeared in 1719 and cotton workers began to use the Flying Shuttle around 1750, this greatly increased the availability of commodities and brought about major social transformations, each of which involved other new innovations—urban planning, stock markets, labor movements, and so on. Even one of the most insistent critics of the ways in which civilization had "progressed" toward inequality and greed, Jean-Jaques Rousseau, still believed that ". . . one . . . distinguishing characteristic of man . . . about which there can be no dispute . . . is *the faculty of self-improvement* . . . " (1984, 88).

The readiness for the new had numerous wellsprings, including capitalism, secularism, democracy, science, and encounters with other cultures through European imperialism. The intellectual foundations of this openness lay in the kind of thinking exemplified by M. E. de Montaigne's *Essays* (1575) and by René Descartes' *Discourse on the Method of Rightly Conducting the Reason and Seeking the Truth in the Sciences* (1637). Part of Montaigne's work, "The Apology for Raymond Sebond," builds on early Greek skepticism and asks, "What do I know?" Emphasizing the uncertainty of our knowledge, Montaigne then strongly advocates openness and tolerance.

Descartes goes further. In his work, he pronounces his radical doubt about all that he has learned: the teachings of his instructors, the claims of science, all examples and customs, and all his own prejudices. He then resolves, he says, to "never accept anything for true which I did not clearly know to be such." He further resolves to examine things in as many separate and simple parts as possible and progress to ever greater complexity by rigorously recording every step in order to find secure basic facts.

The meaning of Descartes' words to the history of the concept of creativity is indicated by how absolutely all traditions seem to be thrown overboard in favor of "reason," or as the English thinkers, Locke and Hume emphasized, "experience." Now no stone would be left unturned, all realms would be open to investigation, to analysis, to experimentation, to reinterpretation, to discovery.[7]

Some today consider the Enlightenment sense of rationality to be in strong contrast to any concern with creativity.[8] Abstract reason and a Deist universe do not seem to allow for the spontaneous twists and turns, the inventive spark, the expressive feelings which have become such important aspects of our notion of creativity since the Romantic era. Indeed, in Enlightenment painting, architecture, and music, proportion and harmony were of utmost importance—Bach even felt

that there was "a right way for composing any piece of music, even for what was called a "free fantasy" (Boorstin 1993, 428). It would, however, be a mistake, I believe, to impose our conceptions and ignore the ways in which the Enlightenment sense of progress related to innovation. Imagination was repeatedly referred to, but as an important helpmate to reason. The Enlightenment thinkers were focused on change, the emergence of the new, through ordered progress, rather than through spontaneity.

G. W. F. Hegel, later following up on these ideas, theorized that sufficient increase in quantity inevitably leads to qualitative change, and it certainly seems as if the Enlightenment conception of "progress" expresses this. The "march forward" into the future was a willingness to leave the past behind, as Francis Bacon's idea of "experimentation" and René Descartes' "doubt" indicated. What existed before was thrown in question. Old assumptions were dismissed as "fable," "fancy," or "errors"; traditions were discarded, and new approaches tried. The Brothers Grimm and others invented the science of folklore precisely because they saw these old ways disappearing. If we look at the folktales and legends they collected, we see that magic, talking animals, fairies, witches, trolls, and all manner of supernatural phenomena are presented as the causes of change and the means of solving problems. The contrast between this dying world view and the new economically, politically, scientifically, and culturally dominant belief in human initiative and ingenuity could not be greater.

This is clearly visible in the invention of the *novel*, which expresses an understanding of the difference between "fact" and "fiction," and which almost always relies on human and natural actions—not supernatural ones—to move its plot forward. Jonathan Swift's *Gulliver's Travels* presents this contrast with brilliant sarcasm. It also clearly shows that one could employ extraordinarily creative fantasy in the service of the Enlightenment ideal of rationality. While Gulliver travels to all kinds of supernatural lands filled with fairy-tale characteristics, he continuously encounters beings who challenge him to think rationally about the superstitious, violent, intolerant, and absurd customs of his own British-European culture. Gulliver discovers how his society has raised him to be a cruel and foolish primitive in comparison with the wise members of harmonious societies ruled, for example, by philosophical black women or intelligent horses. Illuminated by reason, our prejudiced society gets turned on its head.[9]

And European society was being turned on its head—though reason played only a part in this transformation. Capitalism, which had been expanding since 1300 from southern Europe to the north, completely changed society by destroying the feudal order. The factory system expanded rapidly and made home craft work nearly obsolete (Bunch and Hellemans, 158); stock companies and banks began to wield greater power than the landed gentry; families were uprooted from their farms and moved to the cities. Already in the early eighteenth century Rousseau de-

nounced the idleness, luxury, inequality, and corruption of the society; a century later, capitalism's leading critic, Karl Marx, saw it this way:

> Constant revolutionizing of production, uninterrupted disturbance of all social conditions, everlasting uncertainty and agitation distinguish the bourgeois epoch from all previous ones. All fixed, fast-frozen relations, with their train of ancient and venerable prejudices and opinions, are swept away, all new ones become antiquated before they can ossify. . . . It compels all nations, on pain of extinction, to adopt the bourgeois mode of production . . . (Tucker 1978, 476–77).[10]

"In one word," said Marx, playing off the idea of the biblical creation story which he otherwise rejected, capitalism "creates a world after its own image." Groups of workers, peasants, and poets attempted to resist this creation in diverse ways, but capitalism continued to grow and transform the world.

An example of this was the rise in bourgeois patronage of the arts. While the merchant class first aspired to imitate the aristocracy in this, it soon surpassed them. This is especially clear in the extraordinary burst of Dutch painting with Hals, Vermeer, Rembrandt, in the seventeenth century and the flourishing of Austrian music with Mozart and Handel, in the eighteenth. The bourgeoisie supported these creations, and many of the artists, working as entrepreneurs, responded in clear ways to bourgeois tastes. While the arts, for example, reached extremes of opulence for the French aristocracy, painting in the most advanced capitalist countries of Britain and Holland focused on glorifying portraits of the bourgeoisie; romanticized genre paintings of the lower classes, barely revealing their painful dislocations arising from the change from feudal to capitalist society; and serene landscape painting, contrasting starkly with the mines and mills now beginning to flourish. In the world of music as well, bourgeois tastes took over. Opera, emerging from the pastorale in the early seventeenth century as courtly entertainment for the aristocracy, became, by the end of the century, much more sophisticated both musically and theatrically as public productions took place in Venice and elsewhere. Similarly, Guiseppe Scarlatti's 1681 transformation of the church sonata to the opera sinfonia overture form led, by 1730, to symphonic music for large orchestras playing for large public audiences. But even in the more emotionally powerful paintings and musical compositions, the Enlightenment ideals of harmony, proportion, and progress were generally displayed.

For the middle and upper classes at least, the idea of perpetual increase and transformation of the past seemed reasonable, orderly, and good. Thus, in England the Royal Society very rationally established its program of "leaving room for others that shall succeed them, to change, to augment, to approve, to contradict them at their discretion" (Mosse 1964, 92). This approach was picked up in the creation of the U.S. Constitution, which in Article V, provided a structure for the various amendments which were later introduced. This can be viewed as a creative solution to the problem of absorbing innovation into a tradition. We might say that the

American political approach, as well as the scientific and economic thinking of the age, emphasized a purposeful evolution toward ever greater rationality. (Herder's and Hegel's views of history expressed this as well.)[11]

The growing awareness of historical change meant to some degree a discarding of the past, and to some degree a desire to preserve it. In point of fact, the increased concern with history and with progress into the future reflects a new understanding of "time," something to which philosophers, like Immanuel Kant, gave great attention. It is obvious that the increased dominance of a linear conception of time over the earlier, more cyclical conception, would result in a different perception of creativity. Now there could be "something new under the sun." Human creativity would have consequences, the world would be changed . . . even if the past was filled with admirable models for imitation.

Thus, as medieval thinking and architecture were abandoned, they were replaced by the "neoclassic" revival of Greek and Roman art forms. While Voltaire emphasized a "universal taste for novelty," he did so by referring back seventeen hundred years to Ovid's *Metamorphoses*. Handel's *Messiah* revolutionized the world of music, but only by returning to biblical themes and by creating a composition so appreciated that it was repeated again and again, establishing a new tradition of what we now call "classical music." Significantly, too, the first museums opened, displaying collections of works from the past for the benefit of public education: Oxford University's Ashmolean Museum in 1683, the British Museum in 1753, the Louvre in 1793. In 1806, meanwhile, Giuseppe Bossi was commissioned to restore Leonardo's terribly eroded fresco of the *Last Supper;* Bossi took the liberty of making what he called "not a copy but rather a renovation based on good authorities" (A. R. Turner 1993, 93). In all these efforts, as well as those of the Encyclopedists in France and the social contract theories of Hobbes, Locke, and Rousseau, we can find both a look back and a look forward.

REVOLUTION, MODERNITY, AND THE INVENTION OF CREATIVITY

ENLIGHTENMENT, REVOLUTION, AND ROMANCE

The Enlightenment concepts of reason and progress have continued, in many ways, to characterize major tendencies of modern thought, particularly in terms of economic and scientific thinking. Born of these concepts however, was also the modern idea of "revolution" as the dramatic introduction of the new. Responding to the first stirrings of the American Revolution and eager to push it forward, Thomas Paine wrote:

> We have every opportunity and every encouragement before us to form the noblest, purest constitution on the face of earth. We have it in our power to begin the world over again. A situation similar to the present has not happened since the days of Noah until now. The birthday of a new world is at hand . . . (1953, 51).

Thirteen years later and across the Atlantic, the French Revolution announced an even more radical break with the past. In the name of enlightened reason, the revolution toppled the aristocracy, expropriated Church lands, and even changed the names of the months. Proclaiming "the sovereignty of the people" and "the suppression of all the established authorities . . ." (Decree of Dec. 15, 1792; Mosse et al., 1964, 168), French troops overran much of Europe and at home set up the guillotine to decapitate the opposition. Within a few years, even many enthusiastic initial supporters of the revolution were overcome by fear and revulsion from the violence unleashed.

This so-called Reign of Terror helped throw into question the Enlightenment ideals of ordered reason and progress, and the world of European thought was transformed. This was most apparent in the new, "Romantic," tendency to view poetic and artistic creation as an emanation or outpouring of emotional energy rather than as a reflection of ordered development. William Wordsworth, in his

preface to the *Lyrical Ballads* of 1800, for instance, no longer portrays poetry as the reasoned imitation of nature, but as "the spontaneous overflow of powerful feelings" (1968, 1278). Wordsworth and several other major poets and artists in England and Germany found inspiration for those feelings in nature—not in the formal, ordered gardens of the Enlightenment, but in natural settings. In his *Lines Composed a Few Miles Above Tinturn Abbey,* (1798), Wordsworth seeks solace from "the din of towns and cities" of the industrial age in the "sublime" landscape. The contemplation of nature, he says, provides "life and food for future years," and "the anchor of his purest thoughts" (1264–67). It seems as if the Romantic Movement's turn to nature was in direct proportion to the rise of industrialization, mechanization, and urbanization; it was a turn to the peaceful, the eternal, the divine, in the face of the mad rush toward progress, change, human doing, and human making. But Wordsworth is keenly, even painfully aware of the march of time, and his turn to nature is not a return to cyclical thinking; nature gives birth, and as such, inspires those who properly worship her. Not rational striving nor willful revolution (though many of the British and German poets initially supported the French Revolution), but quiet contemplation, would allow the most powerful forces of creativity to well up in the Romantic artist and writer.

He who could "commune" most effectively with nature so that "the spontaneous overflow of personal feelings" produced great works of art was called at this time a "genius." While this Latin word had originally referred to a guardian or special spirit of a person, place or group, by seventeenth and eighteenth century England, genius had come to denote both an innate power in certain individuals and extraordinary individuals such as Shakespeare. By 1800, the psychology of creativity shifted the locus of genius from the faculty of "judgment" to that of "imagination." The quality of genius as the innate power of inspiration, expressed itself in the natural spontaneity of the imagination. Creativity was in a sense, beyond the conscious, purposeful control of the individual genius creator—in fact, Samuel Taylor Coleridge, and others viewed imagination and inspiration as "organic"—(Abrams 1962, 157, 187 ff), and yet that individual was still emminently worthy of honor.

While this notion is somewhat reminiscent of Plato's and Homer's view of the poetic inspiration of the muses, it differs from these earlier views of creation by minimizing or discarding a sense of divine or traditional authority over the creator and by lauding the poet's ability to receive and manifest the hidden powers of creativity through his imagination. The idea of the "creative imagination," first formulated haltingly by some Enlightenment thinkers, was now enthusiastically endorsed by scores of English, French, and German writers (Engell 1981). Indeed, for Coleridge, the imagination is "the primary agent of all human perception," and ". . . a repetition in the finite mind of the eternal action of creation in the infinite I am" (1968, 1440–41). The imitation of nature became less significant; creative self-expression was the goal.

This shift from imitating external nature to organically expressing internal emotion and images and from a focus on reason and proportion to spontaneous outpouring corresponded to the change in the meaning of the words "art" and "culture." Much earlier these words had referred, respectively, to "skill" and "natural growth." The changes initiated in the Renaissance led, by 1820 at the latest, to "art" being no longer primarily a skill, but a domain of special creativity, and the greatest artists were called "geniuses." "Culture" was no longer merely an agricultural term, but primarily a word used to refer to the most elevated accomplishments of humanity. Art was understood as a key, if not the key expression of culture.[1]

And despite the natural metaphors for creativity, the building of culture was proclaimed to be strenuous and exalted work: "Creative art . . . demands the service of a mind and heart heroically fashioned," said Wordsworth (*Thanksgiving Ode* 30–1816); for Gustave Flaubert, heroic struggle epitomized creative endeavor. While the medieval poet Boccaccio had hailed the Greek god Prometheus as an inspirational image, the Third Earl of Shaftsbury started a key strain of modern thought by actually likening the poet or artist to Prometheus. Within the next century, Herder, Goethe, Schlegel, and Shelley picked up on this idea, focusing ever more strongly on the rebellious, antiauthoritarian nature of Prometheus and the artist. The artist creates new worlds and rules there "according to his own laws," said Schlegel (Abrams 1953, 157–158, 251–2).[2]

The change to the modern era is epitomized by Goethe's transformation of the character of Faust, who is an extreme case of such genius. While the medieval and Marlowe versions of the Faust legend show him condemned to hell for trading his soul in exchange for great, creative powers, Goethe's Faust wagers his soul, but saves himself in the end by dedicating his creative abilities for the benefit of humankind. Faust's study of the Bible leads him to believe he should produce something useful, and after many temptations to do otherwise, he finally creates an environment in which others can be free and creative. Faust thereby finds fulfillment, and instead of losing his soul, ascends to Heaven . . . which is itself portrayed as the scene of eternal creativity.

While Shelley's and Goethe's creative heroes work for others, these artistic geniuses are nonetheless set off from all others, both the masses and the bourgeoisie. Indeed, like Beethoven, their creative hero continues on his creative pursuit regardless of others' understanding or acceptance of his work. The artist hero is elite, an extraordinary individual. Clearly, the focus on individual creativity, as opposed to imitation of nature, reflects both a new psychology of the creative process and a new concept of the Self.

This focus on the Self was given theoretical grounding by Immanuel Kant's *Critique of Pure Reason*, which gives priority to "experience" over "pure reason" as the key to knowledge, and says that the conditions for experiencing anything are the preexisting mental categories which structure how we think and which comprise

what he calls the "transcendental ego." Strictly speaking, says Kant, we can never truly know God or "the thing in itself"; we can only know what we are capable of perceiving. Kant called this a "Copernican Revolution in Thought," because the basis of knowledge would no longer be the "real" objects of the world, but to a greater degree, the Self. Indeed, in a way that went far beyond Descartes, Kant helped make the Self the significant object of study, the focus of creative power. Understandably, "self-expression" supplanted "imitation of nature" in the world of art.

At the same time, one of the most important ideas of Kant and his contemporaries was that reality might be perceived in terms of opposing elements. Kant discussed the "antinomies"—that a number of fundamental claims about existence could be defended in opposition to each other; his focus on Self necessarily led to a counterbalancing emphasis on "the other" (something highlighted later in Hegel's philosophy). For the poet, William Blake, the dualism of body and spirit, reason and emotion, sacred and profane, led to a resolution in the *Marriage of Heaven and Hell*. Stendhal, Marx, Nietzsche, Kierkegaard, and Freud all followed with their dualisms of reason and emotion, capitalist and proletariat, nature and consciousness, conscious and unconscious. For many of these thinkers, the "dialectical" interaction between the "opposites" was the crucial locus of activity.

The late eighteenth- and early nineteenth-century elevation of the individual self may also be viewed dualistically, for it was manifested in two separate, but related strands vis à vis creativity. One strand, which has come to dominate modern and contemporary views of art and literature, was that of romantic poetry and art with their focus on the inspiration, imagination, and self-expression of the individual creative genius. The other strand, which has played a far greater role in modern science and economics, was the continuing influence of Enlightenment and post-Enlightenment science and capitalist democracy, with their focus on ingenuity, invention, and problem solving. Both cases are clearly based on the Enlightenment notions which guided the individual rights doctrines of the American and French revolutions; and in both cases, the creative individual was honored.

Thus, one of the most significant works of the late Enlightenment and early modern era was the *Autobiography* of Benjamin Franklin—the self-presentation of a creative genius and self-made man, a printer, democratic politician, capitalist economist, writer, scientist, "tamer" of electricity, inventor of useful instruments, and founder or cofounder of several organizations and institutions, including the American Philosophical Society (dedicated to the promotion of invention), and most significantly, the U.S. Constitution. So impressive was Franklin that even the serious and sedate Kant could call him "a modern day Prometheus" (Flatow 1993, 5). However, Franklin's *Autobiography* does not merely reflect how extraordinarily creative he was, but it also expresses his belief that everyone could and should emulate him. Promethean or not, Franklin's view of politics and society emphatically rejected the importance of inherited "nobility," and his view of creativity shared

nothing with the conception of the divine inspiration of a few poetic or scientific geniuses. His notion was distinctly "democratic," individualistic, and entrepreneurial.

> ... I have always thought that one man of tolerable abilities may work great changes, and accomplish great affairs among mankind, if he first forms a good plan, and, cutting off all amusements ... makes the execution of that same plan his sole study and business (1932, 101).[3]

Despite the fact that it is questionable whether Franklin himself always followed this advice, he repeatedly stressed the importance of individual industriousness and ingenuity as the "Way to Wealth" and success. These notions, coupled with the words of Thomas Jefferson's *Declaration of Independence*, that "all men are created equal" and the French Revolutionary motto, *liberté, egalité et fraternité* furthered the separation of human creativity from the divine and thereby placed it more firmly in the sphere of human merit.

In point of fact, Franklin's idea of formulating a plan and working hard to fulfill it, and moreover, the specific plan he formulated reveal a general disbelief in the powers of "fate" and a lack of concern for any divine "grace" which might aid him. Through human effort alone, great things can be accomplished! Prayer and propitiation of supernatural forces are gone from Franklin's account; as he admits, too, "humility" is the least of his virtues.

It is difficult to underestimate how radically the concept of creativity alters when fate and grace are ignored. Humans are now both liberated and burdened by the responsibility to make their own destinies. As capitalist economic theory and the "social contract" theories of politics had proclaimed, individuals were on their own, and these theories were generally perceived as being reflected concretely in the republican-democratic political revolutions and the capitalist Industrial Revolution of the era. Monarchy and aristocracy were eliminated in the United States. The medieval class structure or estates was demolished in Europe, and the old guilds, long in decline, were now officially abolished because of the French Revolution. What we call the "Industrial Revolution" emerged, especially in England, as individual inventors and entrepreneurs managed to attain wealth and renown seldom achieved in earlier times by so many commoners.

This democratic elevation of numerous individuals as creators also created a public which appreciated their creations. Inventors James Watt and Richard Arkwright had already become famous in England, and many tried to emulate them. No wonder Franklin could redefine man as "the tool-making animal." The rise of the middle class also led to the growth of public museums; the first modern public concerts at Telemann and Bach's Collegium Musicum in Leipzig (rather than concerts sponsored by church or aristocracy); public subscription libraries; public gardens and parks; initial efforts toward public education, and the first modern efforts to abolish slavery and to grant women equal rights.[4] All of these efforts

reflect the idea that the fruits of creativity should be accessible to all and that *everyman* has the possibility of being inspired to creativity. After all, as Ralph Waldo Emerson later said, "the goal of civilization is emancipation."

This notion was related to the Enlightenment ideals enunciated earlier by the French Encyclopedists, Diderot, d'Alembert, Rousseau, Voltaire, and d'Holbach, who conceived of the universality of knowledge and the "rights of man."[5] The French Revolution was fought in the name of these ideals, even during the Reign of Terror. Indeed, the ideal of human emancipation was developed and advocated despite or maybe precisely because human rights, equality, and anything approaching universal reason were so blatantly absent. Kant and the French Encyclopedists wrote during an era frequently termed "benevolent despotism." Racism and misogyny were generally taken for granted, despite claims of universality. International conflict was widespread, colonialism thriving. And fifty years after the French Revolution, Heinrich Heine could compose *Germany, A Winter's Tale*, from exile in Paris, parodying the conformity, repression, and censorship of his native country.

But Heine's critique only makes sense if we recognize how many others had come to share the ideals of individual human and civil rights. Wilhelm von Humboldt, for example, wrote that the goal of his discourse on government was to highlight "the absolute and essential importance of human development in its richest diversity." These words, taken as the motto for John Stuart Mill's 1859 treatise, *On Liberty*, concisely express the ideal of universal fulfillment that the Enlightenment, German Idealism, and many of us today value.

Von Humboldt's idea was enriched by Friederich Schiller, who completely reversed Plato's estimation of the role of the artist in society. In the *Aesthetic Education of Humanity*, Schiller, the democrat, says that "every individual person, in ability and destiny, carries a pure, idealistic human being within" (1972, 11). The problem, however, is that the people must be educated to create a good political society, and yet a good political society must exist for people to get the proper education. The answer to this circle of theory and practice is art. Even those who have no time for art because of their moral concern about the well-being of society should turn to beauty, because it brings harmony. In the ideal state, according to Schiller, reason and imagination, theory and practice are united: freedom and equality are attained through beauty (1972, 7, 24–25, 31–32, 126–8).

This vision derives in part from Kant's theory of judgment but can only be understood in light of the democratic changes of the era and the elevation of the artist to the role of creator and emancipator. Throughout the nineteenth century, issues of individuality, freedom, equality, nature, and creativity were merged and played off against each other.[6]

While Schiller posed his vision as a problem and an ideal, others, like Condorcet, Herder, and Hegel, followed the Enlightenment view that history displayed a tendency toward the progressive betterment of humanity. Creativity and

points

fulfillment were entwined with human destiny. For Hegel, in particular, the movement of all history was toward the Absolute Spirit or Mind, in which the Self recognizes the other as its own, so that all cultural expression is understood to be ours. The path towards this goal is strewn with alienation and conflict—only through this struggle do we work and create.

These notions are carried to their logical conclusion by Karl Marx, who thereby summarizes much of post-Renaissance Western thought. According to Marx, history is heading inexorably to the solution of all conflicts through Communism— societal cooperation to foster the "all-sided development of the individual" (Marx-Engels Werke, Eg. Bd. 1974, 536; Kapital; Deutsche Ideologie).

Marx's emphasis on history and human creation are logical correlations of his rejection of ideas of the eternal and of God. For Marx, as with Feuerbach before him and Nietzsche and Freud after him, God is a human creation, and the characteristics attributed to God are the idealizations of frustrated humans. Since creativity is a primary characteristic of this ideal, we may say that the "divine analogy" of the Renaissance thinkers (because we are "made in the image of God," we are somewhat creative as well) is reversed by Marx—because we are potentially creators, but are not realizing our potential, we imagine an ideal, external, and eternal creator.

In Marx, all the philosophical, literary, artistic theorizing of the era is connected to the dramatic upheaval of the Industrial Revolution. Indeed, he insists that these ideas be brought back down to earth. In fact, according to Marx, all the expressions of culture we generally think of as creative are in reality dependent upon and conditioned by the social-economic material "base."

The most important innovations, says Marx, have been in the technical, material, social-organizational domains, and a society is much more accurately defined by its economic structures than by its works of art. True human creativity can flourish only when the conditions of the social-economic base allow it. Because this base, especially in capitalist society, is filled with contradictions, we are not fulfilling our creative potential. It is in Marx's analysis of "alienated labor" within capitalist society that he shows his complete commitment to the ideals of post-Renaissance Western society. According to him, work should be: universal, many-sided, freely chosen, expressive of man's true essence, in cooperation with others, and formed according to the laws of beauty. Creative labor should connect man with his product, and therefore with his true self, with nature, and with society (Ps Ms, *MEW* Erganzungsband, 510– 522, 530–546, 568–88; Vollrath 1971).

In order for laboring man to fulfill himself in this way, the capitalist negation of creative labor would have to be "negated." While Benjamin Franklin and others may have viewed the pursuit of happiness as consisting of individual "industry" and "ingenuity," Marx and Engels claimed that "the condition of the free development of each is the condition of the free development of all" (Tucker, 1978, 491; *MEW*

4:482). In other words, true individual creativity can exist only in a society in which everyone cooperates and no one exploits another.[7]

Marx shared this ideal with many other thinkers. Fourier, Saint Simon, and their followers had established utopian communities in England, France, and especially in the United States. Robert Owen wrote *A New View of Society* and founded New Harmony, Indiana, to apply his principles to practice. New constitutions for new towns were conceived. Society was to be created anew. These creations did not, however, succeed for long. Instead, modern industrial capitalism, with all its advantages and disadvantages, raced forward, expanding to all corners of the globe.[8]

While industrial capitalism and democratic movements in Europe and America were revolutionizing society, the artists and poets had their say as well. For Percy Shelley, the connection between creativity and politics meant "freedom." Shelley returned to the image of Prometheus, whom he saw as a rebel. But this rebel fought for the liberty of all and was "the Champion of Mankind." He was "the type of the highest perfection of moral and intellectual nature impelled by the purest and truest motives to the best and noblest ends" (1901, 163). Similarly, poetry, according to Shelley, is liberating and divine and acts through the imagination on the moral good. Society may not recognize them as such, but in truth, Shelley said, the poets are the priests of inspiration and . . . the "unacknowledged legislators of the world" (1929, *A Defense of Poetry*, 38).[9]

However, while a few poets and artists were politically active, their power to influence public policy in any direct way was surely less than those leading economic, military, and technological change.[10] Had the poets and artists the kind of political power they claimed, then conceptions of creativity might have reached back to Aristotle and modified his theory by conjoining literary-artistic productivity with political action. This did not happen, but it came close in the widespread reverence for Beethoven, whose stature as a cultural figure was compared to Napoleon's power on the political level.

Whereas Shelley's democratic poet, and Schiller's more humble *Wilhelm Tell*, are "pure, moral heroes," more rebellious and less "pure" heroic types appear in other versions of the Prometheus motif: Goethe's *Faust*, Blake's and others' comments on John Milton's *Satan*, the Byronic Hero, and Carlyle's linking of genius, heroism, and historical change in the idea of "the great man," who might destroy even as he creates. This coupling of destruction with creation was a logical consequence of the French Revolution, and neither Marx's theory of revolutionary change nor the heroic rebel motif in literature can be understood without those events.

The sense of rebellious or destructive creativity, as with Marx's view of the proletarian revolution, is not like the earlier sense of cyclical revolutions: the break with the past is thought of as absolute, and in some cases brutal, and for this reason, creation is seen as more truly *new*. Thus, by 1857, Charles Baudelaire's *Les Fleurs du Mal* (with its wonderfully dialectical title) introduces the modernist age by pursu-

ing the satanic-rebellious hero theme wherever it will go. In *The Voyage*, Baudelaire reconnects with the explorers of the Age of Discovery, but is ready to go further:

> But the real travelers are those only who
> leave in order to leave . . .
> And, without knowing why, always say: let us go!
> . . . even in our sleep, curiosity torments and rolls us
> as a cruel angel whipping the sun.
> The fire searing our brain is such that we want
> To plunge to the bottom of the abyss, Heaven or Hell,
> what does it matter?
> To the bottom of the Unknown to find something new!
> (1921, 271, 76).

Cursing God while searching for beauty in morbidity and the gutter, Baudelaire sees himself as Icarus, striving for the heights, but falling into the abyss. It does not matter to him, he claims, for life is art. The ultimate evil is boredom, and the search for novelty becomes its own end.[11] The distance between this attitude toward creativity and the biblical one is enormous. Here, discovery and creativity are intimately bound in the search and the bringing forth of the new. In fact the search becomes more important than what is found.

For Baudelaire, the creative genius emerges through his own will power and in spite of the morality, beliefs, and customs of the majority in the nation. This rebellious creator theme was echoed in different ways by several of Baudelaire's contemporaries, such as Stirner, Emerson, and Whitman; Degas later said, "every artist is a criminal" (May, 22).[12]

The idea of the creative rebel was matched, quite understandably, by the notion that such disrupters of social order were dangerous (see Mary Shelley's *Frankenstein*), or at least deranged. Psychology in its modern sense is an invention of the nineteenth century, and its development had a great deal to do with studies attempting to relate creative genius to madness. Thus, Louis-Francois Lelut's *Der Demon de Socrate* (1836) claimed that Socrates' mention of a personal "genius" or "demon" as inspiration for his ideas was proof of Socrates' madness. Soon thereafter, Augustin Morel (1850), Cesare Lombroso (1864 and 1891), and then Max Nordau (1910), found the genius of scores of great artists, musicians, and writers, including Robert Schumann, Shelley, Baudelaire, Beethoven, and Michelangelo, to be tied to all manner of psychologically degenerative disorders (Prentsky, 1989, 243–252).

Creativity and true madness (at least in the last decade of his life) merged in the exemplary case of Friedrich Nietzsche. He combined the Romantic Rebellion notions of heroic genius with an analysis of Greek art, tragedy, and heroism, Hegel's *Master-Slave Dialectic*, Charles Darwin's theory of evolution, and Arthur Schopenhauer's *The World as Will and Idea*. For Nietzsche, the primary illusion of the social majority is that of the Judeo-Christian God and morality, and the custom of most people is

to "follow the herd" like dumb sheep. The rebellious genius on the other hand, knows that God is dead and that morality is a disguised form of the "will to power"—aimed at lowering the great and strong to the level of the masses. Those who are "noble of spirit," says Nietzsche, love danger and despise the weakness and submissiveness of "slave morality." "The noble type of man experiences *itself* as determining values; it does not need approval; it judges, "what is harmful to me is harmful in itself": it knows itself to be that which first accords honor to things; it is *value-creating*" (*Beyond Good and Evil* 1968, 395).

For Nietzsche, all of life is "becoming," and each moment is equal in value—the only difference is in the form that growth takes. As every artist understands, says Nietzsche, freedom is "facility in self-direction" (*Will to Power* 1967, 374). Life is an art form, and the noble individual creates his life and his values as he wills to. The coming Superman owes nothing to tradition or to the society around him, creates without concern for good or evil, and creates without concern for final intentions (*Beyond Good and Evil* 1968; *Will to Power* 1967, 379). The creator is spontaneous and natural, but his work is an expression of will. This will is hardened by the resistance of nature and society, which causes pain and suffering, but this, in turn, fosters creativity. The *Will to Power*, usually regarded as Nietzsche's ultimate value, is inseparable from the *creativity* it always implies. To those who understand—the *Schaffenden*, (the creative ones), Nietzsche's *Zarathustra* says, "you can give birth to a dancing star." /They tried to become as gods.

What we are concerned with here is how creativity is valued in our society. Emphasizing that all values are created, Nietzsche comes to the dramatic conclusion that creativity itself, as the purposeful expression of the will to power, is the highest value. The creation of values, not any particular creation or any other particular value, is ultimate.

Nietzsche is, in this respect, the father of contemporary thought; nonetheless he might view our question of how society values creativity as foolish: not society as a whole, but only a few creative individuals understand what is important; furthermore, how these individuals value creativity is a matter of their own creative choosing—they are not obliged to follow anyone else's values and may change theirs as they see fit. Of course, if they are as brilliant as Nietzsche they'd see that their will to power, that is, their ability to create values, is the basic truth of their noble lives. The Superman is an artist, a demigod, a creator of his world.

This philosophy was opposed not only by empiricists demanding proof, but also by Marxists critiquing its exaggerated individualism, and, of course, by Christians and Jews, denouncing its fervent atheism. And Nietzsche was not the only or most prominent creator denounced by traditionalists. Censorship and public outrage arose to squelch writers like Gustav Flaubert, Henrik Ibsen, Heinrich Heine, Oscar Wilde, and Walt Whitman, and artists like Thomas Eakins, Aubrey Beardsley, and countless others. While the governments of many countries frequently prohibited

certain literary and artistic works from ever being disseminated, in the cases of Britain, France, and the United States in the mid- to late nineteenth century, suppression of creative expression was generally limited to those who would break sexual taboos. In theory at least, virtually any statement could be made regarding religion, politics, or science.

This points to the difference between legal and social tolerance, as is clearly shown in the example of Darwin's *On the Origin of Species by Means of Natural Selection, or, The Preservation of Favored Races in the Struggle for Life*, sketched in 1844, published in 1859, and elaborated upon in detail during the next decades. While the British government imprisoned Oscar Wilde for immorality, it honored Darwin—despite the fact that Christian theologians from numerous denominations viewed the theory of evolution as blasphemy. Darwin himself had anticipated public hostility to his work and reflected in his notebooks how persecuted earlier scientists had been. He therefore hesitated for a decade before presenting his theory publicly, but did so when Alfred Russell Wallace expressed his thoughts on evolution.

Earlier, Johann Gottfried Herder had discussed historical evolution, Charles Lyell had emphasized geological change, and Jean-Baptiste Lamarck had claimed that there was constant, spontaneous evolution in all life forms. Darwin's contribution was to insist that evolution was not random and to present great quantities of documentation indicating that "favorable variations . . . tend to be preserved, and unfavorable ones destroyed" as organisms struggle to survive. The physical environment and the life forms within it are constantly changing; survival depends on developing the fittest means of adaptation. And, in the case of humans, this seemed to underline the significance of ingenuity.

THE INVENTION OF THE WORD, "CREATIVITY"

Darwin's views found widespread acceptance among scientists and among increasingly great portions of the Western populace despite strong denunciations by those upset with his theory's contradiction of a literal reading of the Bible. Indeed, thanks to the theory of evolution, larger numbers of people began to take the Bible figuratively than ever before, exercising their creativity in their attempts to maintain their faith. In fact, a number of thinkers like Henri Bergson and Alfred North Whitehead devised interesting amalgams of biblical, Hegelian, and evolutionary ideas of human and planetary creative development.

But even those disinclined toward science and philosophy seemed struck by the obvious cultural and material changes of the second half of the nineteenth century, which seemed to correspond to and reinforce the theory of evolution and the increasing focus on historical change and individual creativity. Whether or not creativity was the doing of God, it seemed to be part of the natural process, and it was surely visible in human effort. The literary, philosophical, psychological, eco-

nomic, and political elevation of individual self-fulfillment was paralleled by a relentless material creativity, a drive toward progress, growth, and innovation.

For most people, theories of creativity were on the periphery of their awareness, but they could see that the planet itself had been changed by human inventiveness. Great factories with towering smokestacks arose; mines were dug; skyscrapers reigned over cities which expanded to include millions; new towns and suburbs were designed and laid out; railroad tracks covered the earth, and subway tunnels went underneath; miles of perfectly ordered rows of wheat now covered the fields; the Suez and Panama canals and thousands of others were created as well. Those who had known provincial, pre-mechanized, agrarian existence—especially those in Europe and North America—had to be awed, simply by looking at the transformed landscape.

This transformation, which was the result of the dramatic inventive-entrepreneurial activity of the Industrial Revolution, certainly was met with many forms of criticism and resistance—sporadic riots and destruction of machinery took place, legal and political restrictions were imposed. Still, a brief list of some of the countless inventions of the nineteenth and early twentieth centuries—the steam engine, interchangeable parts, the assembly line, trains, automobiles, airplanes, telephones, motion pictures, radios, skyscrapers, toilets, electric lights, refrigerators, steel, petroleum—immediately shows the validity of Samuel Florman's words:

> To be an engineer . . . any time between 1850 and 1950, was to be a participant in a great adventure, a leader in a great crusade. Technology, as everyone could see, was making miraculous advances, and, as a natural consequence, the prospects for mankind were becoming increasingly bright (1976, 4).

Already in the first half of the century, technical schools and universities such as the École Polytechnique in Paris and the Technische Hochscule in Karlsruhe had sprung up across Europe. Technological museums were founded as well, including the ones in London (1845) and Washington (1846), which James Smithson established "for the increase and diffusion of knowledge among men," in order to promote further innovation. In fact, all across Europe and America, the proliferation of patents and inventions, especially between 1875 and 1900, was enormous.

No wonder the International Convention for the Protection of Industrial Property, establishing an international structure for patent registration, was adopted in 1883, followed by the establishment of the International Bureau for the Protection of Intellectual Property. As Alfred North Whitehead later said, "The greatest invention of the nineteenth century was the invention of the method of invention"—the methodical application of disciplined learning from science to the world through technology (1929, 136).

By mid-century, technology and invention gained vast popular attention. Major technological achievements were hailed by the press, honored by governments, and celebrated by thousands in banquets, parades, and pageants. In 1839, for

example, the French government made one of the inventors of photography, Louis-Jacques-Mandé Daguerre, a member of the Legion of Honor, and bought his patent so that others could have access to it and improve upon it. When his Daguerreotype was first shown at the Institute of France, a vast crowd gathered and "there was as much excitement as after a victorious battle" (Gernsheim 1965, 22–23). Soon thereafter, the great enthusiasm for the invention led hundreds to set up dark boxes on tripods all over the city of Paris, according to one eye witness (1965, 69).

In 1851, six million people, among them Marx, visited The Great Exhibition of the Works of Industry of All Nations in London to marvel at the Crystal Palace, the advances in industry, commerce, and the arts, and countless technological inventions. Millions more visited the 1876 Philadelphia Centennial Exhibition, where Alexander Graham Bell first demonstrated his telephone. And thirty-two million people visited the 1889 Universal Exposition in Paris, which was highlighted by Dutert's enormous "machine hall" and Eiffel's 300 meter tower. Significantly, it was not, as in past cases, an architect who designed the "centerpiece" of the exhibition, but an engineer. Engineers appeared as heroes of fiction, and fantasies of the future, like those of Jules Verne, were filled with extraordinary technological creations (Florman 1976, 4–5). In America, inventors were as famous as presidents, and Thomas Edison was hailed as the Wizard of Menlo Park who, with "his" light bulb, "filled the darkness with light."[13]

Of the many great technological inventions of the century, photography was one which changed the way people saw the world and behaved and also altered conceptions of creativity. When Daguerre, Joseph Niepce, and others first introduced photography, the ability to imitate nature was the proudest aspect of the invention. While many hailed it, others denounced photography as blasphemous for daring to "fix the image of God" by imitating the creation so exactly (Gernsheim 1965, 23–24). Niepce called his 1826 work "Héliographie" (sun drawing), and it now seemed that imitation of nature was achievable by machine; that is why, when Daguerre's work was presented in 1839, Paul Delaroche exclaimed, "From today, painting is dead" (Gernsheim, 23).

Paradoxically, while thinkers since Plato and Aristotle had spoken of art as the imitation of nature, the striking imitative capabilities of photography seemed to show even more clearly than the Romantics' theories of art, the inadequacy of the old view. Initial assessments of photography were that it was a pure, mechanical reproduction of nature, devoid of genius or inspiration; Edgar Allen Poe maintained, in fact, that photography and other inventions were suffocating the human imagination. Within a few decades, however, thanks to Alfred Stieglitz, Julia Cameron, and others, it became clear that, like the other arts, photography could involve great imagination and self-expression (Gernsheim 1965, 37–40, 71ff, 115ff). The choice of subject, the framing of it, the lighting, the perspective on it, were revealed as critical, creative decisions. Thus, while the machine could imitate, humans could use it to see the

world in new ways and even to bring something new into being. The ideas of invention and creation began to blend. Photography made clear that technology and art were not necessarily opposites.

The same change of attitude occurred in what we call "industrial design." The routine, repetition, and mass quantities of identical products flowing from the industrial revolution appeared for the most part to be the antithesis of unique and novel creations; still, thanks to William Morris and other designers, some mass-produced use objects could be viewed as works of art, and the designing of technologically advanced objects could be viewed as creative. Indeed, this was an ironic and very self-conscious merging of a romantic nostalgia for past art forms and utilization of new technologies. Thus, the concept of creativity could apply to the introduction of novelty in the realms of both art and technology.

It comes as no surprise, then, that the word, "creative," which had been used since the Renaissance mainly in regard to art and poetry, began toward the end of the nineteenth century to be applied to the technological domain as well. Now, because the power of technology was just too great to ignore, its connection to "mere craft" could be altered. In addition to photography and commercial design, architects intentionally merged form and function. The steel framed skyscraper architecture of the Chicago School of Richardson, Burnham and Root, and most significantly, Louis Sullivan, merged art and engineering in an inspiring and influential way. Science fiction, as well, melded art and technology. The works of Jules Verne, in particular, resonated strongly with the public, and his works were translated and read widely around the world.

By the end of the century, universities like Yale began to acknowledge the inadequacy of the old distinctions and absorbed into their curriculum formerly separate schools of engineering. The "divine analogy" now applied not merely to poets and artists, but also to those modern Prometheans who truly "stole fire from the gods" and forged new worlds in their blast furnaces.

Even within the traditional field of painting, the changes going on were dramatic. Perhaps influenced by the success of photography to eschew realism and consider the effects of light, the Impressionist artists initiated an approach that placed technique, style, form, and color over subject matter. And what mattered most, it seemed, was that this art delivered a *new* perspective. This focus on the process over the content encouraged the proliferation of styles in art which was to follow as well as a whole train of movements in literature and music abstracting away from objects and structures and pointing toward "formalism," technique, and process. When these artists were first rejected by the French Academy, it was no doubt because the members of the academy asked themselves, "but is it art?" The subsequent success of the Impressionists has, to a great extent, changed the question to, "but is it creative?" This is an important shift from "does it meet our standards" to: "is it new?"

The artists concerned themselves with technique, and the technicians concerned themselves with aesthetics, and all were concerned with the *new*. No wonder in 1875 the English word, "creativity" first came into being.

Apparently it was Adolfus William Ward who first used the term "creativity" in his *History of Dramatic English Literature*. Following generations of admiring Shakespeare readers and scholars, Ward filled his description of the poet and playwright with repeated references to his "creative genius." Ward then went on to write of Shakespeare's "poetic creativity" (1975, I:506)—a usage which implies an awareness of multiple types of creative ability. Indeed, Ward criticized those specialists who classify Shakespeare narrowly according to their limited disciplinary horizons and thereby miss the whole genius of his creative activity. While Ward's own disciplinary concern seems to have kept him from relating "poetic" creativity to anything in nonliterary realms, the time was obviously ripe for others to do this.

Indeed, while the word expresses the developments of the era, it appears almost accidently in Ward's work, and it took some years before creativity would find its way into the English language. More than fifty years would pass, moreover, before "creativity" would be used in French and Italian, and it was not until after World War II that the word became common enough even in English to be regularly included in standard dictionaries (Webb 1987).

Still, the invention of the abstract noun, "creativity," marks a turning point. Now attention could be directed to a phenomenon, capacity, or characteristic noticeable in many dimensions of human endeavor.

No single individual in Western history seemed to display this characteristic across the technological and artistic domains as well as Leonardo da Vinci, and it seems fitting that it was contemporaneous with the invention of the word "creativity" and the establishment of international copyright and patent laws, that Leonardo's notebooks were first systematically studied and published.[14]

It was in this intellectual environment that Alfred Nobel of Sweden then conceived of what has become the major international prize for creativity and achievement. Because Nobel's early experimentation had led to the destruction of his factory and the death of his brother, he was apparently viewed by many as a "mad scientist," and he probably thought at length about the creative process; because he had worked under John Ericson in the U.S. and became involved in the Baku oil fields in Russia, he had a distinctly international awareness. Thus, when he successfully patented dynamite and began to reap great profits from the oil as well, Nobel found the means to endow prizes for the most significant inventions, discoveries, creations, and contributions in physics, chemistry, physiology-medicine, literature, and peace (his successors added economics). It seemed obvious to Nobel and it was becoming obvious to others that there was a phenomenon which cut across all the disciplines and all the countries of the world, and that this phenomenon could also

be measured and celebrated. This phenomenon was the bringing of something new into being; what could be measured was how important and excellent the new thing was. Thus, by the end of the nineteenth century even discovery in natural science began to be compared to creative processes in other realms. Of particular significance for twentieth-century analyses of creativity was the thinking of Hermann Ludwig Ferdinand von Helmholtz (1821–1894). One of the most empirical of scientists, and renowned for his work in optics, physiology, electromagnetism, and the law of the conservation of energy, von Helmholtz was also "enchanted and bewildered" by the beauty of artists like Raphael, awed by the "originality" of Wagner's music, and in admiration of Goethe and Beethoven. Of such artists, von Helmholtz said: "We venerate in him a genius, a spark of divine creative energy, transcending the limits of our rational and self-conscious thought. And yet the artist is a man as we are, in him the same intellectual forces are at work as in ourselves . . ." (Koenigsberg 1965, 440). According to von Helmholtz, the creative process was similar for artists and writers as well as scientists. Asked on his seventieth birthday to explain this, he reportedly said that all creators go through a series of stages: "saturation" or "preparation" (gathering all possible information), "incubation" (digesting and considering the information), and "illumination" or "inspiration" (in which a spontaneous breakthrough or insight occurs).

Graham Wallas seems to have been the first to put in writing von Helmholtz's words, translating them into English in 1926, though by then other authors had built on Helmholtz's notion. Wallas added a fourth stage, "verification" (1965, 79–82), which was influenced by Henri Poincaré's 1906 account of mathematical invention. His description of the unique reasoning of mathematics is coupled with a portrayal—totally at odds with traditional notions since Plato—of a creative process of mathematics which involved as much intuition and imagination as in the arts and literature. The change of attitude can be seen clearly in August Kekule's description of his discovery of benzine chemistry: in his first paper of 1855 on the subject, he did not mention that the discovery was influenced by a dream; when he admitted this in 1865, he was mocked by other German chemists; in 1890, however, he was invited to give the keynote address at the Benzolfest because German chemists were ready to counterbalance extreme empiricism with an acknowledgement of intuition (Schaffer 1994, 27–28).

While Albert Einstein maintained that "imagination is more important than knowledge" and "believed in intuition and inspiration" (in Schwartz 1994, 23), the philosopher-psychologist William James considered the analytical thinking of science and philosophy superior in some ways to art and literature; nonetheless, he, too, was convinced that the process of both had commonalities. Indeed, the capability of making associations between different things was for James the essential characteristic of artistic and scientific genius. The difference, he felt, was between those who instinctively draw analogies—artists and writers—and those who reflect on the analogies they make—scientists and philosophers.

The merging of science and the humanities, with a special connection to creativity and the realms of intuition and dreams, reached its climax in the work of Sigmund Freud and other psychoanalysts like Carl Jung. Freud, in particular, aspired to apply the scientific method to the human psyche; the results of his observations echoed in many ways the teachings of the Romantic writers, German idealistic philosophers, and especially Nietzsche. Freud agreed with the perspective of the Romantics that creativity was an emotional outpouring of the soul, but Freud also agreed with Marx and Nietzsche that many things we say and do, including things we call "creative," reflect hidden motivations. Those "unconscious" motivations, according to Freud, were primarily sexual, and aggressive. Such primitive "drives" had to be suppressed, because society could not tolerate their unbridled expression; by channeling these impulses into creative outlets like art, science—everything that we call "civilization"—we make ourselves neurotic, but we avoid the great dangers to our survival that these impulses would cause.[15] Thus, in a sense, for Freud, creativity is a human necessity.[16]

As questionable as some of Freud's claims were, his influence on twentieth-century ideas about creativity are many. Freud strongly reinforced the idea that we should look for hidden motives behind what people do; he and Jung prompted numerous twentieth-century creators (especially but not merely artists and writers) to seek ideas from their dreams, to capitalize on jokes, slips of the tongue, and other intuitions for their work. Finally, Freud helped bring sex and violence—often derisively viewed as the primary focus of our contemporary media—onto center stage for twentieth century society.

As we saw above, the ancient Near Eastern and European peoples had coupled creativity with biological fertility, and Plato had tied art and beauty to Eros. Erotic and pornographic elements have filled world art and literature since time immemorial. Since Freud, however, many in the West have not only behaved much more freely in their creative expressions of sexuality, but have also come to assume that many forms of creativity express libido, or are a substitute for it.

While some, like Austrian painter Gustav Klimt (1862–1918), and French composer Claude Debussy (1862–1918) imbued their creations with great sensuality, and countless others wrote of love, the pounding, breathtaking music and dance of Stravinsky and Diaghilev's ballet, *The Rite of Spring*, first presented at the turn of the century in Paris, seemed an audible and visual expression of the "primitive" sexuality in our midst. The initial resistance and hostility to the ballet, as to Freud's theory, paralleled the resistance some felt to the overwhelming technological, political, and social changes of the era—just as the pounding music paralleled the throbbing pulse of the relentless, machine-driven changes. Indeed, the pounding machine threatened to drown out all else. Revering tradition, but acknowledging how dramatically the world had been transformed, Henry Adams saw the age as epitomized by the electric dynamo.[17]

For F. T. Marinetti, speed, movement, technology, and passion formed the wave of the future we all should ride. In his 1908 *The Foundation and Manifesto of Futurism*, he combined love of technology with imagery of the Romantic Rebellion, Nietzsche, and the looming violence of the era:

> We intend to glorify the love of danger, the custom of energy, the strength of daring. . . . We declare that the splendor of the world has been enriched with a new form of beauty, the beauty of speed. . . . We will glorify war We are on the extreme promontory of ages. . . . We will sing the great masses agitated by work, pleasure, revolt. . . . (in Chipp 1970, 286).[18]

Futurism was a relatively short-lived movement: World War I made some of its ideas concrete, and several of its leaders were wounded or killed. Furthermore, the dynamism within the world of art itself brought other theoretical and stylistic tendencies to the fore. Nevertheless, relating modernity to the machine and, especially, creativity to dynamism and violence, was a significant tendency of the age . . . as seen in the Italian and German Fascist movements (which cited Nietzsche and the Futurists).

This approach was also clearly present in some ideas of the political actors of the Russian Revolution. While Marx had generally held that the "social revolution" he foresaw would be the result of vast historical forces beyond the control of individuals (*Kapital*, Preface), Vladimir Lenin's theory of revolution is one of determined will and action. The creation of a new Communist society requires, for him, the forceful dismantling of bourgeois society in all forms and the erection of the dictatorship of the proletariat. By forcing these changes and educating the masses, using almost any means necessary, the avant-garde creates the conditions for the stateless and propertyless future society.

By the 1930s, the German philosopher, Martin Heidegger, could compare the creativity involved in the *Origin of the Work of Art* with that of state building, hypostatizing the "great man" of genius who forcefully shapes the world and reveals Being. According to Heidegger, great creations might well require destruction.[19] Meanwhile, Antonin Artaud's *Theater of Cruelty* manifestos extolled "eros, utopia, fantasy, crime, obsession, cannibalism, and blood" (11). About the same time, Pablo Picasso described his creative process and also his view of society in similar terms: "A picture is a sum of destructions. . . . ; the essential, in these times of moral misery, is to create enthusiasm" (Zervos 1952, 56).

However, Picasso painted his masterpiece, *Guernica*, to portray the violent horrors perpetuated by the Fascists. In so doing, he joined with a number of artists and writers of the era like George Grosz, Erich Maria Remarque, and e. e. cummings, who created works opposing war, and with philosophers and politicians like Bertrand Russell and Woodrow Wilson who worked to create the League of Nations and later, the United Nations, in order to prevent mass destruction.

This has certainly been an uphill battle, however. Alfred Nobel, too, was a pacifist, but the dynamite and blasting caps he invented only increased the carnage. Indeed, the creative energy poured into war and the business of destruction has been enormous. Throughout the nineteenth and twentieth centuries, technologies, from interchangeable parts to the airplane, which had been developed for other purposes, were adopted for military uses, and the military drive spawned countless new technologies that were used for civilian purposes as well (Ziman 1969). Thus, the American Civil War witnessed the invention of iron-clad ships, the Gatling gun, and repeating rifles. In 1862 alone, the United States government awarded patents to what was at that time an extraordinary number of major military inventions (1969, 240). World War I resulted in the first tanks, aerial bombs, and poison gas. World War II prompted the inventions of radar, missiles, jets, jeeps, and of course, *the* destructive creation, the atom bomb.[20]

While some formalist theorists of art and literature (Croce, Springarn, and Wilde) expressed a belief in "art for art's sake,"[21] politics and artistic creativity have always been connected. In ancient Mesopotamia, and as far as we know, everywhere else, rulers used art to show their power and to influence the masses, and triumphant countries routinely despoiled losers of artworks in war as a way of appropriating the others' wealth and culture. In the twentieth century, however, explicit theories of the relationship of art to politics became widespread.

Political art has elements of the "imitation of nature" idea in it: both Soviet realism and the U.S. Farm Security Administration's documentary photography claimed to be presenting "reality." Nonetheless, imitation here is, from an outsider's perspective, clearly interpretation, because the goal of such art is to create change in society. Writer Susan Sontag points out that realistic photographers like Walker Evans, Dorothea Lange, Ben Shahn, and Russell Lee:

> Would take dozens of frontal pictures of one of their sharecropper subjects until satisfied that they had gotten just the right look on film—the precise expression on the subject's face supporting their own notions about poverty, light, dignity, texture, exploitation, and geometry (1990, 350).

The coupling of art and politics in many cases echoed Schiller's and Shelley's notions of creativity in service to humanity. Countless individual artists, writers, and musicians had worked with this intent in the past, but by the 1920s, organized movements pursued this approach. Such groups as the Mexican Revolutionary Syndicate of Technical Workers, Painters, and Sculptors, the Federal Art Project of the American Works Progress Administration, and especially the German Bauhaus movement, believed that the creative arts could and should serve to help build a better, more social world (Selz 1970, 456ff). Leon Trotsky, in *Literature and Revolution*, claimed that Soviet art would "lend beautiful form" to the process of "social construction" and "psycho-physical self-education." Art would be carried to new

heights, and the average person under Communism would be stronger, more rhythmic, more musical, more like Aristotle, Goethe, or Marx (in Chipp 1970, 466).[22]

Deciding what is art is hardly easy, and critical thinkers can view virtually any example from the arts as a type of propaganda; even "art for art's sake" can be seen to have a message. But when the idea that art is supposed to serve a higher purpose is adopted by those with power, it easily leads to prohibition, censorship, and repression of any form of creativity which goes against that higher purpose. Thus, Trotsky, opposed to a narrow interpretation of what would qualify as "revolutionary art," nonetheless insisted: "We ought to have a watchful revolutionary censorship. . . . The new art will be realistic. . . . The Revolution cannot live together with mysticism; nor can the Revolution live together with romanticism . . ." (463). However, as Soviet art moved away from a depiction of the masses to heroic images of Stalin, the censorship that developed proved far more extreme than Trotsky called for and ultimately claimed him as its victim.

Lumping together Soviet realism with practically all forms of modern art, Hitler denounced these movements as Jewish-Bolshevik-Negro degeneracy and opposed them with his own forms of social-political creative destruction. While Hitler imitated countless dictators before him in many ways, he initiated or fostered new forms of mass spectacle, construction of highways, architecture, monuments, a vast bureaucracy, extraordinary military power, and concentration camps. He also called for "the foundation of a new and true German art." New as this was to be, it was also meant to be eternal:

> But we National-Socialists know only one morality, and that is the morality of the people itself. . . . As long as a people exists, however, it is the fixed pole in the flight of fleeting appearances. It is the being and the lasting permanence. And, indeed, for this reason, art as an expression of this being, is an eternal monument. . . . (Muller-Mehlis 1976, 476–77).

In response, one Nazi museum director said, "the most perfect object created in the course of the last epochs . . . is the steel helmet" (1976, 474). However, Hitler took the power of the creative arts so seriously, that he arranged two simultaneous art exhibitions in 1937: the *Great German Art Exhibition* highlighting "volkish" German art, and *Entartete Kunst* (Degenerate Art) in which 650 of the most renowned avant-garde works of Europe were defamed. Subsequently, sixteen thousand pieces of modern "Bolshevik-Jewish" art were confiscated, much of it sold for foreign currency; the rest burned. The artists (most of whom were not Jewish) were persecuted and threatened with sterilization, imprisonment, or confinement in an insane asylum (S. Barron 1991, 9–10; Selz 1970, 474, 459).

"What becomes apparent is the microscopic attention the Nazi hierarchy accorded the observation and regulation of all aspects of cultural life in the Reich" (S. Barron 1991, 10). Joseph Goebbels established government bureaus to control

virtually everything in the arts, and the Nazis changed the face of Europe. Ultimately, hundreds of museums around Europe were pillaged or even destroyed; thousands of individual works of art were eliminated; technical creations which served the war effort were, of course, appropriated . . . and millions of human beings were killed in an effort to hold onto "being and lasting permanence."

For Hitler, art—and everything else—was to serve the "needs" and "values" of the Third Reich. No form of creativity, no form of human existence, which didn't correspond to his vision deserved to live. Amazingly, despite the horror, even concentration camp inmates managed to create thousands of artworks, writings, and musical compositions. Deprived of work materials and a means of sharing their work, hungry, depressed, anxious, and tortured, many victims still found the will to create (Frankl 1984, S. Milton 1990). Many others managed to survive the persecution or flee to America and elsewhere where their existence, and often, their creativity was appreciated. Similarly, numerous Soviet writers, musicians, and scientists fled the strictures on creativity imposed by Stalin, benefiting their host societies. Indeed, many of the most prominent names we associate with creativity in this century fled either Nazi Germany or the Soviet Union: Einstein, Freud, Stravinsky, Marc Chagall, Thomas Mann, Solzenitstyn, Mies van der Rohe, Mikhail Barishnikov, Alfred Eisenstaedt, Hannah Arendt, Bertold Brecht, and countless others.[23]

The recitation of these names reminds us of the dramatic changes this century has witnessed. Hitler's desire for permanence in the flux of things grew from the distress he and others felt about these changes. He clearly stated his chagrin about the world of art: "every year something new. One day Impressionism, then Futurism, Cubism, maybe even Dadaism, etc." (Chipp 1970, 476). We might well add: Symbolism, Expressionism, Minimalism, Free Verse Poetry, stream of consciousness novels, atonal music, jazz, modern dance, rock 'n roll—for the arts as a whole have been "advancing" through progressive rejections of existent traditions and making "heroic" forays into new, uncharted territory ever since the Romantics, Baudelaire, and the Impressionists. As painter Arshile Gorky exclaimed: "The Twentieth Century—what intensity, what activity, what restless, nervous energy" (in Chipp 1970, 532).

It is understandable that the Nazis and Soviets were not the only ones to be distressed by the newer artistic ventures of their age. Even before Hitler and Stalin took power, "mainstream bourgeois morality" had been shaken: that is why Wilde, Flaubert, Whitman and others were censored, why Darwin was denounced, and why riots broke out when *The Rite of Spring* was performed. What we call "modernism," that vast multidimensional movement in literature and the arts, spanning perhaps the time from 1848 until 1918, intended to overthrow tradition by revealing its order as false. Unlike the romantic rebellion of Shelley and others earlier, these later generations had no powerful god or state to oppose and no specific goal to aim at.

In the new world, things were seen as disjointed, atonal, broken. Heinrich Ibsen ends *A Doll's House* with a door slamming; Picasso paints two eyes on the side of a head composed of angled planes; Alberto Giacometti sculpts *Hands Holding the Void* (the Invisible Object); Gertrude Stein's *Lady's Voices* is theater without characters; Lewis Carroll's *Alice* enters a Wonderland of nonsense, where "what is, isn't, and vice versa";[24] the poet, William Butler Yeats, writes: "Things fall apart, the center cannot hold" (1968, 2383). No wonder surrealism and dadism flourished.

While many writers of the first half of the century were strongly influenced by Freud's and Jung's theories of the unconscious, which emphasized how much of our lives is out of our rational control, some of the most modern or progressive literary and artistic works might be viewed as the translation of Einstein's theory of relativity and Werner Heisenberg's principle of indeterminacy or uncertainty. With all in motion, no fixed point could be located; reality is not simply a given "out there"—it depends on the observer's position and measurements. This was brought home by the tremendous development of motion pictures. Not only could entire historical epochs be presented in a two-hour time span, but the imagery could be slowed-down or sped-up, viewed close up or from a distance, framed in diverse ways, edited, or revised. The great world wars of this century, the rapid pace of technological change, the decline of religion, and the common philosophical view that no system of thought is ultimately workable have all paralleled this sense of relativity and uncertainty as well.

Into this situation, which appeared to many people as chaotic and overwhelming, came not only fascist and all other manner of political solutions, but, for some, nostalgic yearnings for tradition or a resurgence of religious fundamentalism. For others, art has, ironically, served as a religion-substitute (Barzun; Herman).[25] Indeed, some artists have claimed extraordinary powers to reveal the hidden, to explain society's innermost meaning, to play God (Chipp 1970, 180–187), and today millions of people stand in silent reverence before the creations displayed in our museums.

For large numbers of people, however, art is unimportant—yet another example of the disorienting and chaotic features of this century. As Joseph Herman notes, in fact, artists are on the margins of society, they exist "by some freak of nature" (1978, 120). Far more powerful in our society are those in business and technology who profess belief in "innovation," "entrepreneurship," and "ingenuity." But the word "creativity" has come to embrace all these as creative expression. Creativity, therefore, might truly be said to serve to some degree as a religion surrogate. Indeed, in the aftermath of World War II, creativity began to be the focus of widespread attention in the United States and abroad.

CREATIVITY IN THE CONTEMPORARY GLOBAL CONTEXT

While the word "creativity" had been invented seventy years earlier, and a continuous stream of writers, inventors, artists and others had contributed to the cultural development of the idea of creativity, World War II nonetheless marks a kind of watershed in the history of the concept and its role in our society.[1] It was following the war that the word first became common and appeared in most English-language dictionaries. The worldwide economic depression of the 1930s, the concentration camps, the mass destruction and dislocations of World War II, the explosion of the atom bomb, the rapid postwar rebuilding, all helped produce an unprecedented awe about the human potential to create and destroy and made many question reality as never before.[2] At the same time, the relief of having (for the moment) survived the horrors of war and the pride in having "come out on top" allowed the United States and the Soviet Union to push forward in relentless building and then paranoid competition. Controlling nearly half the world's economy and optimistic but fearful as well, the United States in particular began to focus on both the theory and the practice of "creativity."[3]

In 1948, Alex Osborn's *Your Creative Power* popularized what a few corporate researchers and a number of cultural leaders had been pointing to. In 1950, J. P. Guilford, the president of the American Psychological Association, called upon psychologists to study creativity, and this call resulted in literally thousands of studies. According to one of the leading students of creativity,

> Governments became interested because the sheer physical power and, by a very short step, political power that comes from inventiveness had suddenly (with Hiroshima) become so manifest; commerce is newly interested because the increase in goods, services, and profits is most evidently dependent on new ideas; religion is interested because old meanings have been destroyed and new ones call to be created; the individual is interested because to create is to be more fully and freely oneself. Perhaps at no other time in all of human history

has there been such general recognition that to be creative in one's own everyday activity is a positive good (Barron 1968, *Personal Freedom,* 7).

Within a generation, "the analysis of the nature of creativity [became] one of the chief intellectual commitments of our age" (L. White 1963, 273), a ubiquitous feature of American and then global culture, and a largely unquestioned value of great importance.

Creativity could attain this status because of the way it has been embedded in and integrated with the other developments, concerns, and values of the twentieth century. However well we understand their theories, many of us assume that Freud and Einstein were correct: much is out of our conscious control, and everything seems relative. Today, we readily acknowledge the validity of what John Dewey said fifty years ago: "Domestic life, political institutions, international relations, and personal contacts are shifting with kaleidoscopic rapidity before our eyes. We cannot appreciate and weigh the changes: they occur too swiftly" (1990, 413–14).

Indeed, the advocates of the dizzying "advance" of artistic, technological, and political movements have been focused on the newness of each step. Since the end of the last century, they've coined phrases for their work such as "art nouveau," "avant-garde," "cutting edge," "new wave," "the moderns," and "postmodern." These terms, so taken for granted in our culture that they're the stuff of daily advertising, reveal a love affair with change and rejection of tradition that goes far beyond the world of art. Science and business, for example, speak repeatedly of "the next frontier," "innovative solutions," and "high-tech" alternatives to existing modes of operation. Making the *new* is our culture's agenda.

The material changes alone are constant and dramatic. World population has trebled since World War II. Capitalism and Western technology have combined to unleash a "flood of novelty": twenty-five million patents have been granted in the past two centuries (Haggart 1988, 183). When we think of the frantic pace of trading in the stock markets of the world, we realize that business changes by fractions of a second.[4] And this has been coupled with social-material developments such as: multiculturalism, globalism, the rise of women, social and geographic mobility, efforts toward democracy, depletion of natural resources, the persistent threat of violence and destruction, genetic manipulation. All this is portrayed through film, television, and computers, which overwhelm us with images and information.

These developments have greatly accelerated the social-cultural transformations of the past centuries which have undermined the seeming certainty of traditional values and pushed us into a global and relativistic context. Every aspect of our lives seems touched by change, and with each passing year, the intensity of change seems to increase. It is understandable that creativity has assumed considerable significance in our culture. We expect, desire, and fear the new. Many of the changes we witness have been propelled by innovation, and we need to be creative to cope with these changes. What's more, in the face of all the changes, creativity

seems to be one of the main values we can cling to: it is an expression of our talent and of our hope.

Today, creativity generally refers to the phenomenon of bringing forth something new in virtually any realm of human endeavor. This interdisciplinary perspective is new. Also new are the egalitarian attitude that almost anyone, from any walk of life can be creative, the multicultural attitude that creativity can been found anywhere on Earth, and the overwhelmingly positive value we attach to the word.

Such an understanding of creativity has been growing steadily since the Renaissance, but hardly anyone in Renaissance Europe would have recognized our concept. By the same token, our understanding of creativity is changing at this very moment—through the words of this and other books on the subject and the crucible of change we call "global culture." Indeed, this book's "history of the concept of creativity in the West" naturally elides into a look at the conception of creativity in our global culture.

SOME CULTURAL CHANGES AFFECTING OUR CONCEPT OF CREATIVITY

In the last century, and even to some extent today, the word "culture" referred mainly to the greatest achievements of human creativity in art, science, literature, music, and perhaps religion. Today, however, these phenomena are often viewed as instances of "high culture," for the anthropological use of the term—to describe the totality of customs and beliefs of a people—has become overwhelmingly dominant. Now, the word "culture" is very often used as part of the word "multiculturalism."

This is particularly clear when we examine how anthropology has affected the world of art and ideas about creativity in general. The rise of the field of anthropology at the end of the nineteenth century might be understood as the West's attempt to describe and comprehend the rapid changes, globalization, and relativity of the era.[5] Anthropology was a tool, but also an expression of the West's confrontation with others, and, finally, with itself. When anthropology began, Europeans perceived themselves as being "cultured" and others as barbaric. By the early twentieth century, however, the term, "culture" was being extended by Europeans to all the world's functioning societies. At the same time, "high-culture" in the West was changing: artists like Braque and Picasso consciously incorporated African sculptural imagery in cubism and everyday objects in their collages, and composers like Liszt and Gershwin merged classical Western musical forms with popular musical forms from previously denigrated groups like gypsies and African-Americans. As a result, an increasing number of exotic, primitive, everyday, or archaic objects came to be seen as "artistic creations." They were equal in aesthetic value with the greatest Western masterpieces. By mid-century the new attitude that "primitive art" was "art" pure and simple had been accepted by large numbers of educated Europeans and Americans.[6] Today we look for what is unique and new and for what

appears to us to be a good example of a particular motif, and then we absorb it into what James Clifford has called "the imaginary museum of human creativity" (235–6). Indeed, literary, visual, and performing artists from all around the world are adopting ideas and motifs from one another with increasing frequency, and often with fascinating results.

However, this multicultural appreciation has also reinforced the Western drive toward relativism, because we include many creations whether or not we understand their original context or can assess their quality—in fact, such assessment might be rejected as elitist or ethnocentric. Therefore, as art critic Donald Kuspit says, all these "creations" of different cultures are prized, and the "value" of each one is overstated. Things are so relative, that nothing stands out as any more valuable than the next thing (1990, 43ff). Everything begins to appear as art; everyone and everything is creative.

However, with art everything and everywhere, its meaning seems completely up for grabs, and its value seems to be whatever the market will bear. Sometimes we cannot even tell if the "artist" is a charlatan, hoping we'll pay reverence and money for junk.

"Quality" is, of course, still given as a determining factor for curators, art dealers, and purchasers, but anthropological and postmodern thinking lead many to recognize how ideological and indefensible the assessments of quality may be. Nonetheless, judgments are made, and, more often than not, it is money, that is, the market, which makes the judgment. Nineteenth and twentieth century art of Europe and America is the most valued monetarily right now, with individual paintings fetching tens of millions of dollars. Because of this, art theft and forgery are common.[7] Speculation in the art market is also widespread, with the result that works by little-known artists are collected for their potential increase in monetary value, and masterworks of creativity are held for five years only to be sold for profit. Indeed, art is now often collected without any expectation that it will have lasting value; it is collected "for the moment." Understandably, expectations of creating lasting masterpieces have diminished, and the development of "conceptual art"— despite the excellence of some efforts—is clear testimony of the transitory.

The commercialism, ubiquity, and transience of artistic creativity is manifested in multiple realms. What is more, the electronic media have greatly accelerated this trend and disseminated it worldwide. The development was already perceived mid-century by socialist thinkers like Walter Benjamin, Theodor Adorno, and Max Horkheimer. Benjamin in particular emphasized how the uniqueness of any work of art is thrown into question by mechanical reproduction—now we can buy copies of copies of copies. By the 1960s, however, Andy Warhol showed how the popular culture created by mass production and the media could itself be viewed as art and how art and consumerism were intimately tied. Today, the merging of "high" and "low" culture, the multiculturalism, the global media, the transience,

the commercialism and populism are all visible in the West's museums. Once collections of curiosities, then treasure houses of the past for the society's elite, museums have now become entertainment centers with spectacular shows, lectures, films, stores, cafes, video installations, classrooms, performances, and outreach to the vast multitudes.

Indeed, it has become politically necessary to democratize art. Jane Alexander, recent director of the United States National Endowment for the Arts, has argued strongly that art is hardly an elitist affair: nearly one million people visited the Matisse exhibit at New York's Museum of Modern Art; the Endowment supports work by people in Harlem, the Appalachians, and tribal villages. . . . "Art," Alexander says, "is everywhere in our daily lives" (Jackson 1995, 6). This is a perhaps diluted version of what Schiller had in mind with his concept of the "aesthetic education of humanity." Today, however, while attempting to educate "the masses" to appreciate "high art," as Schiller might have intended, we have also elevated "mass art," and, as Auguste Rodin and Josef Beuys urged, proclaimed that everyone shall be an artist. In fact, relatively inexpensive technologies like the photo camera, videocamera, computer, and electronic keyboard have allowed vast numbers of people to indulge in creative endeavors with much less training than artists or musicians of the past. And because the commercialization of creativity is so powerful in our society, we are tempted, as soon as we sense talent in our selves or even our children, to market it.

This extension of creative possibilities to middle-class individuals around the world is tied to the globalization of the art world and the way in which anthropology has come to define culture for us: every group has its culture, almost every culture is worthy of respect, and all creations of all cultures have some meaning.

What is more, this inclusive attitude of ours has contributed to the century-long expansion of our concept of creativity beyond the realm of the traditional arts. This is in part because so much of the "primitive art" we now prize patently served as *use* objects. Navajo pottery and New Guinean canoes are use objects, incorporating the highest technological developments of the users, as well as their religious beliefs and their striving for artistic quality.[8]

Technologies made obsolete by advances in the West are often viewed as "crafts" and therefore as creative, while what is mechanically reproduced is usually not viewed as unique, and therefore, not creative.[9] Still, the rise of mechanical reproduction in the nineteenth century occurred alongside admiration for certain types of technological innovation, and the realization that the same kind of impulse might be expressed in technological innovation as in art gave birth to the term "creativity."

This fact, along with the realization that utility and artistic creativity may coincide in works of other cultures has probably contributed to our ability to see the artistry in our own technological achievements. Aren't our airplanes every bit as graceful as their canoes? Isn't the design of that automobile as new and unique,

as creative, as the objects we've rescued from the historical decline of other societies? And if cooking pots are worthy of being treasured in our international museum, then is it merely the production of such pots that is creative, or may the activity of cooking also rightfully be called so? Why not computers? Sports? Politics? Tourism?[10] Now, even activities which have no tangible material products can be viewed as "creative."

This conceptual shift has been greatly influenced by the changing social roles of women in the twentieth century. All around the world, women have at least gained entrée to domains that were traditionally male, and especially in the West, women have made their mark in traditionally creative domains, like science, painting, music, and writing. But the rise of women has also helped alter what types of activites count as creative. Western males not only have begun to value works from non-Western cultures, but also works previously regarded as "mere women's things." In the past, many of the realms of activity reserved for women were often denigrated by men as "mere craft"—at best—they were neither art nor science. Much of the pottery and weaving women traditionally did seemed too practical to be considered art and too common to be valuable. Now, with the distinctions between craft and art fading, so, too, are distinctions between women's work and men's, at least theoretically. Indeed, women's efforts in realms like cooking and childrearing can now be appreciated as creative . . . in part, because increasing numbers of males are participating in these realms. At the same time, the disappearance of traditional gender roles (gradual as it may seem at times), has left many throughout the world confused, and creativity is often required to navigate the uncharted waters.

Still, one of the widely agreed upon points among those who study creativity is that a lack of concern with traditional gender roles is characteristic of the creative personality (Amabile 1983; McKinnon 1968). Creative men seem more sensitive and emotive (stereotypically feminine traits), and creative women seem more individualistic and assertive (stereotypically masculine traits). Indeed, creative individuals have caused many in the society to recognize these traditional distinctions as erroneous. Nonetheless, even some progressive Feminists claim that women's creativity is significantly different from that of men—more open and more collaborative (see Gilligan 1985).

Interestingly, the male-dominated business and scientific worlds have pushed collaborate creativity as well throughout this century. In the process, they have modified the long-held ideal of the solitary creative genius. Although Edison was revered in the last century as an "inventive hero," he actually played a major role in developing what are now routinely called "research and development" teams. While the image of individual creativity continues to thrive, collaborative innovation has now become commonplace. J. M. Ziman and Lewis Thomas moreover, see the sharing of scientific information through conferences and journals as a primary feature of modern science's process of discovery.[11] This is despite the fact that com-

petition in the world of science is sometimes almost as fierce as in the world of business, where collaboration is almost always a competitive tool. The rise of "white collar" service industries in place of "blue collar" productive ones has also allowed the West to expand its concept of creativity to include new activities. Indeed, the key players in the new global economy are, according to Robert Reich (1983), "symbolic analysts" who manipulate data and words, and oral and visual symbols—business managers and consultants, computer programmers, bankers, scientists, and professors. Unlike artists or inventors, these analysts create no obvious, tangible product—but they do create, and often enough, many of us experience the consequences. However, since no concrete object need be involved and almost any kind and degree of activity might count as "creative" as long as something "new" occurs, not only the well-paid leaders of our "information age," but also the "troops" may now be viewed as creative: parents, teachers, secretaries, may, in certain circumstances, all be perceived today as creative.

This expanded range of meaning for the word has been further enhanced by the postmodern focus on "hermeneutics" or "reception-theory" that has emphasized the role of the audience's response to a work. The creation is understood not to be a static thing, but dependent upon and evolving through the infinitely diverse "readings" of it. As a result, not just the producer, but also the interpreter of the work can be called "creative." This not only reinforces the democratic character of creativity but also the sense of motion and change, which already by mid-century was reflected in art like Alexander Calder's mobiles, Walt Disney's cartoon animation, motion pictures, and the new medium of television. From Einstein's theory of relativity, through the vast societal transformations of the twentieth century, to postmodernism, the creative subject and object have come to be recognized as being in motion.

In a sense, we are returning to Aristotle's understanding of the unique initiating quality inherent in human action and thought—but we have eliminated his separations between theory and practice and between different disciplines. Our conception is democratic and interdisciplinary. This attitude congealed sometime in the 1950s in the United States and has spread throughout the world. Speaking for many intellectuals, Abraham Maslow said:

> I learned to apply the word "creative" . . . not only to products but also to people in a characterological way, and to activities, processes, and attitudes. And furthermore, I had come to apply the word "creative" to many products other than the standard and conventionally accepted poems, theories, novels, experiments or paintings" (1968, Psychology of Being, 137).

In our society today, almost any activity might be considered creative. Common usage has now caught up with the implications that the abstraction "creativity" implied when it was first formulated one hundred years ago.

In many ways, this development has been propelled by business activity. Starting in the United States, "creative problem-solving," "creativity training seminars," and "innovation" have become catchwords ever since the 1930s and 1940s. And with the geometric expansion of global trade and financial markets throughout the twentieth century, American business has exported these notions of creativity to every corner of the world.

While the goal of making a profit is obvious, solving the problems in getting to that goal is now commonly understood to be a primary task of business and economics. Virtually every realm of business—from conception, to research and development, to production, to marketing, to personnel, to finance, to management—is filled with problems that need to be solved. At each step, proper identification of "the problem" and creative strategies toward their solution are necessary.

Clearly, this kind of problem-solving in business (as in science or technology) seems far more methodical and purposefully directed than does the expressive creativity of art and literature.[12] While much of creativity may always have been a matter of problem-solving, this was not so highlighted in descriptions of creativity in the past—in fact, the Romantics' focus on the "spontaneous outpouring of emotion" seems the diametrical opposite. Today, without ignoring the indispensable roles of intuition, inspiration, and emotion, we can look at the work of creators such as Michelangelo, Shakespeare, or Beethoven, and see their struggles to solve problems in their work. For them, and for those working in the arts today, the problem may be: How can I mix form and color for just the desired effect? How can I convincingly change this character's behavior and attitude, now that I've described her in such detail? How can I best work in the brass instruments here?

As we have seen, the creations of art, music, and literature were perceived in the West first as imitation of nature, then as the creator's imagination of reality, and finally as the expression of the creator's feelings and innermost being. For us to now see that artistic expression can also coincide with problem-solving is an important addition.[13] This is the reverse image of the development noted earlier in the cases of Kekule and Poincaré, where scientists recognized that inspiration and unconscious feelings were valuable in their problem-solving efforts. These two developments are reflected in the formulation and usage of the word "creativity," which tells us that the processes of invention, discovery, and creation in many fields are similar.

The belief that this is so was initially based largely on the anecdotal evidence of prominent nineteenth- and twentieth-century creators' first-hand accounts of their work. From Coleridge to Poincaré to James Joyce to Picasso, these accounts have helped confirm the validity of von Helmholtz's depiction of the stages of the creative process, which included conscious effort and hard work as well as spontaneity, inspiration, and intuition.

This intuitive realm, understood to be outside the creator's conscious control ever since Plato, became associated with the unconscious and with mental disorders

in nineteenth- and early twentieth-century psychologies. These associations lived on in the work of Freud, whose views of unconscious urges seemed validated by the madness of the two world wars. However, Freud also saw the pivotal role of dreams and therapy in bridging conscious and unconscious, and this was carried further by Jung, who believed that artists, like shamans and therapists, could transform themselves and others by bringing the stuff of the personal and "collective" unconscious into consciousness.[14] By mid-century, several creators and a wide public had come to agree with these notions. Writers like Thomas Mann, Herman Hesse, D. H. Lawrence, Nikos Kazantzakis, Franz Kafka, Marcel Proust, and artists like Salvador Dali, Pablo Picasso, and Jackson Pollock created works which spoke of unconscious impulses, utilized dream content, or claimed to bridge the conscious and unconscious or order and chaos.

Indeed, by the 1940s, and certainly by 1950, surrealist and "action painting," "stream of consciousness" writing, and especially jazz music, had come, in many ways, to present their processes as their products. The creators and their works received great acclaim, and the psychological focus on the creative process became a cultural concern. It was in this context that psychologists like J. P. Guilford and others, primarily in the United States, began to carry out systematic studies of creativity.

Already, in the 1920s, following up on the work of Alfred Binet in Paris and Lewis Terman in California which led to the Stanford-Binet IQ test, Terman and his associates began a long-term "Life Cycle Study of Children With High Ability." In the 1950s and 1960s, MacKinnon and others associated with the University of California's Institute For Personality Assessment carried out studies of scientists, architects, musicians, and others who were commonly agreed to be creative leaders in their fields. The point of this research was to identify common traits of creative individuals and to draw lessons from them. Guilford, Flanagan, Murray, Torrance, and others carried out countless tests of creativity to determine how the characteristics identified in the gifted students and leading creative adults might apply to masses of U.S. military personnel and school pupils.[15]

While many of these tests were conducted by military, business, and educational organizations which would seem to have had a vested interest in maintaining conformity, their conclusions corresponded closely to those espoused by humanistic psychologists like Carl Rogers, Abraham Maslow, and Erich Fromm, who decried the conformity and materialism of the society and looked for creativity in all individuals. According to Fromm, we should distinguish between "creating something new" and a "creative attitude" (1959, 44); or as Maslow said, between "special talent creativeness" and "self-actualizing creativeness" (1968, Psychology of Being, 137). The creative attitude, these thinkers suggested, might be found in anyone—we need not look only at Mozart or Einstein.[16] It was therefore perfectly reasonable to examine what made such outstanding individuals creative—everyone could learn from them.

Here we see that the ideals of the Enlightenment have come to complete fruition by mid-twentieth century. In the American democratization of creativity, anyone could be found to have the "creative spark within," and a major task that government, business, and education set themselves was to ignite that spark. In pursuit of this goal, the idea has emerged that people can be trained to be creative—or at least, more creative. Many believe that certain techniques can be used to reduce socially conditioned and self-imposed blocks to creativity and to develop the habits of divergent and associative thinking, and imagination, which are fundamental to creativity.

While many artists and others continue to disdain the focus on "problem solving," and consider the idea of "creativity training" ridiculous,[17] much of the current literature on creativity moves almost seamlessly between business innovation and personal self-help, between problem-solving and self-expression. This is so common, in fact, that we now take it for granted, but it represents a sea-change in attitudes about creativity. It is impossible to imagine anyone in medieval or Renaissance Europe, for example, reading a book with a title akin to *How To Be More Creative*.

It is also hard to imagine, before the rise of our commercial society, a creativity industry such as we have today. And small as the number employed in the field may be, there is a sense in which this creativity industry epitomizes the world of business, for it professes to be commited to "innovation," "entrepreneurship," and expansion. As Peter Drucker has said: ". . . entrepreneurs innovate. Innovation is the specific instrument of entrepreneurship. It is the act which endows resources with a new capacity to create wealth. Innovation, indeed, creates a resource" (1985, 30). Not merely business people and economists but workers in countless fields think this way.[18] While innovation and entrepreneurship have long been considered fundamental parts of capitalism, the classic economic definition of "resources" included land, capital, and labor. Today, the important roles of risk-taking, invention, and vision, assumed by the founders of businesses and the symbolic analysts, are recognized. Indeed, the extremely high pay given to select workers and managers is often justified by virtue of the value of innovation and entrepreneurship.

The commitment to innovation means a commitment to new products, new markets, new ways of producing, new ways of financing. But this is a ceaseless effort: today's new widget is certain to be replaced by "a new and improved" model tommorow. While patented inventions of fifty years ago might have given a corporation a twenty-year lead over commercial competitors, today a two-year lead over a competitor is often considered good (1988, Haggart). While in past eras a number of generations might have commited themselves to a public work taking centuries to complete (the cathedrals, for example), a decade, or at the most, two, of research and development is considered quite long today. Indeed, speed is of the essence.

Accordingly, expressions associated with creativity in our commercial society, like "high-tech," "leading edge," and "innovation" itself seem to carry with them the idea of fast-paced change. The value of creativity in business is temporary, and this

colors our thinking about creativity in almost every realm. Surely, this is in part because business has successfully pushed major advances in transportation and communications technology, and thereby changed our relationship to time itself. Jets, phones, computers, film, and television have all contributed to the great speed-up of our lives. They have helped create what seems to be an ever shrinking world—it is no longer unusual to fly to other continents, research ancient history, or check current stockquotes on our laptops, and call home or office enroute. Anywhere we go, we can find ourselves deep in cyberspace . . . or in the shallows of television sitcoms. We live in the electronic global village Marshall McLuhan (1962) described forty years ago.

Prescient as McLuhan was, it was the German thinkers, Karl Otto Apel and Jürgen Habermas, who first theorized the international society of individuals communicating with one another which has found concrete expression in the Internet, built by American computer programmers.[19] For the German thinkers, the idea was the extension of the Enlightenment ideal that every individual have the opportunity to express him- or herself creatively and in rational discussion with the rest of humanity. Ironically, the Internet arose from the United States military's desire to link academic institutions, defense industries, and the government, for the purposes of national political power. Nonetheless, the United States Defense Department's intentional decentralization of the network, its desire for new ideas, and its apparent lack of concern with controlling the germination of those ideas have led to what many view as a radically new world of thought that transcends all national boundaries and is pursued by government, business, academe, and others.[20]

Thanks to the rapid expansion of this "electronic superhighway," millions of people around the world now share a virtually infinite diversity and quantity of ideas. Surely, the creative image we are pursuing with this is the universal library of human thought, accessible to every individual when and how he or she wants it, a library that each of us can add to as fast as we can create.[21] But there is more: this digital library of words, numbers, sounds, and images can be clipped and cropped, reframed, merged, melded, erased, and recreated—there is no end to the possibilities. The Internet has reinforced the contemporary idea of creativity coming from anyone, anywhere, any time; it has sped up our lives and brought us further along toward the merger of information, entertainment, technology, and art, a new way of communicating, and to some extent, a new way of being.

This new way seems to require constant creativity and constant adaptation to what has been created. We have little alternative but to be creative; conveniently, we also believe that creativity is the highest goal of the individual and of humanity.

THE GLOBAL IDEAL OF CREATIVITY

The world's creativity has become ours to admire, buy, compete against, and worry about. At the same time, scientific, artistic, economic, and political forms of creativity

take place within a global environment and are often consciously directed toward a global audience. Prominent scientists, architects, musicians, and others travel the world, influence each other, and are at home among their colleagues in almost any country. The global economy is a reality, and advocates of business innovation, the creation of new products and markets, problem-solving, and creativity training are to be found in Thailand and Morocco, as well as Tokyo and New York. And the marketing of these values is global as well, thanks to the media. Goods, data, money, ideas, and even personnel are shipped around the world constantly. Capitalism's reduction of nearly everything to commodities means that what is rarest is often what is most valued (the so-called law of supply and demand); that is why creativity, the production of the new and unique, is so prized.

Thanks to capitalism, along with the major technological changes and the cultural developments noted above, creativity is now a global concern. Today, the idea of bringing something into being, the positive valuation of it, the interdisciplinary character of the process, the social expansion of it to include almost "anyone," and the notion that people can be trained for it, all define creativity. The motto of Xerox Park in Silicon Valley, Invent the Future, has become a virtual mantra around the world.

Obviously, not all people everywhere share this view completely—many disagree and some are opposed—but the sentiment can be found all across the planet. There can be no doubt that major differences exist and are treasured in different cultures and regions—Japan, for example, a leading player in the global marketplace, holds to many traditions which might seem to run counter to what one might expect of a world power. But such expectations have developed precisely because we believe in a global culture. Long-serving Sony Corporation chairman Akio Morita would not have exhorted his fellow Japanese to be more creative in his books and speeches, and Japanese author Masao Miyamoto would not have written his bestselling *Straitjacket Society*, criticizing the restrictions to innovation in his homeland, if they had not come to share the global ideal of creativity.[22]

This ideal has been made possible not only by world trade, telecommunications, and tourism, but also by such institutions as the United Nations Educational, Scientific, and Cultural Orgaization (UNESCO), which has attempted to play a significant role in preserving the creations of diverse cultures (see its World Heritage List) and in encouraging new creations with seed money. All around the world, a large range of organizations, museums, journals, universities, and so on recognize and encourage creativity from individuals of all nationalities.

Furthermore, the awareness of our mutual dependence has prompted the concerted efforts of certain individuals to create international institutions. Since the 1850s, organizations such as the International Postal Union, the Red Cross, the League of Nations, and a contemporary host of intergovernmental and international organizations ranging in focus from ecology to music to space exploration are the

consequence of great political-organizational creativity and have fostered creativity in other domains. The United Nations, itself, our grandest collective creation to date (with all its weaknesses), arose from the carnage of World War II, when many saw the necessity of transforming the international political landscape. And we can see that this creative hope lives on at the turn of the century in the words of international leaders like Nelson Mandela, Jimmy Carter, Mikhail Gorbachev, and Kofi Annan, who speak of human dignity, innovation, and creating a global community.

Thus, ideas of universality originating in the Bible and tied to conceptions of culture and creativity enunciated by Enlightenment and nineteenth-century thinkers have reached full flower in the world cultural exchange of our day. We speak of "global culture" and believe we know what we mean. The image of our blue-green Earth, seen from outer space, the result of twentieth-century ingenuity, symbolizes this. All around the world people can be found who speak of creativity in the modern, Western sense of the word and herald it, believing it will better the world.[23]

In fact, some of our society's most outstanding creators aim at nothing less than the restructuring of Nature, something made possible by the splitting of the atom and the recombination of deoxyribonucleic acid (DNA). Already, animal, and even human genes have successfully been cloned. Some people have no doubt that the newly patented life forms created through the marvels of biotechnology will feed us and keep everyone on Earth healthy and content. In the words of biologist, James Bonner: "We have in our hands the first rudimentary tools by means of which we can escape extinction and lift our species to a new and better one" (Foote 1982, 96). Indeed, the direction of Nanotechnology, involving genetic engineering and atomic manipulation, points to nothing less than the complete restructuring of molecules. This, it is hoped, will create infinite food and energy supplies and more healthy and powerful human beings.

So it is not merely that we extend the concept of creativity globally and to all realms of human doing; it is now the case that our creativity has allowed us to transcend the planet and restructure life itself. But, of course, the hopefulness we might feel is matched by the fears of nuclear, genetic, and general ecological disaster with which we live. No wonder the Frankenstein motif is still so influential—the fear that we may not be able to manage our own creations is deep. And with the help of the film industry, doomsday scenarios are for us all too imaginable.

Whichever image of creativity prevails—whether that of continuous, infinite advance, or of total destruction, an image of hope or fear, we all seem to expect that the dramatic changes, which we've seen this century, will lead to even more dramatic ones in the next.

This is why Alvin Toffler's book, *Future Shock,* resonated so powerfully with many readers around the world a generation ago. And the rapid changes Toffler described are not merely difficult for individuals to accommodate, but for whole

societies as well—maintaining the integrity of traditional belief systems in the "Information Age" is a major challenge. All traditional cultures are in flux; every society's valuing of creativity is shifting rapidly. This has, of course, spawned a backlash. Individuals and groups assert their identity, cling to their traditions, and fight others in the name of those identities. As Benjamin Barber put it in his *Jihad vs. McWorld,* the clash of "cosmopolitan future" and "tribal past" has put the whole world in upheaval (1996, 4). "Ethnic cleansing" and fundamentalist political movements against the radical changes of our era abound. Nonetheless, the onslaught against traditional identity and the movement toward greater individualism are relentless.

CREATIVITY IN THE POSTMODERN CONTEXT

"Modernism's vanity," says art historian Joseph Giovannini, "is that, being predicated on invention rather than convention, it could hardly be surpassed by anything other than its progressive self" (1998, 81). However, the material and cultural transformations have been so massive, and novelty seems so all-pervasive today, that even our concepts of history and thought have been revolutionized. At the beginning of the century, modernist thinking proclaimed that the "center could not hold"; in the postmodern thought of the late twentieth century, there is no longer even a center. The idea of postmodernism (germinating in Heidegger's mind in the mid-1930s even as he embraced the Nazis, but developed and made popular by Michel Foucault and Jacques Derrida, ca. 1970) is that there is no fixed position from which to assess "history" and no obvious structure to "historical" content.[24] Subject and object are equally ambiguous. "Structure" is invented or discovered, but may be altered right away. Power, use, or a unique *je ne sais quoi* determine what is tradition, what is history, what we think. Thus, creativity becomes a constant of our lives, but who and what it is that should be called "creative" (everyone? everything? being? nothingness?) remains an open question.

Postmodern thought has complemented the radical relativism wrought by capitalism, the bomb, telecommunications, anthropology, and genetic engineering to foster the belief that finding objectivity is impossible, that all is interpretation, that the subject is an illusion, that in its most extreme form, knowledge is impossible.

No wonder Western art turns to minimalism, then to abstract expressionism, then to "conceptual art"—which in some cases blurs all lines between object, subject, presentation, and observation, so that ultimately, whatever can be conceived at all can be called art. Masterpieces of literature and art history, even of what should be taught in our schools, logically become eminently debatable subjects. According to postmodern theory, every creation, every life form—including people—is a "text" to be read and interpreted, and no text or "reading" holds primacy.[25] As a result,

literary criticism, art history, and philosophy begin to merge more and more with anthropology, which seems to some people to have as its "ultimate aim" the "dissolution [of] all the forms under which human experience is presented to the socialized mind" (Gell 1992, 41). What we thought to be the case isn't; traditional differences give way to multiculturalism, and then, to globalism, while the individual human beings who make up the world begin to think of themselves, not as subjects, but as "texts," and at best, as works of art.[26]

This is an ironic twist to other major forces of change which seem to increasingly reduce us to mere cogs in the machine and to threaten our existence entirely. The extraordinary blossoming of corporate, governmental, and other bureaucracies, coupled with the massive displacement of workers through automation and strategic "downsizing" might help us think of ourselves in the third person, as texts, but they hardly help us imagine ourselves as evolving works of art. In the face of nuclear war, how can we think of ourselves at all? No wonder the subject seems lost. The radical changes of the global culture leave many longing for creative fulfillment and frustrated at its inaccessability.

Caught between social forces that seem to overwhelm our identity and intellectual claims that we have none to begin with, almost all of us insist upon the importance of our individuality and search for community as well. Millions of people around the world ignore or resist the ideas of postmodernism, of contemporary art, of anthropology, and insist that subject and object are quite clear, that reason holds sway, that there is a divine and/or natural order, that their own national-religious loyalties are "right." Instead of postmodernism and global relativism, people seek values; in the face of change, they long for some kind of permanence.

We seek values in traditions, in ethnic and national identity, in love, family, work, and religion. And in a world where traditions, community, family, and work are in flux, some also seek value in art, which Barzun calls the "religion of the modern age," or in self-actualization psychology, which Maslow felt could be a "religion surrogate," or in technology, which Bonner and others hope will allow us to "escape extinction" or at least build a better world. However, in many of these cases, the desire for permanence is expressed, paradoxically, in celebrating creativity and change. Indeed, especially those committed to postmodern thought seem to take creativity to be important.

One could say, in fact, that in this world of flux and competing assertions, *the belief in creativity* is one of the few values that has gained widespread acceptance. In some respects it has supplanted other values, but more often than not, it is held alongside the others. In many respects, creativity is *the* twentieth-century value, the currency of exchange between conservatives and liberals, Americans and Asians, businesspeople and artists. Almost everyone resists particular forms of creativity and advocates others, but few reject creativity in general—even important religious leaders who are dedicated to tradition, like Pope John Paul II and the Dalai Lama,

repeatedly speak of "creativity."[27] In fact, our global culture is infused with what might be called a "metaphysics" of creativity.[28]

This metaphysics, starting from the Western Enlightenment, has been advanced by major nineteenth- and twentieth-century philosophers in subtle but mutually reenforcing ways. While Herder, Condorcet, and then Hegel and Marx had variously conceived of history as an inevitable march toward greater awareness, and the Romantic writers spoke of spontaneous growth and self-expression, early twentieth-century thinkers like Nikolai Berdyaev, Henri Bergson, Alfred North Whitehead, and Pierre Teilhard de Chardin presented "process philosophies" that emphasized the creative element on an organic and planetary as well as on a human level.[29] Teilhard in particular, mixed biblical themes with Hegelian ones to emphasize the global unity of consciouness. While some of these philosophers have been criticized and to a considerable extent ignored in the past few decades, modified versions of their ideas live on, especially in the sizable New Age literature on creativity. Betty Edwards, Shakti Gawain, Dan Wakefield, Ken Wilber, Marianne Moore, and a host of others seem to view ours as an era of global consciouness and have written about "creating from the spirit." Lois Robbins goes so far as to call ours "The Age of Creativity." And in fact, these ideas infuse almost the whole of contemporary writings on creativity as well as the daily lives of many individuals: all is process, all is capable of blossoming, growth is the goal of humanity, "connecting" with one's inner self-spirit-soul brings greater creativity, and creativity is of major value. Creativity, simply put, is our collective destiny.

Even philosophies like Existentialism, which generally denies that we have any destiny, implicitly supported creativity. Deriving from thinkers like Kierkegaard, Nietzsche, and Heidegger, Existentialism reached broad audiences after World War II through the novels and plays of Jean-Paul Sartre, Albert Camus, Samuel Beckett, and others. For these thinkers, the only certainty was that each of us is thrown into the world, naked and alone. We are condemned to decide. We create, not knowing what we are supposed to do or what our limits are.

The postmodern critique of the autonomous Self coupled with the obviousness of global interchange today have helped make existentialism seem antiquated—and yet in many ways, "global culture" is a culture of billions of individuals experiencing the loosening of ties and therefore increased pressure to make individual decisions. The weakening of traditional communities pushes each individual to find traditions and communities where he or she can, because the clear social roles through which we were defined have lost much of their validity. This might be seen as liberating, or frightening, or both—but it absolutely means that each individual bears greater responsibility for defining him- or herself.[30]

The dominant influence of Western culture within the global society has pushed individualism as an ideal at least since the Enlightenment, and the strong

resistance to this ideology by religions and governments around the world is, in a sense, proof of how strong this influence is. Indeed, "self-creation" has taken on center stage in the global ideology of creativity. While the Frankenstein myth might refer to the monsters we may let loose in the world, the idea of "inventing oneself" is the image of hope[31] and change for of our era.

Of course, individuals throughout history have looked at death or the divine and seen the transitoriness of existence, and some have tried to create "monuments" of word, stone, deed, or flesh to perpetuate their names. To some extent, the drive toward self-creation today is a continuation of those ancient dreams, but to some extent it is also based on the sober realization that none of our creations is permanent, that some are dangerous, and that we must nonetheless create.

Today, great numbers of people across the globe believe it is their right and also their responsibility to recreate themselves. This is portrayed literally and figuratively in the novel, *Face*, by Cecile Pineda. Apparently based on fact, this story tells of a Brazilian barber, who, disfigured by a fall and unable to pay for costly surgery, recreates his own face with home surgery. He fights class oppression, social ostracism, lack of education, and excruciating pain in an heroic effort.

But this extreme and realistic case of "creating oneself" is meant to be an archetypal image for all of us. It is not just that millions of people remake themselves through cosmetic surgery, organ and limb transplants, or psychotropic drugs. The ideology of self-creation expresses a merging of the art, psychology, politics, and metaphysics of our culture: everyone has the ability to create, and each should create him- or herself as excellently as possible. This ideal has long been professed in the creed of the "self-made man," epitomized by Benjamin Franklin and a host of others whose ingenuity brought them "from rags to riches."

And the ideal of creating oneself continues to be espoused across the wide spectrum of our individualistic society, from conservative business people to avant-garde artists. The ideal persists, despite our budding awareness of the magnitude of global culture and the uncertainties of the postmodern critique of self.[32] In fact, the threats to the self that those developments imply may well be the reason for the emphasis on self.

Thus, in the midst of abstract minimalism, surrealism, political and social realism, and conceptual art, portrait painting has continued to be a major trend of twentieth-century art.[33] And at the end of the century, portraiture has been heralded as the "newest trend" in the world of art, apparently because cultural forces have led to a desperate search for a sense of identity. This was evidenced by the Venice Biennale's 1995 exhibition, *Identity and Alterity* and the New York Museum of Modern Art's blockbuster 1996 show *Picasso and Portraiture* which asked, "are all portraits self-portraits?" and demonstrated how Picasso's work emphasizes subjectivity even as it deconstructs representation.[34]

As we saw above, Albrecht Dürer's self-portrait of 1500 helped alter conceptions of subject and object and exemplified a dramatic change in the importance of the human creator: the artist became as significant a focus of attention as any religious icon. Indeed, the celebrity status accorded such artists as Picasso today seems at first blush the fulfillment of this tendency. And yet, Picasso's self-portraits appear incredibly distorted, and he, and a number of other contemporary, prominent artists have parodied their status as "art stars." The works of Marcel Duchamp, Jeff Koons, Annie Liebovitz, and others are aimed at "subverting the whole concept of the artist as an 'immortal' . . . ," according to critic Dan Cameron. He speaks of the "current trend toward putting on and taking off disposable identities;" the artists feel free, he says, "not to take identity seriously" (1994, 154).

This seems a natural development in the context where postmodernism has "deconstructed" the Self, globalism has undermined all traditions, technology seems to threaten existence, and creativity, thoroughly commercialized, is our common currency. The feathered cape from Peru, the Sputnik and other Soviet space artifacts, medieval European manuscripts, and Picasso's signature have all become commodities. Ultimately, as Andy Warhol showed in his portraits of Marilyn Monroe and Mao Tzedong—and in his own life as well—even the creative person becomes a commodity as a celebrity.

Celebrity in our culture today is different from the renown certain outstanding figures of the past seem to have achieved. Most of us today, including the celebrities themselves, are simply too aware of the role of the media in fostering celebrity, and we are too aware of the transience of fame. That is one reason that the certainty, clarity, and stability of Dürer's work is absent from the portraits of today. True, Picasso's egoism probably equalled or even surpassed that of Dürer, but Picasso's self-portraits, especially the later ones, show an ape-like head, an empty eye-socket, a decomposing image. Picasso seems to tell us that despite his outrageous ego, he is struggling with his self-identity. And when Woody Allen asks us through his films to be amused at how seriously he takes his own identity crisis, we laugh but also nod in sad recognition that Allen might be portraying our common plight.

And yet, we all know that his exaggerated concern with self-identity pales in significance with the difficulties faced by billions of humans around the world unmoored by the global economy, the demise of Communism, the destruction of the environment, and the decline of traditional cultures. In the United States today, the average person is expected to change jobs seventeen times during his or her worklife; some of these changes are driven by desire, some are forced upon us. Millions of refugees cross international boundaries and pour into overwhelmed metropolises around the world, "freed" (in the positive and negative senses of that word) from the identities their traditional social roles previously gave them. And even if they

believe their lives are subject to God's will or to fate, the Russian doctor driving a taxicab in New York and the Amazonian Indian living in a Brazilian favela seem to know: they, too, simply *must* recreate themselves.

In fact, self-creation is the challenge for all of us today. We do not feel this challenge every minute, because we assume identities, and this usually works practically enough, but almost all of us sense the excitement and the fear of the fact that all is in motion and that the motion is increasingly rapid and global. The creation of the Self, the identity of the creator, and the creative realm in between (*la difference*) become the highly charged problems for each human being in the flux of global culture. Thus, the frequently reiterated challenge of the countless creativity books and workshops of our era, namely: Be yourself! is far more difficult than we want to admit. Who are we anyway?

1

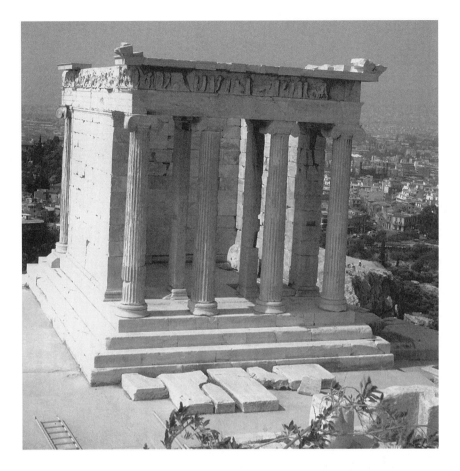

PLATE 1. *Temple of Athena Nike.* This temple, in the Acropolis in Athens, Greece, and dedicated to the victory of the goddess of wisdom, handicrafts, and war, is a highlight of fifth century B.C.E. Doric-Ionian sculpture and architecture, presenting classical Greek ideals of order, balance, harmony, and beauty. It was the site for the Panathena Festival, which celebrated springtime fertility. The temple stood next to the world's first civic art museum and near the Parthenon, above the city. Below, to the right, are the remains of the *agora,* the marketplace, where philosophy and politics were disputed. (Courtesy of Susan Light, 1981.)

118

PLATE 2. *Roman Coliseum.* This excellent example of first century C.E. Roman architecture was originally used for gladiator fights, persecution of Christians, and other "public amusements." It now serves as a major tourist attraction for the city of Verona and as an open-air theater for opera performances. To watch and listen to a modern interpretation of a three hundred year old musical form while seated in a two thousand year old structure is a striking lesson in the possible transformation of human creations. (Courtesy of Susan Light. Taken at Verona, Italy, 1987.)

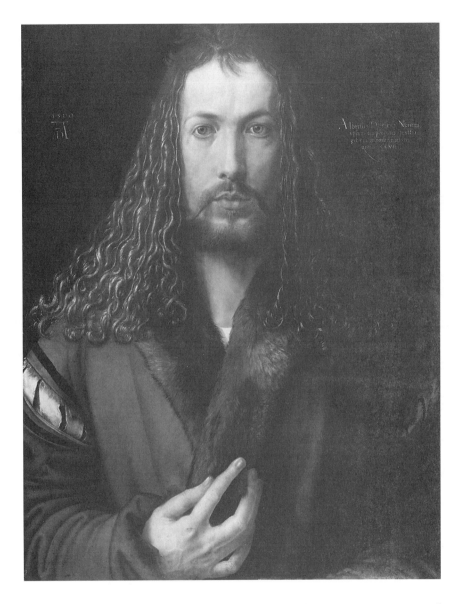

PLATE 3. *Self-portrait in Fur Jacket (Selbstbildnis im Pelzrock)*. This oil painting on wood (27″ × 20″) by Albrecht Dürer, (1500) is virtually a "secularized icon" (Janson 1977, 464). Dürer employs a traditional medieval religious form and common northern European style to carry out a radical portrait, not of Jesus or a saint, nor even of an aristocrat, but of Dürer himself. Coinciding with the vast cultural changes of capitalism, protestantism, the discovery of the Americas, and numerous technological advances, Dürer's self-portrait represents a key moment in the Western elevation of the individual creator. (Courtesy of the Bayerische Staatsgemaldesammlungen, Alte Pinakothek, München.)

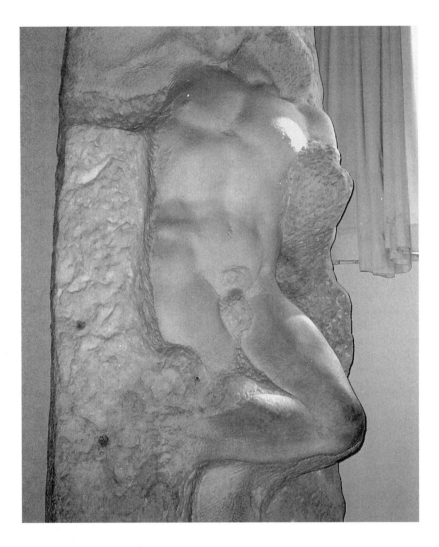

PLATE 4. *The Prisoner* Or *The Waking Slave,* Or *The Waking Giant,* by Michelangelo Buonarroti, ca. 1532? (marble, approximately 8'). This is one of several incomplete sculptures created as part of an elaborate funeral monument for Pope Julius II (the only completed works are the "Moses," the "Dying Slave," and the "Rebellious Slave"). Subject to the pope's command, Michelangelo reluctantly had to abandon this project and turn his attention to painting the Sistine Chapel (a truly spectacular work, despite the artist's reluctance). Ironically, the incomplete sculpture of the prisoner seems to convey, even more clearly than Michelangelo's other works, the artist's neo-platonic vision of freeing the essential idea concealed within the stone by "simply" chipping away all else. While Michelangelo was greatly revered during his own lifetime, it seems that it was not until our era that works like the "Prisoner" could be revered as not merely "unfortunately" unfinished, but as masterpieces precisely in their incompleteness, for the work seems to speak volumes about the creative process. (Photograph by Robert Paul Weiner, 1995.)

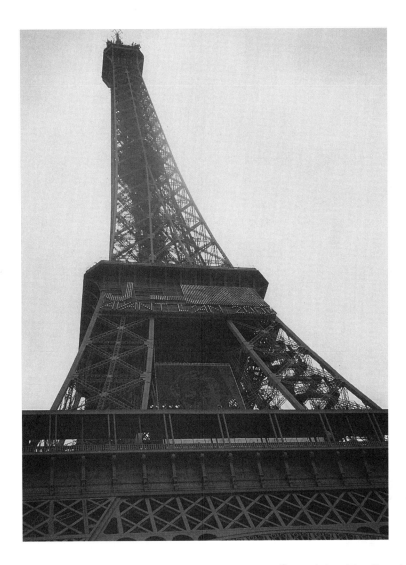

PLATE 5. *Eiffel Tower.* The open-lattice wrought iron tower (984′) was designed by Alexandre-Gustave Eiffel for the 1889 Centennial Exposition of the French Revolution. Glass-caged elevators by the Otis Company of New York helped make the tower one of the premier tourist attractions of the world. The nineteenth century saw the merging of technology and aesthetics, the emergence of world fairs and expositions of "arts and industry," and the invention of the word, "creativity." While the structure was initially quite controversial, Eiffel's merging of engineering with graceful architectural detail led him to be called the "magician of iron." The tower had a major impact on subsequent construction. Early on, Eiffel used the structure to conduct experiments in aerodynamics, and since then, the tower has sprouted broadcast antennae, an electronic events display board, and a high-altitude restaurant named for science fiction writer, Jules Verne. (Courtesy of Barry Martin. Photograph taken in Paris, France, 1998.)

PART TWO

Cross Cultural Variables

While the ideology of creativity has spread rapidly in conjunction with the ever-increasing globalization of human society, even the most cosmopolitan advocates of this ideology represent in some ways the diversity of their cultural heritages, and the mass of humanity is surely very deeply embedded in particular cultural traditions. Indeed, a main theme of our era is unity and diversity—globalism and multiculturalization.

Thus, India, Japan, Iraq, Nigeria, Peru, Russia, Brazil, Senegal and every other of the world's 180 or so countries—for that matter, every one of the two thousand or so ethnic-natural groups listed by the United Nations—has expressed what we call "creativity" in some ways. It is likely that we could find explicit statements from each and every one of those cultures responding to the dominant Western-global concepts of creativity and indicating how they define and value creativity themselves. This section examines some of those cultural responses.

THE IDEOLOGY OF CREATIVITY IN THE UNITED STATES

Since the creativity of other cultures is so impressive and American ideas about creativity are so inextricably bound with the traditional ideas of Western culture, it might seem mere chauvinism to focus a special chapter on creativity in the United States. However, the United States does deserve special attention here. Not only has American creativity contributed significantly to Western and global culture, especially in the twentieth century, but American ideas about creativity have also been a subtle but pervasive part of that contribution—in fact, one could say that America has successfully marketed its conception of creativity to the world. And despite the fact that the governments of other countries may sponsor the arts, the sciences, or businesses to a greater degree, Americans, as well as citizens of other countries, frequently maintain that American society is more open to innovation and creativity than others. What seems to stand out in America is a widespread and emphatic cultural-societal attitude that creativity is good. Indeed, American patriotism seems to include belief in newness, innovation, change, and the future. Creativity is, in fact, an important American value.

The roots of this attitude are deep. The seventeenth-century European view that America constituted the New World encouraged imagination and belief in "infinite" opportunities. Blind to the culture of the native Americans, many Europeans regarded North America as a tabula rasa upon which anything could be written, a place for new beginnings, a place where the future held endless possibilities.[1] (See Locke 1924)

As mentioned previously, Benjamin Franklin achieved world renown not merely for his extraordinary inventiveness, but also for his self-invention: his life provided generations of Americans with a classic prototype of the "self-made man." This image complemented the claims of Thomas Jefferson's *Declaration of Independence* that Americans had the right to sever their historical ties with Britain, disband the government, and form a new one. Not only did they "declare" their "independence,"

but the revolutionary rhetoric of Tom Paine's *Common Sense* was echoed by the Great Seal of the United States, which proclaimed the *novus ordo seculorum*, the new order of the world. Such ideas as these would have seemed outrageous to earlier generations: while enlightenment Europe spoke of "progress," only in America could one take seriously the radical possibility of starting from scratch and making anew.

Paradoxically, the possibility of beginning anew fit quite well with one key tradition the early European settlers carried with them: the biblical notion of "the promised land." Those who ventured toward America viewed themselves as "the chosen people"; once there, they would surely be reborn. Following God's commandments, they would build the New Canaan, the godly "City on a Hill"; they would be blessed; they would be "fruitful and multiply" (Winthrop 1931, 4–5). As Robert Bellah has pointed out, this imagery has survived and flourished throughout American history (1975, 1–35), expressing itself not only in the doctrine of Manifest Destiny of the nineteenh century and the cold war ideology of the twentieth, but also in creative religious developments such as revivals and "born again Christianity." A striking nineteenth-century statement which clearly connects these biblical themes with the ideas of America's future and creativity are Herman Melville's words:

> ... And we Americans are the peculiar, chosen people—the Israel of our time; we bear the ark of the liberties of the world. ... God has predestined, mankind expects, great things from our race; and great things we feel in our souls. The rest of the nations must soon be in our rear. We are pioneers of the world; the advance-guard, sent on through the wilderness of untried things, to break a new path in the New World that is ours. ... The past is dead, and has no resurrection; but The Future is endowed with such a life, that it lives in us in anticipation (1960, 143–144).[2]

The dominant American religious tradition was, of course, Protestantism, and the willingness to protest, dissent, to go one's own way, characterized the early pilgrims as well as many who later pioneered paths westward. Protestant moral puritanism sometimes reacted vehemently against the "breaking of new paths" that Melville mentioned. However, the so-called Protestant Work Ethic came to be a key aspect of Americans' perceptions of their pioneering efforts. Hard work, commerce, industry, progress, and innovation in business became the focus of America's "special destiny" and its look toward the future—creativity in the literary and artistic domains assumed much less importance.

Given the strength of the biblical tradition, one of the most interesting of American contributions to creativity is religious freedom.[3] While some degree of religious tolerance existed in England, the Netherlands, and elsewhere, no country had yet followed the French political philosopher, Jean Bodin's call for a legal

separation of church and state until the United States did in the First Amendment to the Constitution. As a result of the twin guarantees that no state religion would be established and that no prohibition would be made against any form of religious expression, thousands of religious groups have been created throughout American history, and at the same time, the development of secular thought has proceeded with relatively little interference.

The importance of freedom of religion in America for creativity can hardly be underestimated. The United States has given birth to all kinds of new religious movements, from the Mormons, Christian Scientists, Jehovah's Witnesses, and Reconstructionist Jews, to various New Age movements. Tele-evangelism is an American creation which is spreading globally and helping transform American politics as well. Even traditional religious denominations imported from Europe have been transformed to some degree in the American social context. And, of course, religion has infused a tremendous amount of American art, music, literature, and architecture, creating uniquely American idioms.

Perhaps more significantly, the constitutional prohibition against a state religion has provided opportunities for forms of creativity which in other cultures are blocked. However else religion may be defined, it is clear that religion always implies a prioritizing of values. Thus, in ancient Israel as well as in contemporary traditional societies, creativity is appreciated if it is in service to the divine and tolerated only if it does not contradict the primary belief system; if the political, legal, and social structure of the society is directly tied to one religion, those who go astray from the belief will often be silenced. In the absence of a single, unifying belief system, the possibilities for creativity are virtually limitless. Indeed, in the nondogmatic quasi-religion of New England transcendentalism, imagination, spontaneity, and creativity rose to great importance.

Nonetheless, there are certain tensions in American society between the biblical sources of America's sense of "chosenness" and the profane creativity which has taken place in the society. While this is seen most often in the Puritan-inspired attempts to restrict "obscenity," the issue is more general. In fact, there may well be a logical tension between belief in the ultimate truth and importance of a religious doctrine on the one hand and commitment to a system which not only tolerates divergent beliefs but also advocates exploration on the other.

Facing this issue, the framers of the Constitution sought to make the law a major protection of and encouragement to creativity. The guarantees in the Bill of Rights,[4] especially those for free speech, assembly, print, and belief, have been viewed by many as crucial to creative activity. Certainly, most Americans view these rights as the hallmarks of democracy and generally believe all human beings should have them; most would probably agree, as well, with people like Jacob Bronowski and John F. Kennedy, that neither art nor science nor any other form of creativity could truly flourish without these rights.

The Constitution itself is a collective creation which prescribes ways in which new laws can be passed and old ones amended; it calls upon justices to interpret the laws, which they have done quite creatively. It provides a framework within which law and politics can creatively evolve. This is precisely what Thomas Jefferson seems to have hoped for when he expressed his idea of "continuing revolution":

> Each generation is as independent of the one preceding, as that was of all which had gone before. It has then, like them, a right to choose for itself the form of government it believes most promotive of its own happiness; conse-quently, a solemn opportunity of doing this should be provided by the Con-stitution (1944, 675).

While many of the founding fathers apparently viewed the Constitution as a temporary "makeshift" (Morison and Commager 1962, I:319), its combination of stabilizing structure and elasticity has allowed it to outlast any other written con-stitution. As Supreme Court Justice Oliver Wendell Holmes wrote in *Missouri v. Holland*, 252 U.S. 416, 1920: "... we must realize that ... the words of the Constitution ... have called into life a being, the development of which could not have been foreseen completely by the most gifted of its begetters."[5]

In contrast to the unifying value structures of religion, the Constitution implies that a multiplicity of values—however diverse—is supportive of a healthy society. The freedom to choose values seems to both require and foster creativity. Of course, the constitutional sanctioning of slavery until 1865 and the unwilling-ness of the branches of government to prevent the social, economic, and legal oppression of women and racial and ethnic minorities until recently seem to us today in direct contradiction to that openness to a multiplicity of values. The "Three-fifths" compromise in the original constitution, for example, allowing slaves to be counted both in terms of representation and taxation, was undoubt-edly a creative political maneuver ... but it also helped maintain slavery in the country, which at the very least hindered most blacks from exercising their cre-ativity in any significant, public way.

Nonetheless, the history of constitutional amendments and judicial interpre-tations of the Constitution reveals—whether or not the founders expected this—a clear, though hard fought, evolution toward inclusiveness and expansion of civil rights. In addition, the relatively limited prohibitions enumerated by the Consti-tution has allowed for all manner of social experimentation.

In fact, the ideas of creating a new social-political contract and of the unique (religious) chosenness of America harmonized to produce one utopian, communitarian experiment after another throughout American history. From Plymouth, Massachu-setts, to New Harmony, Indiana, to Sun City, Nevada, to Big Sur, California, groups like the Congregationalists, Shakers, Mormons, Mennonites, Fournierists, Owenites, Hippies, Gays, New Age Enthusiasts, Nudists, and well-to-do retirees have created

and contributed to the development of a host of ideal community structures (Guarneri 1991, Fitzgerald 1986). In many cases, the ideas for these creations—planned cities, utopian communities—came from Europe, but the fortunate combination of relative political tolerance, a population adventurous enough that it had uprooted itself to move here, and plenty of open space, allowed experiments like these to be tried out repeatedly in the American Wilderness.

The American concept of creativity has been greatly shaped by the many ideas held in our culture regarding the connection of "nature" and America. The seventeenth-century pilgrims, for instance, associated their American "wilderness" experience with the trials of the Israelites and Jesus in the wilderness, which led to their rebirth and salvation; at the same time, the rich bounty of the land helped inspire visions of rediscovering or recreating the Garden of Eden. (Winthrop; J. Edwards 1966, 138; Bellah 1975, Nash 1967). The vast, open areas of America allowed eighteenth-century political thinkers to treat Locke's and Hobbes' notions of a "state of nature" as a real possibility and to create a new, American political contract.[6]

The nineteenth-century European Romantics' enthusiasm for nature as the source of creativity also found fertile ground in wilderness America. Even politicians like DeWitt Clinton could ask: ". . . can there be a country in the world better calculated than ours to exercise and exalt the imagination—to call into activity the creative powers of the mind, and to afford just views of the beautiful, the wonderful, and the sublime?" (Nash 1967, 70). Novelists such as James Fenimore Cooper and Wallace Stegner, poets such as Walt Whitman and Gary Snyder, painters such as Thomas Cole and Albert Bierstadt, photographers such as Edward Curtis and Ansel Adams, essayists such as Henry Thoreau, John Muir, and Annie Dillard, have been inspired by the magnificence of the American landscape and have created enthusiasm for it. For many, the singularity of American art and literature lies precisely in its strong response to nature. Significantly, these creative individuals did not rest in a complacent nostalgia for a natural world they saw diminishing daily, but rather, they helped to invent the extraordinary American national park system, created for the preservation of wilderness and the "re-creation" of the people (1967, 67–121).

To a great extent, nature appeared as the open space within which the early settlers and later immigrants could be creative. As Roderick Nash has pointed out, however, the early pilgrims also viewed the wilderness as an enemy to be vanquished for the sake of righteousness. Indeed, during most of American history there has been a widespread belief in the goodness of replacing nature with the creations of "civilization." De Crèvecoeur called Americans "a race of cultivators" (1971, 12). As the *Chillicothe Supporter* editorialized in 1817: "Looking only a few years through the vista of futurity, what a sublime spectacle presents itself! Wilderness, once the chosen residence of solitude and savageness, converted into populous cities, smiling villages, beautiful farms and plantations!" (in Nash 1970, 23).

The focus on nature early took on a decidedly commercial and technological tendency, and by mid-nineteenth century, "wilderness America" was beginning to surpass the most powerful nations of Europe in economic power. Already in 1851 at the World Exhibition in London, American entries won first prize for technological inventions. The public marveled at creations like the McCormack Reaper, which soon completely transformed agriculture in America and elsewhere and profoundly affected demography and societal relations. So impressive were the American entries as a whole that observers began to ask: "What makes America so inventive?" While Karl Marx concluded that America's open space and limited pool of available labor gave a strong incentive to technological innovation (MEW, 4:547, 132), others emphasized the ready availability of vast natural resources and the power of American capitalism. Whatever the explanation, the extraordinary burst of inventive energy in America was visible to all.

For some time in the nation's history already, the celebrated Franklin and the multitalented Jefferson (who was also the nation's first patent commissioner) had been revered for their inventiveness; however, a large part of their renown was due to the political creation they, along with George Washington and others, helped bring about. By the second half of the nineteenth century, however, the obvious fallibility of major political figures of the Reconstruction era, the striking advances in technology, and the rapid expansion of the economy helped elevate inventors to a level of public honor previously reserved for statesmen: George Eastman, Thomas Edison, and Alexander Graham Bell became household names and were treated as folk heroes.

Edison, in particular, was lionized in American culture as the greatest creator at least since Franklin. The news media, which he utilized for public relations so well, billed him as The Wizard of Menlo Park. He understood how to build on the work of others, how to adopt his discoveries in one realm to different ones, and how to take advantage of large-scale infrastructures. His ability to raise capital and inspire and push his workers was extraordinary, and as a result, he won 1,093 patents, became wealthy, and changed countless lives.

Like Franklin, Edison's story expressed the "rags to riches" theme celebrated in the novels of Horatio Alger and which seemed to parallel the rise of upstart America to a world power. Andrew Carnegie and some other successful Captains of Industry also followed this pattern, and even those who did not used public relations to make it seem as if they did. Indeed, Andrew Carnegie, J. P. Morgan, Jay Gould, John D. Rockefeller, when not denounced as Robber Barons, were hailed as creative heroes who "made themselves" and "built America." The merging of business, technology, capital, invention, and media-driven public relations has strongly colored American attitudes toward creativity as entrepreneurship and practical inventiveness. Where once there were rags, now there are riches; where once there was darkness, now there is light: the self-made individual, close to God, heroically creates *ex nihilo.*

At the same time, however, collaboration early became a key to corporate innovation. Edison's combination of factory and laboratory became a model for team research aimed at profitable invention. Throughout much of the twentieth century, it was the Bell Telephone Laboratories of New Jersey, named in 1925 for the inventor of the telephone, which has been the premier example of creative research in our society. In the last few decades, the model has switched to a loose association of otherwise competitive high-technology companies and venture capital in conjunction with academic research—as embodied by Silicon Valley.

While America has had a hero-cult for its inventors and entrepreneurs, its democratic bent early caused it to reject the European "great man" theory. Inventiveness was not seen as the result of extraordinary individual gifts or genius, but of the kind of hard work anyone might be able to carry out. Benjamin Franklin presented himself in his *Autobiography* as no more gifted than others—in fact, he offered himself as a model of what one could accomplish through industry. Similarly, Thomas Edison claimed that his creativity was 99 percent sweat. Despite the fact that Edison and Franklin possessed that special additional 1 percent of whatever makes for creativity, the ideology of democracy insisted that everyone could potentially invent, just as everyone could become president. That is why, in this century, several private corporations, the United States government (especially the military), foundations, like those of Ford, Rockefeller, and Carnegie, and academic institutes, like that for Personality Assessment and Research at the University of California, Berkeley, all have focused attention on analyzing the character of creativity. As Frank Barron of that organization stated: "It would be interesting and possibly very useful if we could learn more about the nature of creative activity, so that we might more readily find and foster creativity in individuals in our society, for the common good of all" (Barron, *Personal Freedom* 1968, 8).

One of the important consequences of these perspectives was the invention of completely new and classically American concepts of creativity: namely, problem solving and creativity training. In a nontraditional society such as ours, or rather, in a society with a tradition of the pioneer in the wilderness, anything in any realm may appear as a problem, and every problem may be viewed as a challenge subject to a creative solution. The kind of optimism this attitude requires has often been judged to be a hallmark of American society.[7] Equally optimistic is the belief that people can be trained to be creative—or at least, more creative—an idea common in America today.[8]

It is plain to see that innovation in general, and American innovation in particular, has changed the world. Perhaps because of its extensive territory, the United States has led the world in almost every aspect of transportation and telecommunications technologies. There can be no doubt that the United States government's relatively benign control of the media has allowed the subsequent merging of information, entertainment, and technology to take place more rapidly

in the United States than elsewhere. In many ways, American creativity is commercial. A tremendous amount of creative energy is put into advertising, and it dominates the structure and sometimes the content of the various media. The media is big business and serves big business as well.[9]

In fact, many critics view the American media as not merely coopting creative talent, but as undermining creativity in general by tending to mesmerize audiences with emotionally engaging material which fails to provoke critical thinking. This is done, according to Marxists and other critics, to assure that Americans are a nation of consumers, and consumers need not be—must not be—critical or creative. One could claim, however, that the art of selling has become a primary creative activity in the United States, precisely because consumers are not so passive and need to be persuaded.

The quest for profit has led to support for artistic creativity in some interesting ways. Aside from the substantial business of art and entertainment and direct corporate sponsorship and foundation grants to the arts, several billion dollars from individual donors has been encouraged by the American system of tax deductions.[10] Therefore, while it is true that the United States government directly supports the arts less than do many other governments, the American system of tax credits results in a huge amount of indirect government support. (Because that support may be skewed to the tastes of wealthier donors, direct grants from government are still crucial for many arts groups and projects to survive and flourish in the United States.)

While many artists insist that creative expression should not be commercialized and that genuine inspiration is not subject to creativity training, theorists of American education, moving between self-expression and problem solving, play and purpose, began intensively in the 1960s to emphasize creativity in the curriculum in order to nurture creativity in the pupils. Thousands of books and articles have been published on the subject, and all manner of imaginative and experiential learning approaches have been introduced into the curriculum in order to supplant a learning environment considered dominated by "rote learning."

This educational reform has coincided with a strong multicultural emphasis, in part because examination of other cultures' traditions relativizes our own and thereby might free us to be more innovative. The conservative reactions to these developments, expressed in the "back to basics" and "cultural literacy" movements generally do not seem opposed to creativity; rather, they seem based on the premise that certain foundations of knowledge will serve as a better springboard for greater growth.

Indeed, despite major differences in educational philosophies and between attitudes in art, education, psychology, and business, the serious study of creativity continues to flourish in the United States. Significantly, ideas from these different approaches have been integrated into the broader cultural debates without much conflict—no doubt because creativity studies are so thoroughly American.

Conservatives and liberals alike especially seem to find the "self-actualization" or "human potential" psychologies of Maslow, Rogers, May, and others normal, believable, and right. The work of these theorists to help everyone express and fulfill him or herself, to *create* him or herself, is as American as Norman Vincent Peale's *The Power of Positive Thinking.*

Both the creativity training of the business world and the reform curriculum of education assume the legitimacy of the premise: all are potential creators and merely need guidance and effort to realize that potential. As Brenda Ueland put it in her influential 1938 book, *If You Want to Write,* "everybody is talented, original, and has something to say.... You (too) have the creative impulse" (1987, 1: 10).

When creativity is discussed in American schools, however, it rarely is presented in the ways covered in these pages, but rather, mainly in terms of the arts ... and the arts, unfortunately, are usually slighted. Furthermore, study of the arts becomes less and less important as one advances in schooling, is almost never required at the college level, and is often the first area to be cut when budgetary problems are addressed. Arts programs which have resisted budget-cutting efforts have often done so by convincing others that their courses help students with their other "more critical" and "more practical" subjects. Sparten vs Athenian

The arts are, in addition, barely supported by the federal and state budgets. The United States government's 1997 spending of $250 million for the National Endowments for the Arts and the Humanities together represents less than one-tenth of 1 percent of the total federal budget. (Tax deductible gifts to the arts almost never go to public schools.)

One might therefore expect that with American society's overriding focus on business and with relative government and educational neglect of the arts, that artistic creativity in the United States would be minimal, but such has not been the case. Aside from some fine examples of colonial American sophistication in the areas of architecture, furniture making, and silver work, the arts in America began to express their own creative way in the mid-1800's with writers like Longfellow, Thoreau, Melville, Dickinson, Stowe, and Whitman, and with painters like Bierstadt, Cole, and Catlin.

However, it was really in the second half of the nineteenth and early twentieth century that American creativity in the arts and humanities developed to a point of independence from Europe: this was evidenced by architects Louis Sullivan and Frank Lloyd Wright; photographers Alfred Stieglitz and Louis Hine; writers Ernest Hemingway, John Dos Passos, and F. Scott Fitzgerald; philosophers John Dewey, William James, and C. S. Peirce; composers Scott Joplin, Charles Ives, George Gershwin, and many other creators.

By the Roaring Twenties, the Jazz Age, Gertrude Stein could write about "the Americanization of everything," and Duke Ellington could say, "the whole world revolves around New York." In fact, "Negro" music, disseminated through radio

and the phonograph, first took America by storm, and then became an international phenomenon. Meanwhile, Isadora Duncan and Martha Graham revolutionized traditional European concepts of dance.

By the mid-twentieth century, American artistic creativity had achieved prominence throughout the world (this was clearly tied to America's economic and military preeminence, the artistic-intellectual emigration from Nazi Europe, and the emergence of America's formerly oppressed cultural minorities.) Abstract and Pop Art, Modern Dance, Jazz, Blues, Rock 'n Roll, Hollywood Film, skyscraper architecture, and television programming were realms in which the American arts scene rose to global importance.

Many around the world, including a number of Americans, continued to view the United States as uncultured and uncouth, but the power of America's creativity (propelled by the nation's wealth), helped undermine traditional European distinctions between "high" and "low" culture. Indeed, the Americanization of everything in the arts conspired with the moves in American business to democratize creativity and bring about the widespread interest in the subject after World War II.

Still, however influential American art came to be, it was clearly overshadowed in many ways by business. In the cases of television, film, rock 'n roll, the power of American business has clearly played a role: the *marketing* of artistic creativity has taken on a unique dimension in American society.

This commercialism has also succeeded (where education has perhaps failed) in bringing masses of Americans to art museums and concerts. Museum attendance in the United States is among the highest per capita in the world. [11] What's more, the number of Americans who take courses in art, music, and dance outside of school is very high, and the numbers who engage in the arts on a casual and amateur basis is enormous. Whether the proportion of Americans doing this is higher or lower than that of citizens of other countries would be difficult to assess. It is also difficult to say whether this interest in the arts is for the sake of education, entertainment, or creativity; surely, the merging of these elements (for better or for worse), seems to be the next frontier of American culture—and wherever the next frontier seems to be, Americans seem bent on going, in part because our media ceaselessly markets the excitement of "crossing the next frontier."

In point of fact, the image of the "frontier" has long been a crucial element in American culture. This was literally so in nineteenth-century landscape painting and in twentieth-century western films, and it continues to be a staple of American advertising and entertainment. The image of the frontier has also entered into many aspects of American creativity in a figurative sense. Indeed, while the frontier theme expressed one dimension of the American encounter with nature discussed above, the dominant and, for our understanding of creativity, most significant aspect of the mythology was the focus on the drive to cross frontiers. Somehow, the word, which originally denoted a border, and then, the border between "civilization" and "the

wilds," came to express the confrontation with and push toward the unknown. Thus, early pioneers, like Daniel Boone, and later explorers and settlers who "crossed the frontier" westward, have been greatly revered in our society. Historian Frederick Jackson Turner no doubt attributed too much to the open frontier when he said that democracy in America was dependent upon it; however, he was probably right that the natural frontier offered new fields of opportunity, a chance to escape the past, and a stimulus for certain creative traits.

> The result is that to the frontier the American intellect owes its striking characteristics. That coarseness and strength combined with acuteness and inquisitiveness; that practical, inventive turn of mind, quick to find expedients; that masterful grasp of material things, lacking in the artistic but powerful to effect great ends; that restless, nervous energy; that dominant individualism working for good and evil, and with all that buoyancy and exuberance which comes with freedom—these are the traits of the frontier . . . (1947, 37).

However, according to Turner's influential essay of 1893, the frontier was now closed, the tabula rasa gone—the first period of American history was finished. "Fortunately," said Turner, "movement has been its dominant fact, and unless this tradition has no effect on a people, American energy will continually demand a wider field for its exercise" (1947, 38). According to William Appleman Williams, fear of the closing of the domestic frontier and the belief that Americans would demand a wider field for their exercises, led Presidents Theodore Roosevelt and Woodrow Wilson to pursue expansionist international policies. This was, of course, a continuation of the long-held American belief in Manifest Destiny, namely, that it was the European-Americans' right to expand, to push forward, regardless of Indians or Mexicans in the way. Incorporating traditional European ideas of "progress," "culture," and capitalism and the biblical ideas of "chosenness" and "making a way in the Wilderness," this cluster of concepts supported American expansion across the American continent and as far as Vietnam.

This expansion was viewed as "nation-making," as creating a strong and unique America; subsequently, it expressed a desire to transform, to recreate an image of America wherever we went. Echoing the Puritans' belief that America would be a "city on a hill, . . . a light in the darkness," generations of Americans believed that our society's structures and values should be incorporated throughout the world (Bellah, 1975). Other peoples then would revel in our freedoms and prosperity; the millions of immigrants to America seemed to prove that everyone wanted to be like us. The push beyond existing frontiers meant establishing Coca-Cola and MacDonald's, if not instituting American style government abroad.

This drive, coupling idealism with greed also included continuous military effort, as we roamed "from the Halls of Montezuma to the Shores of Tripoli," and therefore also continuous innovations in armaments, from the Winchester repeating

rifle to the atomic bomb, and beyond. The image of the frontier seems to carry fear with it—of the unknown, of the barbarians on the other side of it, of the "enemy"— so that when we conjure up pictures of the frontiersman, he's almost always imagined carrying a rifle.[12]

But for many twentieth-century American thinkers, the frontier has been conceived of in the broad sense of any kind of challenge which elicits a creative response. Thus, Franklin Delano Roosevelt, convinced in the 1930s that America had reached its "last frontier" geographically, called for creative social reorganization (1938, 750–751), and his New Deal policies transformed American life. Then, too, all manner of technological advances, from telecommunications, to genetic engineering, to everyday household gadgets, have been heralded by scientists or advertisers as crossing the threshold of a "new frontier."

The practice of science in the United States is popularly viewed in this light. Almost every American television show and mass appeal magazine about science seems to mention, if not emphasize, the "frontiers" of science. Scientists are seen as great explorers, crossing the frontiers of the known and discovering the new. The competition to be "the first across" is intense, and Americans are proud that their corporations and educational institutions are world leaders and that Americans have won such a large proportion of Nobel Prizes. In fact, the frontiers of the known do seem to be pushed back continuously, and where science has not yet succeeded, ever-popular science fiction has.

No wonder John F. Kennedy picked up on the theme of the frontier in 1960 and connected it with the old ideas of American civil religion to give a new clarion call for creativity.[13]

> It is time for a new generation of leadership—the new men to cope with new problems and new opportunities. . . . The new frontier of which I speak is not a set of promises—it is a set of challenges. It sums up not what I intend to offer the American people, but what I intend to ask of them. . . . Beyond that frontier are uncharted areas of science and space, unsolved problems of peace and war, unconquered pockets of poverty and surplus. . . . It would be easier to shrink back from that frontier, to look to the safe mediocrity of the past. . . . But I believe the times demand invention, innovation, imagination, decision. I am asking each of you to be new pioneers on that new frontier (Schlesinger 1965, 59–60).

As Kennedy's words make plain, the metaphor of the frontier has been expanded to all areas of the unknown. For Kennedy, the future itself was the frontier—his words are reminiscent of Melville's quoted earlier and of thousands of American thinkers and eager immigrants who believed in America as the future.[14] Kennedy's words also make plain the idea that a frontier is a challenge which prompts a creative and courageous response. Because the areas are "uncharted" and "unconquered," bravery is necessary: the visionary inventor is one who boldly enters the new territory.

Whether it is a matter of social, technological, or mental frontiers, the word now denotes those temporary boundaries which our creative power will allow us to transcend. To the extent that we perceive ourselves as pioneers in a frontier society, we value creativity.

As Walt Whitman had written a century earlier in Pioneers! O Pioneers!:

> O you youths, Western youths,
> So impatient, full of action, full of manly pride and friendship. . . .
> All the past we leave behind
> We debouch upon a newer mightier world, varied world,
> Fresh and strong the world we seize, world of labor and the march,
> Pioneers! O Pioneers!
> We detachments steady throwing
> Down the edges, through the passes, up the mountains steep,
> Conquering, holding, daring, venturing as we go the unknown ways,
> Pioneers, O Pioneers!
>
> (1881, 83, 183).

That this attitude permeates popular American culture is obvious. The fear, the excitement, the determination, the hopefulness are contagious and undisputed. Disneyland, for example, capitalizes on this belief and actively propagates it by offering its visitors: Frontierland, Fantasyland, Adventureland, and Tomorrow Land.[15] American advertising, politics, education, and technology all ring with variations on this theme.

Even in the most notorious example of American political repression of creativity—the 1947 House Committee on Un-American Activities (HUAC) and Joseph McCarthy's subsequent Senate investigations of Communists in the film industry—the frontier myth was reinforced. It was not creativity per se that was under investigation. However, the desire of film industry executives to win congressional approval and consequent blacklisting of actors, directors and screen writers who refused to declare under oath that they were not Communists severely dampened creativity in several areas. As a result, American film and television were directed to a special degree throughout the 1950s and 1960s to war films and that other unassailably patriotic genre, "the Western"—which further perpetuated the frontier myth (1974, Adler).

And as we enter the twenty-first century, we continue to revere the early pioneers and frontiersmen; we correspondingly consider the breaking down of barriers a positive value. This merges with our admiration for the American revolutionaries, the religious "dissenters," the "lonesome cowboy" heroes of western novels and films, the Marlboro Man of commercials, and even the beatniks, hippies, and the Rebels Without A Cause,—as can be seen in the strong American "highway literature," of which Jack Kerouac's On the Road is one of the most famous examples.[16] As Ralph Waldo Emerson put it in Self Reliance, "Whoso would be a man, must be

a nonconformist. . . . No law can be sacred to me but that of my nature" (1968, 491). Even Andrew Carnegie, while advising young business graduates in *The Road to Business Success*, says, "there never was a great character who did not sometimes smash the routine regulations and make new ones for himself" (1971, 157).

So strong is this image of the rebellious, creative individual, that many of our society's creative heroes are routinely viewed as mavericks and iconoclasts, and both their debt to others and their collaboration with others are generally ignored. We tend to see the creative individual as the cowboy loner who follows no rules but his own, yet comes to a town and solves its problems. Even violent criminals, like Jesse James, Clyde Barrow, and Butch Cassidy have been romanticized in film as independent-minded, rebellious outlaws, creatively outwitting the authorities until the end.[17]

American admiration for individualism is not merely a rejection of collectivism, but also a refusal to accept limits and barriers others take for granted. This, of course, is viewed as an essential attitude for creativity in the prevalent conception of our Western culture. However, the hero of American western novels and films is ultimately *not* a creator of values in the Nietzschean sense. The values of the American "individualist" hero are, for the most part, the traditional moral ones of our society. John Wayne would never act like Baudelaire; the American Superman fights for "truth, justice, and the American way."[18]

That is why the image of the creative rebel in American society has generally not included women or African-Americans, for their rebellion would be too threatening to the dominant social traditions. Such "marginalized" groups have their own images of creative rebels, such as Margaret Sanger or Malcolm X; only in relatively recent years could someone like Martin Luther King, Jr., advocate of "creative extremism," achieve the status of a national hero . . . and he could do so only because his words and deeds were so firmly anchored in traditional American religious and political rhetoric. Indeed, a significant part of the oppression of women, Blacks, Indians, and others in America has been the dominant culture's refusal to consider these groups capable of being inventive or creative.

Despite great social diversity on the one hand, and the mythology of the creative rebel on the other, the dominant ideology has allowed the United States to exhibit great consensus regarding many primary values. Even many members of the historically discriminated against minorities accept this ideology (DeGeorge 1990, 47). We may, in fact, be a nation of sheep—French writer, Alexis de Tocqueville, thought the greatest danger in American society was mass conformity—but, ironically, one way we conform to each other is in our belief in the heroic individual: the discoverer, inventor, creator, protestor, rebel.

Because these ideas are so interwoven and so ingrained in our society, it should come as no surprise that, when J. P. Guilford and other psychologists carried out tests in the 1950s on thousands of soldiers (who were, of course, obliged to

follow orders) the theorists "discovered" that those individuals who were most creative were, of course, least suited to following orders. And perhaps this is not ironic at all: we believe that the iconoclastic hero upholds our morals in the end and is a "true blue American." No wonder Frank Sinatra could extol a fervent patriotism while singing, "I did it my way," and the Hippie counter-culture could lampoon that same patriotism, while singing in unison, "Do your own thing."

We are conformists in our belief in individual uniqueness; that your creativity and mine might be in extreme conflict is obvious to all but largely unspoken. We avoid some potential conflicts by focusing our creative energies to a great extent on private initiatives rather than public works, in part because the latter requires more compromise, and in part because of the ideology of individualism.

Thus, the American understanding of creativity fits perfectly with the rest of our society's belief system. We believe in individuality, but we're democratic about it. This is the New World, the "land of the free and the home of the brave." We believe in equal opportunity—with the proper training, everyone can be original, independent, creative, and self-actualized—in one realm or another. And, what's more, everyone *should* be creative, because creativity is good, it is American. Political conservatives, as well as liberals, those committed to "tradition" and those committed to "progress" alike all seem to share this premise to some degree, even if they disagree about the realms and ways in which creativity should be exercised.

No wonder the last few decades have witnessed such an explosion in creativity books and seminars and such widespread use of the word and its cognates in everyday American speech. This contemporary obsession incorporates an extraordinarily eclectic blend of traditional American ideas, including the "pursuit of happiness," the "ideal of the self-made man," the "power of positive thinking," humanistic self-actualization psychology, the myth of the frontier, the glorification of the rebel, enthusiasm for technological invention, marketing, and the profit motive. New Age self-help texts, educational theorists, and strategic business innovation seminars alike espouse the doctrines of belief in one's own potential, the willingness to follow one's own heart or mind, and the cult of bringing into being something new.

It is unlikely that any other country concerns itself with creativity to the same degree as does the United States, and it is unlikely any other country has so completely merged the idea of creativity with its broader cultural ideology. And if it is true that "the chances of innovation are improved if innovation is expected with high frequency to maximize values" (Lasswell 1959, 212–3),[19] then, perhaps creativity flourishes to the greatest extent in the United States. Indeed, millions around the world would probably agree that America is among the leading countries, in many respects *the* leading country, in creative developments in art, music, agriculture, medicine, genetic engineering, space exploration, communications, artificial intelligence, and other fields.

Of course, not everyone, everywhere in the United States is equally commit-

ted to this ideology: Christian fundamentalists resist some creative efforts in the arts and in medicine, for example; environmentalists resist some business innovations and expansion. Furthermore, it is hardly the case that everyone is blossoming creatively at the moment. There are great differences among individuals and among regions in the United States. And, despite the powerful ideology, it is obvious that creativity is hindered in numerous ways and that many Americans feel frustrated in their creative dreams. Significant material, social, and legal obstacles exist. However, the degree of frustration mirrors the degree of desire for and expectation that one can and should be creative. In other words, the common concern with overcoming obstacles to creativity reveals the power of the American ideology of creativity.

Then again, perhaps it's not creativity, but an obsession with faddishness that is fostered by the American quest for "the new." In the American world of commercially driven electronic entertainment, "infinitely repeated novelty" is suggested: new sitcoms, new detergents, political and social news all appear and fade from memory faster than a politician's "sound bite." Soon, Andy Warhol's prediction will no doubt come true: each of us will receive our fifteen minutes of fame (or did he say fifteen seconds?).

Perhaps, then, everyone can be creative—just not in any substantial way. Indeed, critics from both the Left and the Right argue that the openness, tolerance, and opportunity of America, far from encouraging profundity or creativity, have instead deadened them. If everything seems possible, if the frontier seems wide open and anyone can cross it, if there are no restrictions at all, if "you can do your thing, and I'll do mine" . . . then the need to struggle, the essential challenge is diluted, standards decline and creativity disappears. The society becomes, as a result, a vast television wasteland.

What is more, strikingly negative social trends in the United States, such as high crime, divorce, drug addiction, poverty, and increasing class differentiation surely have diminished opportunities for many individuals to be creative in any way beyond figuring out how to survive.

Meanwhile, artistic creativity thrives abroad, and high-tech development is going on from Italy, to Brazil, to India. Only recently have Americans begun to realize that our creativity in the problem-solving area may be equaled or surpassed by that of other nations. Despite widespread ignorance of and indifference towards other countries, Americans occasionally take note of advanced transportation, health, and welfare approaches from Canada and Europe. If they look carefully, they note that Iceland and Israel have the world's highest per capital Internet use, and that dozens of Silicon Valleys have emerged around the world. Despite current economic difficulties, Japan has a disproportionately high level of innovation, and on a per capita basis, the Japanese win more patents than do the Americans.

Moreover, as the United States attempts to meet the international competi-

tion by working ever harder, the ensuing reduction of leisure time will no doubt skew creativity in America even more toward innovation and problem-solving and even further away from the arts and self-expression. And since the United States has fewer scientists and engineers on a per capita basis than many other nations, America might appear destined to decline as a center for creativity, be it artistic or techno-logical[20]—though every other country also has a significant challenge as our global, multicultural society further develops. Indeed, that development might make it irrelevant how creative the United States is compared to other countries.

European-Americans have come to appreciate, even revere, some of the cre-ations of African-Americans, Native-Americans, Asian-Americans, and Latin-Ameri-cans which their ancestors formerly disdained. American creativity is now unabashedly multicultural. At the same time, it is becoming ever more consciously global. America has always borrowed from others and has always been a society of immi-grants. As Librarian of Congress, James Billington, said of Poet Laureate Joseph Brodsky, "he has the open-ended interest in American life that immigrants have. This is a reminder that so much of American creativity is from people not born in America" (Associated Press, 1/29/96, A20). What is more, many of America's most creative citizens are immigrants and members of that international community of scholars, artists, musicians, scientists, athletes, dancers, and business people who move from country to country with relative ease. For them, and for increasing numbers of others, creativity takes place in a global context. National borders simply are not as significant as in the past. Indeed, American (as well as European and Japanese) business interests seem to be causing people, ideas, and money to flow continuously in every direction.

And along with these movements comes the ideology of creativity, dissemi-nated in large part thanks to American telecommunications technology. MTV is seen around the world, and everyone is dancing to the beat. Coca-Cola, IBM, and other U.S.-based multinationals have subsidiaries almost everywhere on the globe. As I write, American creativity consultants are marketing their books and seminars around the world as well.

And the same forces which are bringing about these developments are push-ing "the next frontier" of the infinite, instantaneous, feedback loop of all of us (who can afford it) talking, listening, buying, selling, entertaining, informing, imagin-ing, and creating together at once in virtual cyberspace. Thus, we return to creativ-ity as a global concept, through which the deeds and works, individuals and groups from all corners of the world and all types of activities may be viewed as creative. It is therefore hard to distinguish what is "American."

If America does still seem unique, it may be because its ideology of creativity is such a fundamental aspect of the culture and is supported by global economic and military power as well as domestic multiculturalism. The power allows the dissemi-

nation of the country's culture; the multiculturalism gives the country the potential to relate more fully to the global culture than is the case for most other countries. In the final analysis, when we look at America, we are looking at a culture that, paradoxically, has a tradition of creativity. This, too, would make America unique, except for the fact that people the world over, to greater or lesser extent, seem to be adopting an ideology of creativity and making it their tradition as well.

CONCEPTIONS OF CREATIVITY IN "TRADITIONAL" AND "NON-WESTERN" CULTURES

As we have seen, the context for creativity at the end of the twentieth century is global: New York museums display Yoruba master carvings near Dutch master paintings; Kuwaiti businesspeople discuss ideas from American self-actualization psychology as well as business innovation with their Indonesian counterparts; and artists, scientists, and musicians move from country to country with relative ease, frequently speaking of creativity. But we know that at the same time, ethnic, national, and religious rivalries are widespread and acute, and that the global culture we believe exists is itself largely the continuation of the Western imperialism of the last few centuries. In fact, because our Western culture is so dominant globally, we have the power to propagate false or at least distorted images of other cultures all around the world: today, rural Pakistanis might encounter images of Brazilian creativity filtered through the prism of American advertising. And when people speak of "creativity" around the world, they primarily use this English word, because the concept is not a normal part of their languages and the West has succeeded in influencing them so powerfully. Indeed, the power of Western/global culture tends to overwhelm all unique group identities.

Group cultural identity may be based on many factors, but having a certain degree of common belief and customs persisting over time is fundamental. The more commitment the new members and following generations have to the customs and beliefs they've inherited, the more the group may be called "traditional." While the traditions that such groups follow were themselves created and have evolved, their originators often given great reverence, and new traditions inevitably arise, virtually every society also resists—to varying degrees—whatever seems incompatible with their most important inherited beliefs and customs. It is easy to see, therefore, how more traditional cultures are threatened and disrupted by their encounters with the dominant Western culture: our economic, military, and

technological power produces direct social-material changes in the lives of the people, and our cultural ideals call upon everyone to question the past and one's identity and celebrate the new.

THE WESTERN WORLD'S PERCEPTION OF "TRADITIONAL" CULTURES

This difference between the "traditional" and the "new" has been discussed in the West for several centuries, and in fact has been an important element of Western culture at least since the Renaissance, when feudal structures began to break down and a number of key figures explicitly challenged authorities and questioned traditional assumptions. These challenges were stimulated in part by the new ideas brought home by fourteenth through sixteenth-century European travelers and explorers who marvelled at the sights and customs of meso-America, China, India, and Africa. But the awe some adventurers felt quickly gave way to the conquistadors' realization that European military technology gave them the power to dominate, pillage, kill, and enslave those other cultures. The long-standing European sense of superiority, which had been based until then mainly on national and ethnic chauvinism and a religious doctrine distinguishing between the "saved" and the "pagans," was greatly reinforced by the disparity in raw power.[1]

This power helped legitimize the relatively new cultural traits, and Europeans subsequently distinguished themselves from other peoples in the world on the basis of these traits. While many cultures (such as the Chinese) have viewed themselves as "civilized" and others as "barbaric," the imperialistic successes of the West throughout the world helped confirm its belief that it was "advanced" and others were "backward" or "primitive." While some Western thinkers, like Rousseau, de las Casas, Montaigne, and Swift critiqued this attitude, many other Europeans carried the Western/non-Western opposition to the extreme of truly "human" versus "animalistic." A certain degree of respect achieved toward the end of the nineteenth century substituted the terms "modern" and "traditional," but the West has continued until recently to view itself as dynamic and others as static.

Today, we still commonly think of a culture as "traditional" when we believe its social roles, customs, and beliefs are handed down unchanged. Such cultures seem to us to have fixed social roles and structures which determine what people can do and say, while in our modern society, what individuals do and say supposedly establishes their social positions (Bauman 1971, 287; Babcock 1993, 90). In other words, we believe that a traditional society determines the conditions of creativity, while a modern society is determined by the creative activity within it. And those in the West generally consider their society superior for this reason.

In line with this sense of superiority, Western thinkers of the Enlightenment era such as Herder formulated theories of history in which peoples were viewed as advancing through several stages, starting with nature and primitivism and pro-

gressing until they reach the heights of advanced, modern civilization. Europeans sought their own "primitive" origins through studies of language, folklore, archeology, as well as history. Through ethnography and comparative religions, they also explored the peoples they had colonized as examples of earlier stages of cultural development. And what they found fascinated them. Centuries earlier, Europeans had been filled with curiosity when the explorers brought back stories and the individual Native Americans from the New World; by the end of the eighteenth century, "orientalism" had swept European and American art and fashion, and the "noble savage" ideal was common in Western literature; in the mid-1800s, Emerson, Müller, and Schopenhauer found inspiration in Asian philosophy and religion. By the end of the nineteenth century, the ethnographic museums of Europe were drawing great crowds, and soon thereafter, Western artists began to adopt ideas from primitive cultures. In the twentieth century, the end of direct, political colonialism, the emergence of the United Nations, the minority civil rights movements in the United States, and the rise of global media, trade, and tourism, have allowed for a new level of appreciation for so-called traditional cultures.[2] In part, this seems to be because the West's great dominance has led to the virtual disappearance of many of these cultures, and we are concerned about losing all memory of them; in part, we've come to see the excellence of certain individuals, customs, and creations of traditional peoples.[3]

Surely, one of the ironic results of the West's desire for novelty is that, today, we are intrigued by the countless "traditional" artifacts we find around the world. While these things might attract us because they seem new to us, many of us also believe, as Freud did, that the "primitive" expresses our innermost or original selves. Like Paul Gauguin in Tahiti, we seek out the "primitive," and if we cannot reach exotica abroad, we look at the objects in our museums or buy them in our galleries and boutiques.[4] Intrigued by the ancient "creation" myths of these cultures, too, our writers incorporate them as novel and mysterious elements in their works, and our teachers review them in the classroom as "multicultural" supplements or alternatives to the Bible. Our media and advertizing, too, play upon the exotic and adventurous dimensions of these "primitive" cultures.

Because we're often unknowledgeable about these other cultures, creations of theirs that appear novel to us may actually be mass-produced for export, and our assessment of their quality may be very naive; but serious Western scholars and art collectors visit these cultures and make a point of determining what are unique and culturally significant works. However knowledgeable we are, the Western focus on the objects as individually valuable artifacts isolates and abstracts them from the much larger cultural fabric of which they are parts. Furthermore, even though we might value these works as artistic masterpieces, most people in the West also value them as commodities, and this may be completely antithetical to the values of the culture from which we seek to acquire these things.[5] On the other hand, peoples

around the world have always engaged in commerce, and today, many people from traditional cultures seem quite pleased when outsiders buy their works and appreciate them as art—whether or not the outsiders understand the contexts of the creations.[6]

Most of us would probably agree that appreciation is enhanced if we do understand the cultural backgrounds of the creations. The problem is, understanding our own culture, let alone someone else's, is no easy task. Just as we implicitly define something by clarifying what it is not, we understand a culture *as* a culture, only by conceiving of it as a coherent whole, a system of relations circumscribed and relatively fixed. We ask of any culture, what are its long-standing customs and beliefs. The idea that a society has traditional forms significantly aids us in this conceptualization. Thus, we somehow often think of ancient Egypt or China as coherent wholes, despite their thousands of years of evolution. Conversely, many of us think of our culture as so creative and so dynamic that we ignore the traditions which shape us and have great difficulty perceiving the characteristics of our own culture. Calling other cultures, but not ourselves, "traditional" has long been an important aspect of the West's self-definition. This is especially the case in the United States, where images of the New World, "the future," and "the next frontier," have filled political rhetoric and are widely believed.

However, there are primary and secondary tendencies, dominant and minority cultures in every society, and these necessarily shift over time. Within the West, political and religious conservatives emphasize the importance of traditions, but many of these same conservatives share with others a strong commitment to innovation. For their part, people in the societies we view as traditional may proudly insist that they are, or may vehemently deny the description as a case of European-American self-deception, bigotry, or willful manipulation: indigenous American tribes were described by Westerners as so fixed in their customs that while some tribes were in fact wiped out, others were declared "dead" simply because their traditional patterns no longer seemed to exist—as if the group concerned was incapable of or had no right to evolve (McNickel 1972, 33).[7] Traditional societies may value the past and put limits on contemporary behavior, but they would not survive at all if they couldn't change.

In many cases, traditional cultures are strongly tied to nature, and while this trait is now often praised in the West, it was long viewed by Westerners as proof of the essential primitivism of these peoples. That is why, even today, Native American cultural artifacts are sometimes displayed in natural history museums—sometimes, in fact, they are displayed right across the hall from the dinosaur skeletons—as if the people, too, were extinct. For some peoples, like the Tarajas of Indonesia, social customs, economic structures, and religious beliefs might be so bound to a particular natural environment that when members of the culture move elsewhere, their

traditions might not make sense and/or be long retained. However, a number of American Indian nations have experienced forced migration and yet have retained varying degrees of traditional cultural identity; and despite a 2000 year Diaspora and quite different beliefs, Jews have done the same.

Hardly any culture on earth has been able to maintain its traditions completely unaffected by outside influences. Trade, war, missionizing, tourism, language, and technology have spread culture from one group to another, and each group has changed as a result. James Clifford reminds us that when Margaret Mead studied the Polynesians in the 1930s she was "annoyed" to find them unconcerned about preserving their own cultural integrity and instead collecting and adopting some Western cultural forms; but as Clifford adds, we have no right to expect members of other cultures to be purists when we are not and never have been (1988, 230 ff). Long ago, trade routes crossed the Americas, Asia, and Europe; Rome and China were trading during the reign of Marcus Aurelius; the Mongols opened up trade between Asia and Europe; the Arabs tied these regions to Africa; people, foods, and animals were exported around the world; ideas, inventions, and customs traveled as well. Images of Portugese appear in sixteenth-century Benin (Africa) masks; images of Africans appear in Renaissance European paintings. The influences could be multidirectional, even despite colonial domination: Indian artists painted Western-style portraits of British rulers and patrons as well as more traditional (Indian and Mogol-influenced) images of British people, while British artists painted "exotic" Indian scenes and individuals.[8]

Obviously, the outside influence of modern secular society is not necessary for a traditional society to engage in trade or even to mass produce objects for export, and such activities do not in themselves mean that the society has ceased to be traditional—such a society might still strictly limit what may be created, who is allowed to create it, and how the creations are to be used (within that society at least). This was certainly true in ancient Teotihuacan, for example, which nonetheless exported luxury ceramics as early as 250 C.E. from central Mexico to all over meso-America, influencing standards of art and culture throughout the region (Fine Arts Museums of San Francisco 1993:18). This, of course, altered all the cultures involved—but it also led to the establishment of new traditions which, in turn, were followed for generations and even centuries. Likewise, Athens in 400 B.C.E. was exceptionally creative in our modern sense of the word and actively engaged in commerce around the Mediterranean, but it still had very traditional structures for creativity.

The example of ancient Athens confounds the common Western view which associates traditionalism with authoritarianism. While the Taliban rulers of Afghanistan today seem to demand an absolute adherence to their view of tradition, many contemporary American Indian groups aspire to maintain traditions which they claim include relative tolerance and democracy.

The term, "traditional," then, is descriptive to the extent that a society manages to circumscribe the realms and manner of creativity by handing down largely determinative structures from generation to generation. This happens in part because traditions are sufficiently revered that they serve as models for future work. The traditions also provide a crucial framework for comprehending and integrating all kinds of new developments. Repetition and reinterpretation of inherited practices are therefore hallmarks of successful traditional cultures. Continuity and cultural identity go hand in hand.

These characteristics apply whether we are discussing a contemporary, nonliterate, Hmong village of one hundred in Southeast Asia, a complex, traditional society like that of Ancient Egypt, or a present-day Amish community in Pennsylvania. There are, of course, tremendous differences between such cultures, but traditional does not mean small-scale, isolated, or primitive; it is rather a generalization used to describe a strong degree of commitment to valuing inherited ideas and customs. Hence, we are not so wrong in viewing Ancient India, China, Egypt, or the Mayan Culture as coherent wholes: despite their lengthy histories, they seem to have successfully maintained many key beliefs and practices over long periods of time. For these and a number of other cultures, then, the word, "traditional," can be applied, so long as we keep in mind its relative meaning.

Certainly, *every* culture has some degree of commitment to its traditions, and for that reason, even the United States might be called "traditional" as well. However, many of the most widely held traditional beliefs of the United States are virtually identical to the ideology of Western dominated global culture—and this culture embodies certain ideas of individualism, linear historical progress, the scientific questioning of assumptions, the commodification of goods and services, and the admiration of the new and unique, which have spread globally and directly threaten the authority of tradition and inherited beliefs and therefore the perpetuation of every particular culture. "Fundamentalist," "nationalist," and "tribalist" reactions to this onslaught are, as a result, widespread: cultural identity, social roles, and therefore, self-identity are at stake. It is understandable that many traditional societies wish to circumscribe what we call "creativity," for creativity is, in a sense, the name of many of those activities which alter society.

Even many secular Westerners today feel concern that "traditional cultures" are being "threatened with extinction." Throughout our century, various Western historians, philosophers, politicians, and others have waxed nostalgic about tradition, even though, as Edward Shils has pointed out, "no society was ever as dominated by tradition as these writers made it appear . . ." (1981, 19). Nonetheless, this nostalgia has helped fuel nationalist political movements and has been translated by some anthropologists into a desire to "preserve" other cultures in their traditional style (Medicine 1972; McNickel 1972).

Many anthropologists play a creative role in explaining other cultures to us and in educating indigenous peoples about how to deal creatively with our dominating culture. Some anthropologists help traditional cultures organize against corporate exploitation, lobby for protective but nonrestrictive government regulations and aid, and sometimes attempt to market domestic products so that the culture can maintain its traditional livelihood (Deloria 1992; Ortiz 1972). The credo, of course, is that the Western anthropologist should do only what the locals want, but the mere fact of his or her presence explaining how the "outside" world operates is a delicate balancing act between interference with and protection of the indigenous people (see, for example, the organization, Cultural Survival).[9]

In the past, and even to a considerable extent today, the West has been far more interested in preserving the artifacts than the people and way of life of traditional societies. We have engaged in what James Clifford has aptly called "culture collecting": we grab hold of the fruits of other cultures' creative efforts and put them in museums or up for sale.

Conquerors have always lusted after "the spoils of war," and even today, despite the 1907 Hague Convention against this, such pillaging goes on; and despite the 1970 UNESCO Convention against it, international art theft goes on as well. National museums of Brazil, Mexico, Australia, and the United States display countless works of local tribal cultures that were never freely donated or sold by their creators.

And, of course, mass production from the Industrial Age through today has undercut local, handmade production by economies of scale and uniformity of standards.[10] The handmade items then, at best, often become folk crafts. To some extent, particularly when traditional works are bought from the creators themselves, this "culture collecting" by our museums and folk art shops might positively be seen as a type of rear-guard action in which we attempt to "rescue" what we are destroying (Clifford 1988, 230). Other positive efforts, such as the American Indian Arts and Crafts Bill of 1990, are aimed at encouraging contemporary artists to practice traditionally, even though "throughout the world of Indian art, debate rages over the use and misuse of the terms traditional and contemporary" (LaFramboise and Watt 1993, 9). And this debate is one many of us, not just American Indians, are engaged in.

APPROACHES TO CREATIVITY IN DIVERSE "TRADITIONAL" CULTURES

Of the many contemporary cultures which appear to us, or consciously attempt to be, "traditional," each will respond in a different, creative way to the pressures exerted by "creative," modern, secular society. Sometimes, cultures cling tenaciously to traditions we might think of as extremely chauvinistic, bigoted, even evil and

vicious. Sometimes, cultures embrace "modernism" with such gusto that they race headlong into environmental and social destruction. All around the world, people are faced with the task of finding a balance between tradition and change.

If we look, for example, at the Kaipo tribe in the Amazon or the Karen people in Burma, we see them struggling to maintain their traditions (and their traditional economic land bases) in the face of change. In doing so, the Karen use modern weapons, and the Kaipo use video cameras and Western-style public relations. All these "modern world things" alter their societies, but Karen and Kaipo apparently believe that the alterations that come with these technologies are less threatening than other possible changes. Thus, these peoples are creatively attempting to preserve their traditional ways of life, and to a certain degree, they are succeeding; for how long, though, we have a right to wonder, because the forces arrayed against these groups seem overwhelming. Reactions in our Western culture to our encounters with traditional societies is sometimes peculiar. When such cultures looks weak to us, as the Kaipo do, we often applaud their attempts to maintain their "cultural integrity"; our anthropologists sometimes go out of their way to aid in those efforts and are concerned, even upset, when locals seem eager to adopt ideas and customs from our culture. On the other hand, when a traditional culture appears strong and rejects our influence, as do the Iranians, we are offended; when they see our influence as nefarious, we—especially our government and corporations—are resentful, even fearful.

That is hardly the case for Western tourists and art collectors heading toward Bali in Indonesia, where several centers for traditional art, dance, and music have sprung up as a way for the Balinese to preserve their culture and survive economically. Outsiders, struck by the artistic activities of the Balinese (the whole population seems to paint, sing, and dance to a far greater degree than elsewhere) often describe that society as extremely creative. However, this perception is based on the assumption that art and creativity are synonymous, for most of what appears to be creative in Bali is limited to what we call the "fine and performing arts." Furthermore, except for some recent developments in painting in the last few decades, almost all the artistic activity in Bali seems to have been devoted to following classical patterns. One gets the impression that the same dance with the same costumes and the same moral theme has been performed each week since the Middle Ages. This is consistent with the fact that in Balinese society,

> Actions which are culturally correct (*paket*) are acceptable and aesthetically valued. Actions which are permissible (*dadi*) are more or less of neutral value; while actions which are not permissible (*sing dadi*) are to be deprecated and avoided (Bateson 1942, 119).

These generalizations, in their translated form, are true for most or all cultures, ours included, but the encouragement to be culturally correct in Bali is strong, whereas

in a country like the United States, people may not even understand what "culturally correct" means, or, if they claim to, will certainly disagree about what fits under that standard. Such disagreement is, in fact, a prominent feature of American society. In Bali, cultural correctness seems to be relatively obvious to virtually all members of society, and it seems that creativity is expected to fit into certain recognizably correct structures. Within these structures, creativity certainly flourishes, often in ways that outsiders can barely grasp—as Clifford Geertz has convincingly shown, all kinds of Balinese customs and behaviors, even ones like cockfights, might express and serve as "positive agents in the creation and maintenance" of social sensibilities (1973, 254–5); that is why Geertz adopts the traditional Hindu designation of cockfighting as an "artform" (1973, 249; Tripathi 1990, 14–17).

This socially controlled creativity works despite centuries of interactions with other cultures, including Javanese and European domination, decades of international tourism, and the adoption by many Balinese of advanced technology. Culturally correct, permissible, and impermissible actions are less a matter of law here and in other traditional societies than of customary mores. Extended families still live in group compounds. Children grow up under the watchful eyes of family, neighbors, and the gods. Even though children might be permitted to dance to Western music, they are taught at a very early age the traditional, "culturally correct" dances. Often, young people who might be described as delinquents or criminals in the West are sometimes no longer called Balinese by their neighbors, but rather, Javanese, apparently because the Balinese expect all members of their own culture to follow traditional norms and (a) view those who break the norms as not belonging to their culture; and (b) hold other expectations of them. Here, as in many other parts of the world, the watchful eyes of the community might evolve into the "evil eye" against those few who wish (or dare) to oppose community norms.[11] The effect of this type of social structure on creativity is probably considerable.

Not to be ignored, either, is that, in any society, the more fixed and obvious class differences and social roles are, the more this circumscribes who may be allowed to engage in what type of creative activities and under what circumstances. Thus, a male warrior and a woman weaver from the same society may be subject to very different norms to which they must conform, even if they are allowed some degree of latitude within their respective domains. Both the force of these traditional roles and the possibility of altering them in the face of global pressures without fully abandoning tradition are displayed in Bali today.

Latitude regarding traditional structures has always been visible as one is distanced from the geographic, cultural, political, and economic centers of power in a society—that is one reason, aside from the vanity of rulers, why some people in ancient Israel, China, and Rome argued for greater centralization of power. The countryside village might have very stringent rules of social behavior, but standards of culture imposed by or adopted from the capital might be more loosely adhered

to than in the capital itself. Conversely, the provincial villages may long resist changes in style which have come to be accepted in the capital. The lower classes will not have the material means to imitate the ideals of creativity honored by the upper classes, and for that reason may create in unique ways—we see this in folk art around the world. Indeed, the poverty of many traditional societies has often necessitated extraordinary inventiveness: the inability to acquire a new model or replacement parts often leads to unusual substitutions and imaginative reconstructions.[12]

Other conceptual factors which tend to shake up what might seem to be rigid societal rules are the myth of the trickster and celebrations like the feast of fools or carnival, which are prevalent in many traditional cultures. The trickster god or spirit, whether in the ancient Germanic religions or in American Indian ones, serves as the spoiler, the disrupter of ceremonies, the comic, or anarchic element (Hynes 1993).[13] In the feast of fools, the usual social hierarchies are set topsy-turvy, and in carnival or Mardi Gras, taboos against inebriation, and sexual license are largely disregarded. The dances, masks, parades, songs, and social interactions associated with the tricksters and carnival interestingly express traditions of parodying tradition, and in these efforts, great creativity is exercised.

Finally, it should be clear that each society, however traditional, will differ as to which domains of activity will be more restricted and which will allow for greater creativity. While the arts seem to be given freer reign in Bali than are social relations, commerce seems to have the least traditional limitations imposed upon it (the arts seem to be strongly encouraged by the society as a whole, especially as part of touristic commerce). If we look at a group like the Orthodox Jews, meanwhile, we see that artistic creativity is quite limited for traditional religious reasons, while creative interpretation of the Torah and Talmud is virtually required, particularly of males. Creativity in business has also become characteristic of this social group (in part, because of medieval restrictions and urgings placed upon it by the Catholic Church); even today, however, creativity in this sphere and elsewhere is subject to the religious restriction against working on the Sabbath.[14] In the cases of both the Balinese and the Orthodox Jews, there is an interesting and no doubt difficult balancing act between commitment to cultural traditions and the increasing involvement in the global marketplace, which is overwhelmingly secular, modern, and indifferent, if not outright hostile, to the unique differences of traditional cultures.

Finally, in the late twentieth century, people in the West have begun to acknowledge that works of these other cultures might be "creative," as we define the term. But we should also see that some other cultures might be operating with somewhat different senses of what it means to be creative; our term may not easily translate into their languages. This is difficult for us to see, in part because the global dominance of our conception of creativity allows us to forget that there are other notions of it. Indeed, the focus on *newness* in our conception reinforces an

historical attitude so that we seldom recognize the common ground between Western and traditional societies' views.

When we examine traditional societies more carefully, we might recognize that the opposite of creativity is not tradition, but thoughtless habit and routine. Within a traditional framework, repetition of a pattern may or may not be a routine, mechanical process; it could also be an opportunity for personal interpretation of that pattern. For example, while there are several clearly repeated "types" in the masks and sculptures of ancient Teotihuacan, the variety of images presented and materials used is extremely diverse. We shouldn't expect anything less, but somehow, many in the West have viewed tradition as necessarily "backward," and repetition as necessarily "uncreative."

It is easy, for example, for an outsider to look at a seemingly simplistic and often repeated image of an animal in clay, cloth, or paint, as clear evidence of primitiveness and lack of creativity. However, it could well be that the image expresses a sacred, ceremonial obligation, is intentionally abstract, and intentionally open to multiple, symbolic meanings. Indeed, as Michael Cardew has emphasized, traditional designs are often not meant to be "explained"—the imagery helps maintain a sacred mystery while drawing attention to it (1978, 18). According to Leslie Marmon Silko, the southwestern Pueblo people never seek realistic portrayal of a particular elk, for example, but presentation of the general elk itself. "Pictographs and petroglyphs of constellations or elk or antelope draw their magic in part from the process wherein the focus of all prayer and concentration is upon the thing itself, which, in its turn, guides the hunter's hand" (Silko 1990, 678–9). Each work involves preparatory prayer, and each object portrayed reveals its integration in a whole network of symbolic relations within the society. Similarly, northwestern Indian totem poles might regularly display frogs, beaver, eagles, bears, wolves, and human images to honor family ancestry and to tell particular stories about ancestors, but it is reasonable to assume that the images always carry multiple symbolic meanings. Therefore, however repetitive the image may appear to outsiders, the possibility, perhaps the necessity, of diverse interpretations would seem to require considerable creativity.

What is more, we are likely to find that traditional cultures utilize their creations in multiple ways. Wooden paddles of the northwest American Indian tribes are used for stirring acorn mush; because they are often elaborately carved, they may also serve as decorative pieces when not in use; they are given as gifts, usually from a man trying to impress or please a special woman. Similarly, in the West today, cutlery may have intricate designs and be given as a special wedding present—but the phoenix or serpent images on that cutlery are merely decorative; these symbols once had common, powerful implications, but today, those meanings are most likely to be ignored. Conversely, the images on a bowl or paddle of a traditional person would most likely carry mythic-religious-cultural

signification. In this way, the everyday "use object" is integrated into the whole of the cultural web.

For this reason, many museums go to great lengths to explain the contexts of the objects they display from traditional cultures. The Metropolitan Museum of Art in New York, for example, offers a thirty-five minute film of the "Art of the Dogon" of Mali, so that the masks displayed can be visualized as they are used in ritual dances and so that the historical-social-religious meaning of the works can begin to be understood. Much less background information is provided to accompany most Western art works in the museum's collection, presumably because many viewers are expected to be (though often are not) familiar with the context—indeed, many works are presented with no information other than title, artist, and date, as if the work stood completely on its own. This fits well with the West's admiration for the new and unique. At the same time, it has led some in the West to take the broader context of individual creations so for granted that they believe in "art for art's sake," as if the creator came from nowhere and the work related to nothing. As Rekha Jhanji has said, these Western obsessions with "novelty" and "art for art's sake" often blind us to an appreciation of creativity in traditional societies, where art may be a form of religious service and expression of divine models in unique forms, rather than novelty per se. As we can see from medieval Christian icon painting, adherence to traditional subject matter and even to traditional style need not hinder great artists from producing particularly powerful or meaningful works. While thousands of Madonna and Child images were painted, the differences between the creations of Cimabue, Fra Angelico, Simone Martini, and Giotto are striking to those who are familiar with the genre; when the work of these Italian artists is contrasted with that of medieval German, Catalan, or Russian painters, the differences appear enormous.

Similarly, in Bali today, the question is not whether the same pattern is constantly repeated, but whether or not the work is infused with a creative passion which results in a unique presentation of the traditional themes. Paintings and dances produced for the tourists are unlikely to show this passion, but they might. Works produced for the connoisseur—local or foreign, who has come to understand the culture and its creations—must show such passion, or at the very least, technical refinement. But so, too, might "ordinary" things like the decorative flower arrangements created daily for religious ceremonies—if the audience consists of gods, the artist must strive for greatness.

At the same time, works composed for the gods or according to divine wishes also must, in some cases, follow the precise instructions of the gods. This was the case with the Biblical specifications for the construction of Noah's Ark, the Ark of the Covenant, and the Temple. In ancient India as well, the Hindu gods are credited with having created painting, music, and the other arts, and sacred texts prescribe the exact measurements and even the particular colors for depictions of various gods.

Having conventions of creativity and models to follow does not mean that an individual creator cannot be unique or that there are no differences in quality of the works. Every society seems to have standards of excellence.[15] In fact, exact imitation and perfect repetition of another's work is extremely hard to achieve, until mass production is introduced. As art historian, E. H. Gombrich, has said, no work of art ever follows a model in its entirety, and as poet-historian Laurence Binyon has said, to approach a theme as masters before have done "tests [the artist's] originality far more severely . . . than if he had set out on a road of his own in the deliberate quest for originality" (Layton 1991, 184; Boorstin 1993, 425). Each individual invariably creates in a slightly different manner, both in terms of technical refinement and interpretive nuance; and it is difficult to imagine a society, no matter how traditional, which would completely ignore or disparage those differences.

While the responsible person or persons are usually unknown to us, it is likely that virtually all the traditions we see were generated at some time by creative individuals. Thus, anthropologist Marion Wenzel discovered that the Nubian art she had initially thought to be a contemporary expression of ancient tradition was in fact attributable to the work of one Ahmad Batoul in the 1920s (Layton, 1991, 228–29).

In other cases in which clear changes in traditional practice are visible, this often seems to be the direct result of unique dreams or visions. Artists, musicians, political leaders, and especially shamans (who may embody all these other roles as well), will often have as their explicit goal the connection of their personal vision with another individual's or the community's needs. To do this involves formulating that unique, personal vision in terms of more traditional, more common, cultural structures, but also, perhaps, modifying those structures to express the specific experience; the result might in fact be the creation of a new tradition (180ff).

But even in more ordinary circumstances this is true. For example, according to Silko, Pueblo people

> . . . are happy to listen to two or three different versions of the same event or the same humma-hah story [stories from the age when humans and animals talked to one another]. Even conflicting versions of an incident were welcomed for the entertainment they provided (1990, 680).

Storytelling is a highly creative art, even when the stories are handed down generation after generation and the content is revered as sacrosanct. The written work we know as Homer's *Iliad* is generally viewed today as the product, frozen in time, of a long tradition of creative storytelling and singing about legendary events.

In a sense, this oral tradition allows for greater creativity than does our literary tradition, despite Western prejudices to the contrary. While the art of storytelling is certainly circumscribed in a traditional society, its oral character

prevents the original creation from ever being "cast in stone," and new tellers and new listeners may creatively evolve the work indefinitely. While readers in a literate culture will invariably reinterpret a written text, it is rare that we remove words or add sentences. For us, the written text becomes "authoritative" and therefore sacrosanct in its way. In fact, it is in part thanks to the power of the written word in our culture that written ethnographic depictions of "primitive" indigenous people helped fix those cultures in our minds as static (Medicine 1972, 24).[16]

Not merely storytelling, but also traditional music, dance, and theater express both repetition of patterns and constant opportunity for creative reinterpretation. In the Dogon culture of Africa, "music, like speech, is believed to have the power to enrich the life force of the listener and to restore order to the world" (Metropolitan Museum); for this reason, excellence of performance counts. And, of course, when dance, music, and theater pieces are well-known, the audience can compare the quality of the performances and may become critical of all but the best. There may be resistance in the community to major alterations of a classic, but there may also be genuine enthusiasm for an unusual but respectful rendition. In the West, too, even where the script and the director formally determine what an actor is supposed to do, he or she might exhibit great creativity in playing out the role. And here we can see how creativity in a circumscribed context functions in our culture, too: Western actors, dancers, and musicians will probably not keep their jobs if they fail to display any creativity, or conversely, if they display so much that it threatens the director's and/or audience's conceptions of the piece.

In the act of creating, a traditional artist's individual approach is as important as that of a modern Western artist, even though the traditional artist is readdressing established themes (Jhanji 1988, 162–63, 171). While Hindu tradition specifies thirty-two "sciences" and sixty-four "arts,"[17] for example, contemporary sitarist Ravi Shankar reminds us that some students have merely "parroted" the tradition, while others were "creative geniuses who absorbed the traditions and added to and enriched them" (1988, 14). Describing the creative work of a musician performing classical Indian *raga*, Shankar says:

> A *raga* is an aesthetic projection of the artist's inner spirit . . . But the notes of a *raga*, by themselves, have no vitality or force. The musician must breathe life into each *raga*. . . . Through the guidance of the *guru*, and by his own talent and genius, the musician learns how to make the bare notes vibrate, pulsate, come alive (1968, 23).

Shankar himself is an extraordinary example of a modern, cosmopolitan man performing traditional national material and winning audiences for it all around the world, in part, by creatively merging his music with Western classicists like Yehudi Menuhin and rock 'n roll musicians like the Beatles. Through these collaborations, Shankar apparently developed new understandings of the traditions he had been

taught. At the same time, Shankar managed to resist what he considered the corrupting fetishism of celebritydom in the West.[18]

Another interesting example is that of Willie Seaweed, an early twentieth-century Kwakwa Util (Kwakiutl) Indian from British Columbia. Trained as a shaman and political leader, his traditional responsibilities included wood carving for his tribe. Seeing his people decimated by disease and succumbing politically, culturally, and economically to Anglo-Canadian society, Seaweed carved both to restore pride to his people and to show Anglos the greatness of his tribal culture. In doing this, he modified traditional themes and techniques and produced works prized today by both the Kwakwa Util and the international art community. Seaweed's popularity has allowed his descendants to follow in his footsteps, making a living in capitalist society by creating from, and to some degree, transcending their traditions.

Often though, "if an [American] Indian artist ventures into commercialism, he or she must contend with the perception that creativity or culture has been compromised" (Fox and Coron 1993, 24). Some members of Indian and other traditional cultures find themselves very restricted by the dominant society's fascination with and willingness to purchase *only* stereotypically traditional art. In her critique of the current state of Native American Indian art, Margaret MacKichan, director of the Sinte Gleska (Lakota) Art Institute, finds neither creativity nor traditionalism. Much of what is thought of as "traditional" is not indigenous, she says, but rather,

> . . . an outgrowth of the Santa Fe and Oklahoma Schools of the early twentieth century, and the pervasive Pan-Indian Movement. Ironically, the style of art connected to these movements was superimposed on Kiowa, Pueblo and other groups of young student artists by well-meaning white teachers, in order to help them "find a style" that was marketable (1993, 22).

So blatant has been the commercialization of Indian artists for the past few decades that Zuni Edmund Ladd could baldly state, "we've gone from ritual to retail," and Maidu Harry Fonseca could paint his superb parody, *Coyote and Rose Doin' It At The Indian Market* (Heard Museum).

While irony and humor no doubt help, institutions like the Smithsonian's Museum of the American Indian seriously address the consequences of European American dominance on American Indian culture. In one 1994–95 exhibit, *The Journey of Interpretation*, individual creations are compared from the perspectives of Western art historians, Western anthropologists, and Native Americans from diverse walks of life. In another exhibit, *This Path We Travel*, an extraordinary mixed-media collaboration of fifteen contemporary Indian artists and leaders from throughout the Western Hemisphere reveals their struggles and joys in exploring each others' traditions and unique creations.[19]

As this effort makes clear, creativity is hardly reducible to art. Indeed, according to anthropologist, Victor Turner, life in virtually all cultures is filled with *liminal* (threshold) events and experiences which are fertile contexts for creativity.[20] When everyday structures and symbols are altered, as they intentionally are in initiation rites and so on, individuals and whole societies encounter significant opportunities to consider and recreate themselves. What is more, according to Turner, every period of social upheaval and reorientation similarly calls forth such creative response. Indeed, as Jacob Neusner has said about the Jewish people's response to the brutal oppression they have often experienced, seemingly disastrous encounters with outside forces may actually provoke some to believe even more strongly in the creative power of their tradition (1975, 198–99).

Bearing this in mind, we should recognize that no matter how striking the artwork created by a member of a traditional culture may be, probably the most important way in which a group like the Kwakwa Util can be viewed as creative is in the ability of the remaining members of this tribe to survive as a group at all, given the epidemics and political oppression through which they suffered a century ago and the "upheaval and reorientation" accompanying the global market today.

When we think of the enslavement and genocide of traditional peoples by conquerors throughout history, we realize that there is hardly a guarantee that groups will survive. If they do, they must adapt their traditional cultures to new circumstances. This is true, whether, for example, an artist or thinker enthusiastically tries out a new idea gained from another culture, whether he or she simply attempts to deal with the societal changes taking place, or whether the person is making a desperate attempt to survive by creating works which will win favor economically or politically from a dominant outside culture. The process of adapting tradition to changed circumstances will always involve some degrees of problem-solving, inventiveness, and/or imaginative expression, and in some cases, it may involve great creativity which leads to a far more powerful tradition than previously existed.

The survival of a group's traditions through change would seem to require that the members of the group strive for their common good, but this struggle is obviously also a very individual matter, as Dan Namingha of the Tewn-Hopi nation has remarked *(This Path We Travel)*. The fact that we know the names of artists like Namingha, Shankar, Seaweed, and other men and women, and that we can purchase their creations, shows clearly that these individuals not only maintain connections to their traditional cultures but are part of the Western dominated, capitalist, global culture as well.

However, to the extent that an individual emphasizes traditions at all, that person necessarily also asserts his or her affiliation with a group of people stretching back in time and related not merely by blood but also by common beliefs, particularly religious beliefs. This has a direct influence on the creative process. For example, no matter how completely traditional artists adapt their work to the outside

culture, those we've mentioned and many others are inclined to train extensively with those more experienced in the tradition and then practice meditation, prayer, ritual offerings, cleansings, or other forms of purification as a necessary part of preparing to do any kind of significant work. Of course, this is the case with Hindus, Tibetan Buddhists, Orthodox Jews, and others copying sacred texts, or when a Brazilian Condomble worshipper carves an idol or paints an icon; but special preparatory efforts are common for a wide range of creative activities in a number of traditional cultures. For example, the practice of abstaining from sex and alcohol for some days before a major creative project is common in many cultures; individuals who are known not to abstain are usually condemned, prevented from carrying out the project, or otherwise punished. In many cultures, lengthy prayers to the divine and recitation of ancestors' names often proceeds a creative endeavor. These rituals all seem to aim in some way to moderate the significance of the individual Self by focusing on the larger realities of community, universe, and the divine. In the West today, a few individual creators may follow such rituals, but these rituals are entirely a personal matter, subject to change, and rarely an issue for the community; the society at large cares far more about the finished product than about how it came into being or about the spiritual or moral perfection of the creator. The character of the process is of greater importance in traditional societies, because the creative work continues to be perceived as part of a larger web of relations.

RELIGION

In many respects, what makes a society cohesive in a "traditional" sense is the centrality of religion. Religion expresses and determines what people consider to be reality—how it came to be, how it is structured, how people should behave. One common form of behavior in traditional societies is, accordingly, ritualistic, because in religious rituals, the community commitment to a shared reality is expressed and reinforced. In a positive sense, religion highlights and sanctifies; in a negative sense, it restricts: where there is reverence and ritual, there is also taboo—that which simply must not be done. While Americans may buy and sell paintings of the Madonna and debate in Congress whether Serano's painting, *Piss Christ*, should be supported with government funds, other cultures might find the sale of religious objects incomprehensible and the mere thought of Serano's work utter blasphemy. Obviously, while many creators have been accepted by their traditional societies, a considerable number throughout history have been killed, tortured, censored, excommunicated, ostracized, or ignored.

In the West, the biblical distinction between divine creating and human doing dominated conceptions of creativity for centuries, and in line with this conception, human activity was ideally supposed to follow divine commandments; the pursuit of novelty was viewed in many cases as irrelevant or evil. Major segments

of American society still adhere to this biblical perspective but at the same time share the common national ideology of creativity, which in some respects contrasts with that perspective. Of course, there is no single Christian, Jewish, or, for that matter, American view on creativity or anything else: different denominations and individuals are more or less "traditional" in their attitudes, and will, to differing degrees, resist different kinds of creativity that others accept. Nonetheless, because commitment to the dominant Western conception of creativity includes a willingness to reject tradition and to adventure into the realm of the new, it poses a threat to religious belief. Because religion is about "ultimate reality" (Tillich), commitment to it will inevitably prevail over any other commitment.

This is why Hindus, Buddhists, Taoists, Native Americans, fundamentalist Christians and Moslems, and Orthodox Jews, despite all their differences, may all join in the chorus of denunciation against the prevailing Western conception of creativity. This conception, is, they might say, egoistic, immoral, aggressive, blasphemous, destructive of society and the environment, and even illusory.[21]

A brief look at some of the major Asian religions may be illustrative. Many Hindus and Buddhists, for example, might say that all our seemingly impressive creations are illusory (samsara). Unlike the biblical God, the Hindu gods create and destroy endlessly, and we humans are on a nearly endless wheel of birth, death, and rebirth. This is a wheel of suffering and illusion, and no amount or greatness of external creations will break this wheel—only enlightenment (moksa or nirvana) will. For Hindus, moksa involves the dissolving of the individual self into the universal Brahman; for Buddhists, nirvana involves the realization that there is no Self, that the Buddha-nature is our nature, and that when desire ceases, suffering will as well.

Creativity in the Western sense might be seen as absurd from common Hindu and Buddhist perspectives: either nothing new ever comes into the world, or there is an endless stream of "new" but insignificant things. Individuals who desire to create something new live in ego illusion. There is nothing to create: "Thou art that . . . true thusness" already. Westerners might well counter that Hindu and Buddhist productions like the Bhagavad Gita, Angkor Wat, and Haiku poetry, were indeed new and unique creations. In truth, there have been great schools of Hindu and Buddhist art throughout Asian history, but in many cases their works are specifically aimed at teaching the worthlessness of human striving and the need for detachment. However excellent, creations are not to be fixated upon as important— they are at best means to the higher ends.

Not only is creativity valued differently in Asian religions from the dominant Western model, but the creative process as well is perceived in a different light. The sixth century B.C. Chinese Tao te Ching, which has strongly influenced Zen Buddhism as well as many contemporary Western thinkers, disparages willful striving and proclaims we wu wei (passive doing or actionless activity) as the way to create

Read part

and live well. "Not seeking fulfillment," the sage is "not swayed by desire for change" (chapter 15). Not fullness, but the "void" is crucial to Chinese and Japanese aesthetics. This was the case with medieval Chinese landscape paintings, Zen gardens, and poetry, and it continues to be the case even in heavily industrialized, contemporary Japan, where the concept of *ma* refers to the "between," the space within which everything takes place. As famed architect, Fumihiko Maki, has said, "We appreciate the meaningful void" (D. Rosenthal 1993, 22). The goal is not to fill the void or to impose shape or order on the world through human will, but to be receptive to the nature of the cosmos and to work with it. The nameless *Tao* is the mother of all things, and he who sees this knows his own nature and "the Way." Thus, he takes no credit for what he does (chapter 2).

The Western belief in invention and novelty and the West's celebration of individual accomplishment seems as foreign to this view as possible. In practice, however, some kind of compromise does in fact take place—while the sage supposedly takes no credit for what he does, Taoists in fact venerate Lao Tzu as the author of the *Tao te ching*.

To adherents of the various religions of the world, each one's own religion does not appear as a "creation," but as the "truth" regarding "ultimate reality." Nonbelievers, however, might well look in amazement at the creations we call religion. The various religions have also thus far been the most powerful source of human creativity on earth, shaping society, thought, art, architecture, and so much more. Religion doesn't merely strongly influence most aspects of a society's life, it also is the context for great intellectual/spiritual creativity on the part of scholars, shamans, clergy, and theologians who work to expound their religion. Just as an artist's commitment to following a tradition does not preclude the possibility of a unique interpretation of that tradition, commitment to a faith hardly excludes creative interpretation of that faith. Indeed, the histories of the world's religions show an ongoing struggle between doctrinal uniformity and a proliferation of competing interpretations. The fact that Jesus and Paul, for example, clearly viewed themselves as faithful Jews while creating what we call "Christianity" and that Luther and Calvin felt they were returning to the essential Christian tradition when they opposed the Vatican and created Protestantism shows that religious traditions are tremendously fertile in possibilities and that the precise definition of those traditions is often a matter of dispute.

But, of course, a "traditional" society is one in which a common consensus frames such disputes and all the creative interpretations of the particulars. Inherited myths and rituals are the primary means for maintenance of this framework. As noted earlier, not tradition, but thoughtless repetition or routine, seems to be the opposite of creativity, and when rituals and myths are carried out "by the letter" without "the spirit," the tradition ultimately dies, unless it is reborn thanks to a new, creative interpretation.

For many religions and traditional societies, myths of creation play a significant role in reinspiring the adherents. Tied to the cosmological myths are often other creation stories about the invention or introduction of various human activities or customs: myths of the first hunt, the control of fire, the beginnings of agriculture, the origins of the moral code, and the creation of "the people" keep the idea of generation alive.

For example, the traditional Dine'e' (Navajo) creation story, which is represented in several different versions because of its oral character and the rural dispersion of the population, generally depicts a number of different worlds which evolve from one to the next: the insect, the swallow bird, the grasshopper, the animal, the present-day human, and the future world of harmony. This myth is meant to accompany rituals of beginning; in the nine-day "Blessing Way" ceremony, the myth is chanted and reflected upon in sand paintings and in other ways (Leeming and Leeming 1994, 202–208). One of the many stories deriving from the greater creation myth of the Navajo is that Spiderwoman taught humans how to weave, providing divine inspiration to Navajo weavers. Indeed, artistic creation, animal and plant fertility, and the creation of the cosmos are often tied directly to one another, as can be seen in the Pueblo Indian understanding of "Clay Old Man and Woman," who were sent to earth by Spiderwoman and who are addressed by all potters (Babcock 1993, 87–88).

According to scholar Mircea Eliade, the people in traditional societies experience themselves as participating in "the creative act *par excellence* when they ritualistically celebrate their cosmogonic myths" (1959, 158). These rituals usually connect the creation of the cosmos with the cycles of nature: day and night, the waxing and waning of the moon, the turning of the equinoxes, birth, death, and rebirth. As a result, creation is apparently viewed as unique and yet also continually renewed. As in the case of the ancient Greeks and Hebrews, personal creativity derives from divine creativity, and ritual reinforces this. Divine creativity has ultimate priority, and human activity is of consequence only by virtue of its relationship to the divine. Human creativity may well be for current use or enjoyment, but is done (in theory at least) with an eye to eternity.

HOW LEGITIMATE IS THE DISTINCTION BETWEEN "TRADITIONAL" AND "MODERN" CULTURES?

Great artists and writers of Western society have also created with an eye on the eternal (Blake, Dostoyevsky, Van Gogh come to mind) but we seem to believe in the eternally *new*, not the eternally *same* or eternally *repetitive*. The Biblical tradition has infused the West with a linear sense of history (despite the cyclical elements in Judaism and Christianity).[22] This linear thinking allows us to conceive of a divine creation *ex nihilo* and the new breaking into history. As the West developed in the

Renaissance, this direction of thinking encouraged people to focus on invention, discovery, and creation, and to take individual credit for it. And in a secular age, it has allowed many of us to believe that what we are doing is independent, unique, and free of any divine imperatives or limitations.

Of course, only a small minority in the West would deny their limitations or rule out a role for the divine in their lives, but the willingness to subject one's own beliefs and therefore religious doctrine to questioning and criticism is a common and defining aspect of Western culture. Moreover, the West's distancing from tradition and religion goes hand in hand with an emphasis on scientific reasoning and individuality.

In contrast, the combination of religious piety and community cohesion in traditional societies has generally meant that, except perhaps for legendary founders of certain arts, the names of most creators are forgotten after a fairly short amount of time. The fact that artistic creativity may remain anonymous makes it no less creative or valuable. It is patently obvious how highly such creations as the fabulous art treasures in Tutankhamen's tomb in Egypt, the great temples, vases, jewelry, and palaces of ancient India, Mexico, and China were held by these societies—they required vast expenditures of time and money to create, were preserved and protected, were taken as treasures by invaders, and are still glorified by us today. Still, the names of the creators and their assistants (often slaves) generally remain unknown to us.[23]

In some cases, the collaboration in the creative effort is such that there is no need or ability to single out an individual creator; even when one person stands out, humility and piety may dictate anonymity. In addition, the most important creations of traditional societies are usually perceived as communal property. Totem poles, for example, are created of, by, and for the clan. Similarly, the five hundred year old *q'epis* of sacred textiles from Coroma, Bolivia, are believed by the Aymara community to be the garments of the ancestors and therefore the key to community well being. The collectively owned and religiously venerated works were recently stolen (bought?), apparently, by American art dealers. For these dealers, the garments were beautiful works of art which could be sold profitably to museums or individual collectors; for the Aymara, the loss of the *q'epis* "hit at the very core of their existence and their survival as a people" (Lobo 1991, 43). As Coroma spokesperson, Pio Cruz said, ". . . we carry out the veneration of our ancestors through our *q'epis*, and we consult them for advice about our communal works . . . we today are their continuation. We are maintaining these traditions" (Lobo 1991, 45).

Clearly, the question of ownership of particular creations reveals a stark difference in world view between "traditional" and "modern" societies. While "we the people of the United States" collectively own and venerate our national parks, the capitol, Independence Hall, and the loss of these would be viewed as a national tragedy, few would view this loss as a threat to our national identity, and we would

almost certainly rebuild the structures and carry on with our society. We look at human creations as human, not divine—most are exchangeable commodities, and even the most important ones are for sale ("privatization" of national resources is a political buzzword in Europe and America, and Russia recently auctioned off its space program souvenirs, including the capsule from the first human space exploration in history). In the "Global Marketplace" the differences between cultures, their locations, and their creations are transformed into monetary data and transferred electronically around the world with dizzying rapidity. In the "embedded economies" of traditional societies, on the other hand, religion, social relations, and nature determine or at least take precedence over economic activity, even for those living at subsistence level. Furthermore, while both traditional and nontraditional societies might treasure that which is unique, modern secular culture tends to treat that which is most common as least precious, and something mass produced almost always as "uncreative." In a religious society, however, even a crudely made or mass-produced icon will be saved and usually honored. If it has religious significance, it usually cannot be discarded or repaired, even if it is ugly, torn, or broken, except through some special rituals, if at all. The moment when such religious objects are put up for sale to outsiders should probably be defined as the moment when the society stops being "traditional."

The commercialism of Western society is tied to two particular inventions which reveal precisely where the line is to be drawn between our "modern" conception of creativity and traditional ones: laws of patent and copyright. These laws, first developed in Renaissance Venice and London, affirm the importance of what is new and seek to prevent imitation through a system of monopoly and royalties. We award copyright and patent only to that which has not been done before. We have government offices for these legal designations, and individuals and companies frequently fight over their rights under these designations, because they can help them attain money and therefore power.

How different in a traditional society! The legal protections we grant individuals and corporations against their competitors would make little sense where the cooperation and cohesion of the community is the primary goal. And the Western desire to root out plagiarism in writing and to expose "fakes" in art would take on quite a different twist in a culture where creativity can best be understood as inspired imitation. To overstate the case, we could say that a traditional society dictates, "you must imitate," while our society demands, "you dare not."

Corresponding to this difference are other important ones regarding social roles and education. While every group socializes individuals and has some degree of division of labor, "traditional" societies stress not only the imitation of inherited creative paradigms but also the continuation of long-established social roles. In India, "when an individual practices a certain craft, his caste is that of the name of his craft" (Tripathi 1990, 17). Certain clans may hold traditional privileges and

responsibilities which are different from those of other clans. Men and women will often have different opportunities and will not be allowed to encroach on each others' domains. There are also often clear systems of apprenticeship. In some cultures, only a very special calling, coming from a vision or some other powerful source, will entitle someone, under approval of the elders, to take on a new role. In any case, definitions and expectations of social roles will be much clearer in a traditional society.

That is why, for example, when Helen Cordero created her clay storyteller figurines and thus broke gender boundaries and altered the artistic traditions of the Conchiti Pueblo people, it served as a minor revolution within the culture (Babcock 1993, 70ff). While this clearly shows that such changes are possible, it also shows how rare such changes are in a traditional culture. Thus, however true it is that "there have always been gifted individuals who can bend the culture in the direction of their own capacities" (Benedict 26), each culture also resists this to varying degrees, and traditional cultures resist it especially.

In the dominant Western society there are some parallels to the role structures of traditional societies, but the ideology of merit over inheritance, the profession of equal opportunity, and the power of a money economy lead to considerable shifting and revision of roles. In the West, there are books and courses on creativity and even "creativity training seminars," because many in the West proclaim that everyone can and should be creative. The notions that women as well as men, and that people of all ages and classes should be allowed and even encouraged to engage in creative pursuits within the same realm of activity is inconsistent with the beliefs and structures of many traditional cultures, and that is why, for example, the current global revolution in women's rights is causing major tension. (This is true, of course, even in the "more developed" West, because traditions regarding gender roles are still changing.)

It is often said that a major difference between "modern" and "traditional" societies is that the former is technologically oriented and the latter nature-oriented.[24] To some extent, this is true, though traditional societies certainly have their technologies, "primitive" as they may seem to those in the "developed" countries, and though Westerners certainly relate to nature (however aggressively it may seem to traditionalists). In truth, a desire to live in harmony with nature, and skepticism, even outright hostility, to some technologies have been widespread in the West at least since the Romantic era. And, as we've seen, traditional peoples today may in fact use "advanced" technologies while attempting to maintain their traditions. This is because it is not entirely a matter of the technology itself, but of the attitudes toward it: does the new technology fit with the community's needs? Does it contradict primary beliefs? To the extent that a traditional society understands the natural environment to be the source of most of its physical needs, and to the extent that it perceives the earth, sky, plants, and animals to bespeak the divine, that

society will strive to make sure that any new technology it adopts fits with "the ways of nature."

In some respects, modern society's commitment to the "scientific method" seems to distinguish it from traditional cultures; but it is a common Western mistake to think that people from traditional cultures don't routinely formulate questions, employ trial and error, and seek to verify judgments through experimentation. What is different is that traditional cultures limit the realms of existence to which those methods may be applied—for the central tenants of religion and community well-being are based on the authority of the divine and/or the ancestors: there are a priori truths about these realms, and taboos against crossing them.

That is why it is virtually inconceivable that a traditional society would accept the kinds of challenges to and criticisms of its core values that our society does. Thanks to the tradition of First Amendment Rights from the U.S. Constitution, the Supreme Court has allowed all manner of protest against the Constitution, almost any variety of religion and any critique thereof, even the burning of the United States flag. This would hardly be tolerated in most societies insisting on the integrity of their cultural traditions and on the responsibility of the individual to the community.

As we've seen, however, things are not so absolute. We must remember that mainstream Western culture (never a monolith) acted very much like a traditional society until the modern era. While Einstein is revered as a hero by many in our century, Galileo was denounced as a heretic in his day. Still today, many "conservatives" in the West are aghast at the kinds of experimentation occurring in the society and work doggedly to assert "traditional values" in the political and social realms. Indeed, many people in the West have a firm sense of religious doctrine which determines how they proceed in life, what kinds of questions they will entertain, and so on. As the American Library Association's annual "banned books" exhibition makes clear, many groups in our society regard certain forms of creative expression as intolerable breaches with traditional values. At the same time, many "progressives" work to recover, resurrect, or even invent new traditions as a means of strengthening their movement (Kwanza, Women's History Month, etc.). The environmental movement, too, progressive as it may seem to some, seeks to "preserve and protect."

What is more, traditionalism thrives in many parts of Western society, even where there is an explicit commitment to creativity: repetition of classical masterpieces is common. Our highest praise, moreover, is often stated as, "he's another Michelangelo," or "she's a regular Einstein." And even where imitation is explicitly forbidden, it routinely occurs: plagiarism is widespread in Western colleges and universities. At the same time, millions of creative individuals, like Shankar and Seaweed, have managed to challenge or revise the established beliefs and practices of their traditional communities without suffering major conse-

quences. We must remember that all the inventions of prehistory occurred in traditional cultures, which generally must have tolerated, even preserved, and disseminated those inventions.

Nor should we ignore how much creativity in the Western world continues to follow traditional patterns today. We, too, for example, celebrate creative performances which follow classical paradigms: Beethoven, Verdi, and Brahms are performed repeatedly around the world today. Indeed, all that we refer to as "classical" music,[25] opera, or ballet is repetition and reinterpretation of traditional material. The same is true for most gospel and folk music and often even for popular music (Lennon and McCartney's *Yesterday*, for example, has been performed and rerecorded in more than two thousand versions). This is also obviously true for the countless performances of Shakespeare's plays. Indeed, in our culture, people commonly follow written instructions in the forms of musical scores, choreography, and dramatic scripts, which are then presented with varying degrees of individual interpretation.

In fact, creators of all kinds are inspired by past creators. That is why museums and libraries exist. Most writers, for instance, don't merely learn the art of writing but are motivated to emulate or transcend particular writers they have read and enjoyed or been provoked by in some way. (See T.S. Eliot). Furthermore, historians, philologists, archaeologists, and, indeed, most academics, in their varying ways, can be creative, not merely by uncovering something new about the past, but primarily by reconceptualizing existent material. While we can appreciate Madame Curie's reputed claim that she studied radioactivity "because there was no bibliography," most scientists and academics fill their works with references to supposed "authorities."

All socially acknowledged creativity, however novel, follows some rules, and much of what passes for novelty in our society is unconscious repetition of traditional forms. Those outside a particular field see this more clearly sometimes than do the practitioners. Thus, innovation in business might look like mere variations on a theme to philosophers; creativity in the world of rock music as mere variations on a theme to biochemists.

Furthermore, as Thomas Kuhn (1970) has emphasized in his study of scientific revolutions, traditional views carry tremendous weight and are not readily abandoned, even among the supposedly open-minded, critical scientists of our society. Educational institutions inculcate dominant scientific views, and careers are built up by practicing science as excellently as possible within the framework of those views. Major change is therefore threatening to individuals' livelihoods and society's institutions. This, of course, is true in art and other areas as well.

At the same time, some individuals in the West have consciously adopted elements of traditional and other nonwestern cultures. This is clearly visible not merely in the collections of the art museums, but also in the work of countless musicians who have created hybrids between Western classical, jazz, and rock music

with traditional genres from around the world. It is also visible in the revival and transformation of Western crafts movements, in the adoption of Asian religions and traditional martial arts, in the numerous works entitled, *"Zen and the Art of . . . ,"* in the respect for American Indian earth spirituality, and so on. This may have elements of fadishness, and it may even be exploitative; without a doubt, it also expresses a desire for some of the key features of traditional culture.[26]

What is more, one of the perceived features of traditional cultures—community involvement and collaboration—is actually far more prevalent in the West than our common image of individuality might have us believe. In the corporate world, teams are routinely formed to carry out particular projects, and in academic as well as corporate research, collaboration is common. In the realms of theater and film, collaboration is essential, and a sizable number of contemporary painters and writers have worked together as well. (Paterson) (Jenkins)

Despite all this, our society tends to focus on virtuosity and heroic individual accomplishment; and we consider scientific revolutions such as those ushered in by Galileo or Einstein, or the artistic ones ushered in by Giotto or the Impressionists, as the highest forms of creativity. At first, it is only those who are trained practitioners within the traditional patterns of creativity who are capable of seeing the limitations of that tradition and the value of the creators' new paradigms (Edwards 1968, 454; Schaffer 1994).[27] In other words, by defining creativity as that which alters the status quo, we implicitly acknowledge how much of our society is traditional or habitual.

In any given society, all manner of novelty may emerge, but different societies will circumscribe creativity to varying degrees and in various realms. Different societies recognize particular phenomena as novel and as significant based upon (a) the realms of endeavor they consider meaningful; and (b) the degree to which they believe innovation will be advantageous. Theoretically, the wider the range of human activity considered important, but not sacred or taboo, the more a society looks to innovation as a potential source of benefit, and the more recognized and encouraged creativity will be (Lasswell 1959, 207). Thus, the United States appears to be at the high end of what is essentially a continuum. If a traditional society seems to us to have a lesser degree of concern for some kinds of creativity, it surely does not follow that creativity is absent.

Thus, we must always qualify the differences we believe we see between "modern" and "traditional" cultures. Each cultural group will express these tendencies to varying degrees, and each individual may feel closer to or further from a particular tendency at any given time. It is, however, legitimate and sometimes helpful to note these differences. In general, we might expect that Western culture:

• places greater emphasis on novelty

• accepts and encourages creativity in a wider range of activities

- places fewer social restrictions on creative opportunity
- allows for a greater degree of creativity independent of religious or other archetypal patterns
- is less concerned with "acceptable" or "unacceptable" rituals and procedures in creating
- is less appreciative of and sometimes strongly opposed to imitation
- celebrates individuality, authorship, and ownership
- is relatively unconcerned about how a particular creation fits in with a broader network of social (and religious) structures
- is far more interested—in fact, will almost always—buy and sell creations, that is, treat them as commodities
- reveres not merely modifications within traditional patterns, but especially paradigm shifts or "revolutions"
- believes that people can be trained to be creative
- is more committed to questioning and criticizing assumptions and traditions
- uses the terms "creative" or "innovative" almost always as forms of praise

These tendencies would almost definitely be phrased in other terms if one were speaking from a traditional perspective. Western culture might be characterized as having: a relatively weak sense of community; a dim awareness of and respect for ancestors and traditions; a lack of distinction among creative spheres; a tendency toward vanity, ambition, and selfishness; blindness toward nature and the divine; and an obsession with novelty. (And the corresponding, positive virtues of reverence for tradition, community, nature, and the divine, would be asserted as an important part of traditional creativity.)

The many exceptions to this general dichotomy are significant; they reveal, among other things, the traditionalism of the West and the dynamism of the so-called traditional cultures. It is possible that they also reveal that the modern approach is increasingly dominant and that the effort to maintain traditions is particularly difficult. Still, the broadly outlined differences between the two cultural modes are important to consider. Regardless of whose perspective is presented, and regardless of the relative nature of the differences, the belief that these divergent conceptions of creativity exist is expressed frequently by people coming from the so-called more modern as well as those from more traditional cultures, and this expression has social, political, and economic meaning.[28]

This is not to say that these conceptions have dictated historical reality. Some authors have attempted to measure the relative levels of creativity in different societies (Eysenck 1994; Martindale 1994), but it seems impossible to assess whether or not the contemporary United States, for example, is any more "creative" than was ancient Egypt. The only reasonably valid claim might be that a

broader range of the American population has the right and the opportunity to exercise creativity as it wishes.

CONTEMPORARY GLOBAL ENCOUNTERS

In traditional societies, as we have seen, creativity takes place within a coherent network of custom and belief. What happens when artists, such as those in Bali, forego depicting traditional Hindu stories such as those from the Mahabarta, and paint whatever they want, as we in the West do? Or when creations traditionally carried out by women are given such status in the West that traditional gender power relations are threatened? Or when entrepreneurial efforts create new class structures which alter the society's traditional living patterns? Some societies are very adept at integrating these new approaches to creativity; others break down and suffer; others fight what they perceive as the Western "devil."

Surely, the single most important way in which a society is creative is how it maintains social coherence while integrating change. Indeed, in many ways it is coping with the Western concept of creativity—more than with any individual product or activity introduced—which is the ultimate challenge for any society devoted to tradition. This is because the Western conception includes zeal for the new, the commodification of creations, the singling out of individual creators, and to some degree, the determined rejection of tradition itself.

In this light, it is not so much the painting, dancing, and music of Bali which deserves the title, "creative," as the talented maneuvering between traditional and modern art, between foreign tourism and social integration, between Javanese political dominance and Balinese clan authority which goes on daily. Indeed, a key inheritance of the Balinese is the successful transplantation of Indonesian Hindu culture from Java to the Isle of Bali in the face of Moslem conquerors in the fourteenth century. In other words, adapting traditional ways to changed circumstances is a Balinese tradition. And to some extent, every culture must develop the same ability, if it is to survive.

Today, the interconnection of cultures and the intrusion of Western society into all corners of the globe is a reality. Environmental destruction, mass migrations from the countryside to the city, and the "global reach" of television and capitalism march forward without pause. The clothes we wear, the food we eat, the music we hear, the dollar bill we handle, may have come to us from anywhere on earth. In this context, the *preservation* of a culture or any part of it may involve great creativity—and for this reason, it seems quite possible to be conservative in the literal sense of the word, and still be creative. The United Nations' creation of its *World Heritage List* is a case in point.

Therefore, when contemporary Western authors define creativity as something which changes the context within which it arises (social, political, artistic, or

scientific), we must think this through carefully. J. M. B. Edwards, for example, maintains:

> The *creative* work of art or science does not only claim to be incorporated into the institution appropriate to it; it also claims to modify or even subvert the collective ideology of the institution in some important respect. It is the fact that the claim is made good that enables us to identify the work as creative (1968, 443).

While this may or may not be an accurate definition when applied to our society, it certainly does not apply easily to a traditional one: such a society would not tolerate such subversion, and in fact, would seek to utilize creative modifications in a traditional framework in order to *bolster* societal values. Every culture and every institution which successfully manages to perpetuate itself over time attempts to integrate creative change in this way. Tradition is, in an important sense, this successful integration, which translates the "new" of today into the "inheritance" for tomorrow. And without this continuity, we could not speak of a group cultural identity.

The Americans, no less than the Balinese, have their traditional ways of adapting tradition to change. For example, in the United States, the customary way of integrating newcomers and minority cultures was to require schooling in English and to emphasize Anglo-American customs and beliefs while praising the cultural "melting pot." In the past few decades, however, domestic minority groups have asserted their identities: African-Americans, Mexican-Americans, Native-Americans, and other ethnic groups have proclaimed the importance of their cultural differences and their traditions. As a result, the dominant culture has acceded somewhat to a more "multicultural" school curriculum, and the metaphors of the "mosaic" and the "quilt" (taken from Canada) have to some extent replaced that of the "melting pot." But all the separate groups in multicultural America are caught between their ethnic and national identities, and therefore in important ways also between tradition and modernity.

Maintaining a separate traditional identity is often very difficult, not merely because many people are of mixed heritages, but also because it is virtually impossible to say what the characteristics of a particular cultural identity are. This is excellently portrayed in Maxine Hong Kingston's *Woman Warrior*, a book moving between myth and history, personal biography and family chronicle, China and America, generations and gender roles. The culmination of the book is when the author literally and figuratively "finds her voice"—expressing the ideal of creative self-actualization so honored in contemporary American culture. But Kingston also very clearly realizes that to simultaneously maintain her ties to her Chinese ethnic background she must come to terms with her ambiguities about it. And in doing so, she addresses her fellow immigrants and their descendants, and perhaps anyone

who identifies him- or herself, to whatever degree, with any ethnic or national group: "Chinese-Americans, when you try to understand what things in you are Chinese, how do you separate what is peculiar to your childhood, to poverty, insanities, one family, your mother who marked your growing with stories, from what is Chinese? What is Chinese tradition and what is the movies?" (1976, 6).

Ongoing cultural identity presupposes that there are clear traditions worth maintaining. But in our global culture, the interactions between cultures are so many and so multidimensional and people's lives are changing so much, that identifying traditions may become complicated. How African are African-Americans? Must you like pasta to be an Italian-American? How homogenous is either group? How much of their identity is based mainly on hostility from others or the attempt to define themselves in opposition to others?[29] Increasingly, individuals have mixed ethnic heritages, and anyone might enjoy music, food, and creations from around the world. How clear is the identity of any of the traditional cultures examined in these pages? Each group creatively reforms its traditions on an ongoing basis: new approaches are adopted from others or invented, and once acknowledged, create traditional patterns which may then foster or block new forms of creativity. This process, which has taken place throughout history, has just accelerated to the point of obviousness in our global culture.

And as we can see in the case of Kingston, as well as those of Namingha, Cordero, Shankar, and Seaweed, the evolution of the group is accompanied by the struggles of the individual. Because the modern, global culture has so seriously undermined the coercive authority of many traditional groups, individuals are much freer to pick and choose what parts of their traditions they will retain. The uncertainty of traditional identity allows, even requires, individual self-definition. This is the inheritance of Western culture. And now, individuals in every culture seem destined to take on the challenge of "self-creation" that the global culture calls for. Indeed, modernity and global culture seem to pressure us to create ourselves, whether we would prefer to be sheltered by traditional identification or not.

But how consistent is anyone about his or her identity, and who can understand him- or herself outside of a context? Perhaps the postmodern rejection of the Self is right. Indeed, perhaps the concepts of self-identity and of group-identity, of modernity and of tradition are illusions. As we've seen, the word, "creativity," has taken on so much significance in our culture precisely because all else seems so ambiguous. Creativity is undoubtedly a social construct, referring to some degree of novelty *within a given context*; and yet we are constructing this context through our creative efforts right now. Indeed, the complexities of our "global culture" call for ongoing creativity of an extraordinary degree.

CHINA: FROM TRADITIONAL CULTURE THROUGH REVOLUTION TO . . . ?

China holds one-fifth the planet's population, has one of the longest continuous histories of any culture, and has brought forth philosophies, art, and inventions that people throughout the world have long revered.[1] And today, China seems headed toward a position of major importance in the world's economy. Still, the country has experienced two centuries of domestic turmoil, and for many Westerners China has seemed until very recently, a slow-moving, autocratic behemoth, devoid of the kind of creativity the West has celebrated since the Renaissance. From this perspective, China today seems to be experiencing a transition from a "traditional" to a global "modern" attitude toward creativity—but the situation is definitely more complex than that. Even if prerevolutionary China should be viewed as a classic example of a "traditional culture," a direct focus on the country reveals how sweeping and inaccurate such terms can be: China is the name for an enormously diverse and changing conglomeration of cultures that the Chinese and outsiders agree upon as having some kind of coherent identity.

Because this Chinese identity has embraced more people for a longer period of time than has virtually any other cultural identity,[2] and because of China's size and future importance, China is crucial for us to study. Trying to assess "creativity" in China will not, however, be simple: the "modern/traditional" distinction is hardly absolute, and even in modern China, where a revolutionary ideology prevails, there seems to be no word which easily translates as creativity.

TRADITION AND CREATIVITY IN CHINA

Analyzing the relative cohesion and continuity of Chinese civilization, historian Joseph Needham has emphasized that ". . . the essential style of Chinese thought and culture patterns maintained a remarkable and perennial autonomy," despite considerable intercourse with other civilizations (1954–1985, I:157), and historians Alfred J. Andrea and James Overfeld claim that

The period 500–1500 witnessed a variety of momentous developments in China: renewed imperial greatness, philosophical and technological innovation, economic expansion and a rapidly growing population, new modes of artistic expression, conquest by Mongol invaders, and eventual recovery and retrenchment. Through it all, Chinese civilization kept its basic institutions and way of life intact. (1994, 277)

In the view of historian Ray Huang, in fact, it is "clear that the basic ingredients of the Chinese empire that were to go on for many centuries were already in place . . . in the second century C.E." (1990, 53).

While the views of Western observers might well be suspect (Chinese and Westerners alike might also describe the West until 1500 C.E. as tradition-bound),[3] the fact that twentieth-century Chinese have carried out "revolutions" against what they denounced as the entrenched customs of the past seems to confirm this perspective. The long perpetuation of custom had to do with an enduring peasant agricultural economy, an entrenched literary bureaucracy, dynastic rule lasting centuries, and a dominant ideology which integrated a range of philosophical, religious, and political ideas and maintained a strong sense of continuity.

To a great extent, the literary-bureaucratic class which perpetuated this ideology was allowed such power because it propagated a doctrine of loyalty to the ruler, who was described as "the Son of Heaven." However, the teachers also called upon the ruler to "follow the Way of Heaven" and practice virtue. This call occasionally spurred or justified rebellion—indeed, the Chou dynasty (1100–250 B.C.E.) may have invented the idea of the Mandate of Heaven to legitimize its overthrow of the Shang: according to the *Shu Ching* (*Book of History*, ca. 800 B.C.E.?), one loses the Mandate when one acts immorally. However, for the most part, the rulers and the *literati* who served them claimed that they held the mandate and were indeed "the sons of heaven."

By the fourth century B.C.E., Confucian, Taoist, and earlier ideas were linked to form a kind of composite teaching, in which the Way (the Tao) of Heaven and the Way of Nature are identical. They bespeak harmony, the balance of *yin* and *yang*, active and passive, male, and female; the five elements and the four seasons reflect this as well. When the ruler follows the Way, the earth and society flourish. According to the *Tao te Ching*: "Man follows the earth; earth follows heaven; heaven follows the Tao; Tao follows what is natural" (Bk. 25). This is the mandate, and he who follows this mandate is a *chuntzu*, or "superior man." As the *I Ching* put it: "The character of the great man is identical with that of Heaven and Earth" (Chan 1963, 264).

This does not mean that things are static—after all, the *I Ching* is the "book of changes." Indeed, the first Hexagram starts with: "great is *ch'ien*, the originator." The *I Ching* tells of the movement of *yin* and *yang* and change through the subtle, active force of *chi* (appendix pt.1, ch. 5 and 10). What is more, "The great characteristic of Heaven and Earth is to produce" (appendix, pt.2, ch.1). Nonetheless, the

I Ching began as a book of divination, it speaks of destiny (appendix pt.1, ch. 4), and it claims that there is "nothing to deliberate about, because all roads lead to the same destination" (appendix pt.2, ch. 5) (Chan 1963, 264–269). In terms of creativity, then, this philosophy does not seem to encourage the introduction of the new— the Way is eternal, and our goal is to attain harmony with forces which are far greater than we.

On the other hand, creativity (in the dominant Western sense of the word), certainly was employed in figuring out what response was "natural," appropriate, or consistent with the Tao, the ancestors, or Heaven and Earth in any given circumstance and, perhaps, in convincing others that one was in fact following the Way. In this light, Sun-tzu's *Ping-ta* (*The Art of War*—ca. 350 B.C.E.), emphasized how a commander can conquer by knowing himself, his enemy, the environment, and the climate. In harmony with all these forces, the commander can still employ deception and surprise to avoid the enemy's strength and make use of his weakness. This classic of guerilla warfare, which strongly influenced all the martial arts of China, makes plain that "following the Way" could have its own sense of creativity.

Still, this did not mean inventing new rules. Figuring out what the appropriate response was in a given circumstance was strongly colored by the fact that past examples were supposed to provide clear models to follow. Indeed, the Confucian belief in the eternal has been coupled with a strong historical orientation; a focus on the "future," such as that which has been visible throughout United States history, seems to have been relatively muted in China until the end of the nineteenth century. Only with the revolutions of the twentieth century has a vast cultural drive toward the future been emphasized.

As part of the historical emphasis, an overriding respect for Confucius (sixth century B.C.E.) long held sway, and Confucius himself already had an overriding respect for the past. Although we may agree with Wing-Tsit Chan that "Confucius was a creator" who transformed several key, traditional Chinese ideas (1963, 17,31), Confucius himself said the opposite: "I transmit but do not create. I believe in and love the ancients" (Analects 7:1). In saying that the essential qualification for teaching anything is to "review the old, so as to find out the new" (2:11), Confucius implied that study of the past is prerequisite to creativity. Indeed, he also said that one should avidly study literature, poetry, and music (2:11–19, 8:8).

For Confucius, however, this study was to be undertaken because the "superior man's" virtue would be reenforced by the moral teaching of the ancient verses. All in all, he taught a philosophy of moral and political goodness—highlighted by the line he adopted from the *Book of Songs*, "let there be no evil in your thoughts," or "have no depraved thoughts" (Analects, 2:2), and his golden rule: "do not do to others what you do not want done to yourself" (I:44, XV:23, Essential Works).

While the *I Ching* portrays the *chuntzu* as one who lives in such a balance and harmony with nature that he is self-controlled and self-sufficient (Blofeld 1965, 24),

Confucius strongly emphasized that the superior man was committed to *jen*, virtue. This man "loves learning," "loves the rules of propriety," and when it comes to filial piety, "never disobeys" (I:14, I:15, II:5). Indeed, Confucius repeatedly cited ancient texts like the Book of Songs, which "told of the ways of the ancients" (Whaley 1958, 303) and advocated "following none but ancient teachings" and being "obedient to the Son of Heaven" (Andrea and Overfeld, 1990, 30–31). A purer statement of traditionalism and obedience to authority would be hard to find.

Confucius was one of several prominent teachers followed in ancient China, including such figures as Lao Tzu, author of the *Tao te Ching*, but during the Han dynasty the "Five Classics" which Confucius had revered were canonized, and by 124 B.C.E. Emperor Han Wu-di proclaimed that knowledge of these Confucian classics would be the prerequisite to the imperial civil service. By the end of the Tang dynasty (907 C.E.), knowledge of all the Confucian classics was required, and this remained in effect until the twentieth century. Aside from solidifying Confucius' importance, Han Wu-di's decision spurred the growth of a large administrative body, countless regulations, and a massive duplication of documents. No wonder that by 105 C.E. paper was invented to replace the wood and silk records. This inventiveness, however, reinforced efforts to preserve the past. When, therefore, Wu-di established the imperial university in the late pre-Christian era, a university that had 240 buildings and 30,000 students by 60 C.E., this was a creation aimed at securing a group of scholars with knowledge of the past. Since only a small portion of the population could read and a smaller percentage still had the opportunity to study for the civil service exam, a regular class of *literarchs* developed (Huang 1990, 49–51).

Thus, a significant degree of cultural and political influence lay in the hands of individuals trained to memorize ancient works and to follow the rules derived from these works.[4] While creativity was necessary in devising the governmental and societal structures, innovation was not a cultural priority. As Chunyu Yueh later said, "I have yet to hear of anything able to endure that was not based on ancient precedents . . . " (Andrea and Overfeld 1994, 99). Thus, bureaucracy and traditionalism went hand in hand. Apparently, the struggle to hold together the size and diversity of the Chinese empire required dampening—or at least ignoring—anything we might associate with individual creativity: "for general organization the Chinese tended to look to homogeneity and uniformity, and things unusual were rarely regarded with favor" (Huang 1990, xvii).

This attitude was expressed, paradoxically, even in the original unification of China in 221 B.C.E. under Qin Shi-huang-di (Ch'in Shih Huang Ti), whose ideology was neither traditionalist nor Confucian. The Qin unification was a new creation, and Qin favored the Legalist school, which said that society can be made good only by intentional governmental will and action. The Legalists debunked Confucius' teachings, saying that tradition was irrelevant and even destructive; and they suc-

ceeded in having Confucianism banned by imperial edict. Ironically, Prime Minister Li Ssu felt the need to refer to the mythical five emperors of ancient China to stress that obedience to the past was unnecessary; he noted that the emperors managed to practice good government without imitating anyone else. Li Ssu then went on to denounce the Confucians as those who "learn only from the old" and work against the good of the government. He then added:

> I humbly propose that all historical records but those of Ch'in [Qin] be burned. If anyone who is not a court scholar dares to keep the ancient songs, historical records or writings of the hundred schools, these should be confiscated and burned Those who in conversation dare to quote the old songs and records should be publicly executed; those who use old precedents to oppose the new order should have their families wiped out. . . . (Andrea and Overfeld 1990 I:100).[5]

Emperor Qin accepted these proposals and, in fact, had all critics of his imperial ideology buried alive. Significantly, this brutal repression of others only made it easier, it seems, for Qin to order one of the world's greatest artistic accomplishments: his mausoleum, which contains models of palaces, mountains, lakes, and over seven thousand soldiers (each with different facial characteristics), plus horses, chariots, and weapons. But this was all dedicated to defending the emperor in death—the artistic creativity lay buried for two thousand years, and the energy of the Qin was dissipated.

Still, the unification of China was maintained and the characteristics of Chinese society were solidified in the succeeding Han dynasty. Even the Qin had kept power in the hands of the "court scholars." With the Han, Chinese reverence for the past was revived. Confucianism and Taoism survived and flourished. Indeed, Confucian ideas became incorporated into a kind of civil philosophy with an extensive bureaucratic structure which held sway for the following two thousand years. This is despite the invention of moveable type and the printing of thousands of books, dynastic changes, humiliating Mongolian rule, and occasional contact with the West[6]—neo-Confucianism managed to adopt and integrate all these forces. Even the adoption of Indian Buddhism, which gave China ideas of *dharma*, *nirvana*, cycles of rebirth, and gods, and inspired great artistic creations like the rock temples at Yungang, Longmen, Mo-gao, and Dunhuang, with their thousands of Buddha statues, managed to be integrated into neo-Confucian thought.

Indeed, despite the introduction of new ideas, continuity and stability were maintained in the creative arts through government order and social custom. Throughout most of Chinese history, moreover, "the majority of artisans were state employed, the industry and the crafts being controlled by officials of the central government" (Okazuki 1968, 61). Chinese art has been anything but static, however—as a whole, the bronzes, ceramics, lacquerware, jade, textiles, sculptures, and paintings are extraordinary; individually, there are incomparable masterpieces, ranging

from the Han earthenware Storyteller figure from Szuchwan (first or second century C.E.), which shows astounding liveliness and dynamism, to the magnificent scroll painting, *Clearing Autumn Skies Over Mountains and Valleys*, attributed to Kuo Hsi (eleventh century C.E.), which awes and stills almost every viewer.[7]

Granted that creativity was widespread and great, what were some of the common Chinese conceptions which lay behind these works? The focus on honoring the eternal ways of heaven and nature, the ancestors and the ancient texts, coupled with the Taoist teaching of quietude, merged with the Buddhist goal of overcoming all desires and attaining enlightenment. This formed a perception of the motivations and purposes of creative effort which had a distinctly different tone from the willful innovation and pursuit of novelty highlighted in the West since the Renaissance. Indeed, the Taoist doctrine that "the Way that can be named is not the eternal Way" (*Tao te ching*, Bk. I), and the Ch'an (Zen) Buddhist approach of sitting meditation seem to stand in stark contrast with the biblical focus on the creation and the word and the Greek ideal of becoming "a speaker of words and a doer of deeds."[8]

According to the *Tao te ching*, it is the empty space between the spokes that makes the wheel and the "empty space in the clay vessel which makes it useful" (Chapt 11). For the Taoist, Chuang Tzu, this notion developed into the doctrine of the "void": "vacuity, tranquility, mellowness, quietness, and taking no action are the root of things" (Chan 1963, 208).[9] This means that the "sage should empty himself of everything" (*Tao te ching*, chapter 16), and, "like water, always seek the lowest ground" (chapter 8). The sage engages in "actionless doing . . . creating, but not possessing" or "taking credit" for what he creates (chapter 2).

Although possessiveness, willfulness, and boasting must have been common enough in China for Lao Tzu and others to preach against it, their teaching did not fall on deaf ears. In fact, it was greatly reinforced by Buddhist doctrine. Several schools of Chinese Buddhism (like the Three Treatise School) taught that wisdom lay in recognizing that there is not even a Self. The central doctrine of the Lotus Sutra is that all that seems to come into and go out of existence is illusory, that all is really "one mind," the "Buddha nature"—but that this has no "substance": it can be described only as "true thusness" (Chan 1963, 396–99). We know this truth through "concentration" or "bringing the mind to rest."[10]

Together, the Taoist and Buddhist teachings encouraged a uniquely Chinese aesthetic. This became pronounced and reached full bloom in the T'ang (618–907) and Sung (960–1279) dynasties, which brought forth outstanding poetry, pottery, and landscape painting (which was especially revered because of the meditative goals of emptying the Self and following the ways of nature). In fact, to be an artist was tantamount to being a sage, and many scholars were artists (quite different from traditional Western ideas). Since word and image were intimately bound, the sage was painter, calligrapher, and poet as well.[11] According to fourteenth-century phi-

losopher T'ang Hou, "landscape painting is the essence of the shaping powers of Nature. . . . If you yourself do not possess that grand wavelike vastness of mountain and valley within your heart and mind, you will be unable to capture it with ease in your painting" (Boorstin 1993, 18).

While the goal of the sage was to achieve a complete calm through focused breathing and meditation, one key teaching going back to Lao Tzu referred to the spontaneity of nature, and the sage most in touch with nature shared this quality to a high degree. In fact, Chuang Tzu's words about the "true painter," who "took off his clothes and squatted down bare-backed" became an oft-repeated expression in Chinese aesthetics, apparently because it illuminated art as "the spontaneous expression of the inner spirit" (Chan 1963, 210).[12] For many Westerners, being both "calm" and "spontaneous" may well seem contradictory, but the combination of the two became essential in the art of Chinese painting. Indeed, the calligraphy brush and absorbent paper used in landscape painting required fast work and complete control, since the ink dried so quickly and could not be erased. Artists therefore sought the greatest calm and collection before the fateful first stroke.

The stroke could express both calm and spontaneity, because the moment was perceived as enduring. The brush stroke wasn't something to do and finish in order to move on, but was meant to display motion and eternity at one and the same time. The sense of "now" is drawn-out; it unfolds, as the painted scrolls do. Unlike the framed, completed paintings characteristic of the West, Chinese art shows a before and after[13]; and unlike most Western art, where figures receive centrality of place, Chinese landscapes are often large-scale, and "empty" space is prominent.

Despite the relative insignificance of human subjects in the works and the self-abnegation of the artist, the individual character and the spontaneity of the artist are important. As Kuo Hsi (eleventh century C.E.) said, "in painting any view the artist must concentrate his powers to unify the work. Otherwise it will not bear the peculiar imprint of his soul. . . ." Indeed, according to the seventeenth-century *Mustard Seed Garden Manual of Painting*, one should "avoid the deadening effects of merely copying the methods of the ancients. . . . it is better to be audacious than commonplace" (Boorstin 1993, 421–423).

Nonetheless, the manual follows the virtually canonical rules of painting laid down by Hsieh Ho twelve hundred years earlier in his work, *Notes on the Classification of Old Paintings*. And Ho's own look back to historical precedents is telling. Tradition reigned in the world of art as in the rest of Chinese society. That is why Chinese painting expresses such continuity over the centuries. And when judgments of quality were made, as by Lu Yu in his *Ch'a Ching* (Classic of Tea—Tang Dynasty), the comparison was between whole schools of artists following regional traditions.[14] As we have seen, this traditionalism hardly precluded new interpretations, but for a long time it did limit what could be tried.[15]

Even in the twentieth century, Chinese theater has continued to present primarily traditional material, displaying, for example, the lives of second century figures like Cao Cao, with such regularity and such clear moral distinctions that the red, white, and black colors of the actors' masks and clothes immediately identify them for Chinese audiences (Huang 1990, 72).

Indeed, the "return to the classics" has been a regular feature of Chinese culture throughout its history. At the end of the eighteenth century, for example, the Chi'ien-lung emperor employed hundreds of scholars to edit thousands of classical works. But the fact that a "return to the classics" frequently took place shows that change had occurred and that a single, clear line of traditional, acceptable thought and practice was not followed. The same Chi'en-lung emperor carried out an inquisition against countless other works—his reverence for the past was selective.

There can be no doubt that art and invention have flourished throughout Chinese history and that different schools of thought have competed, even when Confucianism was dominant. As a matter of fact, Li Po (Li Bi), who has probably been the most loved Chinese poet since the twelfth century, was of Turkic origin, refused to take the civil service exam, and seems to have made a point of doing things "his way." And despite the fact that a number of dynasties lasted centuries long, the country was hardly monolithic or static. Flood, drought, famine, war, ethnic-tribal conflict, economic problems, court intrigues—matched by countless positive developments in canal building, astronomy, and so on, meant that change was continuous. Outside influences were great. The Chinese built the Great Wall in the second century B.C.E. to prevent outsiders from entering, but nomadic "barbarians" from the steppes nonetheless managed to drive into China and conquer it. The Buddhist missionaries who crossed the Himalayas converted millions and greatly transformed Chinese culture. The Mongols came from the north and created the world's largest empire, including all of China; their (Yuan) empire opened up China to contact with Christian Europe and the Islamic World. Later, the Ming dynasty sent fleets throughout the Southeast Asian seas and Indian oceans and around 1420, Zheng He led a fleet of hundreds of ships and thousands of sailors to Africa (Kristof 1999, 80–86). In almost all of these cases, the outside influences were absorbed, and the outsiders themselves often "sinicized."[16]

The success of this integration of the foreign is connected to one of the perennial themes of Chinese history: that of the frontier. While in the United States mythology the "frontier" is the locus of new possibilities and a goad to expansion, the frontier in China was often viewed as hostile, for the deserts seemed inhospitable, and the nomads seemed at times to attack the sedentary, agricultural Chinese almost at will. The frontier therefore elicited defensive strategies rather than expansiveness. The Great Wall, for example, the largest construction on Earth, was cre-

ated in order to halt the attacks from outside. This effort failed, but the martial arts approach of falling back and conquering almost always seemed to succeed.

ENCOUNTERS WITH THE WEST

This defensive strategy did not succeed, however, once the West began to penetrate China. While the Chinese were the first or among the first to develop gunpowder and the cannon, it was Europe which combined these and other elements to create modern weapons (L. White 1963, 271–73). As a result, when the Portugese came in 1513 it was an easy matter for them to take the Macau peninsula and turn it into China's trading post with the outside world; soon thereafter, one European country after another came to trade—on their own terms—with the Chinese.

For the next two centuries, the Ming and Qing dynasties provided relative stability and prosperity, and Chinese porcelain, rugs, clothing, and furniture traded to the West spurred "orientalism" in fashion there. Still, the Manchu rulers demanded absolute authority from the majority, and Confucian bureaucrats failed to revamp the economy or spur technological development in any significant way; to some extent they were contemptuous of commerce and trade, and they maintained that the increasingly great foreign trade was "a favour given by the Celestial Empire to the poor barbarians" (Andrea and Overfeld 1994, 368). Looking at China from the West, meanwhile, economic theorist Adam Smith noted that eighteenth century European travellers described China in "almost the same terms" as had Marco Polo five hundred years earlier, and even Chinese thinkers like Chang Sue Chang (1799) were beginning to suggest that it was now time to take a new perspective and look toward the future (Huang, 194). By 1842, the Opium War and Treaty of Nanking underscored this necessity in the harshest terms: Western power had greatly surpassed that of China, and China would be obliged to change or suffer continuous repression.[17] Not only did the British enforce their reprehensible "right" to addict the Chinese with opium, but they greatly accelerated the process which allowed several other foreign powers to have trade privileges with and even colonies in China. The Chinese, and particularly the emperor, were now humiliated, but every effort was made to maintain "face," and hardly any steps were taken to learn from the "morally inferior" Westerners—in fact, the American offer of blueprints of modern military equipment was politely rejected (Huang 1990, 202). Small-scale steps toward developing Western-style industries made hardly any headway, because there was virtually no financial, physical, or social infrastructure for it. Not only did the government lack a creative response to the incursions of the West, but it continued to view the changing character of Western constitutions as proof of barbarism.

Even before the Opium War, governmental oppression, upper-class oppression of the masses, extreme taxation, intolerance toward Moslem and other minorities,

and widespread hunger had led to popular unrest; a number of rebellions took place, and millions of people were killed. The dynastic system, traditional Confucian values, government bureaucracy, and the class structure were now under fire; the economic drain to the West further exacerbated the misery of the masses. In this context, much creative energy was directed toward maintaining the traditional system, but there were also increasing efforts to radically change it.

TWENTIETH CENTURY DEVELOPMENTS AFFECTING CHINESE CONCEPTIONS OF CREATIVITY

By the second half of the nineteenth century, China witnessed large-scale unrest and the emergence of a series of reform movements; at the turn of the century, China suffered ignominiously in war with Japan and in the Boxer Rebellion; in 1906, the Chinese adopted a "modern" constitution; and in the Revolution of 1911, spearheaded by Sun Yat-sen's United League, two thousand years of imperial and Confucian rule of China came to an official end. Sun's Three Principles of the People, which guided the League, expressed the goal of "nationalism," but replaced the Chinese traditions with overtly foreign ones: democracy and socialism. However, dissension within the League, the continued influence of the Western powers, the rise of Communism, ongoing economic deprivation, and finally, the massive Japanese aggression of the 1930s and 1940s left China in extreme turmoil. This turmoil continued through the Civil War of 1945–1949 and returned in the Cultural Revolution of 1966–1976.

Throughout these struggles, Chinese leaders have tried to deal with Sun Yat-sen's recognition that "we have the greatest population and the oldest culture . . . but we are the poorest and weakest state in the world" (J. Gray 1985, 142). According to Sun, the avowed "democrat," China suffered not only from extreme governmental corruption, but also from too much liberty and equality—the solution, he felt, was creation of greater national unity under a government of "discoverers" and practical men (1985, 143). And here, despite his revolutionary approach, Sun centered his ideology on the Confucian standard of "filial devotion." Similarly, while Chiang Kai-shek wrote in *China's Destiny* (1947) that the rebirth of the state ". . . depends particularly on whether or not social customs and people's way of life can be cleansed of the old and changed to the new, so that the people may be fully qualified as citizens of the modern age" (201), he reverently quoted Sun and Confucius and strongly emphasized "filial piety" (165, 166).

By the end of World War II, however, many Chinese were ready for more radical change. Chiang Kai-shek was obliged to leave the mainland for Taiwan after suffering great losses to his erstwhile allies, the Communists, in the Civil War of 1945–1949. Although traditional attitudes and behavior have persisted in many ways in China since that time, it is fair to say that the victory of the Communists

and the establishment of the Peoples' Republic of China (PRC) under Mao Tzsedong marked a clear break with Chinese traditionalism.

For Mao, the goal was nothing short of the complete revolutionizing of Chinese society. He worked doggedly to eliminate all "reactionaries" who would cling to the corrupt past and all "imperialists" from abroad who would control China for their own capitalistic purposes. In the place of centuries of oppression and misery, Mao and the Communist Party would "build a socialist state with modern industry, modern agriculture, and modern science and culture" (1972, 28). Mao's creative goal was "the permanent Communist Revolution."[18] Such an approach, which calls for change in every realm, seems to imply "creativity" in the most absolute Western sense of the word, but Mao's revolution had a very specific direction and had little tolerance for those whose creative insights prompted them to want to go another way.

Mao's revolution followed the traditions of Marxism as imported from the Soviet Union, but as modified by the Kuomintang government of the 1930s, honed in the Long March of the 1930s and 1940s, and elaborated by Mao, Chou En-lai, and others. In line with Marx, Mao saw the "cultural superstructure" as a reflection of the social-material "base." For this reason, all forms of creativity were perceived as either supportive of or antagonistic to the goals of the proletarian revolution.

> In the world today all culture, all literature and art belong to definite classes and are geared to definite political lines. There is in fact no such thing as art for art's sake Proletarian literature and art are part of the whole proletarian cause. . . . All our literature and art are for the masses of the people (299–300).

Indeed, according to Mao, all creative energies of the Party should be directed toward serving the masses. In one particularly famous talk, Mao indicated that this did not mean that only one view would always hold sway:

> Letting a hundred flowers blossom and a hundred schools of thought contend is the policy for promoting the progress of the arts and sciences and a flourishing socialist culture in our land. Different forms and styles in art should develop freely and different schools in science should contend freely (302–3).[19]

Despite these words, Mao's other speeches were filled with words like "right" and "wrong," "true" and "false," "the enemy," and so on. Ruthlessly, he and the party apparatus set out to "correct mistaken ideas" by teaching the peasants and "reeducating" the bourgeoisie.[20]

In his denunciation of "liberalism," Mao describes the type of person who must be "corrected." Such a person ". . . shows no regard at all for the principles of collective life but follows his own inclination. . . . Does not obey orders but gives pride of place to his own opinions. Demands special consideration . . . but rejects discipline" (246). When we recall the common traits of the "creative personality"

as highlighted by Barron and Harrington in the introduction, it becomes clear that some of the very characteristics which Mao found unacceptable are ones which are specifically applauded in the West.[21] Of course, diverse Chinese writers, even those who supported Mao, revealed unique qualities in their creative efforts, and some, like Huang Qiuyun went so far as to insist that commitment to the cause of the masses required exposing problems in Communist society itself (Siu 1990, 289–292). Still, the goal of "knowing the peasants" reiterated continuously in the first three decades after the Revolution overshadowed any idea that one should "know thyself."

In the post-Mao 1980s, the "humanistic" critique of China (influenced in no small part by East European socialist critics of Soviet rule like Adam Schaff), dialectically used Marx to question his teachings. While Marx had taught that the end of private property would also mean the end of alienation, the "humanists" saw rampant alienation even within "socialist" China. Nonetheless, this realization led neither to a public abandonment of Marx, nor an outright critique of the party, nor to an emphasis on individual fulfillment. It did, however, lead to the intense Cultural Discussion of 1984–1986, with the "one hundred schools" debating the subject of "modernity"—how it opposed or integrated tradition, to what extent it was a matter of science and technology or aesthetics and literature, what the roles of Marx and Mao would be, whether anything called "democracy," and to what extent a uniquely Chinese version of modernity was possible (Jing Wang 9–39, 208).

In many respects, this Cultural Discussion began to broach many of the key issues that are the subject matter of this book. Implicit in all these discussions is the question of where to look for creative initiative: is it history, society, material conditions, the party, the masses, or the individual that engineers the future? And creating the future had become the theme of twentieth-century revolutionary China, for the misery, alienation, and oppression which had been experienced and continued to be experienced called for constructive change. For Mao, this had been a matter of "continuous revolution"; by the mid-1980s, it was a matter of developing *xiandai yishi* (modern consciousness). In this context, American author, Alvin Toffler's *The Third Wave* (translated in 1983), emerged as one of the most influential works in contemporary China, for it described a leap toward the future through technological revolution (Wang 1996, 39–41).

And this fits well with the economic reforms of Mao's successors, Deng Xiaoping and Jiang Zimen. After Mao, it became bitingly clear that even though the country had managed to become a nuclear superpower and a member of the U.N. Security Council, a new economic direction, a "Readjustment" (as the government called it) was necessary—after all, China continued to have extreme economic problems and could see all too clearly that Taiwan and Hong Kong had achieved radically higher per capita income levels.[22] Under Deng, therefore, Communist China took the approach of attempting to modernize the economy through domes-

tic enterprise zones, small-scale capitalism, and *kai fang zhengee* (an open door policy), a specific strategy aimed at adopting other countries' advanced technologies and equipment (Ho and Huenemann 1984, 78). Encouraging vast amounts of foreign investment, the party seems to be following the principles of the martial arts— falling back and learning the "enemy's" strengths, in order, ultimately to overpower.

This might fit with Marx's idea that the "capitalists will be their own grave diggers," except that the Communist *v.* Capitalist opposition seems to be fading fast. It is difficult to understand how the burgeoning capitalist economy with its striking increase in class divisions can be described as "Communistic"—except that the State continues to control the economy in many ways and that all the changes introduced since Mao are purported to be for the "collective good."[23] Meanwhile, material consumption, small-scale entrepreneurship, and it seems to some, greed and corruption, are rampant throughout the society.

Deng's economic reforms paralleled to some degree the great Culture Discussion, and to some degree spurred hopes for further changes in the social and political realms, changes involving calls by Western-influenced thinkers for some kind of "democracy" and "liberty." These hopes, plus widespread frustration that the economic reforms were not yet leading to prosperity (something the party itself acknowledged in 1987) led to the 1989 mass demonstrations in Tianenmen Square, which were ruthlessly disrupted by the military upon the orders of Deng. Afterwards, the systematic arrest and silencing of all those suspected of ties to the democratization movement took place. Those called "human rights advocates" in the West were imprisoned by the government for "counter-revolutionary propaganda and incitement"—even though some of the counter-revolutionaries included workers like Han Dongang, who agitated for the traditional socialist goal of better working conditions. The government showed it would not tolerate the threat to its control that street demonstrations represented, especially demonstrations that could draw one million participants. Some have called the government's approach a matter of "castrating the thinkers" (Kristoff and Wudunn 1994, 242ff). While the memory of Tianenmen is upheld primarily by citizens of Hong Kong, exiles, and foreign nongovernmental organizations, the Chinese government's crackdown—followed by its 1999 persecution of the Falun Gong movement—seems to have seriously dampened efforts towards creative changes within the political realm for the time being.[24]

And yet, according to some analysts, creative problem-solving in China consists to a great extent in figuring out clever ways to appear to toe the party line and follow government dictates even while not doing so. Aside from widespread efforts to circumvent the rules (something which happens in other countries as well), many Chinese seem compelled to create and go along with obvious fictions in order to conform to unrealistic government decrees. Bureaucrats may insist, for example, that a product is available even when it is not or deny an illegal practice occurs because it is not supposed to (Bauer 1986, xv, Alpert 1996). Undoubtedly, this

approach requires great creativity; undoubtedly, too, it is a continuation of the "traditional make-believe" of imperial China, which honored the "age-old doctrine that truth always emanates from the top downward. A pronouncement from the throne was a deed accomplished . . . " (Huang 1990, 215).

Since the revolution (if not long before), commitment to the official ideology of Marx, Lenin, Mao, Deng, Jiang, and its various permutations has required the ability to say more than one thing with an official pronouncement and to interpret correctly which of several possible meanings is the correct one. Thus, when Wang Ruoshui focused on the unity of Marx's thought in order to criticize socialist bureaucratism and elevate humanism, he tried to protect his orthodox "left" flank by emphasizing Mao's concept of permanent revolution. His party critics however, saw through this defense and carried out a clever counterattack, denouncing Ruoshui Wang for being *too* "leftist"—like the discredited Gang of Four (Jing Wang 1996, 10–14).

> Those familiar with the subtle strategies of criticism and countercriticism at which the Chinese (both politicians and commoners alike) have been adept throughout history know how to decipher this treacherous device of counterattack. . . . The subtle mechanism underlying this psychological warfare has undoubtedly obscured the initial hidden agenda of both the accused and the accuser (1996, 14).

It does nonetheless seem that some of the post-Mao reforms have opened up realms of creative possibility. For example, despite Beijing's authority, the decentralization of power which began in 1983 has definitely allowed at least a few new "flowers" to bloom, as provincial governments express some of the kinds of social, economic, and cultural diversity which existed before Communist control. What is more, the continuously expanding trade, investment, and cultural exchanges with other countries seems to be accompanied by shifts in popular attitudes and expectations. Creativity aimed at the collective good seems to be mixed with an increasing degree of individual entrepreneurship.

But creating art in China today is not easy: eight years after the persecution of Tianenmen, not only were Wang Shuo's works still banned, but filmmaker Tran Zhuangzhuang (*The Blue Kite*) was blacklisted; Zhang Yimou and Zhang Yuan were prevented from going to Cannes to receive awards outsiders sought to bestow on them; Wei Jing Shun was imprisoned, and the foreign publication of his writings was denounced as interference in Chinese internal affairs (San Francisco Chronicle 5/14/97). Repeating what seems a perennial refrain, the head of China's Propaganda Department, Ding Guangen, declared in spring 1997 that filmmakers should produce more works depicting socialist ideals; President Jiang Zemin, while calling for a "spiritual civilization," has indicated that this means that writers and other creators must follow party doctrine.

These declarations, the censorship, the blacklisting, and the political repression would not be necessary, of course, if the government did not see the social power of artistic and literary creativity. Indeed, the state news agency, Xinhua, specified strict regulations for journalists precisely because it acknowledged them as "engineers of the soul" (SFC 2/4/97). Surely, the CCP works hard to block creativity, because it is a threat.

Since the early 1980s, a number of determined and creative individuals, in fact, have felt emboldened to take new and different approaches in their work. Chinese writers, artists, and filmmakers have sought new ways to merge Marx and Mao, traditional Chinese culture, and elements of Western enlightenment and modern thought. Dai Houying's 1980 novel, *Ren a ren* (Human Beings! Human Beings!) was followed by Li Zhun's *The Yellow River Rushes On*, in which he attempted to combine ideas about the struggle of the masses with respect for the traditional Chinese family, and ideas about love and individual personhood.[25]

Today, the last decade's humanistic movement in the arts is apparently looked upon by the Chinese avant-garde as "crude" and "sentimental." Liberating to some degree, perhaps, humanism also played into Western stereotypes of the noble struggle for human rights against an oppressive Oriental dictatorship. While the bulk of the population seems to have replaced interest in human rights with fervid consumerism, writers and artists have gone through a sweeping series of self-critiques and movements—trying to go beyond postmodernism to a supposedly non-Western, postcolonial, Chinese *houxinshiqi* (post-new-era). Emblematic of this new movement is the work of Wang Shuo, a writer whose sarcastic, mocking, and playful ideas were copied on T-shirts (before being banned by the government) and whose name was a household word in the early 1990s. In the new era, greed and consumerism abound—everyone is "cruising for profits" with second jobs and trades; in the Chinese "post-new-era," this is lampooned even as it continues to be carried out. Following Wang Shuo's catchword, *wanr* (play); "hip" Chinese half-jokingly ask one another: "What are you playing at today?" (Jing Wang 1996, 9–10, 289, 261–5). Describing the creative cultural developments of the 1990s, Jing Wang comments:

> But perhaps China's cultural subjectivity is just an imagined stake in the new naming game. . . . (Need we remind ourselves that the life span of a literary and cultural controversy in post-Mao China rarely exceeds a year?) Yet whether I attribute the coining of the lackluster term "post-new-era" to the critics' high-minded postcolonial politics or to their characteristically impulsive pursuit and abandonment of one trend after another, the casting aside of the buzzword "postmodernity" in favor of a term that smacks of indigenous periodization is a cultural event in itself worthy of attention (261).

While some Westerners like political journalist Orville Schell (1994) note that this avant-garde discourse takes place in the midst of an incongruous blend of

Multiple Intelligences

capitalist, communist, and lingering neo-Confucian thought, most of us in the West are oblivious to these newer Chinese cultural movements and find it difficult to grasp how intensely the Chinese now wrestle with questions of creativity and modernity.

In fact, when the prominent American analyst of creativity, psychologist and educator, Howard Gardner, visited art schools in China (and it is significant that he could do this), he came away convinced that the Chinese approach barely supported "creativity" in the Western sense, even for those students who were being "groomed" to be the next generation of "creators" (150).[26] According to Gardner, there is

> virtually total consensus . . . on how children should be trained. . . . Not only is much of the training simply tedious drill; but the kind of investigating of options, or opportunities for personal expression, which are never completely absent in a Western context, is essentially "off-limits" in China (1993, 150).

Gardner acknowledges that originality and the "exploratory attitude" so central to the West exist in China, but he maintains that efforts toward them and appreciation of them are exceptional. Overriding priority is given, instead, to mastery of "the basics," and only when one achieves near complete proficiency may one indulge in modifications or slight innovations. Gardner's own concern for creativity was often enough "(mis)understood as calling for complete license"; indeed, he found that there seems to be no direct way of translating "creativity" into Chinese. Still, Gardner's contacts agreed that originality and bringing something new into being could be important elements—not just in the arts, but in politics, as well—they understood Mao's Long March as creative in its way (1993, 281). What is more, authoritarian dictates from political and educational officials and conceptual ambiguity about what constitutes "creativity" hardly mean that everyone in China walks in lockstep or is uncreative. Many commentators note that large numbers of Chinese will do anything they feel they can "get away" with; indeed, some Chinese seem to value an across-the-board approach to experimentation, innovation, free expression, and so on.

While this attitude seems rare on the mainland, it is much more pronounced in Taiwan—which has in recent years intentionally defined itself as different from Mainland China precisely in terms of creativity and freedom.[27] While the Kuomintang Republic of China was traditionalist and authoritarian in many ways from the time of the move to Taiwan in 1948 until the lifting of martial law in 1988, it felt compelled to change when the world ejected Taiwan from the United Nations and replaced it with Communist China. Increasingly, the majority in Taiwan's Kuomintang government advocates the previously taboo policy of separating completely from mainland China.[28] Unquestionably, even though many in Taiwan are very committed to traditional Confucian or Buddhist ideas, Taiwanese culture as a whole is more international or Western than is that of the mainland. Cultural Affairs official

of. Japan's luck creativity

Charles Chung-lih Wu notes that "Our youngsters know Hollywood stars better than they know anyone in Chinese literature or opera. . . . If they are boys, they also know every NBA player's name, height, and scoring statistics" (Viviano 1997, A9).[29] For the Communists on the mainland, this is evidence of Taiwan's subservience to the capitalist West; for the Taiwanese, it is evidence that they are free to choose how to be. In the emphatic words of writer/choreographer Lin Hwai-mih: "In Taiwan, nobody will take shit from anybody, especially from anybody in government Ours is a society that tolerates tremendous freedom of speech and behavior, even a tremendous amount of abuse" (1997, A9).

In the West, conceptions of creativity are intimately tied to conceptions of freedom, and most Westerners question whether mainland China in particular is free or creative. For their part, the mainland government seems to believe that it can co-opt energies directed toward political expression by allowing a greater degree of cultural and social experimentation than in the past and encouraging new opportunities in the economic realm. Here, the freedoms which do exist seem to be allowing for considerable innovation and entrepreneurship. The mainland still lags far behind Taiwan and the West economically, but when a society of one billion plus inhabitants with considerable natural resources suddenly stops thwarting and instead encourages economic and technological creativity, its possibilities seem infinite. This is why many business people and political leaders from around the world expect dramatic change for China—and point to the last decade's growth as evidence. Capitalist outsiders may fear the country's future economic clout but want to capitalize on its opportunities now as best as possible. Nowhere else on Earth is there such a vast pool of labor and such a potential market. As a result, Chinese exports and foreign investment in China are growing steadily each year.

Thanks in large part to this participation in the global economy and in small part to the controlled cultural exchanges with other countries, China's integration into "global culture" is growing rapidly. Many in the West have accepted Chinese philosophical ideas, foods, acupuncture, pottery, and martial arts. The Chinese population has increasingly adopted Western consumer goods, fashions, and television programming, but the government, perhaps with good cause, controls this carefully. The fear that the West will corrupt or control is great—not only because the CCP has a specific, authoritative vision of the future, but especially because the power of the West to dominate has been so clearly demonstrated.

That is part of the reason why major conflicts have arisen in China's involvement with the West. A few years ago, for example, the United States and China narrowly averted what the Western media called a "trade war" over issues of intellectual property rights.[30] American trade negotiator Charlene Barshefsky accused the Chinese of ignoring past promises to control "piracy" of film and music cassettes and computer software and claimed that Xinhua, the official Chinese news agency was in "massive violation" of international trade laws when it attempted to severely

regulate the activities of Western news agencies (Financial Times 6/18/96).

In truth, the Chinese government has long considered it a matter of prerogative to control the foreign as well as the domestic media, and its concern with "intellectual property rights" is lukewarm at best. For the West, these issues of freedom of the press and copyright are fundamental: they lie at the heart of the ideas of individual freedom, creativity, private property, and profit that pervade the culture. In the traditional Chinese view, however, imitation was emphasized, and the West's attempt to prevent such imitation through patent and copyright laws made no sense. In contemporary China, where economic expansion takes priority and where the collective good outweighs the property rights of any individual or company, domestic or foreign, patents and copyrights seem of minor significance—unless they must be respected as the precondition for further trade with the West[31]—in which case the government might say whatever it believes the West wants to hear.

And here we see how complicated it is to examine the Chinese conception of creativity. As is true in other countries, the Chinese government's public statements may or may not be consistent with its intentions. But even if the leaders were attempting to be as clear as possible, they might be very hard pressed to articulate what is so in flux, so complicated, and perhaps so contradictory. While some countries wrestle with the transition from traditional to global culture, and some, like the United States, have relative consensus about an ideology of freedom, democracy, and creativity, China seems to have quite a bumpy situation. Aspects of the dominant global-Western-capitalistic conception of creativity; the teachings of socialist doctrines of Marx, Mao, and Deng; traditional Chinese neo-Confucianism (with its mingled Taoist and Buddhist elements); bureaucratic intransigence and political power struggles; a cultural recognition that silence is valuable and the spoken word ambiguous; and an experimental cultural avant-garde—alternately oppose, play off against, and merge with one another in fascinating, but also unpredictable ways. Who can possibly decipher it? Even the official government decree of today might be meaningless tomorrow.

This has not stopped investors from Taiwan, Japan, Europe, and North America from pouring billions of dollars into the mainland, making it the number two country in the world for foreign investment (after the United States). Everyone seems aware of the volatility of the situation, but many analysts believe that China's GNP will surpass that of the United States sometime in the next century.

The Chinese are keenly aware that Communism is in question throughout the world as never before since 1917. And in China itself, the importance of ethnic, class, and geographic diversity has resurfaced significantly. Who knows how long the Chinese government will profess Communism? We may well wonder, too, how China will absorb Hong Kong without being influenced by any of its democratic leanings. Will the mainland succeed in regaining its "lost province" of Taiwan? Will it maintain its present policy toward Tibet? What effect will the increasing envi-

ronmental pollution—perhaps the worst in the world—have on social-political-cultural change? Will China allow more foreign investment but succeed in preventing foreign ideas? Will the memory of Tianenmen stay alive? Can Chinese society balance individuality and collectivism in a way that becomes a model for the rest of the world?

Many people believe that the use of Western television, film, and especially the Internet, might well be the Chinese government's "Achilles heel" (Eckholm 1997, A3). While the government seeks to "safeguard security" by restricting access to and specifying fines and criminal punishment for any Internet material "defaming the government," advocating independence movements, or showing pornography, the government has not been able to block all foreign news or human rights information and can barely control e-mail messages. For example, the electronic magazine *Tunnel*, written and edited on the mainland and distributed back to it through a Silicon Valley e-mail address apparently reaches thousands in China (A3). Indeed, Internet criticism of the government is increasing, and the sign of its significance is that government officials feel compelled to respond to it (Pomfret 1999, A12). This is a clear sign of global creativity transforming national societies.[32]

Meanwhile, President Jiang Zemin seems to have approved of a starkly critical analysis of Chinese corruption and immorality by He Qinglian (Faison 1998, A4). He has also apparently commissioned a major study by the Chinese Academy of Social Sciences on democratic systems around the world and a potentially "democratic" blueprint for the future by political scientist Wang Huning (Hutzler 1998, A10). Aside from the fact that these reports are "secret," even publicly announced studies would not necessarily lead to particular consequences. Still, during President Clinton's visit to China in June 1998, most observers were struck by the new degree of openness and debate with which Jiang was willing to engage. In fact, Clinton concluded his visit with extensive praise for Jiang's "vision and imagination" toward a more democratic future.

In his effusive praise for Jiang, Clinton emphasized the classically American values of imagination and future-orientation, main components of the American conception of creativity. However, even if China has adopted some similar attitudes in this respect, it would be foolish to expect identity (especially since Chinese condescension toward the West seems as ingrained as Western condescension toward others). As we have seen in previous chapters, moreover, it is commonly the case that a culture stresses creativity in some realms but not in all; we have seen that governments can be quite dictatorial in general and yet allow, even encourage great creativity in particular domains. The widespread Western belief that political freedom and democracy are the prerequisites to creativity—a belief that some Chinese obviously share—may continue to be rejected by the mainland Chinese government without their dampening all forms of creativity in the culture. In fact, if China continues to develop without major violence, its size, its juxtaposition of the two

Western traditions of capitalism and Marxism, and its juxtaposition of the two with its own long cultural history, will almost certainly provide a powerful base from which to create a major new force in the world.

The potential seems great to Chinese and to outsiders alike, but what does this mean? When Deng, Jiang, and others talk of "building the new China," we may well wonder how many of their fellow citizens believe that they can build *creatively* in the Western and increasingly global sense of the word. Still today, it is very common among mainland, Taiwanese, and emigré Chinese, however creative they may appear, to consider astrology or the *I Ching*, and to speak of "fortune" or "destiny" in human affairs. In this traditional conception, the forces of the universe are huge, and we can at best mold ourselves harmoniously to them. The world is not the blank slate many in the West seem to believe, and we are not all-powerful creators.

There is undoubtedly a strain in Chinese society which seems to express some of the Western ideas of "self-actualization" and "self-expression," but enough of the most independently minded creators have been censored or imprisoned that intimidation is widespread. The great and seemingly arbitrary power exercised by the CCP must conspire with the sense of destiny to produce a feeling that the future will bring what it will, regardless of individual effort. Commitment to innovation, then, must be tempered with a stronger sense of humility or even impotency than among people who believe that they can shape the future through their actions.

And yet Westerners should not be too quick to judge; many Chinese seem to believe that the forces of destiny are working precisely to empower their efforts. As Ray Huang reminds us:

> When a nation of one billion persons completes a revolution that lasts more than a century, the magnitude of the movement may justify the reconsideration of the terminology and phraseology settled on before such an earth-shaking event. Obviously, China's problem in modern times, tracing its origin hundreds or even thousands of years back, is not something that can be easily characterized by labels developed from the Western experience (1990, 251).

The Chinese have long been as condescending toward other cultures as the West was. Even today, despite their awareness of the West's power, most Chinese, according to Jing Wang, continue to maintain a strong sense of superiority and view the West as "raw and depthless." Citing, but moving beyond the views of Western historian, Arnold Toynbee, Wu Huanlian, for example, maintains that "the future . . . will choose China eventually. . . . It should be taken as the choice made by the entire world to identify with Chinese culture. This is the sinification of global culture, the return of History to itself" (Jing Wang 1996, 209).[33]

But this claim is questionable. China's Marxism, capitalism, and "post-new-era" cultural developments all show the heavy influence of the West. Indeed,

as we have seen, the problem of traditional cultural identity in the midst of global cultural change is great, except perhaps for those who have already taken on the dominant creative global paradigm. What composer Hsu Po-yung has said about Taiwan echoes what Maxine Hong Kingston already told us about Chinese Americans: "it has become very difficult to pin down what it even means to be 'Chinese' . . ." (Viviano 1997, A9). And significantly, this is admitted even by popular Mainland Chinese author, He Qinglian, who has said: "Sometimes I feel I don't understand China at all . . . the more I look at it, the less I understand" (Faison 1998, A4). The revision of national cultural identity into a complex amalgam of provincial tradition and cosmopolitan transformation will continue in mainland China as well as Taiwan. China seems to be dedicated to creating such an identity and to becoming a major force in world affairs. Its efforts may well fail. But some hope and some fear that China will show a new way of creating which merges collective needs with individual desires, spontaneity with calm, silence with expression, and tradition with revolution.

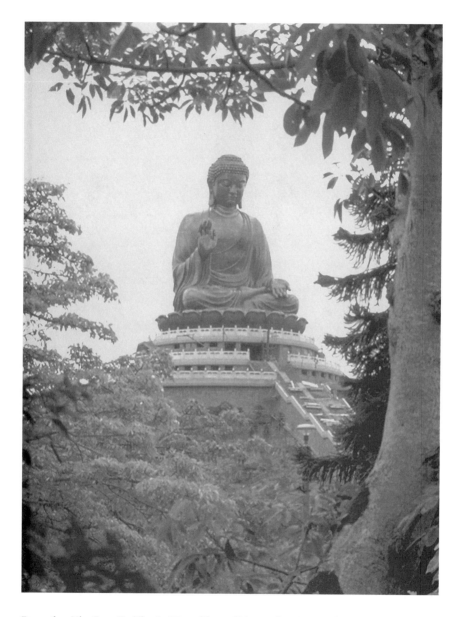

PLATE 6. *The Great Buddha.* In Hong Kong, China, today, in one of the most commercial-ized and technologically advanced cities on earth, religion serves, as it has throughout human history, as a major motivating force for creativity. Here on Lan Tao island, what is proclaimed to be the world's largest bronze figure of the Buddha sits meditating in the "lotus position." The enormous figure helps dwarf human ambition, and the Buddha's serenity seems to encourage a vastly different attitude toward creativity than that which seems to dominate in the West and even in Hong Kong itself. (Photograph by Robert Paul Weiner, 1990.)

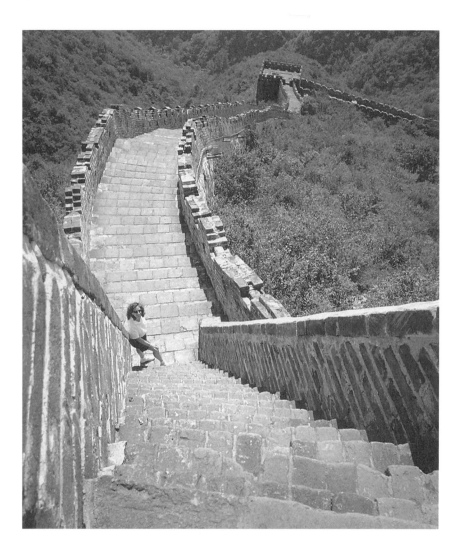

PLATE 7. *American Tourist at the Great Wall of China.* Unlike the frontier in American history, which is generally conceived as a challenge and opportunity for creativity, the Chinese frontier has long been something to defend—against outside invaders. Built by millions of workers mainly during the reign of Emperor Shih Huang ti (third century, B.C.E.), the four thousand mile long and 30 × 40' tall wall is apparently the only human creation on earth visible from outer space. However, the wall never succeeded in keeping out the invading nomads. All the defensive walls, ringing cities and demarcating boundaries around the world, from China to Rome to Zimbabwe, lost their effectiveness when the West turned the Chinese invention of gunpowder into powerful weapons. The airplane, which made defensive walls completely worthless (except as tourist attractions), brought the photographer and the tourist pictured here from America to China, where they were guests of the government for a 1998 conference on environmental law. (Courtesy of David and Barbara Moser, 1998.)

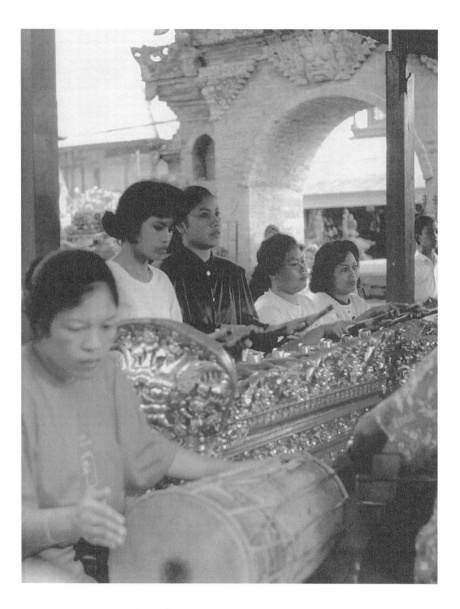

PLATE 8. *Women's Gamelan Orchestra.* Gamelan (or Gambelan) is a 5- or 7-tone Southeast Asian musical form, apparently of Indian origin. The word refers to the main instrument as well as to the orchestra and even to the broader social context in which dance, theater, and music are performed, often with sacred connotations. Traditional as gamelan is, at least a dozen categories of it have developed, and in past decades, the rise of women's rights has led to the formation of the first women's orchestras and globalization has led to the emergence of mixed-gender Western gamelan groups. (Courtesy of Susan Light. Taken in Ubud, Bali, Indonesia, 1990.)

198

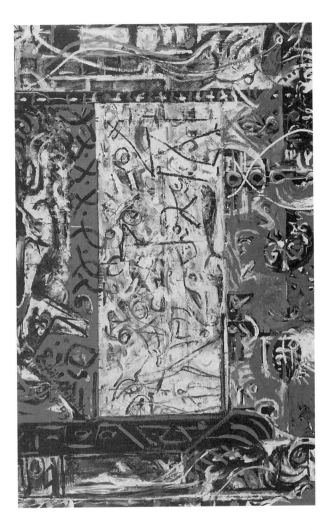

PLATE 9. *Guardians of the Secret.* Incorporating influences from Picasso, the Surrealists, Native American sand paintings, and the theories of psychologist C. G. Jung, Jackson Pollock was a pivotal figure in bringing American art to world prominence in the mid-twentieth century. His combination of conscious control and abandonment to the creative forces of the unconscious, displayed in this early oil on canvas (48³/₈″ × 75³/₈″), led to his "action paintings" of the next few years, in which he would fling paints onto large canvases while in a virtual trance. Pollock described his work as "letting the painting come through" and "being *in* the painting" (in Chipp 1970, 546–47). While some critics rejected his work, others considered him a genius. His highlighting of the creative process coincided with philosophical and psychological thinking of the era and helped lead to the modern study of creativity. His appreciation of traditional cultures and archetypal symbols, displayed here, also contributed to a shift in Western perceptions about creativity in other cultures. (Courtesy of the San Francisco Museum of Art, Albert Bender Collection. Jackson Pollack, 1943).

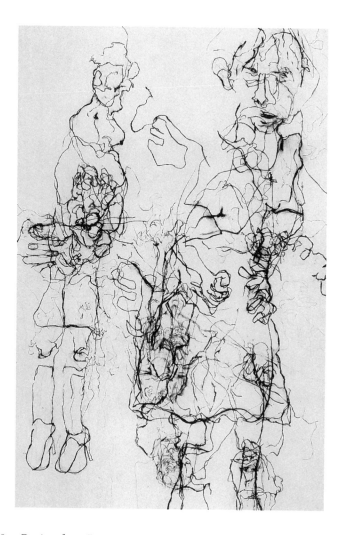

PLATE 10. *Despina,* from *Fragments* Series. The Fine Arts Museums of San Francisco pur-
chased this charcoal on graphite paper (44″ × 64″) for the Palace of Legion of Honor as part
of its effort to identify, support, and collect the work of rising young artists. Liz Leger's
composition of an "artist's statement" reflects a common contemporary practice, aimed in part
at helping viewers understand the work. This is often necessary, because many works of our
era are less literal, and we have such a relatively weak sense of common cultural iconography
compared to the past. For Leger, "each constellation of fragments is unstable and
fluctuating; . . . the fragments of bone, viscera, and organs shift and blend as they wrestle for
definition." Produced half with conscious intent and half automatically, "the drawing
encompassses the deliberate and the spontaneous . . . each scratch and scribble exacts great
care and abandon." While the influence of earlier twentieth-century psychology and art is
obvious, the "fragmentation" epitomizes how many individuals feel today, caught in the
postmodern flux of rapidly changing global society. (Courtesy of Liz Leger, 1997).

200

PLATE 11. *Convict with Homemade Last Supper Clock, Administrative Segregation Cell Block.* Condemned to Death Row and placed in maximum security, this informally dressed prisoner proudly displays his creations: clocks, made with felt reproductions of Leonardo da Vinci's painting of Christ and the disciples at the *Last Supper* (1495) as background, and tea-bag stained popsicle sticks and tooth picks as a decorative frame. Generations of past condemned have passed on this "craft," but each "artist" modifies the tradition slightly. While some of history's greatest creators (Ghandi, King, Socrates) have used their time in prison fruitfully, this man's violent past makes it difficult for most people to value his creativity, however interesting it appears. Ken Light was the first person to have extensive opportunity to photograph those watching the clock and awaiting their "last supper" on Death Row. As with the documentary photographers before him, Light's work is both interpretive and descriptive. (Courtesy of Ken Light. Black and white photograph, 1994).

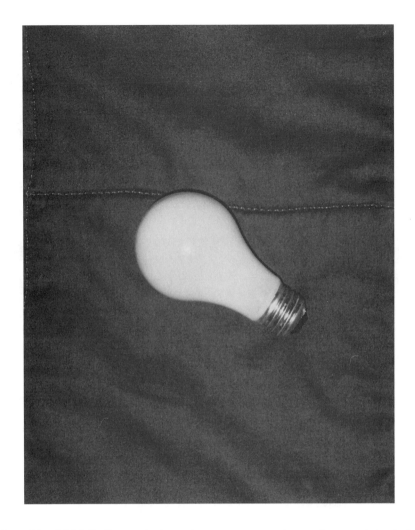

PLATE 12. *Lightbulb.* Commonly drawn in cartoons over a picture of a person's head, the electric light bulb has come to be a visual symbol—which previous cultures did not have—of invention and inspiration. While Joseph Swan and a host of others had been working on the light bulb as much as twenty years before Thomas Edison, his combination of carbon filament in vacuum bulb, power grid to provide electricity, and business organization allowed electric lighting to become commonplace. Thanks to newspaper accounts which played off the word, "illumination" to describe both the light bulb and Edison's inventiveness, many of us have come to automatically link his name with the bulb and link the light bulb with ingenuity. As ingrained as this visual icon has become in our culture, it seems likely that its days are numbered—the technology of lighting is changing, and other artifacts, like the silicon chip (already several decades old), seem more indicative of innovation today.

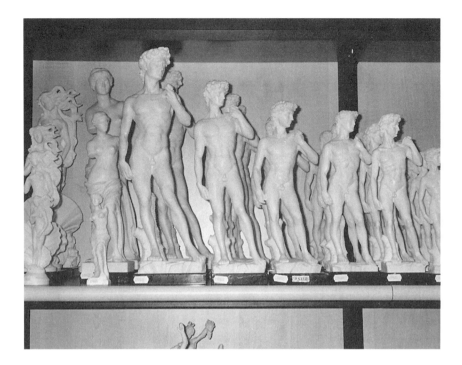

PLATE 13. *Infinite Davids.* Michelangelo's thirteen-foot sculpture, *David* (1504), was originally placed in front of the Signoria (city hall) as a symbol of civic pride. Along with the magnificent expression of thoughtfulness and readiness for action evoked by the sculpture, the work is also a masterpiece of problem solving, for the marble block from which it was hewn had seemed to other sculptors too awkwardly configured to be useful. Expressing their love for the sculpture, the city has preserved it by placing it in the Accademia Gallery. The worldwide admiration for Michelangelo's sculpture, coupled with modern manufacturing techniques and capitalism, have led to mass production of foot-tall plaster "Davids" for the tourist market. These works are reminiscent of religious icons; the long lines of museum goers waiting to see the original seem like modern pilgrims in awe of the artist, whom Vasari called "the divine Michelangelo." No wonder a "religious fanatic," believing in the biblical commandment against "graven images," attacked Michelangelo's sculpture of the *Pieta,* which is located in the Vatican. (Photograph by Robert Paul Weiner, taken in Firenze, Italy, 1995.)

PART THREE

Creativity in Practice

EVERYDAY OBSTACLES TO CREATIVITY IN OUR SOCIETY

While traditional and non-Western societies may resist or present alternatives to the increasingly global ideology of creativity, even within the West, creative efforts routinely encounter a wide range of obstacles. In fact, in a society such as ours, where creative fulfillment is so prized, whatever seems to be in the way of that fulfillment will be viewed negatively. The number of possible obstacles to creativity is therefore virtually infinite. That is why the individuals mentioned at the beginning of this book expressed frustration about their creative efforts and that is also why most books and courses on creativity focus so much attention on overcoming blocks to creativity.

The most common blocks are surely all those internalized doubts, criticisms, categorizations, and negative self-images we might absorb from parents, teachers, peers, and the broader culture. In addition, there are countless problems of daily life that might interfere with one's being creative: hunger, exhaustion, demands of family and friends, workload, sickness, mental and physical handicaps, inability to access needed resources, distraction, depression, lack of ideas. These problems are part of the human condition, and even the most celebrated creators are subject to them at times. Lack of time, indeed, mortality, limits all human creativity. And, of course, other people might oppose what we seek to create or how, where, or when we intend to do it. Even positive things, like a day at the beach or love, can compete with our creative drives so that we are deeply torn as to which direction we should pursue.[1]

SOME GENERAL SOCIAL, MATERIAL, AND ENVIRONMENTAL BARRIERS

The American idea that anyone can be creative in any way hardly guarantees such creativity: we are not created equal in regard to creative abilities. Aside from whatever differences in talent which might exist genetically, all manner of social conditions support or hinder creativity. While the well-to-do have the ability to expose

themselves and their children to every form of education and stimulus toward creativity and have the resources to exercise and publicize their own creativity, the less well off are clearly far more limited in their possibilities.

That is why authors from Aristotle to Marx have said that the realm of necessity must be taken care of before freedom, learning, and, of course, creativity can begin. Cervantes said that "when a poet is poor, half of his divine fruits and fancies miscarry by reason of his anxious cares to win his daily bread" (1979, 24), and Virginia Woolf maintained that a person must have some money and "A Room of One's Own"—free time and private space—in which to create. Such good fortune is not alone sufficient for creativity to flourish, but it does seem helpful.

Because this is generally so, we know nothing about the ideas and intentions of the millions of human beings who have died without these basic prerequisites to creativity, and we'll never know what they might have achieved and contributed. We do, however, have some extraordinary testimonies, such as that of Carolina Maria de Jesus, author of *Child of the Dark*. Her diary of life as a ragpicker in a dismal Brazilian favela shows at once the near impossibility of being creative in such a destitute situation and, at the same time, that extraordinary individuals, like Carolina, can create, despite, and in reaction to, such conditions. Generally, however, we expect that the kind of dirty, noisy environment, the lack of free time, and the lack of food and medicine characterizing Carolina's situation would constitute serious obstacles to most people's creativity.

Perhaps the most powerful block to creativity comes with crime and violence. It is obvious that war, street crime, domestic violence, and, of course, accidents and natural disasters tremendously hinder creativity. Aside from death and physical mutilation, individuals may be traumatized sufficiently that their creative abilities are diminished or destroyed. Creative projects which people have worked on for years may be cut off before completion. Often, all creative energy gets funneled into figuring out creative means of survival or recovery.

It is remarkable, however, how differently individuals are affected by the environment. Carolina, for example, continued to write her diary despite being surrounded by violence and being a victim of theft; many artists, writers, and musicians managed to create even in the Nazi concentration camps. Prison cells have served some writers well (Eldrige Cleaver, Mahatma Ghandi, Jean Genet), while lush and luxurious villas have no doubt lulled others with the comforts they offer. Some creators need the tranquility of nature (H. D. Thoreau, Georgia O'Keefe) or absolute silence (Marcel Proust's room was soundproofed with cork); others prefer the hustle and bustle of a big city sidewalk cafe (J. P. Sartre) or even the raucous environment of a nightclub (Toulouse-Lautrec).

Some people become so dependent upon a particular physical environment, or for that matter, particular stimuli (drugs, alcohol) or particular technologies (the computer, for example), that in the absence of these aids, their creativity comes to

a halt. It would seem that being able to choose one's tools and environment would be of tremendous importance to creativity; and yet all kinds of economic, political, and cultural factors might severely limit that choice. At the same time, the ability to make the most of circumstances, however limiting they may at first appear, is in itself a primary aspect of creativity, and the disruption of habitual patterns may, at times, be just the jolt a creator needs to move forward.

The materials and technologies we use for creativity are constantly in danger of breaking down, getting lost, proving more complicated than we expected, or failing to accomplish our purposes. Computer users may spend hours or days trying to figure out a new program or wrestling with a problem they believe is solvable only to lose all their work due to a power surge. Opera divas get sore throats and cannot perform. Even with the greatest of vision, creative ideas simply cannot bear fruit without adequate tools and materials: it took more than four hundred years before Leonardo's "flying machines" were built.

And even when material resources are available, societies have typically limited access to them to specific classes and categories of people. Slaves obviously were severely limited in how and what they were allowed to create. In some traditional societies, only women would do the weaving, only men would do the carving or pottery, only the shaman would sing special songs. In medieval Europe, feudal class and guild structures were generally quite exclusive. The result, of course, was that most people were limited to creating only within very narrow spheres of activity. Often enough, the realization of one's social limits was enough to prevent even the fantasy of creating outside one's "proper" sphere.

In diverse ways, these forms of social oppression have continued up through our times. Sexism, classism, and racism have been long entrenched. Discrimination obviously can frustrate creativity or distort it. A black lesbian in the United States, for example, might expend so much energy defending her race, her gender, and her sexual orientation, that she may have a very hard time focusing her creative zeal on her chosen field of mathematics. Those who have faced and continue to face discrimination (however subtle) often find that their creative efforts are ignored, and when they are sufficiently valuable to be recognized, this is often attributed to factors which deny the creators full credit. The anger and frustration people feel in these circumstances sometimes translate into an impetus to creativity.

In a society with such a developed division of labor as ours, creative activity has to a large extent become a *professional* activity. Far more of us assume the role of audience than of actors.[2] Creativity becomes institutionalized and cultivated for and by elites, their managers, and promoters, leaving out whole groups who do not exercise creativity at all, (though there are surely ways in which the audience—listener, observer, reader—can be creative). Also, while "star" performers in any field may inspire many toward imitation, professionalism may intimidate many others into thinking of their own work as "inferior."

In American society, the word, "creativity," is used for many degrees of achievement in almost all fields of endeavor, but we single out people or works as *especially* creative when they stand out from the rest. Competition—not merely in terms of talent and quality but also in terms of resources for production, dissemination, and successful marketing—determines what will stand out. The pressures arising from this situation constitute enormous blocks, and only a small fraction of the population seems to be sanctioned by society to pursue a life of creativity as it wishes.

Each society has its different realms of taboo, and one of the strongest in Western society has been sexuality. Rodin's sculptures of nudes embracing, Edison's first presentation of motion pictures showing Little Egypt's seductive *Dance of the Seven Veils*, D. H. Lawrence's *Lady Chatterley's Lover*, all scandalized large parts of late nineteenth- and early twentieth-century European and American society, and of course the initial response to Freud's theory of the libido was outrage. Wherever the boundaries have been set—from the showing of bare legs at the beginning of this century to the showing of oral sex today—the society has sought to restrict the dissemination, and sometimes the production, of the "obscene." For better or worse, this has limited the creators. (Of course, these efforts at restriction have often had the unintended consequence of stimulating great interest in works that might otherwise not have been viewed as particularly creative.)

Socially, creators may be ignored, celebrated, or persecuted. When a society does celebrate a particular creator, that person frequently serves as a role model to others, thereby perpetuating the values that type of creativity furthers. In our society, inventors, business leaders, astronauts, athletes, and generals often appear as such creative heroic role models, but so do musicians and actors, and, sometimes, writers, artists, doctors, and teachers. Rarely do any of these figures remain long in the public mind. On the other hand, groups may ostracize or protest against creative individuals, companies, or other organizations. Such protest action may, itself, be very creative, as was the American Civil Rights movement; it is often directed toward getting government involved in restricting or supporting specific types of creativity. Even without government action, social harassment might prove a very effective obstacle to a creator's work. The "evil eye" continues to pressure people into conformity in societies around the world (Hauschild 1982), and widespread hostility to homosexuality keeps many "in the closet."

With the help of strong religious or philosophical beliefs, supportive family and friends, or independent wealth, some individuals resist what at times appear to be overwhelming pressures opposing their creative efforts. Without such supports, extraordinary self-confidence would seem to be necessary for a person to continue creating.

Paradoxically, each of these "supports" may turn into an obstacle to creativity. The responsibilities most of us assume as we mature may, at any given time, thwart our creative urgings. Commitment to a job, to family, to friends, or to maintaining

one's possessions may all loom as terrible blocks to our creative energies when they call for first priority, even though our commitment in many cases is not really from a sense of duty, but from love.

EMOTIONAL BLOCKS

On the surface, the notion that emotions may block creativity is patently obvious; however, individual creators work best under differing emotional circumstances. Psychologists have widely divergent views about emotional conditions favoring creativity, and so have artists, writers, and other creators: while some seek an environment "free of emotion" in which to work, others acknowledge that all creative work is a matter of passion, whether in science or in art. Understandably, then, the kinds of emotional situations which might block creativity are many and complex.

American views of creativity since World War II have tended to conjoin creativity with emotional well-being, and for many, having the opportunity to be creative brings happiness. Analyzing what prevents such fulfillment, psychologists such as Barron, Rogers, and Maslow, and a host of contemporary creativity consultants (Ray and Myers, Adams, Bono) view insecurity, guilt, discomfort with ambiguity, fear of risks, as major emotional blocks to creativity and consider the individual who successfully overcomes those blocks and creates to be fundamentally healthy.

This perception is the diametrical opposite of the various writings of the nineteenth and early twentieth centuries by Lombroso, Morel, and Nisbet, who related creativity to madness (or degenerative psychosis) and Freud, who generally viewed creativity as neurotic sublimation (Prensky 1989, 245).

Both approaches have some merit. While Michelangelo created great works of art despite frequent bursts of anger at his patrons and competitors, and Florence Nightingale initiated great reforms in health care despite suffering decades long from nervous disorders, it is probably true, as Virginia Woolf has insisted, that anger, defensiveness, and "self-consciousness" distorted the work of Charlotte Brontë and many other women and men (1957, 71–77).

While in Havelock Ellis' 1904 study of British "geniuses" (which included scientists, writers, artists, politicians), only 4.2 percent were found to be "demonstrably" mentally ill, more recent studies by Andreasen, Jamison, and others have repeatedly shown far greater frequency of depression and manic-depression among artists, writers, and musicians than among the general population. Jamison believes that the heightened degrees of concentration, sensitivity, associative thinking, grandiose notions, and swings from contracted to expansive senses of self (all characterizing manic-depression particularly) help serve creative production well, if these tendencies are managed. (See, for example, Slater and Meyer's charting of the extraordinary peaks and troughs of musical composition which parallel the manic versus the depressive years of Robert Schumann's life (Jamison 1995, 66a)).

Of course, if individuals cannot transcend the debilitating aspects of such mood disorders, they might stop functioning effectively or might become so distressed that they become suicidal (which in fact is disproportionately common among artists, writers, and musicians). The painter, Edvard Munch, and the sculptor, Auguste Rodin, for example, were unable to continue their work because of their distress. Writers Ernest Hemingway, Sylvia Plath, and Virginia Woolf killed themselves. But depression is a widespread phenomenon, hardly limited to artists and writers.

However, while the bent of these studies and the common belief in the "mad" scientist or artist is that some kind of disposition or organic composition causes both mental problems and creativity in some individuals, it could also be that the countless stresses of pursuing a creative interest in a resistant society might depress anyone. Indeed, the myth of the alienated or mad creator expresses how the general population sometimes treats creative individuals. And it is easy to see how a person working at the "cutting edge" of any field might feel very lonely and alienated; almost all who work in the arts struggle economically and encounter repeated rejection as well. Indeed, as Julia Cameron has put it, "an enormous amount of what we think of as neurosis is simply misery over unexpressed creativity" (Madrigal 1996, A25).

A degree of _sadness_ does not, however, seem to interfere with creativity. Indeed, Aristotle called the poetic personality "melancholic," and poets like Emily Dickinson and Anne Sexton certainly seem to have deserved that appellation. In a 1975 study of madness in art, L. Edel found that "nothing is more chronic among writers than their sadness" (1005–1012). We take it for granted, in fact, that "you got to suffer to sing the blues," and we apply this bit of folk wisdom far beyond that particular musical genre. As Warren Steinkraus has said, "the ability to rise above personal tragedy and suffering seems almost commonplace among creative artists" (1985, 46). We barely know about the millions who were unsuccessful in their attempts to overcome such suffering.

The struggle of individual painters, musicians, and inventors is often so great that many have collapsed from the effort: they become addicted to drugs or alcohol, commit suicide, become destitute, go insane. We usually do not see the pain in the finished product, but it is often there. Some of the pain is voluntary: the creative experience can be torturous for some, like Coleridge and Giacometti, but still chosen by them. For others, the pain of effort and exhaustion, of making choices, of exposing themselves to criticism and rejection, of being subject to social-political oppression, of suppressing conflicting emotions, or of feeling guilt for transgressing social or religious taboos, can be tremendous. Although, "we cannot say that pain is a necessary factor in artistic creativity . . . it is indeed pervasive" (Steinkraus 1985, 52).

If a culture values pain and suffering as redeeming (as medieval Christian Europe did in some ways), the sacrifice necessary for creativity may be upheld more

easily. Creativity may also be used as an antidote to pain or as a therapy. Indeed, the pain of *not* creating is sometimes so great that individuals risk jobs, relationships, respect, and even their lives in their attempts to go on creating. Recently, for example, the Italian actor, Massimo Troisi, pushed himself, despite warnings from his doctors, to a premature death, in order to complete *Il Postino*, a film dedicated in large part to the subject of creativity.[3]

In our culture, committed as it is to the "pursuit of happiness," too serious an approach to life is sometimes viewed as a major block to creativity. Thus, humor, play, idleness, and joy are advocated by many writers, teachers, and consultants on creativity as keys to unleashing one's creative potential (Koestler, Adams, De Bono). Those who cannot "let themselves go" are then viewed as unfortunately blocked. This view is matched, however, by the near unanimous emphasis among creators that discipline and hard work are necessary components of creativity. These two conceptions are not in opposition, if we are referring in one case to an attitude helpful toward the germination of a creative idea and in the other case to the means of developing and manifesting that idea. Surely, a lack of discipline would be at least as serious a block to creativity as a lack of humor or a sense of play.

Throughout history, countless people have used drugs or alcohol to "loosen up" or to go beyond the normal bounds of their conscious experience. From American Indian use of peyote, to Chinese poets using plum wine, to Coleridge's opium use, and Hemingway's alcohol consumption, individuals have found that the exaggerated emotions and altered perspectives they've gained from drugs have stimulated their creativity. Obviously, however, this stimulation can also diminish creativity. Drugs often lead to inflation and deflation of personality; frequent use can dull the mind; addiction can weaken the body and so divorce one from social reality that whatever creativity occurs, it is barely comprehensible to or interesting to others. Addiction might also be coupled with debilitating anxiety—that the drug will not be accessible or that no one will care about the person who creates his or her creation. ~ Stephen King)

Fear is clearly a major obstacle to creativity, and Rollo May was therefore right to focus on *courage* as the prerequisite to creating. Of course, creative individuals may be quite insecure in some realms of life and still accomplish things of significance if they transcend their insecurities in their chosen field. A musician may have anxieties about public speaking but perform her instrument on stage magnificently. A scientist may be awkward and boorish in society but brilliant in research. Fear of proceeding in that research, would, however, seem to be an overwhelming block to creativity. (Tolkien)

For many creative people, the completion of a creative project is very anticlimactic, leading to depression, listlessness, and anxiety until a new project emerges. As a result, some avoid bringing their creative projects to completion, either by continually tinkering with them or by abandoning them at the last minute. In

short, the need and desire to be in the creative process is so strong that it unintentionally can become a hindrance to its own actualization.

Fear of embarrassment is common to almost all people in almost all societies, and presenting one's creative efforts—whether a new idea, a dance, a painting, or an invention—puts one in the potential position of being ridiculed or ignored. From this might arise a fear of failure, something particularly likely when we attempt to convince others that our work merits attention and reward. A few seem able to slough off such rejection casually, but many become demoralized and, after a while, give up. Many become defensive. Such defensiveness might protect the creator enough to continue with his or her ambitions, but it may also distort the product. Sometimes we defend ourselves against rejection by not creating with all our passion, thus also diminishing the potential greatness of the creation. Many however, intentionally fight to overcome their fears and do create. In some extraordinary cases, like those of Freud, Munch, Plath, and Woody Allen, creators somehow find the courage to make their own fears the subject of their creativity.

In the realm of science, curiosity might well have a partial element of fear mixed in: the desire to discover could include some anxiety about what might emerge. Those working with genetic engineering or nuclear energy would likely feel this way. And, of course, in science or the arts, those who know that their efforts are subject to censorship and that they might be imprisoned or tortured for their work have good reason to waiver before proceeding.

And in general, the fear of death, or at least the recognition of its certain arrival, may block anyone's creative desire. The angst might freeze us into inactivity. The sense of fatalism might demoralize us, so that we feel nothing is worth the effort. This is despite the fact that the expectation of death has spurred many to try to leave behind a "name" for themselves and that the need to cope with the power of death has stimulated all kinds of creative beliefs and practices around it.

For some people, the desire to create is simply too powerful for fear or any other block to interfere with their work. For the poet, Amy Lowell, the words come "with an imperious insistence which brooks no delay; they must be written down immediately, or an acute suffering comes on . . ." (Ghiselin 1952, 111). For many writers, scientists, and artists, the curiosity, the eagerness to push forward, the need to express themselves, or the passion for perfection will simply not let them rest. They will stay up all night, ignoring almost all other needs, until the passion is satisfied or they collapse from exhaustion. Paradoxically, this passion itself can elicit great fear in some creative individuals, since it appears so akin to madness. It can so completely overwhelm the person that personal relationships, economic survival, all other responsibilities are sacrificed to it. For this reason, suppressing such passion may make sense.

To proceed in the face of all these diverse fears requires great ego strength. In fact, this is a primary characteristic of creative individuals, according to Barron

and Harrington's extensive analysis (1981, 453). Throughout the process of creation and after it as well, individuals must deal successfully with ambiguity—material not easily categorized, ideas only vaguely intimated, a product that may never quite feel perfect, lukewarm responses from others. Tolerance for such ambiguity is cited by countless authors as crucial to creativity (Fromm, Barron, Adams, for example), and discomfort with uncertainty is clearly a block. Some people will be unable or unwilling to immerse themselves in an ambiguous context because of their need for order. Individuals who are creative, of course, will be attracted to the ambiguity and seek to find or make order in it.

Similarly, as every teacher knows, some people find the anxiety they feel in the face of a deadline a positive goad to creativity, while others freeze at the mere thought of having to complete something within a specific amount of time. Competitive struggle may be deleterious in some circumstances, but in others, it fuels creativity. This is usually the case in business, or, for example, in warfare. In the world of art, we could look at Michelangelo, who created masterpieces in competition with Bramante, Raphael, and Leonardo. In science, Francis Crick and James Watson raced Linus Pauling to discover the double helix structure of DNA.

Even if not all competitive creators are as "arrogant and opportunistic" as Crick describes himself and Watson (S. Hall 1990, 44), a great measure of self-confidence is necessary for creating something for public acknowledgement. Competition intimidates countless potential creators. The fear of losing or doing poorly can be overwhelming. So stressful is the competition among concert musicians, that some have fainted or even vomited on stage during recitals . . . "only the strong survive." To the extent that many women have been taught not to compete publicly, they may either not be able to present publicly what they have created or they may feel guilty about asserting themselves.

Even in the world of business, many individuals fear competition, and some think it counterproductive. That is why research and development teams are given leeway to explore and imagine, sometimes for years, without the pressure to produce something tangible. Michael Ray and Rochelle Myers have chapters of their 1986 book, *Creativity in Business*, entitled, "If At First You Don't Succeed, Surrender," and "Do Only What is Easy, Effortless, and Enjoyable." These authors and countless other creativity consultants say these things precisely because their readers and listeners share their assumption that a focus on competition and extrinsic rewards can be an enormous block to creativity.

MARKET ECONOMY AND WORKPLACE HINDRANCES TO CREATIVITY

Competition is, of course, a primary feature of the capitalist market economy which presently reigns in most of the world. In theory, the best products and the most talented creators succeed in this environment—that is, the society rewards the

greatest creativity financially. However, countless factors might prevent a beautiful composition or a better widget from succeeding. About 80 percent of all new businesses fail in the first year of operation. Since physical survival is so tied to economic success, the competition of the marketplace is often perceived as a tremendous obstacle to creativity.

This competition manifests itself in two primary hindrances for those who would succeed: the costs of doing business (whether we're talking about an artist who needs paint, canvas, a studio, and publicity, or about a large corporation like Sony or IBM that requires billions of dollars each year to proceed); and winning customers (which is a cost of doing business in terms of marketing, but might prove to be resistant to any expenditures).

In general, the greater the economic support received by an individual or organization for creative work, the greater the level of creative production we might expect. This expectation is not always fulfilled, of course: wealthy people are not necessarily creative, individual inventors sometimes outshine corporate research and development departments, small repertoire theaters may succeed while well-financed Broadway shows flop. However, backing does tend to be a crucial element in most cases, and creators who are not already well-off become dependent on corporate, governmental, academic, or individual (angel) patrons. Indeed, these patrons and their agents actively recruit potential and especially proven creators (J. M. B. Edwards 450–454).

Thus, in the arts, the adage, "nothing succeeds like success" reaches extraordinary degrees. A Cezanne or Van Gogh painting may garner $40 million, while thousands of artists, even ones who have won an award or two and gotten galleries to show their works, may not be able to sell their paintings for the cost of the paint and canvas. Fifty big "stars" have Hollywood at their feet (for the moment), while 90 percent of the Screen Actors' Guild members are unemployed and thousands more can't afford to join the Guild. The big publishing houses crank out millions of books by "big name," best-selling authors and perhaps a few dozen titles by new authors each year. The music industry is at least as focused on selling big name stars.

This is all so obvious, we barely think about it, but the reality is that the volume of well-financed production virtually drowns out the smaller voices, no matter how creative they are. And yet, perhaps out of resentment and envy, perhaps out of a recognition that fame makes some "fat and lazy," many seem to feel that only struggling artists and small-business entrepreneurs can be "truly" creative . . . in other words, that success itself is a block to creativity.[4] That is why many investors seek out small entrepreneurial efforts.

In every society, appraisal, publicity, and dissemination of creative work reflect the values of the power structure and indicate which forms of creativity are valued and which are not. Not merely Marxists, but countless artists and writers maintain that the only form of creativity really encouraged in American society is innovation

in business. To the extent that the arts are valued, it is when they succeed as marketable commodities.

Indeed, "value" in this society is almost always thought of as monetary value. Discovery for its own sake, spontaneous self-expression, the free exploration of the imagination, all take place within a society where the individual knows that the fruits of his or her curiosity or expression will potentially be translated into dollars—if he or she is lucky. What's more, the play of the imagination takes place in an environment filled with a surfeit of objects produced for sale and advertised in every possible way, so that we find ourselves, even against our wills, singing the tunes used to market Pepsi or Coca-Cola. Adorno, Horkheimer, and many other critics have railed against the resultant deadening of our ability to be creative and think critically. In past decades, concerned American citizens have worked for government limitations on television marketing aimed at children, whose naivete as consumers makes them especially vulnerable to advertising. Many agree with Stephen Kline, who maintains that: "Children's imaginative play has become a target of marketing strategy, allowing marketing to define the limits of children's imaginations" (1989, 299).

Marx wrote in *The Paris Manuscripts*, one hundred fifty years ago, that the capitalist interpretation of every resource, process, product, and relation as a potential commodity is the antithesis of human expression and fulfillment. While there may be major ways in which a market economy does foster creativity, its role as an obstacle to it is tangible to those who struggle within it.

Meanwhile the business world seeks to reach every possible market segment on Earth. American-, Japanese-, and European—based international corporations are active around the globe, and one result is that local creativity is often derailed: national costume gives way to blue jeans, national folk music to rock 'n roll, local performance of music, dance, theater, and storytelling to the viewing of American television reruns.

Because vast amounts of capital may go into the production, marketing, and distribution of a particular product (be it rock music or an automobile), widespread recognition and purchasing of these products becomes essential to cover the initial costs and make a profit beyond them. Hence, "creativity" is often directed toward mass appeal. Intellectually demanding material will therefore often be dropped.

What is more, the competition for patents and trade secrets and the fear of losing the fruits of creative research to industrial espionage have pushed corporations to focus even more than before on the speed with which they can market and profit from an invention rather than on any long-term benefits from it (Haggart 1988, 185–87).

With the channels of publicity and dissemination controlled by increasingly few commercial interests and some forms of creativity requiring big funding to get off the ground in the first place, individual creators following their own demons or inspiration may never get heard or seen. Simply carrying out a patent search and

registering an invention might be prohibitively expensive for them; marketing a song, painting, book, or invention can be exhausting. And the expenses of patenting, producing, and marketing continue to increase dramatically as technologies grow more complex and the economy grows more global.

Often, therefore, individual creators have to survive through other forms of economic activity (as the saying goes, "Every taxi driver in New York is a writer, and every waiter an actor") and maintain their creativity as a "hobby." They and their product may thus be marginalized. If they are fortunate, they find work close to their hearts, and, for example, teach music, even though they wish to be composing their own.

Individual creative entrepreneurs face acute competition. They work, usually, on one project at a time, and that work may not be easily replicable, so that natural disasters, theft, and such leave them productless and penniless. Patrons and contracts with large corporations may help an artist, consultant, or small inventor for years, but at the end of this time the company or patron may not wish to or be able to continue, leaving the small entrepreneur without a financial base. The work itself might be lonely and exhausting.

Furthermore, large-scale efforts have an advantage over smaller ones because there is a strong societal tendency to go in for "spectacular," "virtuoso," or "blockbuster" forms of creativity, as opposed to preventative or maintenance forms of activity. This fits with our understanding, as opposed to that of traditional societies, of creativity as producing *novelty* and transcending frontiers. For example, extraordinary surgical feats which challenge some doctors' creativity and save the lives of a few may get preference over basic health education which saves the lives of millions. Exploration of outer space may be supported more than creative approaches to housing the homeless (Pacey 1983). Ongoing maintenance of almost any complex matter requires continuous creativity, but our society values far more the initial creative act of generation. Also, less tangible forms of creativity, like teaching, consistently receive less acknowledgement and compensation in universities than research and the production of books.

The way our economy is structured, the development of new products and new marketing strategies aimed at new markets is so "natural" that the advertising of "revolutionary new" widgets and laundry detergents is commonplace. The word "creative" has become a cliche in our commercial society, and "true" creativity has become almost impossible to identify.

Despite the commercialism, interest groups form non-profit organizations, and many of these are dedicated to supporting creative research, writing, invention, art, theater, dance, or music. Grant money from nonprofit foundations plays a major role in keeping alive a number of small theaters and museums, individual writers, artists, and musicians. However, the lion's share of grants and fellowships goes year after year to symphonies, large museums, and a few relatively prominent artists and

writers whose success at grant writing is the envy of countless others. As in the private sector, name recognition and heavy backing keep a small number of creative groups and organizations succeeding, while most others keep working precariously, or are compelled to give up.

Furthermore, the most heavily supported art and music is not contemporary, but classic, that is, creations of the past. The sponsors understand and appreciate the fruits of nineteenth-century creativity better than they do most things being created now. They feel, perhaps legitimately, that time will help us sift through all the diverse creations of our era to pick what is great and what is worthless. Meanwhile, young creators struggle and wither.

Moreover, the tax-deduction opportunities for those who give their support to creativity often heavily favor predictable patterns: for example, successful alumni from elite universities donate to their alma mater, thereby increasing the chances of success for the next generation of graduates from these institutions; some of the money which might have gone to taxes does not; public universities have less in their coffers; and their graduates generally have a harder time competing.

Even though managers generally view creativity as "useful," and corporations frequently speak about "innovation" in their advertising and annual reports and must in fact innovate to stay competitive, "creativity . . . has not always been seen as playing an important role in the design and structure of organizations" (Mumford and Simonton 1997, 1). In fact, corporate bureaucracies often become rigidly formal and may greatly inhibit creativity. "Although no manager wants his or her [own] freedom of initiative reduced, it is an unusual manager who does not attempt to routinize the areas under his or her control" (Adams 1986, 149). As a result, the possible dimensions within which a worker may be creative are sometimes severely limited.

Furthermore, in a study of European and American corporations which did allow innovative change, Michael Brimm found that in not one single case did the sponsor of that innovation benefit professionally. In some cases, their careers suffered while their innovations brought success to the company. Brimm "suspects" what many other critics take for granted, namely, ". . . that most organizations and their individual managers live uncomfortably with sponsors and their innovations. Those who are motivated to introduce change are more difficult to manage than those who accept the status quo, and often carry risks for the boss's career as well as their own" (40).

It should come as no surprise, therefore, that a healthy chunk of the vast literature on creativity in business is devoted to the subject of "How to Manage Creative People" (Cochrane 1984). While the thrust of this literature is that creativity is good for business, an underlying implication is that it is a real challenge for business to tolerate, let alone nurture, creative individuals (Scott 1995).

Indeed, although creativity is generally hailed in the business world, the word "creative" may actually take on negative connotations. For example, a subtle critique of a colleague who is viewed as illogical or lacking in discipline might be, "well,

he's rather creative in his approach." Thus, too, the term "creative accounting" has come to refer to clever but misleading financial manipulations.

Creative personnel in research and development departments of large corporations are often pushed and push themselves mercilessly, working, perhaps, seventy-five hour weeks, to beat the competition, even though every "victory" is temporary. These hard-working individuals rarely have time to develop themselves creatively in any other respect than the narrowly defined production or marketing goals toward which all their energy has been poured.

Nonetheless, such individuals often count themselves lucky, because they do have some creative fulfillment and are often well-paid. Not so the overwhelming majority of workers, who may feel affection for their colleagues but otherwise generally experience a near total lack of creativity. This is true even for many who work in the nonprofit sector. The workplace remains an arena of creativity for a distinct minority.

One very unusual and creative solution to this situation is described by Teresa Amabile, who interviewed a worker at a corporation who said, "One thing I've done to stay on is to cut my salary down, so management doesn't worry about what I'm doing every moment . . . I'm here to have a good time . . . I love just thinking things over, just working a problem. I am interested in things that don't work, and I even seek them out. When I see conceptual contradictions, I go get them. Just let me play" (in Joyce 1997, 64).

As unique as this response is (Amabile noted that this worker was the only one of 120 interviewed who held such a view), many creative individuals have chosen to work part time or avoid the corporate perks altogether in order to have more creative opportunities.

POLITICAL OPPRESSION AND LEGAL RESTRICTIONS

On the surface, at least, it seems obvious that the greater the degree of political freedom, the more likely creativity will be to flourish. This was certainly the idea of the American "founding fathers" and of the nineteenth-century European theorists like Schiller, von Humboldt, Mill, and others discussed earlier. It is also the explicit position of twentieth-century American theorists of creativity like Frank Barron, Erich Fromm, and Jacob Bronowski. John F. Kennedy's "new frontier" speech, quoted above, is virtually an American credo, coupling political freedom with creative expression and innovation.

Historically, however, dictatorships have brought forth astounding creations: the great monuments of Egypt, China, and mezo-America are testimony to this. And much of the greatest art, literature, and philosophy we associate with the Renaissance and Enlightenment was produced under the reigns of the de Medici princes in Florence, Frederick the Great of Prussia, and others.

It certainly seems reasonable, though, that where government directs all creativity in some specific directions; where it forbids criticism, a free exchange of ideas, and/or voluntary assembly; where the printable and publicly utterable is constantly censored; where alternative ideas are not sought but punished, that creativity will suffer. This was repeatedly emphasized by Michael Gorbachev and Boris Yeltsin, who disavowed and dismantled what they and many others saw as a very oppressive Soviet regime. And yet, somehow, Pasternak, Solzhenitsyn, and many others wrote great literature, the Soviets were the first to put a satellite in orbit, and Soviet dancers and composers were prominent, if not dominant, in the worlds of ballet and classical music. Generally, however, the Soviet state apparatus was extremely creative in its means of control and propaganda: it disseminated its vision constantly and ubiquitously, and for the most part, allowed only that which it tolerated to come to light—Solzhenitsyn's works had to be smuggled out of the country.

Totalitarianism, as Hannah Arendt defined it in her 1952 book of that name, is when a government organizes all aspects of life and allows no private or individual initiative (creation) separate from that organization. According to Arendt (following Aristotle), the essence of freedom is the ability to initiate (to speak and to act), and both the former Soviet Union and Nazi Germany were supreme examples of the repression of this ability. It is important to remember, however, that many creative individuals—especially at first—willingly lent their talents to the goals of these governments. In the USSR, particularly, great artists and writers rushed to work for the cause in the 1920s (thus Agit-prop art, etc). Werner von Braun, who later headed NASA in the United States, dedicated his scientific talents to his native Germany under Hitler.

However, large numbers of very talented creators like Einstein, Brecht, Freud, and others fled Germany for more hospitable shores, where their energies greatly contributed to their adopted societies. Indeed, oppression of creativity in one realm may stimulate it in other geographic areas or in other realms of activity—Chinese Emperor Hongwin's 1371 ban on private Chinese participation in overseas trade greatly encouraged trade and ceramic production in Thailand; by forcing Cicero into exile, his opponents in Rome gave him the opportunity to write extensively (Cicero 1974, 160).

Even in the most horrendously oppressive situations, like the Nazi concentration camps, artists, musicians, and writers created as long as they lived. In *Man's Search for Meaning*, Viktor Frankl tells of concerts in the camps, and his own book and theory of psychology grew from his experiences in the camps; Sybil Milton claims there were thirty thousand Holocaust art works at the end of the war. These, however, remain exceptional cases illustrating the human need or will to create. Obviously, millions of creative and "ordinary" individuals died in these concentration camps, millions of voices were silenced by censorship, works were destroyed,

ideas thwarted, human beings and their dignity crushed. And unfortunately, this pattern continues today, to varying degrees, in many parts of the world. This is especially true where national governments oppress the creative expressions of religious and ethnic minorities.

Less pervasive but nonetheless important are the political limitations on creativity in Western democracies. For years, government commitment to state-run broadcasting in most European countries led, for better or for worse, to prohibitions against "pirate" television and radio programming. In the United States, the motion picture industry imposed a restrictive code upon itself in 1930 to avoid pending legislation which would have been even more restrictive. And despite the supposed First Amendment "guarantees" of freedom of expression, restriction has occurred in many ways—most notably when Senator Joseph McCarthy and the House Un-American Activities Committee (HUAC) investigated films, books, and plays, which they considered to be "threats to national security" and demanded that Hollywood writers, directors, actors, and producers make public disavowals of any links to Communism. Those who were found to be Communists or refused to cooperate, were deprived of employment and in some cases imprisoned.

Every society forbids certain activities and imposes punishments of various kinds for transgressing the rules. Imprisonment is a clear example of restricting a transgressor's freedom, but ironically, the free time, which many prisoners apparently find oppressively boring, provides some, such as Malcolm X, with a unique opportunity to develop their creative abilities. In Texas' death row, where three hundred men are currently awaiting execution, they "piddle" their time away creating arts and crafts, some of it of high quality (Light and Donovan 1997).

Separate from any specific restrictions on expression, every society's laws might be perceived as limiting creativity in some respects. The creative driving of "good and bad guys" alike in the automobile chase scenes of countless American films shows how innovative we could be if we didn't submit to the restrictions of the traffic laws.

Every criminal is, in a sense, "creative," but criminals might be defined as less creative than those who do not break the laws but manipulate them for their own purposes. Indeed, a major area of creativity in our society lies in efforts to define, evade, interpret, analyze, and enforce the laws. Even conscientious citizens often find laws to be hindrances to their creative impulses: a person might have a wonderful fantasy for constructing or renovating a building, for example, and immediately run into the "walls" imposed by the city zoning and permit departments. In most Western countries, business people continuously rail against government regulation as stifling innovation and development, even though large numbers of citizens are pleased that environmental and health safety laws, such as they are, do exist. Doctors and patients might want to experiment with certain drugs to cure a disease but be warned that it is illegal or still pending approval.

Neighbors might want to hold a street fair only to be blocked because they did not secure the proper permits. These kinds of things happen frequently and are the source of tremendous frustration.

Even laws of patent and copyright, specifically constructed to reward and protect creativity, serve as clear obstacles not only to those who wish to use or copy the material for profit, but even those who want to use the material for public or educational purposes. Currently, for instance, the United States Congress and the Supreme Court are considering whether or not new medical procedures are patentable. While the inventors of these procedures may have created valuable techniques through great effort and personal cost, the American Medical Association views patenting the techniques "unethical," for the resulting royalties would limit patients' access to what may be life-saving solutions.

OPPRESSION AND DISCRIMINATION AGAINST PARTICULAR SOCIAL GROUPS

Societies throughout history have had different degrees of hierarchical structure and division of labor. The more fixed these social divisions, the more restricted have been the creative opportunities of the groups which are not in control. In many cases, members of the lower economic classes are limited not merely because of lack of resources, but also because their appearance, manner of speech, and lack of appropriate contacts prevent their work from being taken seriously by the dominant forces in the society. It is often very hard for someone speaking "cockney" or "hillbilly" English to be acknowledged at Oxford or Yale, even if the speaker otherwise has brilliant ideas.

Indeed, appearances count for much in our society, and numerous studies have indicated that "attractive" and tall men and women are paid more attention than shorter, fatter, "uglier," or more disfigured people. People with physical handicaps do not merely have to deal with their bodily limitations, but also with those in the society who condescend to them or ignore them. The lack of attention and respect such people experience might work as the kind of challenge which stimulates creative responses (when the physicist, Stephen Hawking, who was immobilized with lateral sclerosis, was praised for the brilliance of his theories, he jokingly retorted, "Well, I couldn't succeed in basketball"); but many feel the stings of discrimination and are weakened by them.

In American society, almost all ethnic groups have been the victims of stereotyping and some degree of harassment by others. In the last century, "Irish need not apply," "Go home, Italian Mafia scum," and countless other hostile reproaches—which translated into reduced opportunities—were leveled against various immigrant groups. Each restriction required a creative response in order for the group affected to survive, but despite such creative responses, there is no doubt that creative possibilities were to some degree limited.

Surely one group whose members' creativity has been seriously limited in American history is that of the African-Americans. Aside from the obvious horrors of forced servitude (which helped destablize the African countries), the cultural expressions of Africans were purposely squelched during the centuries of slavery in America, and African-American creativity was ignored or intentionally repressed for generations. An interesting case is that of the "Jim Crow" dance: when a church decree of 1690 forbidding crossing of the feet interfered with traditional African ways of dancing, Black slaves creatively developed a kind of shuffling dance to circumvent the decree. In the 1840s, a Caucasian actor, T. D. Rice, created the *Minstrel Review*, and in it, he exaggerated a crippled slave's performance of this dance. Only whites were allowed to perform this "humorous" transformation of Black music and dance on stage. But this adaptation of African creativity included a portrayal of Blacks as ignorant and happy-go-lucky, which weakened calls for the abolition of slavery. This perversion reached an even more extreme level of absurdity when, in the twentieth century, Blacks were finally permitted to perform on stage for whites, but only by imitating the awkward movements and exaggeratedly big lips and gestures of white, Jim Crow minstrel performers claiming to imitate Blacks! (Riggs, 1980). Similarly, while Henry O. Tanner was painting beautiful and noble pictures of African-Americans in the 1890s, his works were barely known, while Currier and Ives' racist caricatures in the *Darktown Series* had wide distribution (Hudson 1995, 141–151). These distorted images, along with the society's disregard of African American accomplishments, outright repression, and brutality couldn't help but instill what Martin Luther King, Jr. later called "a degenerating sense of 'nobodiness'" (84) in many Blacks—hardly a suitable basis for creativity. Even in our era, in which numerous African-American creators are celebrated, the persistent pain of racism is both a goad to creativity and an obstacle to it.

This has certainly been the experience of American Indians, as well. Decimated by war and disease and often forcibly evicted from their lands, they were also forbidden from speaking their native tongues or practicing their native religions. While some of their arts and crafts were prized by European Americans and either purchased or stolen, the dominant culture generally viewed what the Indians produced as "primitive." When, early in this century, anthropological curiosity and social fascination with "the primitive" were on the rise, Indians were encouraged to practice their traditional arts, but only as long as they conformed to stereotypical patterns.

Obviously, that group which has experienced the longest worldwide record of limitations in terms of creativity is women. Those careers and tasks traditionally associated with women, from parenting to knitting, were for millennia not viewed by men as domains of creativity. To be "creative," a woman had to break into "male" fields, but was faced with all manner of obstacles and exclusions (Vare and Ptacek 1988; Pacey 1983, 97–119; Woolf 1957; Marx 1974). Thus, the number of women

artists, writers, and composers whose work was publicly celebrated in the West before 1750 seems to be no more than a few score. Often those women who succeeded in the traditional realms of male creativity, like Christine de Pizan or Ada Augusta Lovelace, were relegated to footnotes or, like George Sand, assumed male names to get the attention they already deserved. Other women creators remained anonymous or took second place to their husband collaborators, who received far more recognition (see the cases of artists Sonia and Robert Delaunay, and inventors Emily and Thomas Davenport). Women scientists and inventors have been almost completely ignored by historians until the late twentieth century.[5] Amazingly, too, the classic work by H. W. Janson, *The History of Art*, managed to cover three thousand Western artists in the 1962 edition with barely a woman among them! Even today, when women comprise approximately half the country's artists, most galleries and museums exhibit very few, if any, works by women artists.[6]

Indeed, until perhaps 1980, the number of women creators whose work was studied in American schools (with the relative exception of English departments) was minuscule. Lacking positive role models to follow, young girls were less likely to pursue creative careers, especially in the sciences. And with educators recognizing that even today they pay more attention to boys in the classroom and challenge their girl pupils to a lesser extent, it is obvious that women continue to have a hard road to haul. Those who succeed, especially in traditionally male fields like mathematics, must have great determination for they will invariably be viewed as rebellious or odd (Helson 1971, 210–11, 217–220).

Furthermore, as Anaïs Nin emphasized forty years ago, our culture has traditionally demanded little of women beyond the fulfillment of personal family and household duties, so that women who had the creative urge were caught between the guilt of neglecting those duties and the guilt of neglecting their potential (1973, 153). And even today, when women are expected to work and create in the world and an increasing number of men are sharing the household duties, those responsibilities still fall disproportionately on women, greatly limiting their opportunities for creative expression.

Indeed, the culture's strong tendency to connect women's creativity with biological reproduction both relegates the creativity of childbearing to a merely innate biological realm and prevents women from being recognized as creative in other domains. The traditional idea of "feminine" was clearly quite limiting as well. As Betty Friedan wrote in 1963, "The feminine mystique is so powerful that women grow up no longer knowing that they have the desires and capacities the mystique forbids" (137).

These difficulties have diminished, and ironically, the traits often highlighted by psychologists as indicative of creativity (such as emotion, openness, sensitivity, and so on) are ones our culture traditionally stereotypes as "female" (Mackinnon 1968, 439–40; May 1975; J. Adams 1986, 59; van Oech 1973, 25 ff, Chadwick and

Courtivron 1993, 9). What is more, as some analysts (Veblen, Mackinnon; Arieti) have pointed out, groups treated as "marginal" by a society often produce highly creative individuals—and it does seem that today, Jews, African-Americans, Asian-Americans, gays, and women have major places in the world of creativity, or at least in the world of American arts.[7] Toni Morrison, for example, intentionally took on the task of "witnessing" to those "discredited by" the dominant Western tradition and decided to "write literature that was irrevocably, indisputably Black"—for which she won the Nobel Prize. And Jews have won the Nobel Prize in numbers totally out of proportion to their population, far surpassing the success of all other national and ethnic groups.[8]

RELIGIOUS—CULTURAL BLOCKS

Although religion is arguably the single most important source for creativity in the world, it is also often a major obstacle. While almost all the world's religions have been major patrons of education, the arts, and in some cases, the sciences, the express intention has been to have learning and the arts serve the higher purposes of the religion. This is obvious in all the buildings, sculptures, paintings, and musical compositions of a religiously artistic character. Even many works not directly related to religious practice have been viewed as "divinely inspired." Dorothy Day, for example, was so moved by certain "exalted" novels that she asked "whether our Lord hasn't had a close, direct hand in their creation" (Coles 1987, 158). The contemporary Dominican theologian, Matthew Fox, has interpreted the biblical Creation story to mean that the divine is expressed in human creativity.

However, as the stories of the Tower of Babel and the Golden Calf make clear, the biblical God is a jealous one and will not tolerate certain creations. What is more, it would seem that anyone who is seriously committed to a religious tradition—Biblical or otherwise—would *have* to place certain values (such as devotion, obedience, love, enlightenment, or justice) above creativity. This is why the Roman Catholic Church has tried to silence Fox, though in a less stringent way than it sometimes "silenced" dissenters in the past.

The eighteenth-century American theologian, Jonathan Edwards, denounced the many who employ themselves in the service of "sin" and argued forcefully what we *should* be doing with our creative energies:

> God is the highest good of the reasonable creature; and the enjoyment of him is the only happiness with which our souls can be satisfied. . . . Therefore it becomes us to spend this life only as a journey towards heaven, as it becomes us to make the seeking of our highest end and proper good, the whole work of our lives; to which we should subordinate all other concerns of life. Why should we labor for, or set our hearts on anything else, but that which is our proper end, and true happiness? (1966, 141–2).

From this perspective, then, creativity directed toward earthly things is at best of secondary importance; it likely will be frivolous, distracting, decadent, dangerous, or immoral, and it is therefore necessary to oppose it. Such groups as the Amish (shunning new technologies), Protestant Fundamentalists (moves to ban books from schools, stop government support of certain kinds of art, eliminate "pornography"), Moslem fundamentalists (death threats for writers like Salman Rushdie and Taslima Nasrin), and Orthodox Jews (prohibition against images—see Chaim Potok's *My Name is Asher Lev*) immediately come to mind as contemporary cases of religious resistance to what others view as legitimate creativity.

Most religions patronize the arts, but the biblical commandment against graven images has been interpreted by Jewish, Moslem, and many Protestant Christian authorities throughout history to mean that visual portrayals of the divine or the human are forbidden. A number of exceptions to this taboo could be cited, but the strength of this prohibition has been great. A result of this, of course, has been the creation of brilliant geometric and calligraphic art by Moslems, and the diversion of creative energies away from the visual arts and into other spheres by Protestants and Jews.

If it is anything, religion is an assertion of a truth, and when it asserts that there is but one truth and that an elect group has found it, and when, furthermore, that group attains some degree of economic and political power, it can be devastating to creativity of any kind it does not sanction. The Spanish Inquisition was just one example of the Catholic Church's oppression, and the Catholic Church is just one example of a religious absolutism—which might greatly support creativity, but only as long as it fits the doctrine. Heretics, witches, and sorcerers have been denounced and killed throughout history. Waves of iconoclasm, destroying countless artworks, swept through the Byzantine Empire during the eighth and ninth centuries and also passed through other branches of Christianity and most other major religions, including Buddhism and Islam.

Even more dramatic has been the destruction of creativity resulting from interreligious wars. While wars fought more for political and economic reasons today do not usually target museums and religious sites and may even try to avoid harming them, temples, mosques, churches, paintings, and sculptures have been primary targets of religious wars throughout history. Moslems burnt down the temple district of Ayuttaya, Thailand, because the works there were offensive idols in their eyes and because the remaining works might rally the conquered Buddhists. Christian crusaders acted similarly when they marched through Moslem Spain and the Middle East.

These past and contemporary efforts to restrict the creative process or destroy the creative product all express the beliefs that: *(a)* there are higher values than human creativity (divine commandments, love, human dignity, scripture, revelation); and *(b)* that any form of creativity that contradicts these higher ideals should be ignored, discouraged, forbidden, or even punished.

There is, of course, a big difference between ignoring and punishing someone. Outrage over blasphemy, and especially the fear that the a particular creation will be influential, may prompt more extreme measures, like killings. For example, the Egyptian Moslem Brotherhood has targeted a wide range of "blasphemers" for attack, and in 1994 managed to assassinate the Nobel Prize-winning novelist, Naguib Mahfouz, for his literary portrayal of Mohammed. Such actions come as quite a shock to American society, despite frequent, but less drastic, fundamentalist Christian attempts at restricting what others view as creative expression.

Interestingly, the belief that exceptional virtue could lead to exceptional powers of creativity fostered a medieval Jewish legend of Rabbis so holy that they could invent a man—a *golem*—through their prayers and recitation of sacred letters. This religious legend was, paradoxically, transformed into a story of creative impiety in the *Faustbuch* of 1587 and Christopher Marlowe's *Tragic History of Doctor Faustus* of 1604, and a tale of human hubris and creation run amok in Mary Shelley's secular novel, *Frankenstein*.[9] In these works, the relentless curiosity, passionate pursuit of knowledge, and drive to create are presented as leading man to sin. Religious and secular voices alike have been raised against human creators who have, in their critics' eyes, tried to "play God" with their inventions, even inventions which to us today might seem morally neutral. For example, in 1839, the German *Leipziger Stadtanzeiger*'s editorial writers reacted vehemently to rumors that Daguerre had succeeded in developing a photographic image:

> The wish to capture evanescent reflections is not only impossible, as has been shown by thorough German investigation, but the mere desire alone, the will to do so, is blasphemy. God created man in His own image, and no man-made machine may fix the image of God. Is it possible that God should have abandoned His eternal principles and allowed a Frenchman in Paris to give the world an invention of the Devil? (Gernsheim 1965, 23–4).

In the twentieth century, religious fundamentalists (sometimes joining forces with secular groups they otherwise might oppose), have decried abortion, the development of nuclear weapons, and genetic engineering, as sacrilegious attempts to alter or destroy God's creation and as impious and irresponsible attempts to play God. Political demonstrations, legislative proposals, and in some cases, violence have been used to stop these attempts.[10]

REACTIONS AGAINST PARTICULAR TYPES OF CREATIVE WORK

More often than not, people will accept and even advocate creativity in certain realms of human endeavor but will dislike, disregard, or oppose it in others. Some, who view business as value-neutral or positive, accept virtually limitless innovation and expansion in business as entirely legitimate, but might balk at

certain forms of artistic creativity. Many artists, on the other hand, might well feel that art is "beyond good and evil," and that any restriction of artistic expression is a threat to all artistic creativity and therefore unacceptable; they might, however, be strongly opposed to corporate expansion plans in the neighborhood of their studios and deny that business could ever be called a "creative" activity. Scientists might feel that "pure research" is the ultimate form of creativity and should be supported to the maximum by society, but others might be appalled by the cost or direction of their research. Environmentalists might conceive of creative solutions to the destruction of nature (such as debt-for-nature swaps), but devote much of their creative energies to combat the "creative" output of business and science.

Then, too, the desire to block one particular form of creativity may lead individuals or groups to make otherwise inconceivable alliances with others, as in the case of some progressive feminists lobbying and demonstrating with Christian fundamentalists against what they call "pornography." The motivation of the two groups may be different, but the goal—preventing such work from being produced and distributed—is the same.

Individuals may even find themselves in contradiction about creativity as they seek to juggle more than one role in life. For example, Anthony Seeger, director of Smithsonian/Folkways Records, looks at the ownership (copyright) of creative work from the different perspectives of his life as a musician, a researcher, a coproducer of indigenous peoples' music, a record company director, and a member of an international committee on copyright. At any given time he may argue against his producer's interests for those of the indigenous singers or vice versa (Seeger 1991, 36). Seeger's dilemma is an extreme case of a very common one. At any given time we may be forced to choose against proceeding in a creative venture. We ask ourselves, for example, "Do I write my book or read one to my child? Do I sing in the chorus tonight or stay to solve this engineering problem?" In many cases, creative desires are multiple and simultaneous.

Corporations and individual inventors—even artists, writers, musicians, and filmmakers—committed to the value of creativity and innovation, seek to regain the costs of their research and development and to profit from the fruits of their creativity. They therefore go to great lengths to secure patents and copyrights. Competitors often try to circumvent these legal protections by modifying products ever so slightly or, ignoring legality altogether, through increasingly sophisticated industrial espionage and copying techniques (Haggart 1988, 179–189). Thus, the original creators do battle with increasingly creative imitators. For instance, the widespread copying of computer software is justified by computer hackers as a matter of democratic access to information and programs which can help everyone. The creators of that software usually want a financial reward for years of hard toil, transforming their unique ideas into a work of value.

The complexity of the issue was exemplified at the 1992 environmental summit in Rio De Janeiro. There, the Global Treaty on Protecting Biodiversity included plans to give royalties to countries whose microbes are used by private corporations of other countries for pharmaceuticals or other biotechnological inventions. Former President Bush of the United States rejected this treaty, claiming that the private corporations alone are the "creators" of these new inventions (of course, he still believed in the right of American corporations to own other natural resources, like timber and oil). President Clinton, however, later accepted the treaty.

Even within particular communities of creators, major disagreement may exist about the value of a particular form of creativity. As we saw, corporations may solicit innovative suggestions from their employees, but may penalize creative thinking, whether the ideas prove fruitful to the company or not. Scientists committed to research might, at the same time, feel that certain technological developments deriving from their experiments may be inappropriate.

Furthermore, as Thomas Kuhn has pointed out, every new invention or discovery constitutes a potential professional threat to others in the same field, because a major ". . . new theory implies a change in rules governing the prior practice of normal science. Inevitably, therefore, it reflects upon much scientific work they have already successfully completed" (1970, 7). In such a case, some scientists might argue vehemently against the new theory and even attempt to keep research, publication, and financial resources from being available to those supporting the new theory (1970, 5).

Most obviously, a particular creation may be rejected as simply *too* novel, too odd, too incomprehensible, too far beyond current technology or conceptions. Thus, many of Leonardo DaVinci's ideas, such as the helicopter, were simply beyond his era's ability to realize in any concrete way. Charles Ives' early twentieth-century experimental music was widely ignored as too bizarre—it fell outside the limits of what others considered "music." How many eccentric geniuses too far ahead of our time might be among us is impossible to tell—although countless individuals profess to be—and venture capitalists and some organizations seek out people they believe to be creative to support.[11]

Finally, resistance to a particular work may be directed more to the creator of it than to the work itself. Jews might refuse to listen to Wagner's symphonies, despite their musical qualities, because of his anti-Semitism; political conservatives might avoid any films with Jane Fonda, because of what they view as her traitorous action during the Vietnam War; women might choke on a good deal of world literature for its misogyny; when a creator is discovered to be gay, it may cause some to seek out his or her work, while others avoid it like the plague. Many make the decision to separate their animosity towards a creator from their appreciation for the creation. As George Orwell said of the painter, Salvador Dali, "One ought to be able to hold in one's head simultaneously the two facts that Dali is a good draftsman and a disgusting human being" (in Rader and Jessup 1976, 217–218).

EDUCATION AND KNOWLEDGE

In every society, childbearing and education will express and inculcate different definitions and valuations of creativity and will encourage or discourage what we mean by creativity to a greater or lesser degree. Many in America believe that a "liberal education" is the best possible basis for creativity, though it would be hard to prove that the United States today is more creative than societies like ancient Egypt or ancient China, which probably had traditions of education and childbearing which we would not consider liberal or enlightened in any way.

However, "education" originally meant "to lead or draw out," and to the extent that our educational institutions do this, they foster curiosity, exploration, openness, and a reaching toward new horizons, all of which seem characteristic of creativity. Still, as we all know, some teachers and some schools lead students step-by-step toward a preestablished, fixed realm called "knowledge." In that case, the teacher appears as the possessor of the object of knowledge, as the authority who directs the student to a specific end.[12] As a result, genuine exploration and creativity would be minimized. For Albert Einstein,

> It is nothing short of a miracle that the modern methods of instruction have not yet entirely strangled the holy curiosity of inquiry; for this delicate little plant, aside from stimulation, stands mainly in need of freedom; without this it goes to wreck and ruin without fail. It is a very grave mistake to think that the enjoyment of seeing and searching can be promoted by means of coercion and a sense of duty (in Amabile 1983, 3).

In addition, most educational institutions adhere to a system of rewards and punishments, which, according to Teresa Amabile's extensive research, often hinders creativity. The rewards, of course, are usually given for getting the "right" answer. Where there is only one acknowledged "right answer," the room to imagine and be innovative is virtually nonexistent. In line with Einstein, Erich Fromm writes of the natural capacity of children to be puzzled about the world, "But once they are through the process of education, most people lose the capacity of wondering, of being surprised. They feel they ought to know everything, and hence that it is a sign of ignorance to be puzzled at or surprised by anything" (1983, 48).

Almost by definition, a focus on "knowledge" (that which is already known) seems in opposition to our society's belief in creativity as the act of bringing forth something new. On the other hand, knowledge of what has been and is generally functions as a prerequisite to creating anything that has not yet been.

Furthermore, it is clear that the "learning styles" most strongly cultivated in the West are, to use Howard Gardner's terms, the "linguistic" and "logical-mathematical" types. While these are certainly crucial, they often put a damper on imagination. Free play of the mind barely begins before the internal censor de-

mands, "What do you mean by that?" "Can you prove it?"[13] As Julia Cameron has noted:

> Creativity cannot be comfortably quantified in intellectual terms. By its very nature, creativity eschews such containment. In a university where the intellectual life is built upon the art of criticizing—on deconstructing a creative work—the art of creation itself, the art of creative construction, meets with scant support, understanding, or approval. To be blunt, most academics know how to take something apart, but not how to assemble it (Madrigal 1996, 132).

Above and beyond this, a primary characteristic of linguistic and logical thinking is the ability to categorize and generalize. As essential as this may be, categorization necessarily involves a simplification, an ignoring of particular differences, even a stereotyping of things, which leave out the richness of the details and which limit our understanding, appreciation, or even usage of that thing. Calling that thing "a gray tree" instead of a speckled bush, might cause us to paint it differently, to view its economic value differently, to consider its nutritional or medicinal potential differently (See J. Adams 1986; Erich Fromm 1959).

If it is true, moreover, as James L. Adams asserts, that practicing multiple ways of thinking—verbal, visual, and mathematical (and we could add aural and kinetic)—fosters creativity, then we are hindering our students by overemphasizing two primary types of learning. Surely the arts and music departments are the barely tolerated stepchildren of American schools.[14]

TENSIONS INHERENT IN THE RELATIONSHIP BETWEEN CREATIVITY AND SOCIETY

Each society defines "creativity" in different ways, and these definitions invariably mean that certain realms of human activity will be highlighted more or less and that certain individuals will receive more or less encouragement to be creative. We are now so democratic and interdisciplinary in our use of the word "creative" that it is difficult to see that there may be kinds of creativity or groups of creative people we still routinely neglect or minimize. For instance, our society's strong commitment to specialization and productivity means that interdisciplinary work and process-oriented activities have been relatively neglected, even though they are increasingly recognized as creative.[15]

This brings us to the general question of the tensions inherent in creativity in any given society. Since society is a complex web of relationships among people, and since even the most progressive of societies necessarily have entrenched traditions, many individuals may feel the heavy weight of the past as well as the demands of the present on them, and this can greatly reduce any desire to be creative. We might even agree with Ecclesiastes (1:9) that, "there is nothing new under the

sun." Indeed, the all too common movement from youthful enthusiasm and idealism to older exhaustion and cynicism is related in part to an increase in knowledge: we learn that "this has been tried before" and decide not to invest any more energy in the project.

But if the weight of the past and the known hinders creativity, so, in many circumstances, can the power of the future and the unknown, despite the fact that a drive toward the future and a desire to explore the unknown are essential features of creativity. The unknown not only elicits fear sometimes, but always, by its very nature, confuses us as to how to proceed. "Lost in a dark wood," as Dante put it, we may be so stymied by the choice of which path to take that we stay put (which, of course, might prove to be a good choice). Here we see that the known path can be a good guide into the future . . . though it may bring us back to our old problems and probably won't allow us to discover or create.

Even if we return by the old path, however, and even if there seems to be nothing new, each approach may bring something different into relief; new experiences and new attitudes are possible with every step. That is how, as we've seen, traditional cultures conceive of creativity: as reinterpretation of tradition.

In every culture, the socialization process involves inculcating in the population ideas of what constitutes knowledge and how to come by it; standards of behavior; standards of beauty; ideal values, and other beliefs. Education emphasizes these beliefs and habits, the laws enforce them, and so on. Every single new creation or discovery augments these standards and traditions to some degree. Usually, the creations reinforce the customary approach; still, the contours of the tradition are no longer the same (i.e., Monet, Renoir, Van Gogh, Sisley, etc. all might be subsumed under the category, "Impressionist," but each changed how impressionism came to be viewed). And, of course, at any given point, a reigning artistic, scientific or social paradigm might be modified sufficiently that it becomes a *new* paradigm, expressionism, for example. When, in science, new inventions and discoveries have altered perceptions sufficiently, and ". . . the profession can no longer evade anomalies that subvert the existing tradition of scientific practice—then begin the extraordinary investigations that lead the profession at last to a new set of commitments, a new basis of science" (Kuhn 1970, 6). The result is a scientific "revolution," such as that ushered in by Copernicus, who saw the sun instead of the Earth as the center of the cosmos.

Sometimes, moreover, great creativity requires "breaking the rules" (Adams 1986, 64). That is why Martin Luther King, Jr., said that what the world needed were "creative extremists" (92). King's efforts remind us that in many cases, society writes its rules with the purposeful intent of excluding some of its own members. Groups pushed to the margins might try to create in isolation from the dominant culture, might try to win the dominant culture's approval on the basis of the rules given, or might push against the rules, violently, or peacefully as King and others did.

As J. M. B. Edwards has pointed out, while individuals in marginalized groups of a society—Jews, Blacks, Latinos, and Asians in the United States, for instance—may have various insecurities related to that marginalization (and may therefore overly conform to the mainstream), the "creative" individual from these groups

> is an exception to this pattern in that he is able to turn his marginal status, whether sought or unsought, to good advantage. . . . From a sociological point of view, the striking fact about such careers is the ability of the creative individual to alternate periods of disaffiliation and solitude with periods in which a variety of social roles are sustained with great effectiveness (448).

According to Arnold Toynbee, this takes place only to the extent that individuals or groups can withdraw to the margins but then return and have their creativity communicated through the whole of the society.

But society does not merely repress and ignore those it habitually marginalizes, it resists almost by nature all initiatives which might cause it to change its standards and customs. The voices of the excluded minorities, like revolutionary works of art and scientific theories, may threaten the status quo, and the majority may then resist them.

As King's life makes clear, the creative process may therefore be quite painful for the individual who is determined to introduce novelty (Amabile, Steinkraus, May). It comes as no surprise, then, that psychological tests indicate that many of the individuals who are viewed by society as especially creative have high levels of "ego strength," high levels of "psychopathology," and generally low levels of "socialization" (Barron 1969, 71–75). These creators need ego strength to persevere in the face of society's resistance to change, and once they succeed in winning society's approval, the fame further enhances their sense of ego.

And yet, since "the generic disposition in these [creative] experiences is perhaps an openness to experience on the fringes of ordinary consciousness" (202), creators often seem to be on the fringes of the socially "normal" as well. It is telling that our society so often speaks of creative individuals as "eccentric," "bohemian," or "mad." That our society can believe so strongly in the image of the "mad" artist or scientist while simultaneously believing that everyone can and should be creative, might reveal a form of social schizophrenia.

"Normal" is an ethical assessment by a culture, and as Michel Foucault has emphasized, our society pursues "the constant division between the normal and the abnormal" in every domain (1977, 181–2). "Creative" is a similar ethical assessment of a person, act, or object that is viewed (and usually valued) as *beyond* the norm. When a person is outside the norm but *devalued*, he or she is often viewed not as creative, but crazy, criminal, evil, etc.[16] Other societies and future generations may disagree with these evaluations of course, and the individuals we tend to consider most creative are precisely those who alter society's standards!

Describing how the widely used Minnesota Multiphasic Personality Inventory (MMPI) test works, Frank Barron says, "The 'normality' of a subject's response is . . . appraised in terms of its agreement with consensus of opinion of normal adults" (1968, 309). This is the modus operandi of many tests of personality, and indeed, the way most of us most of the time judge "normalcy." Note, however, the circularity in Barron's sentence: "normal" adults judge the "normalcy" of a person's response to something. Circular as it is, this is phenomenologically true of any society.

This may mean that the emerging notion in our society that "everyone is creative" might reach a dead end. The word has thus far meant that some deed or work stands out—goes beyond "the norm." Conceivably, every individual could be creative in some way different from everyone else . . . in fact, this would be genuine individuality, the dream of Western society for the past two or three centuries. In this case, creativity would be the norm; the word, "creative" would mean something like "different." But even then, we might want to impose standards and refer to that which stands out: the creative is not just different, but also somehow significant.

UNINTENDED CONSEQUENCES

Just as virtually anything may become an obstacle to creativity, virtually every creative activity may have consequences unforeseen or undesired by its creator.

When large dams were erected earlier in this century, they were understandably opposed by local people who would subsequently be flooded out and lose their ancestral homes, but the goals of flood control, drinking water, and hydroelectric power were held to be far more important. No one seems to have predicted the tragic environmental consequences that some of these massive projects have wrought, such as silt and algae buildup, evaporation clouds, changed weather patterns, and marine life changes. Likewise, when the Beatles made their so-called *White Album,* they presumably had no idea that it might trigger Charles Manson to carry out a mass murder.

Clearly, the more that is known and the greater the horizon of consideration, the better we can predict the consequences, both positive and negative. Based upon those predictions, we might carry out a "cost/benefit analysis" before proceeding. In the United States today, virtually all medium to large construction projects are subject to "environmental impact" statements. And on some level, we all attempt to weigh the consequences: can I risk the time, money, investment of energy and ego in this project? Often, our initial enthusiasm cools when we consider these things "rationally." Some people give up very quickly.

More dramatically, there may be widespread social hostility to or fear about the consequences of a new creation, even if the idea, in the abstract, finds some approval. That is why the story of Frankenstein has continued to resonate in our

culture. The other important aspect of that story deals with the creator who rues his creation, for many have felt that way. The Renaissance painter Botticelli, influenced by the preacher-monk Savonarola, burned several of his own paintings for glorifying human, instead of divine beauty. Robespierre must have experienced at least a bit of regret at helping set in motion the French Reign of Terror which ultimately claimed him as its victim. Even optimistic Henry Ford apparently had some regrets—he had expected the automobile to allow people to continue living in the countryside and was demoralized when his creation actually increased urbanization.

Indeed, the image of the creative individual who lives to regret his own deeds lies at the heart of Greek tragedy, and hence, of the Western tradition. Sophocles portrays the legendary Theban Kings, Oedipus and Creon, as designing policies which ultimately led to their anguish. Shakespeare's Macbeth follows the same route.

This motif is deeply ingrained in our society and reiterated by all manner of often well-meaning Cassandras who warn us against a certain course of action. Together with the voices inside us expressing rational concerns of the consequences of our work, the image might easily lead us to expect the worst, so that we hesitate to create at all. Who knows how many will be unemployed, who knows what environmental problems will ensue, who knows how much alienation will result among the users of that invention she's working on?

On the other hand, to worry too much about unintended consequences will surely lead to inaction.[17] Without courage, any one of the above-mentioned obstacles to creativity—social, political, economic, religious, or professional blocks—will overrule the creative urge. That is why "ego-strength" is so characteristic of creative individuals and why the books and workshops on creativity so consistently work at helping individuals "follow the beat of their own drummers." One need not be courageous in every respect, but one must have the strength to commit oneself to the creative effort.

In fact, the refusal to be hindered by the kinds of obstacles mentioned above, the willingness to treat these problems as challenges or minor annoyances rather than as roadblocks, lies at the heart of the creative attitude. Indeed, all the restrictions and obstacles mentioned in the above pages may ironically have the unintended consequence of *spurring* creativity. This is obvious in the realm of science, where reputations are made, in part, by disproving or transcending a supposedly unassailable theory. It is clear in the arts and literature, where, for example, concepts of the sexually tolerable are pushed further and further. It is clear in the business world, where success is often perceived as the ability to reduce costs or penetrate new markets or cleverly respond to government restrictions and competitors' power. It is clear in the works of some individuals from marginalized social groups and even political prisoners whose oppressive treatment inflame their creative efforts.

The concept of creative problem solving is based on the notion that we are faced with a challenge that we strive to overcome. In practice, of course, Cezanne's struggle to deal with the problem of light and color hardly seems as significant as a concentration camp prisoner's effort to survive and create anything at all. In either case, however, creativity is the art of treating any kind of obstacle as a challenge to be overcome.

And for those who hold this attitude and practice this art, the less extreme obstacles listed here become part of the warp and woof of the creative process and pale in significance compared with the joy and fulfillment felt in creating.

CHAPTER THIRTEEN

CREATIVITY AND SOME CONTEMPORARY
POLICY ISSUES IN THE UNITED STATES

The many ways in which creativity may be questioned or blocked are to be found in all human societies to differing degrees. While the United States may not present as many authoritarian legal-political blocks as most countries, its aim of adhering to "the rule of law" means that almost any obstacle mentioned above may spur legal or political responses.

And in general, American society is epitomized by constant wrangling about laws and public policy; there are more lawyers and more litigation in the United States than in any other country. Thus, despite its broad-based commitment to the ideology of creativity, the American population subjects many forms of creativity to legal controversy.

In every stable society, including the United States, there must be consensus about at least a few key values. Thus, the American "social contract" implies general acceptance of electoral, representative government; private property; freedom of speech, assembly, and belief; punishment of crimes such as murder, theft—and yet issues and legal cases continually crop up, in part because specific cases provoke conflicts between our primary beliefs. When groups representing conflicting interests clash, many societies appeal to traditional values to attain consensus. Some people in the United States also make such an appeal, but this is also often seen by others as inappropriate, or even as manipulative self-interest. Therefore, our society relies on formal, technical, bureaucratic, regulatory, and legal-judicial means for peaceful cooperation among competing interest groups and sectors of the society. Sometimes the belief in this process is one of the only values we share. And therefore, it is precisely in law and public policy that our value conflicts come so clearly to the fore (B. Wilson 1988, 39).

Thus, national debates rage on countless values issues; as a result, each year sees perhaps twelve thousand new bills passed by the United States Congress, thousands of decisions made by the executive branch regulatory agencies, and perhaps

nine thousand cases examined by the Supreme Court, one-tenth of them considered serious enough to review. In a representative democracy like the United States, any single piece of legislation may be looked at as a multifaceted exercise in creativity: the conceptualization and writing of the initial proposal; the modifications through research on it; the debating, negotiating, arm-twisting, and compromising; the strategic scheduling of consideration of the bill; the connection of it to other bills and budget matters; winning approval of both Senate and the House of Representatives as well as the President. Then, the executive branch and state and local agencies must put what is often a broad, ambiguous, possibly contradictory or barely practical bill into practice as best as possible. Then concerned members of society may go to court over the effect of this legislation on them; lawyers argue as creatively as possible to win; judges and juries consider the situation; if necessary, higher courts, including the Supreme Court, consider the question. Policy making and policy review, therefore, can be viewed in every case as an exercise in creativity. As Robert Blank has explained regarding science policy, for example, every public policy debate may involve multiple, competing factors:

> (1) individual freedom and choice, (2) social or public good, (3) scientific and technological progress, (4) quality of life, (5) human dignity, (6) efficiency, (7) social stability, and (8) alternative concepts of justice themselves based on goals of equity, merit, or need. Reactions to specific innovations, as well as to science and technology in general, will vary depending on the predominant social values (Blank 1981, 235).

These variables affect the specific policy debates regarding all kinds of creativity. If we look at the United States today, we see that American policy, may tolerate, support, or hinder creativity, based upon other presumed values. In general, the following courses are pursued:

1. As the U.S. Federal Budget reveals, government may explicitly support a type of creative endeavor with funding and publicity, as we see in the cases of the National Institutes of Health (NIH), the National Air and Space Administration (NASA), and the National Endowment for the Arts. In addition, a variety of tax breaks and credits aim at reducing the general tax contributions of certain organizations and individuals in order to help them work on their creative projects. In any case, this support reflects the belief that society will be benefited by such creativity.

2. Government may follow a policy of noninvolvement, leaving individuals the freedom to create all manner of things at home or in business and letting the private sector produce and show particular works of art or commercial enterprises.[1]

3. Government may establish certain restrictions or standards which limit the freedom of entrepreneurial ventures or artistic expression. (The Food and Drug Administration, the Federal Communications Commission, and the Environmental

Protection Agency, for example, preapprove commercial entry into their respective areas.)

4. Government may control, prosecute, fine, imprison, or even execute individuals for particular forms of "creative" actions. We have laws aimed at limiting corporate destruction of the environment, against libelous speech, against the theft of copyrighted and patented work, and against all other types of crime, no matter how creative they may appear.

To some extent, the question of supporting a possible form of creativity is a matter of costs and benefits. To what ends should our tax dollars be spent? Which form of creativity can best be helped by government spending, and which can flourish without it? And what standards should be applied to the funding, so that the money is not just thrown at second-rate work? Value issues are therefore implied by these financial considerations. Ultimately, people ask, "Which is of greater importance to the society?" "Which best fosters human dignity?" "How can we allow this?"[2]

I believe our understanding of creativity is enhanced when we look at policy issues where public involvement in creative projects is hotly debated. This is where the question of the appropriateness of creativity—focused on by many authors attempting to present a theoretical definition of creativity—arises. We can see the margins of creativity, for example, in the debates surrounding subjects such as genetic engineering, art and obscenity, abortion, government funding of new technologies, communications law, and so on. Some might deny that these subjects have anything at all to do with creativity, but advocates in each of these debates claim rights such as self-expression, free inquiry, the pursuit of truth, the right to choose, artistic freedom. Other values are also entwined in each case, and none of these stated rights is entirely reducible to "creativity"; nonetheless, creativity is an important aspect of each debate.

CASE STUDY: BIOTECHNOLOGY OR GENETIC-ENGINEERING

Although hybrid plants have been developed through genetic manipulation for more than a century, it was not until the 1953 discovery by Francis Crick and James Watson of the double-helix structure of deoxyribonucleic acid (DNA) and the deciphering of the complete genetic code in 1966 that the possibility existed to directly alter genes by "recombining" their DNA. Indeed, it was not until 1973 that the first gene was cloned and 1974 that the first gene was cloned from one species to a different one; in 1996, the first animal was successfully cloned, and, at the turn of the millennium, the possibilities for cloning and genetic manipulation seem nearly infinite.

Many in the society continue to think of scientific discovery as "mere" disclosure of preexistent realities and may hesitate, therefore, to call science "creative";

they may even have difficulty understanding the creative theorizing and research carried out by Crick and Watson. Nonetheless, the ability to recombine DNA is usually understood to be a clear case of creativity. Indeed, this work has been referred to as "genetic engineering," and we call the product recombinant DNA (rDNA). Therefore, just as conceptions of creativity expanded in the nineteenth century to include structural engineers, it has now expanded to include biologists. There can be no doubt that biotechnologists "invent" new genes. Splicing existing genetic material and recombining it creates a new genetic reality every bit as much as the combining of materials in literary or technical works may be creative. Scientists and corporations have strong financial motivations to call these recombined genes creations or inventions, and they have succeeded in convincing most governments around the world to legally entitle these new creations "patentable."

And because patent law allows these new life forms to be viewed as "property" which can be sold, hundreds of American and foreign firms are engaged in biotechnological research and development, primarily in the areas of medicine, pharmaceuticals, and agriculture: the money to be made is enormous. In fact, when Genentech Corporation went public on the New York Stock exchange in 1980, it set the record for the fastest price per share increase in United States history ($35 to $89 in twenty minutes); when Cetus Corporation went public in 1981, it set a new record for the largest amount of money raised in an initial public offering ($125 million).[3]

But the near-hysterical enthusiasm of investors for biotechnology stocks has been matched by the near-hysterical critics of biotechnology. Because genetic engineering can bring forth things which never were, it is potentially dangerous and, for some, even blasphemous. From an environmental health perspective, the question is, will the new genetic material disturb the balance of existing genetic material? From the religious perspective, the question is, how can we tinker with God's creation?[4]

If there had been no opposition to biotechnology, there might still have been some government involvement in the field, since in 1984 the U.S. Office of Technology Assessment (OTA) felt the need to analyze the commercial competitiveness of the American biotechnology industry relative to that of other countries. The OTA expressed serious concern that the "lead" of the United States in the field might be "lost" to Japan, which had specified biotechnology as the "last great technological revolution of the century" and a "national priority." The report concluded with the recommendation for additional United States government funding for research, even though the "United States efforts to commercialize biotechnology are currently the strongest in the world" (1984, 371, 73, 84).

For the most part, United States government involvement in biotechnology has been determined by the 1980 Supreme Court decision, *Diamond v. Chakrabarty* 447 U.S. 303–309, which ruled that newly designed microorganisms were eligible for the same patent protections as any other inventions. In this respect, regulation of recombinant DNA has been subject to the same general health, safety, and

environmental laws as every other product: the United States Department of Agriculture, the Food and Drug Administration, the Department of Commerce, and the National Institutes of Health are responsible for monitoring biotechnology.

Health, safety, and environmental issues lie at the heart of biotechnological development. In terms of products, the creation of artificial insulin and efforts to replace disease-and-deformity-causing genes are specifically aimed at improving health; the design of bacteria which clean up copper and oil residues is aimed at helping the environment. For opponents of rDNA, however, these efforts do not obviate the genuine threats posed to health, safety, and the environment.

The National Institutes of Health have moreover been the primary support for the Human Genome Project. While not specifically introducing new genetic material into the world, this extensive research effort to determine and map all the genes of human beings is both an extraordinary collective creation and another development which has elicited significant social-political response. While the identification of genetic abnormalities by means of the mapping will enable, in some cases, great medical improvements, there is also great fear that people who have identifiable genetic abnormalities will lose employment and/or be socially ostracized. A raft of recent legislation in the United States Congress has been initiated to protect people from workplace discrimination, loss of insurance benefits, and to guarantee privacy.

While employers and insurance companies resist certain parts of these bills, there is widespread public desire for such controls. Significantly, nothing in the proposed legislation is aimed against the Human Genome Project itself (but rather, how the genetic information may be utilized), and there would seem to be little reason for a geneticist to oppose such bills. Indeed, at the Gordon Research Conference on Nucleic Acids in 1973, many scientists themselves expressed worries about bio-hazards and organized the 1974–75 Asilomar Conference to specifically address the potential risks and benefits of rDNA. The conference participants then urged the National Institutes of Health to establish an advisory committee on recombinant DNA. However, the 1976 guidelines, which barred the release of any rDNA into the environment, applied only to those receiving government funding, not industry research. In 1977, Senators Edward Kennedy and Jacob Javits attempted to have all rDNA research placed under federal control, but to no avail (U.S. Congress 1979, 7). Then, in 1978 the guidelines in the Federal Register called for public participation in regulating the industry.

Still, commercial interests dominate. As a result, even though eight new bills were presented to Congress between 1987 and 1993 calling for limitations on the patenting of genetically altered animals, no action was taken (Lesser 1995, 907). Only because of conservative opposition to abortion, did Congress ban federal financing of research on fetal tissue (something which still leaves corporations free to pursue such research). Like the United States government, both the Organization

for Economic Development and Cooperation and the United Nations also approved moderate guidelines for biotechnology in the face of potential dangers. In practice, however, the only international controls on recombinant DNA are voluntary and aimed primarily at research, not at commercial development. Only regarding biological weapons has any international agreement been reached that emphatically forbids genetically engineered materials from being used—but the monitoring and enforcement of this have been very problematic.

While some activists like Jeremy Rifkin have persistently lobbied the United States Congress and the courts for controls which would keep new organisms from entering the environment, the release of genetically engineered "ice-minus" in 1986 to protect strawberries from frost prompted a general relaxing of concern about the agricultural use of biotechnology because no visible harm ensued. However, when a 1999 Cornell University research study indicated that genetically altered corn pollen had severely affected the monarch butterfly population in Mexico, the European Community temporarily halted transgenic agricultural imports, and concern increased in America as well.

Fears of a "brave new world" of human genetic manipulation abound, especially as biotechnology enters the field of medicine. After all, the new research seems aimed at nothing less than producing smarter, stronger, healthier human beings. Critics ask, who will get the "best" genes? How will this be decided? Will the "weakest" not be allowed to reproduce? References to Nazi genetic experimentation and efforts to maintain the purity of an elite race are frequent. Activist Rifkin, for example, described the genetic manipulation of humans as "eugenics" *(Time,* 8 Nov., 1993). These concerns were exacerbated in 1987 when the U.S. Patent and Trademark Office expanded the court's ruling in *Diamond v. Chakrabarty* to include genetically altered higher animals (USPTO, B. App. and Int. *Ex parte Allen* U.S.P.Q 1987, 193).[5] When genetically engineered cells were then in 1990 injected in humans, and the first human gene was cloned in 1993, the sense of urgency many felt was extreme.[6] And the developmental trajectory is clear. In July 1996, British scientists managed to clone "Dolly" from adult sheep cells; in February 1998, separate teams of United States and Dutch scientists cloned calves from fetal cells; six months later, Japanese scientists repeated the Dolly experiment, and then one month later, Australian scientists successfully cloned the last surviving member of a species of cattle. In what seems to be quite an understatement, cloning expert Robert Foote told the media, "I suppose you could say that . . . the probability of cloning an adult human being is less remote" (San Francisco Chronicle, 6 July 1998, A10) The recent discovery that Dolly was cloned with aged, not youthful genes, appears as a major setback to these developments (Sheep Clone 1999, A1, A17). Still, the Italian bull, "Galileo," was cloned a few months later; the scientific, medical, and corporate interests in continuing to pursue cloning are great, and hopes for "success" have been only slightly dampened.

Although the work in genetic engineering is mainly a matter of recombining existing material, few dispute that we are dealing with human creations equal to or greater in significance than any the human race has heretofore devised. As Robert Sinsheimer has said, "for the first time in all time, a living creature understands its origin and can undertake to design its own future" (Issacs 1987, 84).

The possibilities seem infinite, especially now that scientists have found ways to cultivate undifferentiated root cells which can theoretically be manipulated to grow into any of the body's specific cells, and to keep cells alive way past their expected mortality. Serious discussion of cellular "immortality" now takes place (Wade 1998, A1, A21).

And beyond this lies the even more fantastical realm of "nano-technology," envisioned forty years ago by Nobel laureate Richard Feynman, facilitated by the IBM Scanning Tunneling Microscope, invented in the 1980s, and popularized by Eric Drexler's 1986 book, *Engines of Creation*. Here, physicists manipulating atoms and biologists manipulating genes are converging to a point where the rearrangement of almost any molecule (and therefore the complete restructuring of the world) is possible. Presently, major efforts are underway to "grow" new forms of computer circuitry. (Einstein 1999, B1, B6), but that seems just the beginning. Drexler for one, feels that the creative possibilities here are limitless, but not without their dangers (Regis 1995).

Regarding such dangers, Sinsheimer is quite clear that "the history of mankind gives scant reason to hope that such powers will be wielded solely in the interests of justice and mercy. . . . Are we really bright enough to trust ourselves to begin making these kinds of changes in the human gene pool when we don't know what the future holds?" (Foote 1982, 95). Indeed, already in 1980, in a Letter to the President of the United States, Dr. Claire Randall of the National Council of Churches, Rabbi Bernard Mandelbaum of the Synagogue Council of America, and Bishop Thomas Kelly, of the United States Catholic Conference, declared:

> We are rapidly moving into a new era of fundamental danger triggered by the rapid growth of genetic engineering. Albeit, there may be opportunity for doing good; the very term suggests the danger. Who shall determine how human good is best served when new life forms are being engineered? Who shall control genetic experimentation and its results which could have untold implications for our human survival? Who will benefit and who will bear any adverse consequences, directly or indirectly? (National Council of Churches, Appendix A, 47).

On the other hand, throughout history, popular fears of scientific and technological advances have usually dissipated over time, as the majority, or at least those in power, have come to see the benefits of science and technology.

And the concrete benefits of genetically engineered insulin and pollution-eating bacteria have impressed many with the great potential for improving life through biotechnology.

What is more, scientists' creative impulses are strong. Astronomer Carl Sagan agrees that society needs to "exercise prudence" (1978, 245), but approvingly cites a number of scientists, like T. H. Huxley and A. N. Whitehead, who have argued that society's fears should not stand in the way of learning, and Jacob Bronowski, who insisted that "knowledge is our destiny." Biologist Lewis Thomas can see many reasons to "govern" genetic engineering through government agencies, but he asks rhetorically: "Should we stop short of learning about some things, for fear of what we, or someone, will do with the knowledge? My own answer is a flat no. . . . Learning is what we do, when you think about it. I cannot think of a human impulse more difficult to govern" (1977, 325).

Many would agree with these eloquent pleas that the creative impulses of scientists should have the same opportunities for expression as those of creative artists and writers. Indeed, we might expect scientific research to receive the same constitutional guarantees as those of speech, press, and belief presented in the First Amendment to the Constitution. Large numbers of people probably accept almost limitless scientific investigation but would balk at production of certain things. However, genetic engineering seems to blur the line between scientific investigation and production—what is being investigated is precisely the ability to create new genetic material. Therefore, even if, as some believe, science is neutral and impersonal, the particular case of genetic engineering illustrates the fact that the "distinction[s] between discovery and invention or between fact and theory . . . are exceedingly artificial" (Kuhn 1970, 52). So even if the new material is patentable, should the producing act necessarily be protected as free expression?

Whether or not most Americans would grant scientists unlimited rights to creative research, what has legally protected biotechnology in the United States is the society's overriding commitment to commerce, as witnessed by the Supreme Court's 1980 decision respecting the patentability of genetically engineered materials. This does not mean that Congress cannot impose more restrictions on what is produced or call for more regulation of how it is produced, but commercial interests do carry extraordinary weight in this society.[8]

Coupled with the widespread societal belief in the value of science and creativity in general, public opposition to particular developments has generally been moderate or nonexistent. And even when the public attempts to participate, most people find that the science is extremely arcane and that the policy "decisions respecting science involve immense financial, strategic, and political implications, and the source of values involved in policy may often be hard to locate in the bureaucratic corporate structures by which science is now regulated" (J. D. M. Devrett in B. Wilson 1988, 8).

Still, for many religious traditionalists, genetic engineering is intolerable; for every citizen, the possibility of even a single environmental or health catastrophe is enough to elicit anxiety. The policy debates about these developments will no doubt continue, even if the biotechnology industry's record of achievement continues positively, because every specific instance of genetic engineering provides different dangers. Already questions about discrimination and social morality regarding genetic access loom large. If and when an environmentally harmful engineered gene emerges, if and when significant options exist for parents to modify the genes of their offspring, the public debate will be enormous. Public policy will then reflect a mixture of values and inputs which pertain to creativity in general but are highly charged in the case of genetic engineering and biomedical technologies.

CASE STUDY: OBSCENITY

In many respects, the First Amendment to the U.S. Constitution guaranteeing freedom of press, assembly, and belief has established a very protective environment within which all manner of creative expression may take place. Indeed, this amendment is often viewed as guaranteeing "freedom of expression," and this freedom includes much that we would view as creative. While debates about "obscenity" may or may not include arguments that the expression concerned is creative, the debates raise a number of fundamental questions about the limits to American society's conception of creativity.

The 1973 U.S. Supreme Court decision, *Miller v. California* 415 U.S. 15, led to the determination that a work may be considered legally obscene and forbidden if the average person in a particular community finds it appeals to a "prurient" interest in sex, and if it has no other redeeming social value. Clearly, the issue is not about the legality or morality of sexual acts like rape, prostitution, or sex with minors; the court is concerned with written and visual representations:

> "Obscene" means that to the average person, applying contemporary standards, the predominant appeal of the matter, taken as a whole, is to prurient interest, i.e., a shameful or morbid interest in nudity, sex, or excretion, which goes substantially beyond customary limits of candor in description or representation of such matters and is matter which is utterly without redeeming social importance *Miller v. California* 413:15, footnote No. 1, p. 17 (1973).

These ideas followed from an earlier decision, *Roth v. United States* 354 U.S. 476, 502 (1957), but now the Court specifically distinguished "obscenity" from other activities which were covered by the First Amendment guarantees of free speech and free press:

> In our view, to equate the free and robust exchange of ideas and political debate with commercial exploitation of obscene material demeans the grand concep-

tion of the First Amendment and its high purposes in the historic struggle for freedom. . . . The First Amendment protects works which, taken as a whole, have serious literary, artistic, political or scientific value, regardless of whether the government or a majority of the people approve of the ideas these works represent. . . . But the public portrayal of hard-core sexual conduct for its own sake, and for the ensuing commercial gain, is a different matter" *Miller v. California* 413:15, pp 34–35 (1973).

This position did not remain unchallenged, however. Not only did the defendants assert their right to expression, but even as the decision was handed down, Justice Douglas dissented, noting that "obscenity" was not mentioned in the Constitution and that the current Court members themselves "could not agree on the application" of the "new and changing standards of 'obscenity'" they themselves "had created" (413:15, p.39).

The majority view was further elaborated in the case of *Brocket v. Spokane Arcades, Inc.*, 472 U.S. 491, in which the Court said that the community from which the jury comes has the right to decide if material appeals to sexual interests "over and beyond those that would be characterized as normal" in that community. However, the Court then seemed to reverse itself in *Jenkins v. Georgia*, 418 U.S. 153 (1974), when it overruled one community's decision and said, "it would be a serious misreading of *Miller* to conclude that juries have unbridled discretion in determining what is patently offensive" (Burns, et. al., 1989, 83–87).

Confusing or not, the Supreme Court had to address this issue of obscenity because law is ultimately rooted in and is concerned with the normative codes of conduct in the society—indeed, the moral tone of the words "morbid and shameful" first mentioned by Justice Warren and included in the Court's definition of obscenity, is obvious. In the *Jenkins* case however, the Court threw the matter back to social custom, apparently because it couldn't decide on an unequivocal moral standard.

With this subject, we have an interesting paradox: because novelty often shocks us, the difference between the shock of the new and the shock of the obscene is sometimes ambiguous. Is something obscene, unusual, or creative? Once we become very familiar with a sexual motif, or for that matter, scenes of violence, they may appear neither unusual nor obscene, unless the context is altered. Indeed, according to David Freedberg, "arousal by image (whether pornographic or not) only occurs in context. . . . If one has not seen too many images of a particular kind before, and if the particular image infringes some preconception of what should not be or is not usually exposed (to the gaze) then the images may well turn out to be arousing" (in K. Johnson 1991, 108).

This is not merely a matter of individual experience, but also of historical and cultural conditioning. "Pornography [or obscenity] as a legal and artistic category seems to be an especially western idea, with a specific chronology and geography"

(Hunt 1993, 10). Few Americans today would insist upon covering all nude statues and paintings with veils as was done to Michelangelo's works following the Council of Trent in 1565; the "immorality" suppressed by the U.S. Motion Picture Codes of 1930 hardly seems inflammatory today. Americans may find western erotic paintings "lewd" and some photographs disgusting, but they may be intrigued by and accept Japanese erotic art (108); things that are taboo in other cultures may be quite acceptable to us, and vice versa.

Meanwhile, many Asians may find the public displays of affection commonly engaged in by American tourists far more offensive than artistic expressions of sexual intercourse, and many Europeans who denounce American puritanism about sex may be appalled by the public disclosures of personal "perversions" on American TV talk shows.

For these reasons, it seems to make sense that the Supreme Court emphasized "community standards"—however, as culture becomes more global, local community cohesion is disappearing, and attitudes and values are changing. That is precisely why religious fundamentalists, be they Christian, Moslem, or whatever, and cultural traditionalists, be they conservative Republicans or Ibo nationalists, resist the advances of global culture: they want to keep their sense of community identity and fear or resent its disruption.

In line with this, the Supreme Court's idea that state or local communities be the arbiters of "normality" seems quaint in this era of global telecommunications and mobility. Indeed, can one define "normal" without defining the community? If art critics from New York, London, and Paris travel to Cincinnati, Ohio or simply take an interest in art shown there, are they to be excluded from the "community" which decides what is obscene? If Reverend Donald Wildmon and his Mississippi-based American Family Association manages to arouse association members from across the country to rally in Cincinnati, are they part of the community? Are artists the community? Museum goers? All residents of Cincinnati? As philosopher Alan Montefiori has said,

> We no longer live in one easily identifiable and self-identifying community, but within an overlapping, criss-crossing, highly heterogeneous number of communities with their more or less different languages, which are natural (everyday), conceptual (abstract intellectual), and ideological (political-religious, value-laden) (1988, 27).

Indeed, if arousal or "prurient interests" are to a significant extent a matter of personal and cultural background, and if communities are in flux, can we easily speak of ethical norms? This returns us to the general problem discussed earlier about creativity in context. As Lasswell has emphasized, "*norms of expectation* are involved in perceiving novelty or the lack of it in a given pattern. *Valuative norms* are obviously involved in judging that an innovation is 'valuable'"(1959, 203).

Obscenity clearly breaks with the second, but perhaps only because it breaks with the first. The Supreme Court's notion that "the average person in the community" be the one who sets the standards for obscenity adds considerable difficulty. Even if we could decide where the borders of the community lie, deciding who is the "average" person would not be easy. In fact, this points to a conceptual problem that lies at the heart of this book: if creativity is by definition something which transcends the ordinary, can the "average" person judge its merit? As democratic as is our current concept of creativity, we still widely believe that some people are more creative than others. The "average person" by definition is not the most creative member of society and may not understand the newest developments in the arts or sciences. This average person may well therefore defer to experts on the subject.

That is precisely what happened in 1990 in Cincinnati in *Contemporary Arts Center, et al. v. Arthur M. Ney, Jr. et al.* 735 F. Supp. 743—S.D. Ohio (1990), better known as *The Mapplethorpe case.*[9] This case resulted from the fact that director Dennis Barrie and the Contemporary Arts Center of Cincinnati were indicted for "offenses of pandering obscenity and illegal use of minors in nudity" because of their display of painter-photographer Robert Mapplethorpe's works. (The fact that Mapplethorpe was gay no doubt exacerbated the animosity toward his works). In response to the indictment, Barrie and the Art Center asked the courts to stop the local police from interfering with their art exhibit, claiming that holding the exhibit was a matter of their federal civil rights. And the court ultimately agreed that "the public interest in the First Amendment protection outweighs any other consideration." This decision did not change the court's position that some works may be appropriately forbidden as "obscene," but it did show how difficult it is to distinguish obscenity from "art."

After acquitting the museum directors, jurors told reporters that despite their revulsion over seven particular photographs in the exhibit, they were influenced by the prominent defendants and "expert witnesses" who unanimously insisted that the works were art (Cembalest 1990, 141). The jurors, in short, accepted these experts as part of the community, indeed, as wise ones or standard bearers of the community. (Most likely, these jurors would have responded similarly to scientists serving as witnesses on trial).

Indeed, the jurors' willingness to go beyond their immediate sense of normalcy and accede to the wisdom of "experts" points to an ambivalence in *Miller v. California* itself. The Supreme Court Justices argued that, on the one hand, community norms must prevail, but on the other that the kind of "literary, artistic, political or scientific value" that was missing from obscenity could be such that even the majority of the population might dispute it. This implies that some particularly wise people—why not specialists in a given discipline?—are able to recognize "value" that the majority cannot see.

In theory, the "wise ones" are the justices themselves. Indeed, the conclusion to the Mapplethorpe case stated, "Whether or not an item is obscene is a matter for judicial determination in accordance with *Roth v. United States*" (735 Federal Supplement 743—S.D. Ohio 1990). This meant that community standards would be determinative, but that the judiciary—ultimately the Supreme Court—would decide about those community standards! And this is precisely why Justice Douglas lampooned Justice Peter Stewart's statement about pornography in *Miller v. California* that "I could never succeed in [defining it] intelligibly, but I know it when I see it."

This is significant, not merely in terms of art or obscenity, but in terms of norms and creativity. To a real extent, "normalcy" is the prerequisite to perceiving something as creativity—it is the backdrop. At the same time, new norms continuously emerge as the creators and appreciators of innovation set them. Creators are social leaders. This does not mean that this elite always makes up the norms. They may be responding to all kinds of economic, political, social, religious, natural, and traditional forces. And at any given moment, jurors and voters may reject the ideas of the elites and impose all manner of restrictions on them. Indeed, the *Miller v. California* case had made the "average person" in the community—not the Supreme Court Justices or disciplinary experts—the ultimate arbiter of mores.

And despite the jurors' abdication of this role in the Mapplethorpe case, there is a sense in which the mythic "average person" of Cincinnati plays a crucial role in influencing national conditions of creativity. Unwilling to have the government censor or ban a creative work he/she finds revolting, this person may nonetheless decide that the government should not support with tax dollars anything that seems remotely related to that work. This issue has emerged in many cases, including the 1999 Brooklyn Museum show of contemporary British art, which mayor of New York, Giuliani, refused to support. Earlier, such resistance was courted and incited by Senator Jesse Helms and others who attempted to eliminate and have succeeded in greatly reducing federal financing of art.[10] Indeed, the Cincinnati museum had already lost National Endowment for the Arts support, and aware of the extent of popular pressure, director Barrie had returned $300,000 to local government coffers "so that no charges of taxpayer subsidized 'pornography' could cloud the issue" (Beal 1990, 320).

Even before Helms' efforts, the government's financial support for the National Endowment for the Arts—which was founded in 1965 "to foster the excellence, diversity and vitality of the arts in the United States and . . . to help broaden [its] availability and appreciation"—represented less than one-twentieth of one percent of the federal budget.[11] Indeed, the arts are often viewed as marginal in our society. The jurors in the Mapplethorpe case expressed largely hostile attitudes toward the art world, despite their acceptance of the experts' views. Perhaps this is partially because the average person recognizes that every act of

creation is an alteration, a stepping away from, perhaps even a direct attack on society's norms.

At the same time, this average person's resistance to change and rejection of "abnormality" is rarely consistent or absolute. The average person may also be curious and hopeful about change; he or she may be creative in his or her own "small" way. Patterns change, customs are constantly evolving through the efforts of individuals and groups, and those who can articulate the changes hasten the arrival of these changes. As one juror said after the trial, "it was not pretty to see, but Mapplethorpe did show us something new about our society" (Cembalest 1990, 141).

But creators like Mapplethorpe seem to many people not "normal." His homosexuality shows this, his pursuit of an artistic career shows this, and the specific works he created show this. As we saw above, nineteenth-century psychologists focused attention on the madness of great artists and writers; even today, creative individuals rate high in all tests of "psychopathology" and "sexual androgyny" (Barron F., 1969). Creative individuals are often viewed as abnormal, even deviant, but those whose creativity is publicly recognized often have very strong egos—they are convinced their approach is right. Clearly, the museum directors, artists, and art critics in the Mapplethorpe case displayed such ego conviction that the jurors acceded to their values.[12]

The Mapplethorpe case arose because enough people viewed enough of his works as "art" to debate the issue of whether other aspects were obscene and because the Contemporary Art Center aspired to a certain level of public legitimacy. This clearly differs from the production and marketing of most "pornography" which intentionally elicits prurient interest and which titillates in part precisely through its marginality and illicitness. Even so, the people involved in the making of "porno films" might claim to be "actors" and "directors" or even "artists." No doubt, the makers of pornography may be quite creative, especially in their marketing techniques. The content of the pornography, too, must show some new twist in order to keep the viewer or reader from becoming bored. This new twist may be as minor as the sexual position of the actors or the number of people involved in sex, but there may be more substance.[13] In some cases, purveyors of pornography could care less whether their works are creative or not, but those who call themselves "artists" (and many do for both legal and self-esteem reasons), will claim that they are being creative. We *do* distinguish between art and pornography. Is the latter such because it is too familiar? Too banal? Too lacking in creativity?[14]

Or does the difference between obscenity and art lie with creators and the audience? Mapplethorpe, the museum director, the art critics and historians, the museum goers, and the media supporting Mappelthorpe's works had social, economic, and political clout. The producers of porn may or may not have strong egos; the habitues of the corner porn shop usually do not have high status in our society.

No doubt, some rich and famous go to such shops, but they do not want others to know—they do not display pride about this. This is a matter of class and of context.[15] It seems highly likely that the jury would have decided otherwise had these same photographs been on display in a porno shop.

If creativity is defined as "appropriate novelty," the key factors of social recognition and acceptance let us know what is creative and what is not. The problem is that usually at first only *some* members of society recognize an example of novelty as "appropriate," while others may seek to block it out. Indeed it seems that it could hardly be otherwise. That is why Lewis Thomas can say: "It is hard to predict how science is going to turn out, and if it is really good science it is impossible to predict. This is the nature of the enterprise" (1977 326).[16]

According to Thomas, if you try to cut off the process of inquiry, you eliminate science altogether. And some feel this way about artistic expression as well. Still, the desire to limit some forms of creativity is widespread, and in many ways reasonable: what individual, what society, will tolerate the limitless pursuit of creativity? But who is to decide? Interestingly, the U.S. Supreme Court calls for the average members of the community to play an important role in judging obscenity, while federal regulation of biotechnology merely allows the general public to participate in policy discussions. This is because far more Americans hold "traditional" beliefs about sexuality than they do about the values of science and business—and they expect more benefit from innovations in those realms than from art. It is also because the average members of the community have even less confidence about their understanding of science than they do of art and therefore defer to experts even more.

CONCLUSION: CREATIVITY AND BEYOND

In the preceding pages, we have looked at the evolution of the concept of creativity in the West, diverse cross-cultural perspectives on creativity, and concrete issues related to creativity in our society. It is clear that the ideology of creativity has grown to global dimensions, and that people around the world have been extremely creative in innumerable ways—but it is also clear that the practice of creativity may generate great controversy and run into countless obstacles. We arrive in a new millennium with the spreading consciousness of our global culture, but aware of the conflicts with our local loyalties. And we arrive with the consciousness of the extraordinary potential (for good and evil) of our creative powers—it is fascinating and frightening to contemplate the goals of self-fulfillment and self-creation as applied to genetically engineered "immortal" cells. We do not know where our collective creativity will bring us the next hundred years, but we can see that creativity is all about *going beyond*. And we continuously debate what is beyond creativity.

Every definition of creativity implies some recognition of going beyond the given. The "creative" is not the average, the routine, the normal, the habitual. This is true even when we accept a broad, democratic perspective about the "creative attitude" or a traditional culture's relatively circumscribed approach: even a slight change of nuance or reinterpretation, if viewed as creative, is a "going beyond." In more radically new creations, we see clearly that the creative effort is a movement into the future, the unknown—the beyond. In some cases, the creative activity carries us so far beyond the frontiers of what we know, that it is incomprehensible, and we find those pushing in that direction "mad" or deviant—but those who cross major frontiers and return to offer us appropriate creativity are legitimately called "visionary."

From the Bible, to Plato, to the rituals of traditional cultures, to the Romantics, to Poincaré, Freud, Jung, and twentieth-century art, we've come to understand that at least part of the creative process involves an openness to that which is seemingly beyond the powers of the individual's ordinary consciousness. This beyond may be addressed as god, the muses, the unconscious, nature, the cosmos, the inner self. Allowing things to "incubate," trusting that inspiration will come, are ways we temporarily abandon our efforts to rationally control everything. Virtually

every contemporary writing and course on creativity expresses the belief that significant creativity can occur only when people become receptive to powers or forces beyond their ordinary selves.

Beyond creativity as well lies the context within which it occurs. As we have seen, creativity is very much a social construct. It is embedded within the material conditions, expectations, conceptualizations, laws, mores, and values of each society. What is possible (feasible and allowed) in one culture is not identical to what is possible in another. In every culture—and not just traditional ones—each creation comes into being, is understood, and is valued as part of a larger web of relations of people, things, institutions, and beliefs beyond that particular creation.

What is striking is that some creations go beyond their immediate and local context and become part of the world's "imaginary museum" of creativity. In some cases, the individual creator intended or hoped that this would happen, but often not. Today, thanks to universalist ideals, multiculturalism, capitalism, and the media, the audience for every creation is implicitly global, and the museum is vast. However, the time frame for appreciation has been greatly reduced by our commercial and technological powers and by the enormous quantity of what we collectively have created. Creativity contributes to, but is also swallowed up by these greater forces.

And most importantly, each individual and each group has needs and desires which go beyond the commitment to creativity. Often, creativity seems to be transcended by the other values we hold. The discussions of policy debates, obstacles, and cultural traditions showed that such values as nature, human dignity, morality, the divine, enlightenment, tradition, or community, held priority for many people, however much value they were willing to grant creativity.

THE DIALECTIC OF CREATIVITY

Beyond creativity lies everything else we value—but creativity is our movement toward the beyond. The complex play of these notions points to the many intertwined themes of this book. As the book has enfolded, several apparent dualisms or dyads have been acknowledged:

- tradition and modernity
- familiarity and novelty
- dominance and marginality
- normalcy and deviance
- popular and elite
- average and exceptional
- conscious and unconscious
- the West and other cultures
- past and future

I think that there are interesting and important parallels between these pairs. Each seems to express the play of "creativity" and "beyond" in different but related ways. It is, however, very difficult to think out all the variables here, not in the least, because these terms force us to think so interdisciplinarily; but it seems plain that creativity, as our culture presently defines it, highlights the tensions which exist within many of these dyads. Power plays a key role in some of these dyads, and we might understand creativity as a source of empowerment and as a response to power. In each case, furthermore, *the given* is the context within which and against which creativity is understood, and *difference* attracts our attention in positive or negative ways. That is not to say that everything on the left side of this list or everything on the right side is "creative." More to the point is the fact that it is virtually impossible to comprehend or value any one of these terms without its correlate, and that creativity seems to reside, as it were, in the tension between the pairs.

As mentioned earlier, conceptions of creativity have been tied to dualisms like light and darkness, life and death, *yin* and *yang*, *nirvana* and *samsara*, Heaven and Hell, master and slave, conscious and unconscious throughout world culture. Significantly, major analyses of the creative process have highlighted what J. P. Guilford called "divergent thinking" or what Arthur Koestler called "bipolar" or "bisociative" thinking. For Koestler, especially, this represented the ability to combine previously unrelated ideas, even seeming opposites, to produce a new insight or invention. But this is also at the heart of irony and humor, which force us to look at how paradoxical things are.

Freud was right that jokes reveal a good deal about us, and Koestler was right that laughter shares with creativity the discovery of hidden similarities. As Koestler recognized, humor is both an example of creativity and a trigger for greater creativity (1964, 27, 87ff). That is no doubt why so may traditional cultures retain their trickster figures to upset their otherwise sacred cultural orders.[1] But the dialectic of sacred and profane internal to traditional societies has been augmented if not superseded by the dialectic of traditions as a whole against or in relation to "modern" global culture. From the perspective of modern global society, traditional cultures are "backward," "exotic," or in some way marginal. From the perspective of people attempting to retain traditional group identities, the situation reflects the dominance of the Western tradition. Often unable to assert themselves against the dominant power, marginalized groups and individuals may turn to humor as an effective form of creativity to diffuse their anger and frustration and to liberate themselves from oppression. To laugh in the face of oppression takes courage, and to make others laugh takes creativity . . . but often enough, there is nothing funny about being marginalized or oppressed.[2]

In the global ideology of creativity, we hold that everyone is potentially a creator and should be allowed to fulfill that creative potential. Paradoxically, one of the dominant ideas in our culture is that it is mainly those who are at the margins

of society—the outsiders, eccentrics, bohemians, nerds, gays and lesbians, maverick inventors and dreamers, women, ethnic minorities and third world peoples—who are the "creative ones." Despite our belief that everyone should be creative, we frequently do not expect creativity to coincide with "normalcy." This makes some sense, since at the very least, the outsider has a different perspective on things. It's a rather funny twist to things when we catch ourselves thinking, well yes, the dominant groups can be creative, too.

In truth, dominant groups and large organizations have the great advantages of holding a disproportionate share of the material prerequisites to creativity; of controlling the media, ideology, and dissemination of creativity; of setting standards and passing judgment on creative efforts; and of stifling the less dominant ones through laws, competition, or brute force. Marginalized and small groups sometimes have the advantage of working outside the laws, of being unencumbered, of having less to lose, and being able to move more quickly. But the most important advantage they have in terms of creativity is that they can grasp the dualism, the differences between the dominant perspective on things and their own, because they are obliged to learn both. They are, by necessity, "bilingual," and this is a great advantage in the creative process.

One thing marginalized but creative people[3] have often joked about is that the "average," "normal" person in the society is the most oppressed of all. It is not just that the average person may be living a life "of quiet desperation" as Thoreau, Kierkegaard, and others claimed, or that the average person is sheep-like, as Nietzsche claimed. One major way in which the average person of our society is oppressed is in his or her alienation from the new, from the other, from the unknown. The average person suffers from "culture shock": people of other colors, languages, and religions, and changes in our own culture—new developments in art, music, and technology—all appear as strange and alienating. Change elicits fear.

To be fair, this "average" situation may apply to all of us, even the seemingly most creative—we, too, share the fundamental characteristics of the human condition, and we might well want to cling to the familiar, at least in some, usually in most aspects of our lives. Habits are hard to break, and the familiar is of value to us all. For each of us in different ways, moreover, clinging to the known past (the familiar) seems to be our refuge in the face of the constant, ubiquitous change of our era. At the same time, the more we cling to the familiar, the more the change seems overwhelming. Most likely, the best approach is a moderate embrace of tradition with openness to the new.

However, there seems to be something in the nature of the new and the creative that continuously disrupts our attempts at moderation. Creative works transcend the ordinary; they are "extraordinary." Creative individuals are not average individuals, and creative behavior is not normal behavior. That is why the "eccentricity" and "madness" of creative genius is so commonly discussed. That is why

Socrates, Galileo, Whitman, and countless others were denounced. One common feature of these creators and of many others is that they combined the ability to understand and use what they had inherited with the courage to move toward the new. As Mihaly Czikzsentmihaly has emphasized, creative individuals are complex and thrive on creative activity, they do not always take the middle road, but move from "extreme to extreme" (1996, 75, 110). That is, they tend to think dialectically: they see oppositions and imagine their transformation. Many creators have acknowledged the truth of this: going to extremes (at times), is a necessity of the process— that is the whole point of "bisociative," or divergent thinking.

Since we have come to recognize that everyone is capable of such thought, our culture has moved from the extreme position that only God could "create," and then to a reverence for individual creative genius, to the increasingly widespread view today that *everyone* is creative.[4] This is our contemporary global inheritance from the Western Enlightenment. Individual fulfillment is now part of our global ideology, but our belief in this is also often the cause of frustration.

If we were to succeed in fulfilling this ideal, if "creativity" were to become a normal feature of our everyday lives and we recognized this in each other, then we would be carrying out the dreams of Franklin, Schiller, Marx, and the Enlightenment ideal of universal individuality. Our multiculturalism would be so transparent that marginalization of any group would seem absurd; the uniqueness of each person would be so prized and obvious that no one would be sheep-like, and average would be synonymous with "unique" or "diverse." Creativity would be our context, change would be our tradition, and we would all be fulfilled. The dialectic of oppression and liberation would be overcome; each would be free to pursue happiness . . . and each would be able to be self-actualized. We would be born again, peace would reign on Earth, and spiritual enlightenment would prevail.

But twentieth-century world wars, modernism, post-modernism, relativity, space travel, anthropology, the global market's electronic trade in ciphers, the bomb, and the recreation of life through genetic engineering . . . have all helped undermine the Enlightenment dream without replacing the traditional cultural identities the Enlightenment itself undermined. Or rather, Enlightenment ideals, traditional beliefs and practices, and postmodern thinking all coexist in incomplete ways within our global context and within countless individuals. As we have seen, whether people come from China, the United States, traditional cultures, or elsewhere, they may at any given time express dedication to particular cultural patterns and values . . . or joke about them.

CREATIVITY AND VALUES

Much of the time, it is no laughing matter that values conflict. Within our increasingly global context, the ideology of creativity is hardly the only belief we espouse,

and the debates about which take priority occur nationally, locally, internationally, and in my heart and mind as well as in yours. Each of us is aware of and constantly influenced by the other; we may hold strong convictions, but not necessarily for long, and our insistence on our beliefs may be merely in opposition to those of others. Most of us, I think, live between inherited and new ideas, communal and individual approaches. I believe this is true for you and me as well as for the Moslem cleric in Iran, even though he may not accept what I am saying. And even if he did accept it, what he and I will tolerate, support, or oppose may be quite different (as different as the Koran and the U.S. Constitution). Where we draw the line is important. Creativity is one of several values each of us holds—but while it is one of the major values for me, it is probably much lower on his list of concerns.

Like most people in the West, and particularly in the United States, I have long believed in the importance of creativity without thinking much about it. When I think about it, I realize that creativity is a primary value for me, but I hold many values that are assumed and intuited, which are usually not clearly articulated.

> Ordinarily, human beings do not think of fundamental values; in times of crisis, however, they tend to do so more frequently. On those occasions, they are more apt to become aware of the conflicts of fundamental values and they make their choices in accordance with the exigencies of the situation, which usually entails a renunciation of one or more of the fundamental values for the sake of holding another. People often do not experience this renunciation as a conflict; it just seems to be the right thing to do (Shils 1988, 50; 52–3).[5]

Thus, when asked, many people in our society would probably say that beyond creativity lie, "human dignity," "national security," "God's Will" "survival," "family," "happiness," "wisdom," "love," and "the environment."

When push comes to shove, creativity seems to be, for many of us, a secondary value, dispensable when in conflict with these "higher" ones. However, the pushes and shoves are irregular in frequency and intensity. Usually my desire to bring greater justice to the world takes a back seat to my creative writing and my ideas for inventions; sometimes, my concern for my children takes a backseat, too— but not for long (that push is big and almost constant). Even if we felt a compelling need to express ourselves, we'd probably stop to save someone—even a stranger— in life threatening circumstances; but if we were literally on the brink of developing a vaccine against a disease afflicting millions, we might stop to think about it: should we interrupt the work to help one person? Many people would act instinctively. Some would stop to weigh their priorities and strategize. But no matter how they may have expressed their values beforehand, the application of those values to the immediate situation is hardly a given.[6]

Even when we have a longer time frame in which to reflect, the general commitment to creativity does not mean exclusive commitment to it. And, of

course, it does not mean that we appreciate every form of creativity—we ask about its appropriateness, whether we should support it, tolerate it, avoid it, or combat it. And this is not merely an individual matter. As we saw in the policy debates around biotechnology and obscenity, creativity is the new and the different, and for that reason, it may bring discomfort, revulsion, or fear. Creators often ask us to overcome those emotions and be open to their efforts. This is sometimes a major challenge for us. In the Mapplethorpe case, the jurors overcame their disgust to accept the idea that the works might have value. I would do the same—but I also feel that it is not merely legitimate, but important, to maintain standards and distinctions about the degrees, quality, and direction of creativity. Diverse as the world's cultures are, each makes choices about what is most important and sets standards of quality; each decides what is truly dangerous, as well. In the United States, conservative thinkers and politicians have been especially insistent that creativity be subject to standards of excellence and distinct limitations. I for one, accept the premise, but draw the line much further afield than these conservatives because of my historical-multicultural-global perspective.

The belief that multiple values might have legitimacy is the multicultural position which so threatens conservatives and traditionalists. But this belief does not imply absolute relativism—it means we must weigh competing values and decide. And in many respects, this deciding is a creative act.

But who decides? And about which cases? We know how difficult this is internationally, but even in the United States, consensus is a problem. If, as the U.S. Supreme Court has suggested, democracy calls for the mythical "average person" representing the "normal standards" of "the community" to decide, then you and I might be excluded from making these important decisions—since the mere fact of our discussing creativity and society in this theoretical way would cause us to be viewed as "intellectuals," not average. And yet the average person frequently defers to experts, and the majority is almost always dominated by an elite.

But the global ideology of creativity has egalitarian, relativist, and democratic implications. Those who believe in it aim to help the average person unleash his or her creative potential to the greatest degree possible, since all of us are members of the same community.[7]

But unleash creativity for what? To what end? We ask not merely what we should limit, but also what I/you/ society should positively encourage. This is a question of values. But, of course, the problem of a democratic and a global-multicultural society is that countless different evaluations of things compete and seem to cancel each other out. We have a hard enough time setting standards for creative effort—which is why we often leave it to the market. The global unsettling of traditional identities and values has led to insecurity and alienation as well as new possibilities. The ideology of creativity, which often overlaps with commercial values, frequently arouses enough passion to transcend market concerns. Employing

our creative talents to formulate a broad social vision for the future which includes creativity but goes beyond it, seems nearly impossible but crucial.

THE CHANGING CONCEPTION OF CREATIVITY

The word "creativity" was invented in the last century to describe a phenomenon which may cross disciplinary boundaries, and since World War II, even those activities which lead to no tangible product have come to be considered realms in which creativity may be practiced and observed. Now, indeed, the humanistic psychologists have convinced many of us that there is such a thing as a "creative attitude" and that self-actualization is our goal.

No doubt most people in the society continue to think first of the arts when the words "creative" or "creativity" are mentioned. But the theorizing of the 1950s has led to the media's ubiquitous use of the terms at the end of the century to describe something visible in a wide range of activities. The more completely we abandon traditional social roles and the more mobile we are, the more we tend to agree that we must express ourselves creatively and we must creatively solve problems in order to survive, live together, and find fulfillment.

To say this is to understand not merely that "creativity," taken in the modern sense, is interdisciplinary, but also that the initiating principle we believe we see in so many forms is, as Aristotle emphasized so long ago, an ongoing phenomenon. In the realms of thought and action, said Aristotle, we constantly act anew. When we say that parenting, teaching, and so on can be realms of creativity, it is because we see that we are continuously given the opportunity—in fact, we are continuously compelled—to come up with new ideas and new approaches. This is not merely a matter of solving the countless problems we routinely come across; our sense of identity and who we are in relation to others is, in large part, a function of our creative expression and our creative coping with life's difficulties.

To the extent that our everyday use of the word and current writings and workshops on creativity express this understanding, they reveal that the conception of creativity at the beginning of the twenty-first century is significantly different from even fifty years ago. Our culture's long-held tendency to celebrate the founding act, the moment of breakthrough, the specific bringing forth of the new is being replaced by a more transitional, developmental, or transformational idea of creativity. While Arthur Koestler could still entitle his seminal work on creativity in the 1960s, *The Act of Creation*, contemporary works are more likely to convey process, as in the case of Mihaly Csikszentmihaly's *Flow*. The model of the great new invention, painting, or discovery appearing as a unique and dramatic event, like God's Creation, has long prevailed in Western minds. However, the twentieth-century process philosophies, theories of the unconscious, jazz music, the electronic media, the increased appreciation of traditional art, the movement from productive to

service industries, postmodern thought, and especially the enormous societal changes have led to an understanding of creativity as an ongoing process, as continuous reinterpretation, renovation, evolution, and improvement. As the multicampus University of California Humanities Research Institute has recently declared, "a pan-disciplinary shift from studying objects to studying processes is occurring. . . ." If we can talk of "creative parenting" or "self-creation," we certainly do not mean that these activities occur one day only—they reflect long-term transformation.

And tied to this shift in focus has been a rethinking of the long-held Western cult of individualism with its celebration of heroic scientists, inventors, artists, composers and writers, and its corresponding lack of interest in these great creators' colleagues and collaborators, or in the communities which have elevated these figures to the status of heroes. In our era, Thomas Kuhn, Ludwik Fleck, Simon Schaffer, and a number of others have pointed to the ways in which scientific discoveries are often collaborative and the ways in which "discoveries" are defined as such by the community of scientists. Ernst Kris and Otto Kurz wrote in the 1930s about the artworld's repetitive schema for making heroic figures of individual artists, and A. Richard Turner's recent book, *Inventing Leonardo*, describes how each generation has formulated its own image of da Vinci. Indeed, the postmodern philosophical and literary notions of "hermeneutics" or "reception theory" emphasize that across the board, the texts of the world are subject to virtually infinite readings. In this light, continuous interpretation and reinterpretation are almost as fundamental as the creation of any work. As Stephen Greenblatt, Wai Chee Dimock, and others have said, the "resonance" of each creation is crucial.[8]

Between a one-sided focus on Great Works and Creative Heroes, a complete reduction of them to the social-historical contexts which brought them forth, and our dissipation of them into infinitely diverse and changing interpretations, lies a middle path. When I look at Michelangelo's works, for example, I acknowledge the roles of his parents, his teachers, his colleagues, his helpers, his patrons (the Florentine Republic, the de Medicis, the Popes), his propagandists (Vasari and others), and the broader social-economic-religious-cultural context; and I also stop to think how my appreciation of Michelangelo has been influenced by my own teachers, parents, and the broader culture. Creativity is a social construct, without a doubt. Recognizing this, however, does not prevent me from appreciating the artist's work. Indeed, I know that I have work to do in my creative encounters with Michelangelo's art. As I grow older I will gain new understandings—but I might lose some of the original "wow" I felt when I first saw his works. I will try to see if you share my understandings, I'll learn from you and try to persuade you, and both of us will change through the process. And although the Sistine Chapel will stay in the Vatican, and the David will stay in Florence, their import will shift as people from Kenya, Korea, and Kuwait log on to the images reproduced on the Internet, comment about them, digitally manipulate them, and incorporate them in their own creations.

I am especially awed by Michelangelo's sculptures of the slaves or prisoners—human forms only partially "liberated" from blocks of marble. These figures tell us very directly about the artist's process, and looking at them, we can only shake our heads in amazement that past generations seem to have been so fixated on the completed product that these works were treated as being of lesser significance. Creativity does not consist in the finalization of an artwork or anything else. Poincaré spoke of the "elegance" of mathematical creations; some people speak about the common feeling we get from great works of art, that they are "just right"—but this sense of perfection is, of course, totally in relation to the understanding and even the mood of the audience. The creator may have changed his or her mind countless times about how long or large to make the work, where and when to end it, and so on, and may keep wanting to make revisions even after others have acclaimed it a masterpiece.[9]

Indeed, it is only because we already recognize that the creative process is fundamental that so many of us have treated Michelangelo's contemporary, Leonardo da Vinci, as the greatest creative genius of Western history, for he was, as Michelangelo critically remarked, a man who hardly finished any of his projects. Perhaps in self-defense, Leonardo maintained that conceptualizing was of far more importance than carrying something out. But as Leonardo discovered in his attempts to make working models of some of his ideas, the carrying out and completion of a project do matter; he reproached himself repeatedly for "not completing anything."

Today we certainly not only value the conception and the completed work, but we also admire the creative process. This is part of the reason why Bill Gates spent millions of dollars to buy one of Leonardo's notebooks, the Codex Leicester. As Gates also knows well, patents are awarded very specifically for the processes leading to an invention. It is not the silicon and copper as much as the ideas embedded in them which have spawned the computer revolution. Creativity resides neither solely in the finished product, nor solely in the initiating impulse or revolutionary, founding act.[10]

This is especially obvious in the social realm. Karl Marx said many valuable and many wrong things, I feel. It was right for him to say that he would not prescribe how the proletariat should function after the revolution, because it should be up to them, collectively, to set up their society; but it was just as wrong of Marx to provide no guidelines about postrevolutionary life to his followers—it was precisely in the "follow-through" that the Soviet revolution failed so miserably. In contrast, the American Founding Fathers saw quickly that their revolution needed serious maintenance and that the Articles of Confederation could not supply the means. Four years after independence, the Constitution was formulated to provide mechanisms for ongoing revisions to the society. Focusing exclusively on the moment of creation, the initiating impulse, or the event, rather than the ongoing process, is completely misleading in the social sphere, where the collaboration of multiple individuals—who grow, change, and interact—takes place.

But such a focus is generally misleading for creativity. It is as if we were to take—as many certainly have—the biblical injunction to be fruitful and multiply to apply solely to the literal act of procreation and not to the crucial long-term task of raising a family (or to any figurative sense). In the ancient world, the begetting of offspring was seen as the archetypal creative act—the etymology of "create" shows this clearly—but in our world today, creativity should, I feel, consist in thoughtfulness about what we are begetting and in a continuous caring for what we have begotten. Parenting, not procreation, is where the most challenging and important forms of creativity take place.[11] All creations may be said to take on lives of their own, but when we produce children—or for that matter, genetic/molecular alterations in the world—we should do our utmost to keep them safe and prevent them from doing harm, while empowering them in the most positive directions possible. Here, even more than in the realm of art, creativity is seen to raise questions of value, questions of appropriateness.

The notion that the originating impulse requires follow-through has accordingly become a common theme in twentieth-century writings about creativity: many creators and analysts of creativity recognize that it is not enough to have a great idea, one must have the skills, resources, and discipline to bring it into being, and in most cases, one must revise and expand, simplify, verify, and redesign repeatedly. Indeed, the "stages" in the process of creation first mentioned by von Helmholtz and Poincaré around the turn of the century have been reiterated and elaborated upon by countless other writers on creativity since then. However, creativity is more complex than a series of stages leading up to a finished product. Every product is subject to further revision, and the stages of the process are not necessarily sequential. Already in the 1920s, Graham Wallace recognized that the "stages" overlap (81–2). As contemporary artist and professor Lou Miller, has said to me, "it's obvious that we move back and forth through these stages all the time."[12] Theory, practice, and insight trigger each other.

The process is in many ways cyclical and repetitive . . . but we hope and strive to spiral to ever greater heights—we try to know more, do better. Often enough, our efforts are interrupted by any of the obstacles that life may throw in our path; sometimes we reach a point of completion and conclusion. We stop working on the project, show it to others, sell it or institute it. Just as often, we realize that the point of "completion" is chosen arbitrarily—some artists, writers, and inventors will tinker endlessly; the process is ongoing. As Gilles Deleuze has said, "Writing is a question of becoming, always incomplete, always in the midst of being formed . . . (1997, 2).

This is as true, I believe, in the creation of all the great works of art, music, and literature we celebrate; it is true when Miller creates pottery; it is even true in technology and business, where the finished "product" is of utmost importance; even in these realms, workers routinely "go back to the drawing board," and improvements

in a product are often being worked on simultaneously with the product's public appearance.[13] The movement back and forth between the various stages is even more obvious in the case of group enterprises like jazz music, seminar classes, collaborative scientific research, and representative democracy: motifs or goals are set down, sometimes quite specific ones, but they grow and change through the interaction of the participants and in the crucible of theory and praxis.[14]

Our society's changed view of creativity coincides with our increased appreciation for creativity in traditional cultures, which allow for ongoing reinterpretation of paradigmatic frameworks. Our changed attitude also reflects the rise of women in our society: the dominant gender roles of the past caused far more women than men to understand that the model of the great founding, in which something new and complete comes into the world once and for all, is not as accurate as the model of ongoing nurturing and evolution for some very important kinds of creativity.

The conception, the initiating act, and the finished product are all important, but the transformational model corresponds in some significant ways to what really happens when people create in art, literature, science, and technology—and it is the *only* model that works when we are discussing creativity in such realms as parenting, teaching, law, psychology, where there is no tangible product and the process is continuous.

This transformational model, especially as applied to the realms of personal growth and social creativity, reveals that the creative process almost always includes coping with the blocks mentioned earlier. Sometimes, it is true, creators experience the "spontaneous overflow of feeling" noted by the Romantics . . . in fact, this may be extremely common. However, the obstacles we may encounter are legion. Therefore, expression will almost always involve some degree of problem-solving. Creativity is an ongoing battle or dance (depending on how it goes) with the world. That is why the survival of traditional cultures, the flourishing of the individual self, and the developing of global culture are such intense realms for creativity.

Nonetheless, the intangibility of the product is a problem even in less fundamental areas, at least in terms of assessment. The creative process is different in each and every case: someone may appear to be sleeping, procrastinating, immersed in feverish activity, or whatever, and we will not know what is incubating and how important that is to the creative effort. And if we do not see a valuable, finished product—or at least a detailed drawing and explanation, as called for in the patent process—how do we know whether we should bother looking at someone's process? This is part of the reason why, even though they might "know better," universities pay so much more attention to a faculty member's publications than to his or her teaching—it is so much harder to assess. If a teacher elicits a response from a student, who knows what import that might have? Neither the teacher, nor the student, nor an outside observer might be able to tell. A certain word, a look even, might change a life—for good or bad. We cannot yet tell, and we may never know.[15]

And if "self-creation" is the task, then the transformational model is the only one we can use to understand it, for it is ongoing. What is more, self-assessment here becomes an essential part of the "product"—which evolves continuously and in many respects eludes anyone's grasp until or even long after death.

THE DIFFICULTY OF ASSESSING CREATIVITY

Every society has conceptions of hierarchy and standards, of degrees of excellence and creativity; however, the combination of multicultural interchange, the interdisciplinary and democratic expansions of the concept of creativity, and the emphasis on process have all made evaluation of creativity extremely difficulty. It is hard to determine quality, and it is hard to assess importance.

The difficulty of assessing creativity which is ongoing is obvious, but the assessment of *any* kind of creativity is virtually as complicated. Reviewing numerous instances of mistaken government and "expert" prediction about technological needs and possibilities, Peter Drucker has concluded: not only is "technological assessment" of this kind impossible but also it is likely to lead to the encouragement of the wrong technologies and discouragement of the technologies we need" (Teich 1990, 214). Drucker is hardly alone in this judgment, and when the society's ideological commitment to freedom of the market and freedom of expression and exploration are added to the equation, we can see why restraints on biotechnology, for example, are so minimal.[16]

And if the imposition of limitations on technological creativity is problematic, it is even more so in other realms. For psychologist Carl Rogers, the social-historical difficulty of assessing when to restrict creativity is the main reason we should not try to do it. In defining the creative process, Rogers purposely makes "no distinction between 'good' and 'bad' creativity." It could be a matter of painting a picture, developing a scientific theory, or even of devising instruments of torture (1959, 71). For Rogers, the creative process is inherently valuable, because it leads to the "self-actualizing" of the personality. Nor can we discriminate about good or evil products of creativity.

> The very essence of the creative is its novelty, and hence we have no standard by which to judge it. Indeed, history points up the fact that the more original the product, and the more far-reaching its implications, the more likely it is to be judged by contemporaries as evil. The genuinely significant creation, whether an idea, or a work of art, or a scientific discovery, is most likely to be seen at first as erroneous, bad, or foolish. Later it may be seen as obvious (1959, 73).

Thus, creators we presently highly value, such as Galileo, Van Gogh, or Socrates, were viewed in their own day as unimportant, immoral, wicked, or insane.

As Teresa Amabile has said, "ultimately, it is not possible to articulate objective criteria for identifying products as creative" (31). Indeed, after decades of

administering "creativity tests" to students and military personnel, psychologists have come to accept the fact that there is no direct correlation between high creativity ratings on the tests and real-life creativity (Guilford 1962, 158; Barron and Harrington 1981; Mackinnon 1968, 438).

Even more problematic is comparing and assessing creativity in different cultures: who can say whether or not classical Nigerian bronze sculpture is "better" than that of ancient Greece or nineteenth-century France? According to Lasswell, societies which encourage creativity would seem to have the greatest likelihood of being creative. This makes common sense. However, a society need not be democratic to encourage creativity—the de Medicis in Florence and Frederick the Great in Prussia demonstrate this. The interests of those leaders, coupled with material prosperity and a host of other variables like the development of cultural ideas and technologies, seem to have been more influential than the political structures. In fact, an authoritarian government aiming at creativity may produce as great or greater creative works than a democratic society, since the autocratic government can marshall all resources in the pursuit of the work and sacrifice so much else. Nor is it necessary for a society to share the dominant Western conception of creativity—ancient India, Egypt, and the Mayan Empire prove this.

And who can judge the *quality* of the creative activities in different cultural contexts? "Value" (in the singular) implies measurement, but trying to determine the value of a creation or creativity in general by measuring it seems impossible. Even if the efforts of some scholars (Martindale, Eysenck, Khaleefa, and others) to "measure creativity" in different cultures through quantitative analysis helps us see the ebbs and flows of creative energy and production, perhaps this is besides the point. If creativity in China and United States could be measured, many contemporary Chinese might ask with some reason, is the common good always served by maximizing the creative opportunities of individuals? Surely, if the enormous Chinese population ever reaches the point of consuming per capita as much of the world's resources as does the American, the planet would be in a catastrophic state. This is a question of *values* (plural), and this is certainly not subject to measurement. Indeed, the United States policy debates discussed in the last chapter express a similar concern, for they, too, ask when individual and corporate creative rights should be limited for the common good. The question again is not how much creativity, but to what end—and under what circumstances?

CHOOSING CREATIVITY

The inability to assess creativity is part and parcel of our society's general dilemma of assessing anything, of finding any kind of objectivity, of asserting any value unequivocally. Even the attempt to establish legal rules of procedure is exceedingly difficult, as the Supreme Court's effort to define "obscenity" has shown. The rela-

tivity of our postmodern era is strong. Since Kant, and especially since Wittgenstein and Heidegger, philosophy has abandoned claims of "objective truth." Even theorists of science like Polanyi and Kuhn seem to feel this way.

Creativity has emerged as a primary value in part because of this intellectual abandonment of certainty. Traditionalists and conservatives who reject this intellectual attitude, who call for moral and cultural standards and assert absolute truths, must nonetheless live in a world where they are at odds with each other as to which truths are genuine and where their efforts to convince each other, let alone the relativists, is frustrated daily. In fact, the increasing globalization of our society, the incessant change, the input overload, the competing claims, threaten to undermine all identities and beliefs. In our global culture, Catholicism, Hinduism, animism, and atheism strive and collide with countless other "isms," just as, in the world museum, polynesian canoes, moon rocks, and Rembrandt's paintings reside together and demand our attention.

And yet the bathroom graffiti, "punk means no judgments!" is naively unreflective. As much in flux as our lives are, we cannot help judge and act. The fact that some people will follow "reason," others "God," others impulse or instinct, and that others are convinced that certainty is impossible does not eliminate this need. To say with Rogers and Drucker today that societies have often been misguided in their judgments and treatments of creative individuals does not obviate the need for each society to judge as best as possible regarding the support or repression of particular creative efforts. In fact, we do this all the time. Our laws, our budget and tax system, our educational policies, our social customs already express this. Each and every individual's pursuit or rejection of creativity reflects this as well.

Indeed, even if we bring something "new" into being, the "stuff" we work on, the ideas with which we comprehend what we are doing, the audience and judges of our efforts are already in the world.[17] We blindly or creatively attempt to achieve some level of compatibility between our value creations—through persuasion, regulation, or direct force—but most of the patterns and motifs of our intercourse have already been set down for us by our culture, for good or bad. In an ongoing dialectical process, we reinterpret and reshape the world that is the framework for our creativity and that judges whether or not our creativity is appropriate. We create images of ourselves and of each other, and these images shape and in many ways are, our context, our reality. If we create something special, it will be reinterpreted or reused many times and many ways and will be absorbed into our global culture. That is why conscious creation of our social world—from interpersonal relations to the global community—is certainly as important as self-creation and is necessarily bound up with it.

Such conscious creation requires wisdom, judgment, and action. We need to have the characteristics which Donald MacKinnon attributes to creative individuals

who: "Are challenged by disordered multiplicity and by the unfinished, which arouses in them an urge, indeed, a need, to achieve the most difficult and far-ranging ordering of the richness they are willing to experience" (1968, 439). As so many of the studies of creativity have noted, we must have a willingness to live with ambiguity, to create and decide despite the ambiguity.

We need courage, as Rollo May has said, but courage is not merely a matter of willpower. Human creativity is only partially a matter of will or intent. Creativity is also, surely, a matter of intuition, of receptivity to nature, to the divine, to the unconscious, to the community. The stages of the creative process—from inspiration through incubation to elaboration—show some of the forces which transcend individual will quite clearly. Traditional cultures and the world's religions have continuously emphasized these transcendent forces.

But increasingly, we find ourselves as refugees, alienated and uprooted from the familiar. That is why creativity is no longer even a choice—we feel obliged to create ourselves and choose our values. There is no doubt in my mind that some values should have priority over creativity and that our ethical task is precisely to prioritize our values. However, creativity is certainly *a* good in most cases, and it seems necessary for pursuing any other goal or value. Indeed, unless we adopt ready-made doctrine or are in continuous and direct contact with transcendent powers, deciding upon or discovering what our values are is itself a creative process. This is in fact our primary challenge, I think.

The American idea of the "frontier," now a cross-cultural idea, points us necessarily to "the beyond." This is a beyond we discover and we create. The twenty-first century has not emerged *ex nihilo*, because we are inheritors of so much; but creativity is precisely our power—such as it is—to make the world. This is why the ancient linkage of creativity with biological fertility has resurfaced in some contemporary writings which speak of creativity in conjunction with biological evolution (Bergson, Barron). We have adopted the late nineteenth- and early twentieth-century process philosophies with their "metaphysics of creativity," because they make sense to us: the creative impulse is *descriptive* of our lives and the world. The "advocacy of creativity" noted in the introduction to this book is rooted in our understanding of reality. The elevation of creativity to the role of a primary value in our lives is tied to our belief that the spirit of creativity, the power of creativity is organic and fundamental to life itself.

Even though we may believe that beyond creativity lie the great existential, metaphysical, and social-political problems, conflict about these subjects and about the "ultimate good" are so obvious and so deep that we are faced with the possibility that *creativity itself may be the only value honest people with conflicting views can agree upon.*[18] Short of divine intervention, it appears that none of our problems can be dealt with unless we think and work creatively.

Many of us might agree with Karl Marx and others that history and society move in ways such that the individual is of little consequence (Shils, for instance,

maintains that "changes occur very rarely because of individual originality"—1981, 52–53). But it also seems clear that some creative individuals do change our lives— indeed, their creative passions bring forth new works of all kind which structure and influence our lives. It may be so that "extreme clarity in the formulation of values can be dangerous to society" (1981, 50), but it is often people who are obsessed with a very specific formulation of values, who articulate the traditional values of society in original ways, and who believe in forces which transcend the immediate—such as Moses, Jesus, Ghandi, Mohammed, and countless other activists—who are most able to influence societal change.

By this standard, even Adolf Hitler was a creator of values, to be sure. Still, for the past fifty years, at least, most have believed that other values—human survival, dignity, and freedom, for example—must be given priority over the creative needs and values of people like Hitler. Indeed, Hitler is valuable as an example of what we do *not* will to create. He is a reminder that creativity can be truly perverse, and he provides a yardstick so that we can measure the relative insignificance of such debates as the one about Mapplethorpe's photographs. All around the world we find violence, hunger, and alienation. Yet idealized in the Enlightenment, American culture, and the United Nations Charter are our desires for social-political-economic structures which will help as many of us as possible to survive and flourish. Most of us hope for industries, science, and technologies which will bring comfort to our lives and expand our powers without adversely affecting our world; we look, too, for works of art, architecture, dance, theater, literature, poetry, and music which are beautiful and/or thought-provoking.

Right at this moment, the cross-fertilization of creative ideas within the global culture, the recognition of our political, environmental, economic, and social mutuality, and the developments in genetics and the electronic media seem to scream out: "a new world is coming—join in, or get left behind." But in seeking creative inspiration, we should look not merely at art and science, but particularly at the realms of religion, ethics, psychology, economics, and politics—because making ourselves and our world are the most difficult yet most necessary tasks.[19]

For my taste, if we could find the person who is wisest, loves the best, helps others most, and lives most joyously, we would have to elevate that person to the pinnacle of creativity. Perhaps Jesus, Socrates, Confucius, the Buddha, or some other great ethical-spiritual creator would be such a person. But perhaps we would want to see their ethical-spiritual creativity complemented with singing and dancing, and especially with social-economic-technological-environmental-political creativity— in order to deal with our patently unenlightened global situation. In fact, it will never suffice to have such extraordinary role models; our dream is to help everyone gain the insights of being on the margins without anyone being marginalized, to help the average person express him or herself in exceptional ways, and to help all of us progress together. As Schiller said two centuries ago, we need collective and

individual transformation and effort to create beauty. We are talking about self-creation and openness to all that lies beyond. Practicing love, wisdom, and justice in real life is a creative challenge.

We are active creators who bring about the new, but our creativity is always in context. Our conception of creativity has been changing and is changing without our even intending it; what we are valuing about creativity is therefore changing as well. I believe that as our lives and our global ideology of creativity evolve, we will acknowledge more clearly both how much lies beyond creativity, and how creativity is our human drive toward the beyond.[20]

NOTES

INTRODUCTION

1. Here and elsewhere I generally use "America," or "Americans" for the country and citizens of the United States, not meaning to offend any other North- or South Americans, many of whom share many of the same cultural characteristics as the people in the United States.

2. And what about those in our society who admit to being "uncreative?" This may be a hidden plea to be contradicted, or it may be a genuine attempt at self-description. Often enough, this admission is also an expression of frustration, of longing to be otherwise. Sometimes people who feel this way buy self-help books on "how to be more creative," sometimes they sign up for creativity courses, like the ones I teach.

3. This term, as well as the "hierarchy of needs," which supposedly culminates in self-actualization come from psychologist Abraham Maslow. Neither Maslow's name nor a serious understanding of his theories is common, but the terms "self-actualization" and "hierarchy of needs" are used worldwide, in works on business and education. Many people perceive the hierarchy of needs to begin with food and shelter and to culminate in "self-fulfillment." Creative expression is a part of this, according to Maslow, but for him, the "integration of self"—which involves much more than self-fulfillment—is the real goal of human development and psychotherapy. In our contemporary culture, even our personal identities can be creativity transformed. Whether we are following humanistic psychology, Norman Vincent Peale's "the power of positive thinking," the countless self-help or twelve-step movements, or hope to be "born-again" religiously, creation and recreation of our very being is a common dream of our society.

4. Contemporary artist and political activist, Joseph Beuys, routinely encourages "everyone to become an artist." According to Auguste Rodin, "all mankind must follow the example of the artist, or better yet, become artists themselves," because the artist "takes pleasure in what he does" (B. Raffel, 1991, xi).

5. University of California at Santa Barbara, State University of New York, Buffalo, and Duke University in North Carolina, for example, have programs on creativity.

6. "But economic support for cultural activities and products is not the same as economic support for creativity, nor is it possible to prove, simply from inspection of the amount a society spends on art museums, symphony orchestras, libraries, and the like, that the arts of that society are in either a creative or uncreative state" (Edwards 1968, 451).

7. See Frank Barron, Creativity and Personal Freedom, "Introduction," and Creative Person and Creative Process, "Introduction."

8. Such as those by Amabile, Barzun, Boorstin, Gardner, Csikszentmihaly, Lavie et al, Layton, and Schaffer.

9. Gardner maintains that there are currently two primary stances framing creativity analysis: the "ideographic" examination of individual creators, and the "nomothetic" large-scale analysis of types; Gardner seeks to integrate the two approaches in his book, *Creating Minds*, by finding common patterns in seven individuals from different domains of activity (1993, 360). From this perspective, my effort is a kind of third or fourth approach, a cultural or metaanalysis.

10. By 1960, when analysis of creativity had hit full stride in the United States, educational theorist Mel Rhodes reviewed the literature and reported that he had "collected forty definitions of creativity and sixteen of imagination." But he also reported that the definitions "overlap and intertwine" and "the subject of creativity has interdisciplinary appeal." His influential categorization of the definitions arranged them in four basic groups: definitions that pertained to the creative "person," "process," "press" (relation to the environment), and "product" (1961, 17–21).

11. Some of these categories include thousands of books; others include only a handful.

12. Interestingly, Frank Barron expresses both of these attitudes: "The problem of psychic creativity is a special case of the problem of novelty in all of nature. (*Creative Person and Process*, 9–12). But then, in *Creativity and Personal Freedom*, Barron views free will as the sine qua non of creativity (1969, 290–302). New things emerge constantly in nature, but only humans generate novelty by intention. According to Frans B. M. de Waal, however, "The evidence is overwhelming that chimpanzees have the remarkable ability to invent new customs and technologies . . . " (Gould 1999, A19).

13. Regarding the diverse phenomena and degrees of effort called, "creative" Barzun says:

> . . . "creativity" has at least four possible layers of meaning. At the bottom is the commonplace quality of initiative. . . . Next comes the widespread knack of drawing, singing, dancing, and versifying, modestly kept for private use. Above this level we find the trained professional artist, including the commercial, who supplies the market with the products in vogue. At the top is the rare bird, the genius, whose works first suggested the idea that a human being could be called a creator (1991, 9).

14. Thinkers like Carl Hausman and Jacques Barzun said that treating everything and everyone as "creative" reduced the word to near meaninglessness. On a broader level, authors like Bennet, Bloom, and Hirsch have decried the leveling of intellectual standards in society and called on educators to "return to basics."

15. This is even more the case when we begin to discuss other important words, like "discovery," "invention," and "innovation," which are often used in conjunction with "creativity."

16. This is the term used by Barron, Amabile, Webb, and others; "resolution," used by Bessemer, Isaksen, and others.

17. This seems obvious when we are judging paintings or poems (though critics, curators, publishers and investors do this all the time). Measurement in business and science seems much easier, because we use patents, profits, and numbers as forms of measurement— but even this may be misleading: long-term creative development may require years of effort

without profit; one major patent may be more important, ultimately, than twenty "less" significant ones.

18. As psychologist Gordon Allport legitimately says, "While we sometimes get bored with our daily routine of living and with some of our customary companions, yet the very values that sustain our lives depend for their force on familiarity. What is more, what is familiar tends to *become a value*." [his italics] (1954, 29).

19. The determination of something as creative is a judgement and operation of society, and creative products affect that society because they have ideological implications (J. M. Edwards 1968, 443-4).

20. The word, "value," has often been expressed in our society as the *price* of something, as its *measure*, while the word, "values" indicates ultimates in the sense of *beliefs*. Such ultimate values are, of course, irreducible to price and measurement. (B. Wilson 1988, 1). While commercial value is subject to continuous rise and fall, ideal values are subject to reinterpretation, hypocrisy, recommitment, and even abandonment.

CHAPTER ONE: CREATIVITY, THE WEST, AND HISTORY

1. See Rousseau's comments, 90–91. In most traditional cultures, these fundamental inventions were attributed to heroic individuals or gods and related in myths as having happened in the remote past, once and for all. There is little evidence that these myths were themselves thought of as human creations until perhaps, the time of Hesiod, ca.700 B.C.E. Religions were almost definitely not viewed as human creations by their adherents, though the Israelites seem to have viewed most others' religions as human fabrications.

2. As Lasswell put it, ". . . it would be a rewarding and gigantic task to appraise our entire civilization from this point of view. What are the facilitators of which innovations? What are the inhibitors of which? We need to examine every cluster of value-institution practices with these questions in mind" (1959, 210).

3. Indeed, as Lynn White has pointed out regarding the history of technology, "one is as frequently astonished by blindness to innovation as by the insights of invention" (1963, 267).

4. This was clearly noted by Antonio Gramsci in the earlier part of the twentieth century. As Christopher GoGwilt has stated, the expression indicates (1) an international power structure, (2) an imagined cultural identity, and (3) a particular historical development within world history (1995, 15).

5. In James Baldwin's eyes, a white European or North American, however limited his or her cultural horizons, would necessarily be more Western than anyone of color, no matter how cosmopolitan. In *Notes of a Native Son*, Baldwin describes his encounters as the first black man visiting a small, "primitive" Swiss village:

For this village, even if it were incomparably more primitive, is the West, the West unto which I have been so strangely grafted. These people cannot be, from the point of view of power, strangers anywhere in the world; they have made the modern world, in effect, even if they do not know it. The most illiterate among them is related, in a way that I am not, to Dante, Shakespeare, Michelangelo,

Aeschylus, Da Vinci, Rembrandt, and Racine; the cathedral at Chartres says something to them which it cannot say to me . . . (1984, 165).

This line of reasoning is valid, it seems to me, only to the extent that race takes priority over all else—and this has often happened in Western history and continues to happen in many situations, with ugly consequences. On the other hand, a poorly educated, rural citizen of the West, white though he or she may be, may very well feel like a complete stranger in large cities, corporations, universities, government institutions, and may well envy the "power" that an articulate, cosmopolitan man like Baldwin, has in such environments. Most people reading this book would be likely to consider Baldwin far more closely related to Michelangelo and Shakespeare than they would an illiterate Westerner.

6. However, to discuss three thousand years of Egyptian dynasties and the diverse Mesopotamian cultures of the Akkadians, Sumerians, Babylonians, and Assyrians, as well as all their impressive creations and ideas about creativity would require volumes. More to the point is to what extent creativity in these Near Eastern cultures was transmitted to the West.

7. Abraham came from the region; Genesis and several of the Psalms echo passages from the Babylonian creation story, the *Enuma Elish*; Hammurabi's Code is paralleled but transcended to some degree in the laws of Exodus and Numbers. Later, during the Babylonian exile, the Jews adopted dualistic ideas of light and darkness, good and evil, and so on, and these ideas were then passed on to Christianity and the West. And, of course, the Jews sojourned in and were slaves in Egypt, and when they fled, they took Egyptian artifacts with them. What is more, the Egyptian God, Ptah, the patron god to whom generations of Egyptian artisans prayed for inspiration, did his own creating through the power of the spoken word; this probably had a direct influence on biblical theology. For their part, the Greeks were in continuous contact with the Egyptians, and especially with the Mesopotamians, with whom they had considerable trade, religious-cultural exchange, and major wars. The Great Pyramid in Egypt and the Hanging Gardens of Babylonian were among the wonders of the world, in Greek eyes. Herodotus tells us that the Egyptians were the inventors of many things the Greeks took for granted as their own, and later, Plutarch tells us that when the Romans came to Egypt, they were smitten with Cleopatra and in awe of the temples and pyramids.

8. Drenkhahn notes one counter example: the boasting of Irtisen, ca. 2000 B.C.E., a master craftsman and overseer of others (1995, 339–40); recently, however, individual craftsmen's tombs were discovered near the Great Pyramid.

9. While political rulers of ancient China and India also emphasized the importance of founding or establishing something, broader Chinese and Indian religious and philosophical tendencies, which minimized or ignored cosmic creation, moderated this.

CHAPTER TWO: THE BIBLE

1. I am using the word Bible, (The Book) intending the most neutral and all-encompassing term for the various books of the Hebrew Scriptures which Jews call Torah, Writings, and the Prophets, and Christians call the Old Testament, as well as the Christian New Testament. At the same time, it is important to realize that this group of writings comprises many individual books, letters, and songs, written over the course of a millennium, and

canonized by Christians and Jews only after long debate (indeed, different Christian denominations recognize some of the Apocrapha as holy, while others do not).

2. In the next chapter of Genesis, the Bible offers a second version of the Creation story, apparently written prior to the above mentioned one. The second version commences with a preexistent Earth; God forms man from earth, and woman from man. This second version, which is more like creation myths from other cultures, has had far less impact on Western views of creativity than the first.

3. While creator gods exist in Hinduism and Mahayana Buddhism, such gods are not of primary importance in those religious traditions. In Taoism, the "nameless" Tao is the "mother of all things," but does not actively or intentionally "create." In the Bantu religion, a chronological series of gods creates different parts of the cosmos, each god being weaker than the one before; in the Quiche-Mayan tradition, a group of gods debates how best to create the world. In Jainism, those who believe in a creator god are viewed as foolish. Jains ask: "If God created the world, where was he before the creation?" (Mahapurana 4.16ff)

4. This act is meant to mark them as "people of God." Perhaps this is also meant as a kind of dialectical religious magic: by sacrificing the foreskin of the penis, its powers of fertility will be enhanced. In many religions, sacrifice is viewed as resulting in greater strength. This is true for Odin in Germanic-Scandanavian mythology and, in a sense, for all of humanity through God's sacrifice of Jesus in Christianity. At a certain point in Jewish history the ritual of circumcision began to take place on the eighth day of life, apparently to indicate that from that day on, humans take responsibility for the creation.

5. In the twentieth century, some scholars have come to see parallels between biblical Judaism and ancient Near Eastern fertility cults. Not merely the ideal of being fruitful and multiplying, but several echoes in the Jewish liturgical calendar—harvest and planting, full moon celebrations, and even aspects of the Passover seder—reflect this. Previous generations in the West tended to disregard the fertility component of the religion, in part because of their own Platonic-Augustinian repression of the body and sexuality, and in part because the Bible itself shows the theological efforts of creatively adopting the fertility theme to a monotheistic faith and morality religion while keeping the fertility elements from gaining the upper hand.

6. In the original Akkadian/Babylonian version of this story, the gods decide to destroy humankind with the flood because the noise of the human babel was keeping the gods from sleeping; here, in the Biblical story, there is a lesson about something more.

7. Similarly, it is because Joseph is righteous that he is given the ability to interpret the Pharoah's dream (Gen. 40–41).

8. For example, since the High Priest could no longer enter the inner sanctuary of the Temple, all Jews were encouraged to enter the inner sanctuaries of their hearts. The tradition of preserving multiple interpretations of that which was commonly agreed upon as the sacred core seems to have provided just enough cohesion and just enough flexibility for the Jews to live through nearly two thousand years of the Diaspora and still claim some kind of traditional and common identity.

9. Jesus is, in a metaphorical sense, not merely the Paschal Lamb, who is sacrificed for others, but also the Phoenix, who rises from death.

10. Along with the Greek traditions of metaphor and analogy.

CHAPTER THREE: GREECE AND ROME

1. Various Greek authors used *poien* (to make, do, produce), *gennon* (race, family, genus, generate, genesis, generation, coming to be, formation, origin), and other words to describe what we would more or less call "creativity" (Liddell and Scott).

2. Just as the believers in the biblical tradition might hesitate to use the word "creative" for the Bible, Greek believers probably didn't think of the Muses or the Delphic Oracle—which they considered divine sources of inspiration—as creative. On the other hand, the inventions of philosophy and science in ancient Greece were, to a significant extent, a rejection of this view.

3. See also Lynn White, *The Act of Invention* (265–266), who focuses on the relationship between Heraclitus' fragment 22: "All things are exchanged for fire, and fire for all things; as wares are exchanged for gold, and gold for wares," and the dissemination of coinage in the Aegean region at that time.

4. It was certainly more important than having faith or being "fruitful and multiplying." The goal of a noble education, it seems, was to raise those who could speak eloquently and act wisely. Understandably then, Hannah Arendt (1958) views this attitude as a hallmark of ancient Greek culture, but her view seems a bit one-sided.

5. Similarly, when Aristotle introduces the concept of "invention" to Western thought in his *Rhetoric* (II:20), it is regarding inventive argumentation according to standard rules or strategies. Stesichorus and Aesop are mentioned for their brilliant uses of fable as examples to prove their points in debate. Nonetheless, Oliver Taplin is probably correct that we should understand Aristotle's *Poetics* as *proscriptive* rather than *descriptive*: "Tragedians were free in their use of theatrical techniques . . . they chose to convey their meaning by certain actions and sequences of actions rather than others . . . and this artistic choice directs us to their purpose." The goal of art remains for Aristotle an imitation of nature (*Poetics* 4; *Physics* II:2:194A21), a description of abstract human universals, and, generally, a representation of traditional stories (*Poetics*, 9, 13).

6. And even though Aristotle describes true science as the "originative source" of fact, and intuition as the "originative source" of science, he does not seem to be claiming that intuition creates science or that science creates facts (*Posterior Analytics II*: 19.13–17).

7. Herodotus, one of the "fathers" of history writing, focuses great attention on the origins of various ideas and practices, but seems less concerned with the originating per se than with showing how much of Greek culture derives from the Egyptians (who initially, says Herodotus, were "ruled by gods" (II:144)).

8. The ambivalence is also reflected in the Greek reverence for the demi-god, Prometheus. In some legends he is portrayed as fashioning humans from clay (*Pausanius* 10.4.4; Horace, Carm. 1.16.13ff), and he was therefore worshipped by craftsmen as the master craftsman. The other major legend about him was that of his rebellion against Zeus: Prometheus steals fire from the gods to give to humans. For this hubris, of course, Prometheus is tortured.

9. It is understandable, then, why Moses Hadas writes: "Aristophanes is not the most profound or exalted of poets, but he is the most creative" (1962, 1).

10. These conceptions of tragic fate and of individual emotion were, in significant ways, at odds with the philosophies of universal reason and action formulated by Socrates, Plato, and Aristotle.

11. The idea for the museum seems to have expressed Alexander's ideals, but apparently came from Demetrius of Phalerus. His patron, Ptolemy, Soter (323–285 B.C.E.) established the museum, and his successor, Ptolmey Philadelphus greatly developed it. The "museum" at Alexandria was probably more like a university. The first collections of antiquities and writings were probably in the era of King Nebuchadnezzar in Ur, sixth century B.C.E.

12. Every place also had its genius, or what we might call, "spirit." The beautiful mosaic at Pompeii of the *Genius of Wine* shows us, however, that the concept could have a great deal to do with pleasure.

13. Homer similarly said, "You speak with art, but your intent is honest" (*Odyssey* XI:341), implying that the art or skill might be manipulative. Elsewhere, Cicero makes a comparison between Apelles' painting and Panaetius' moral theory, implying a bridge between two forms of creativity that Aristotle placed in distinctly separate categories.

CHAPTER FOUR: TRADITION AND IMITATION IN THE MEDIEVAL WEST

1. See Augustine's attacks on the Pelagians and the Donatists.

2. Saint Thomas was certainly influenced in these views by his teacher, Albertus Magnus, whose *Commentary on the Metaphysics of Aristotle* describes "wonder" as both a physical sensation and the origin of philosophy (including "natural philosophy" (or science) (Greenblatt 1991, 294).

3. Interestingly, Thomas' discussion of "natural law," in which he speaks of "just and unjust laws" (Pt I, Q 96, Art 4), sets the groundwork for later theories of legitimate revolution espoused by Locke, the American Revolutionaries, and others.

4. Sometimes viewed as heretics, sometimes as paragons of faith, several of the great Roman Catholic and Jewish mystics of the Middle Ages pushed the boundaries of society and religious orthodoxy to the limit. The Dominican Meister Eckhart and the Kabbalist Moses DeLeon bordered on pantheism and were denounced for their beliefs that the divine creation is embodied in the world, that the creation is eternal and ongoing, and that everything that exists is spiritually in the mode of Creation. (See Scholem 1961, 222–23).

5. Similarly, St. Augustine and Pope Gregory the Great denounced "wordless" music (music without explicitly verbal religious content), because people might care more about the beauty of the singing than about the message of the Gospel (Boorstin 1993, 428–29).

6. Despite the facts that at least one late medieval author—no doubt many others— called God "the Supreme Craftsman" (de Pizan 1982, 23), and that a significant transition was underway. As Martin Warnke has emphasized, the late medieval courts played a major role in granting artists greater freedom and professional status (Rosenberg 1976, 189–90).

7. Of course, even though Dante follows his "master," Virgil, on the poetic journey through the Inferno and generally follows Church teachings in the content of the work, Dante's own poetry is hardly imitative, and his emphasis that his words can be interpreted

in multiple ways certainly leaves open some creative opportunities for the reader (Letter to Can Grande della Scala, Sayers, "introduction" to Dante 1949, 14–15).

8. The Bayeau Tapestry of 1073–83, showing the Battle of Hastings, is a remarkable secular work which predates Ambrogic Lorenzetti by two and a half centuries, but its influence on subsequent art was far less significant. See also Simone Martini's portrait of Guidoriccio da Fogliano and Memmo di Filipuccio's courtship and wedding scenes from about the same time as Lorenzetti's work.

9. Because the Old Testament was viewed as surpassed by the New Testament and because Jews were often viewed as "Christ killers," they were frequently persecuted and expelled from one country after another. Nonetheless, Jewish translations of Arabic translations of the Greek were crucial to Christian understanding of Aristotle; Maimonides' medical treatises, along with those of Ibn Sīnā's were of great importance; Jewish teachings from the Kabbalah probably influenced Christian mystics; and the Talmudic idea of the *Golem* probably helped inspire the original *Faustbuch*.

10. While Christian persecution of Jews and Moslems (as well as Christian heretics) was widespread and often repeated, for example, Pope Gregory IX called for the confiscation of all Jewish books in 1240, and subsequent Papal authorities demanded the burning of the Talmud—there were also periods of considerable openness and toleration. Because Roman Catholic Christianity believed that Jesus was "the Way, the truth, and the light" and that the pope's word was authoritative and infallible, and because the Papal States had a considerable degree of economic, military, and political power, it proceeded more absolutely than most regimes for an extended period of time (though see China chapter).

11. According to Earl Jeffrey Richards, translator of de Pizan's *Book of the City of Ladies*, Christine published a great range of works and achieved considerable prominence during her lifetime (see his introduction); at the same time, it is clear that Christine was neglected and then virtually forgotten from perhaps 1550 until 1980.

CHAPTER FIVE: THE RENAISSANCE AND THE INVENTION OF THE CREATIVE IDEAL

1. Sir John Davies, *Nosce teipsum: The oracle expounded in two elegies.* Arber, Eng. Garner V, 1599.

2. This seems quite contrary to several of the main points in Plato's *Republic*, of course. (See Dupre, 124–5, note 5.)

3. Preface, folio a vii V, in Abrams 1953, 272–73, 380. By "poet," Landino apparently meant a wide range of writers, not just poets in the modern sense. According to Umberto Eco, the "proto-humanist," Albertino Mussato, had first intimated, one century earlier, that poetic creativity was a gift from God (1988, 165 and note).

4. Scaliger seems to have been the first to have arrived at this conclusion, in his *Poetices libri septem*, 1561. (1607 ed, p.6); see Abrams, 1962, 273.

5. That is why a fair amount of Renaissance writing and aesthetic theory emphasizes the "marvelous"—whether referring to discoveries of new territories, technological inventions, or literary creations (Greenblatt 1991, 293).

6. Cf. Wolfson, "Philo on Free Will," p.163, 138. For Philo, "free will in man is nothing but a part of God's own freedom, with which man is endowed by God" (Wolfson 1947, I:455). Philo certainly considered the Bible to be sacred, but he also considered it capable of being read in a literal, or obvious way, or an underlying or allegorical way. In his *On Allegory*, Philo says that the Biblical story of God's creating in six days cannot be taken literally; the number is simply symbolic of perfection. Philo's allegorical understanding had a great impact on Christian and to a lesser extent, Jewish thought and, Boorstin is correct to view Philo as a creative hero—but Philo did not apparently think of himself or others as creative interpreters but rather thought of the Bible as having multiple layers of meaning implicit in it.

7. According to Shelley, Tasso was the first to use "create." (cf. Barzun in Wilmer 1991; cf. also Abrams 1953, 274). According to Klein's etymological dictionary, Ralph Cudworth first used the word "creative" in 1678.

8. Sydney wrote in the same vein six years before Puttenham, but published six years after him—see Puttenham's *The Art of English Poesy* (3–4). Sydney says:

> Neither let it be deemed too saucy a comparison to balance the highest point of man's wit with the efficacy of nature, but rather give right honor to that Heavenly Maker of that maker, who, having made man to His own likeness, set him beyond and over all the works of that second nature, which in nothing he shows so much as in poetry, when with the force of a divine breath he brings forth surpassing her doings (10).

Soens emphasizes that Sydney combined Aristotelian, Platonic, and especially biblical elements and probably found the idea of the divine analogy in Scaliger Poetices I, 1. For Sydney, the poet "creates an experience" of the divine Ideas created by God (Soens 1970, 63).

9. Interestingly, Puttenham seems never to have heard of his contemporary, Shakespeare. Indeed, according to Adolfus W. Ward, Shakespeare's fame was at least equaled by that of Ben Johnson, John Fletcher, and Francis Beaumont for several generations (1875 ed, vol. I, pp. 507–509, and 502, note).

10. The same is true for the words, "innovate," and "innovation," which emerged in French around 1300, but began to be used frequently in French and English in the 1500s. Recognizing the Aristotelian-medieval notion of "invention" as a mode of rhetoric, Francis Bacon emphasized a second sense of the word—"invention" in the arts and sciences and mechanics—as much more important. And in fact, during the Renaissance, the term seems to have been applied across the board to literature, painting, and technical fields for the introduction of novelty. Still the term was hardly as interdisciplinary or democratic as our word "creativity" today. "Invention" was still primarily used for rhetoric; then as classical rhetoric decreased in fashion, the term was used less and less for literary creation, and more consistently for technological invention, since the patent system and the society as a whole rewarded this type of invention to a greater degree (C. Miller 1996).

11. Al-Hasan's (Alhazan) (965–1035) description seems to have influenced Brunelleschi and Alberti to combine perspective, geometry, and representation of the world (Harry Berger, Jr.). The *camera obscura* was a darkened box into which an image is projected. A forerunner of the photographic camera, it was apparently invented before al-Hasan. (Bunch and Hellemans, 84, 132).

12. Because of their military and commercial value, the technical inventions were legally and materially more prized than any other—it was some time before art and literature would be copyrighted. According to Martin Kemp (1995), many of the most prized late medieval and Renaissance engineering sketches were not very detailed, but pretty drawings; these were used as "marketing tools" to interest patrons in commissioning projects. Mechanics kept their studio secrets for themselves and the craftsmen in their workshops. Still, as Leonardo's notebooks make plain, it was common enough for technicians to copy from each other, despite the efforts at secrecy and the patent system—Leonardo copied his contemporaries' drawings, and he was furious when his German apprentices seemed to steal his ideas.

13. Masaccio was apparently the first Italian painter to sign and date a painting, in 1422 (Bramly 1991, 426). Numerous works continued to be anonymous or pseudonymous, and it is likely that some of these were created by women; however, even Leonardo was still of the generation which did not sign any works.

14. Or at least "to revive the memory of those who adorned these professions [of painting, sculpture, and architecture], who do not merit that their names and works should remain the prey of death and oblivion" (Vasari 1946; Burroughs 1946, xii).

15. See also Stone, 651; Clemens, 5, 51; Saslow notes Michelangelo's neo-platonic belief, expressed in sonnet No. 151, that the sculptor removed the excess from the marble through his "intellect" (this sonnet was highly praised in the Florentine Academy, according to Saslow, 77, 302, 305).

16. As Leonardo says, "when painters have as their only model the paintings of their predecessors, . . . painting declines" (Cod. All., 181r a—Bramly 1991, 76).

17. As Vasari describes it in the prologue to the third part of the Lives, Leonardo's ability to imitate nature was virtually transcendent: ". . . besides the power and boldness of his drawing and the exactitude with which he copied the most minute particulars of nature exactly as they are, [his work] displays perfect rule, improved order, correct proportion, just design, and a most divine grace" (Burroughs 1946, 186).

18. While Plutarch had popularized Simonides' notion that painting was the image of poetry, this linkage was highlighted mainly in the sixteenth and seventeenth centuries. See Abrams (1953) 33, 42. Vasari's work also greatly aided in this transformation; among the legends he apparently originated was that Leonardo died in the arms of King Francis I, giving the artist a stature no "mere craftsman" ever could have hoped to attain (A. R. Turner 1993, 55).

19. As Pope, Julius II was also temporal ruler of the so-called Papal States, which covered perhaps one-third of modern Italy's territory.

20. Galileo was able to increase the magnification of his telescope thirty-fold and could thereby detect mountains on the moon, the milky way, new fixed stars, and the satellites of Jupiter. As McCain and Segal have emphasized, what Copernicus and Galileo did altered a wide range of attitudes and beliefs (1987, 82).

21. One of the greatest of these works was Thomas More's Utopia, which gave the West a new word and significantly influenced both politics and literature.

22. Thomas Aquinas and numerous others had perceived the earth to be round.

23. Though Galileo officially recanted his claim as a result of extreme pressure from the Church, including the banning of his writings. It took until 1994 for the Vatican to express regret about its treatment of Galileo.

24. Independent-minded women who asserted themselves in this way seem to have been ignored, or, if taken seriously, often burned as witches.

25. Luther's terminology interestingly compares with the stance of the artists who positioned themselves in order to carry out perspectival drawings. The artists' separation from and representation of their subject matter, thereby introduced modern art.

26. As great as many of his engravings seem, Dürer apparently did not consider his engraving art in the same league as painting, and he was such a capitalist that he could say: "Only from quickly painted mediocre works can I really make a profit . . . therefore, I will take up engraving again. Had I done this in the past, I would be a thousand florins richer today" (Raab 1993, 66).

27. Dürer had painted at least three self-portraits previously.

28. As Louis Dupre has emphasized, this emergence of the "self as subject" was presaged by the humanist philosophers Tomasso Campanella and Giordano Bruno, and the scholastic philosopher, Duns Scotus (1993, 112–117).

29. Although Luther was concerned about the dangers of the arts, he himself composed music and waxed poetic about it: "When natural music is heightened and polished by art, 'there man first beholds and can with great wonder examine to a certain extent . . . the great and perfect wisdom of God in his marvelous work of music . . ." (Boorstin 1993, 434).

30. And Leonardo was convinced: ". . . human genius . . . will never find an invention more beautiful or more simple or direct than nature . . ." (No. 1205A).

CHAPTER SIX: THE ENLIGHTENMENT

1. See Edward Shils, *Tradition*. As Jacob Bronowski has emphasized, ideas of freedom and democracy (and, we might add, capitalism) have gone hand in hand with the rise of science, because the free inquiry and openness to others' (new) ideas are fundamental to both the political and scientific realms (1958, 93).

2. As Simon Schaffer citing D. T. Whiteside notes, the story of Newton and the falling apple is a classic myth woven around our scientific heroes. According to the myth, the fateful event occurred in the 1660s, but Newton never recorded it, and it was first mentioned in the 1720s (Schaffer 1994, 15–16).

3. John Harrison, who won the prize, spent years struggling to get Parliament to pay him, however (Mokyr 1990, 250. note 11).

4. While some have denied the significance of patents as spurs to invention, Mokyr emphasizes that the subject is "decidedly mixed"—that it had greater or lesser effect in different industries and at different times and places (251).

6. And the century-long, often acrimonious debate between followers of Leibniz and those of Newton regarding who "first" discovered the calculus shows that the prominence and prestige accorded to inventors and discoverers was great.

7. As Louis Dupre has said, Descartes ". . . hoped to restore the foundations of human knowledge by converting moral uncertainty into philosophical doubt and doubt itself into a method for attaining certainty" (1993, 115). In a sense, Descartes' breakdown into simple parts and reintegration of them to arrive at the whole parallels the subject and the method of calculus discovered by Newton and Leibniz (1675).

8. David Lee Miller, in his *Philosophy of Creativity*, for example, sees the classical philosophical paradigm, which achieves its fulfillment in the Enlightenment, as "abstract reason, determinate form, and completed actuality"—something which seems to preclude any manner of creativity in the current sense of the word.

9. The social parody in Hogarth's drawings, Voltaire's witticisms, and Moliere's plays also often involved turning things on their heads in superbly creative ways. Without a doubt, the dissonance between the lofty Enlightenment ideal of Reason and the ugly wars Europeans waged at home and abroad was great.

10. Of course, Marx also maintained the Enlightenment concept of progress in his thinking about the "ever-expanding union of the workers, . . . which ever rises up again, stronger, firmer, mightier," and ultimately takes over, as well as in his belief that "science" could determine the ultimate course of history (Tucker 1978, 481).

11. Giambattista Vico's *New Science* of historical anthropology focused on historical evolution, but he at least realized that progress is never unambiguous.

CHAPTER SEVEN: REVOLUTION, MODERNITY, AND THE INVENTION OF CREATIVITY

1. "Art" and "culture" emerged after 1800 as mutually reinforcing domains of human value, strategies for gathering, marking off, protecting the best and most interesting creations of "man." (See Raymond Williams 1983; and Clifford's summary 1964, 234.)

2. This kind of thinking bridged the Enlightenment and Romantic eras, and went beyond art as well. G. E. Lessing wrote: "The artist of genius contains in himself the test of all rules, while he understands, retains, and follows only those among them which express his feelings in words" (in Ward 1975, 531). Coleridge was perhaps the first in the West to attribute his creative inspiration to a drug-induced dream or reverie. (In his preface to *Kubla Khan*, he calls it a dream; elsewhere he tells us he had taken opium "to check dysentery"; (Ghiselin 1952, 84–85).

3. Johann Sebastian Bach apparently held a similar view: "I have had to work hard; anyone who works just as hard will get just as far" (Boorstin 1993, 428).

4. Abolitionist societies were founded in Britain and the United States, and the French Revolution called for the emancipation of slaves. Mary Wollstonecraft wrote *Vindication of the Rights of Woman* in 1792, and the territory of Vermont became the first modern political entity to grant women the right to vote in 1784.

5. This also corresponds to Kant's views. His "Copernican Revolution in Thought" was not merely an epistemological matter, but an ethical one as well. Reason leads us inexorably to conclude that each individual is an end in himself, since each is a subject. The

moral imperative requires us to treat each action as potentially universal and each individual as we would wish to be treated. Therefore, said Kant, a federation of states in eternal peace is the logical result of universal reason.

6. Jacob Burckhardt's influential *Die Kultur der Renaissance in Italien* (1860) encouraged many to view the Renaissance artists as heroic freedom fighters.

7. Marx's vision of the liberation of humankind toward mutual, creative expression paradoxically is not to be created by humans choosing to do so, but by "the inexorable will of history," (MEW 23:16) which pushes the working class to revolutionize society. Furthermore, this revolutionary change culminates in a secure peace in which no further revolutionizing takes place.

8. In "mainstream" capitalist theory economic activity is seen as driven by creative expansion. Since this expansion is routinely thwarted, economic theorists have as their goal explaining anomalies and creatively figuring out how to eliminate bottlenecks. Business attempts to create new products and penetrate new markets; through marketing, it attempts to reveal its products or services as the solution to a problem, that is, it attempts to offer these as means of satisfying needs, whether others perceive these needs or not. Business is creative in "discovering" problems and providing solutions to them.

9. This was not entirely wrong—some artists, musicians, poets, philosophers, and other writers seem to have played significant roles in defending and criticizing their governments, in propagating political causes, and in some cases, in fighting for such causes or serving in government (Goethe, Jacques Louis David, Lord Byron, Danton, Hegel, Marx, Beethoven). Plato, we recall, saw the power of poets and artists and wished to exclude them from the state; that they should be the legislators of society would be horrifying to him. To others, it simply seemed absurd.

10. At least as influential as Shelley, was Carl von Clausewitz, whose *Vom Kriege* (on war) emphasized a multifaceted, critical, and creative approach to military strategy, one based on the recognition that psychology was as important as weapons, that the defense usually had a great advantage, and that war is politics in a different guise.

11. Baudelaire's approach here is a few steps away from or beyond Voltaire's view of the "universal taste for novelty" (1968, 172). Voltaire discusses a general tendency visible in everyday interests, romance, great literature, and great inventions, to appreciate new approaches to things. For Baudelaire, it seems, this desire for novelty would be too mundane—his search for novelty takes him away from bourgeois existence. This theme reemerges fifty years later in Thomas Mann's *Death in Venice;* however, influenced by psychological theories of the unconscious, Mann has the protagonist, Aschenbach, seduced away from rationality and creativity by a beautiful, flirtatious, but unreachable adolescent boy.

12. And mid-twentieth century writers like Jean Genet and Charles Bukowsky seem to have made it their task to surpass Baudelaire in merging creativity and depravity.

13. Joseph Swan had already invented a light bulb, and James Clark Maxwell explained the wave nature of electricity in 1873, but Edison's astuteness at organizing an electric power grid as well as the bulb, and his penchant for public relations earned him a special place in the popular imagination. Indeed, the fame and glory associated with great inventors, and with Edison in particular, sometimes went beyond what they actually accomplished: Edison's

work with electric power was described by local papers as the "newest marvel" even before he actually produced a prototype (Schaffer 1994, 18). Edison did in fact receive 1,093 patents for his creations. But he was also his own best publicist, and his close assistant, Francis Jehl, compared him to American showman P. T. Barnum.

14. Interest in Leonardo had revived around 1800 and had grown through Walter Pater's influential essay of 1869 on Leonardo's modernity and creativity; da Vinci's notebooks were first published in 1881. In 1883, J. P. Richter published *The Literary Works of Leonardo da Vinci* (see A. R. Turner 1993, 12).

15. Freud thereby added fuel to the earlier psychological linkage between creative genius and madness, but he moderated this as well by indicating that much creative expression is socially condoned neurosis.

16. For Freud, the desire to "penetrate" the unknown, a common trait of creative individuals, was tied to the child's curiosity about sexuality.

17. However, for Henry Adams, the image of the Virgin Mary had been as influential or even more influential than the electric dynamo or any other material reality.

18. See also Marinetti's absurdist and provocative *Futurist Cookbook* of 1932.

19. To be fair, even the religious existentialist moralist Berdyaev spoke of the creative act as a "conquest" and a "victory" (1954, 13).

20. Because creative military strategies for protection/avoidance of these weapons did not keep pace with their invention, casualties in these wars were enormous. And that, of course, was part of the reason for these inventions in the first place. This was creativity with a purpose: military victory, political security, and control. Creators of these inventions were "patriots," serving the cause of the nation (even if that national cause might seem appalling to us). And of course, generals like Erwin Rommel, George Patton, Stonewall Jackson, and others, were extremely creative in their military strategies, sometimes succeeding against vastly superior technology.

21. As Oscar Wilde wrote in the preface to *The Picture of Dorian Gray,* "no artist has ethical sympathies" (a view vehemently denounced by D. H. Lawrence and viewed as absurd by countless others).

22. Most countries use art and culture to win attention and appreciation for political-economic ends, including on an international level. Sometimes museums and governments collaborate in multimillion dollar extravaganzas such as the Mexican art exhibit at the New York Metropolitan Museum in 1990, which glorified Mexico in anticipation of discussions leading to the North American Free Trade Agreement.

23. Several of these people were Jewish, and it is interesting to consider Hitler's and other anti-Semites' reactions to Jewish creativity as well as their influence on the creativity of individual Jews. As Marcel Meth and Silvano Arieti have documented, Jews have been a disproportionately great number of Nobel prize winners and otherwise greatly respected creators (Arieti 1976, 334). Learning has a very high social value for Jews—does creativity? Some maintain precisely that (Kamenetz 1994, 222). It would make sense: Jews survive oppression, gain respect, and so on for their creativity. Is this true of other minorities as well? Does the centrality of the Creator God in their religion play a role?

24. Though Carroll's subject may also be the very traditional one that curiosity leads to trouble (Barzun 1975).

25. According to Josef Herman, "... The artist's images have taken over where religious images have left off" (120).

CHAPTER EIGHT: CREATIVITY IN THE CONTEMPORARY GLOBAL CONTEXT

1. Attempting to depict the context in which we presently find ourselves is almost impossible. This chapter aims to trace some of the major trends of the past half century and especially trends that seem to be continuing as they bear on the question of how we perceive creativity.

2. Many Westerners agreed with Elie Wiesel's depiction in *Night* that God died in the ovens of Auschwitz. For some Japanese and American filmmakers, Hiroshima ushered in the era of mutant horrors.

3. Perhaps in some way the feverish postwar economic boom in America, Japan, Germany, and elsewhere as well as the focus on creativity might be seen as an effort to suppress the great fears that the war and its end provoked. J. P. Guilford reveals that the great interest in the subject which prompted studies like this during the 1950s derived in large measure from the "mortal struggle" against communism "for the survival of our way of life" (420).

4. The New York Stock Exchange advertizes itself to visitors as having "a history of innovation and leadership."

5. And the rise of interdisciplinary studies in the twentieth century expresses the recognition of the interrelatedness of things. Thus, art history, for example, which had focused for centuries on the aesthetics of "high" European culture, now involves a whole range of methodologies and approaches to the contexts of all kinds of things that formerly might not have been called "art" (Serr 1991, 91).

6. Not all Europeans have accepted this, of course. As Clifford Geertz noted in 1977, the anthropological movement to lump together "high" Western art and "low" crafts of other peoples was bound to disturb many Westerners, just as anthropology's lumping together of totemism and Christianity in the nineteenth century had done. But this effort to "deprovincialize" our "social concepts" does not mean that we need to stop judging the respective qualities of things (1973, 261, note 40).

7. Around ten thousand art works were listed as stolen in 1998, and ironically, the single most expensive painting in history, Van Gogh's *Portrait of Dr. Gachet,* which sold for $82.5 in 1990, is presently under suspicion of being a fake.

8. Great Western art as well, from Greek vases to Gothic cathedrals to Bach cantatas, served specific uses, but later Westerners generally believed they understood the context of those uses, and, since the Renaissance, and especially in the past century, Western painting and music have appeared to be ends unto themselves.

9. Though our society's penchant for collecting tends to turn any outmoded use-object—however produced—first, into *kitch,* and then into an *antique.* As a result, we come

close to viewing even some now useless, mass-produced objects as "creative." They then have a new use: as collectable or decorative items.

10. As new technologies surpass old ones, formerly useful things may be ignored or still may be treasured as aesthetic or religious objects. i.e. photography replaced etchings as means of reproducing a scene; and film and video have replaced photography in some ways, but etchings and photos are still valued. New technology gives power to certain countries, companies, individuals who can acquire such aesthetic treasures. People may no longer care about objects others collect as vanished treasures. Tradition declines, utility declines, and fascination with new objects like blue jeans and plastic wares increases.

11. In scientific research, collaboration is extremely common, of course. Lewis Thomas has given us a striking analogy between the way scientists exchange information and the efforts of ants in constructing a hill. Thomas cites J. M. Ziman's article, "Information, Communication, and Knowledge," in which he emphasizes that: ". . . the invention of a mechanism for the systematic publication of fragments of scientific work may well have been the key event in the history of modern science. . . . This technique, of soliciting many modest contributions to the store of human knowledge, has been the secret of Western science since the seventeenth century, for it achieves a corporate, collective power that is far greater than any one individual can exert" (1969, 15).

12. In many respects, problem-solving is fundamental to science. The whole idea of identifying an area for investigation implies a problem, and hypotheses are formulated as solutions; experimentation and verification are, in a sense, efforts to find problems with the proposed solutions. Often, however, pure science is largely overwhelmed by technology. Around the world, governments and businesses have called upon natural and social scientists to identify needs and solve technical problems for the sake of public welfare or private profit.

13. This may be related to our changed understanding of gender roles, for "expression" has frequently been associated with women and "problem-solving" with men.

14. For Jung, in particular, this also meant a collaboration or merging between the parts of the psyche he believed were "feminine" and those parts he viewed as "masculine."

15. Convinced that intelligence tests developed prior to 1950 had ignored creativity and thereby had missed a fundamental aspect of intelligence, J. P. Guilford determined several primary traits of creativity: the ability to see problems; fluency of thought; associational, expressional, and ideational fluency; spontaneous flexibility; adaptive flexibility; originality; the ability to work hard; tolerance of ambiguity; divergent thinking. However, as Guilford himself admitted, high scores on the tests did not necessarily allow for prediction of creativity in real life. (Guilford 1959, 158; Barron and Harrington 1981; Mackinnon 1968, 438). The irony of this, of course, is that some intimation of what "creativity" in real life means (based on the outcome or product) guided the formulation of the tests, and no doubt the same operational definition allowed Guilford to see the lack of predictive validity of the tests. The operational definition seems to have been heavily influenced by the commonsensical view that those individuals considered "creative" by the society (on the basis of their "creative" productions) must have those qualities that constitute creativity. This approach, circular as it is, has been followed in countless studies.

As Geraldine Clifford (1964) pointed out in her critique of the "empirical" studies of Jacob Gretzls and Philip Jackson, which attempted to distinguish "creativity" from "intel-

ligence," such studies are culturally biased, supporting a rationalistic, pro-science, pro-technology, pro-business view of innovation. This is understandable, since much of the testing for creativity in the 1950s was tied with training for creativity, and the military and corporate organizations involved had clear values in mind which creativity was meant to serve.

16. This dovetailed with the democratic intentions of many of the empirically inclined psychologists and with the business emphasis on problem-solving (since identifying and solving problems is such a widespread human trait).

17. Training and problem solving are clearly goal-oriented, and those who achieve in the eyes of the sponsor (corporations, government) are usually rewarded, but the methods used by organizations to enhance creativity often involve open-ended free association, play, relaxation techniques, and so forth. According to Teresa Amabile's extensive research, "the intrinsically motivated state is conducive to creativity, whereas the extrinsically motivated state is detrimental" (1985, 15). In part for this reason, even works such as Ray and Myers' popular *Creativity in Business* are filled with references from Taoism and Zen Buddhism about being natural, spontaneous, and indifferent to goals. Since such indifference is almost impossible in a business setting, many critics consider the idea of creativity in business an oxymoron. However, as Csikszentmihalyi has noted, while "probably very few creative persons are motivated by money, very few can be indifferent to it entirely . . . rewards, both intrinsic and extrinsic, help the flowering of creativity" (1971, 334).

18. In 1995, for example, the European Association of Institutions in Higher Learning held an international conference on "Innovation in European Higher Education." As Jan Thomeer, President of Venlo Polytechnic in the Netherlands said, "Innovation is a continuing process in any field of business. Education is no exception . . ." (1995, 17).

19. Interestingly, life does seem to imitate art. A wonderfully sarcastic premonition of these developments can be found in Jorge Luis Borges' "The Library of Babel" in his book, *Ficciones,* from 1956. Lost in the infinite library, the narrator searches for information which will decode its meaning and give him a purpose . . . but the search seems endless.

The commonly used term, "electronic superhighway" was apparently first coined by Korean-American artist, Nam June Paik, in 1974. Starting with his "Zen T.V." installation of 1963, through "Family of Robot: Grandfather" (1986), and culminating in his "Cybertown: Electronic Superhighway" (1990), Paik combines art, technology, and global culture critique in a direct commentary on the wonders and absurdities of human innovation. Paik claims he first used the term, "Electronic Superhighway," in a proposal to the Rockefeller Foundation 1974; he first published the term in German, 1976.

20. That is not to say that the ideas presented on the Internet—its content—are any newer or more important than ideas presented in the past; nor it is to say that the number of Internet users can yet compare with television viewers, telephone users. What distinguishes the Internet is the possibility of interactive communication among multiple, self-selecting parties. As Eric Schmidt of the Internet Society has said, echoing a key Enlightenment idea, the goal is "to eliminate the middleman and empower individuals" against authoritarian control (S. Rosenthal 1995). Thus, efforts like the Intercollegiate Electronic Democracy Project, which allows students fromm across the United States to discuss public policy, seem to be significant new creations.

21. Despite this ideal image, economics and education will no doubt limit the scope of access to this amazing creation. Furthermore, the difficulty of sifting the wheat from the chaff in the mass verbiage of the Internet is even more daunting than deciding on quality in the world of art, where anything seems to go.

22. And the wonderful Japanese film, *Shall We Dance,* would not have been such a success in Japan and in other countries were it not the case that millions of viewers could identify with the sense of repression and conformity and the longing for freedom and creativity expressed in it.

23. Such thinking permeates the international worlds of science and business, where not just creation but perpetual "re-creation" seems to have become the goal. We are not merely seeking the "perpetual motion machine" of the past, but one with artificial intelligence, one that can continuously innovate, learn, and innovate again.

24. Although the postmodern era is one in which "The idea of progress in history and even in science has been radically relativized" (Redner 1987, 31–32), Louis Dupre seems right in saying that the break with the Western intellectual tradition ushered in by modernism was more profound than the so-called postmodern. Indeed, Derrida and others today seem to be extremely dependent on Nietzsche and Martin Heidegger.

25. Indeed, in Wai Chee Dimock's (1997) "diachronic historicism," the primary concept is the theory of "resonance," for no text has permanence, and the way a text resonates over time and place, not any inherent quality of its own, is what we should note.

26. J. E. Eliot (1998) points out, however, that "concreteness . . . is ironically lacking whenever culture opposes itself to text" Postmodern literary criticism frequently results in formalistic "hypostasization of critical vocabulary as the function of its *object*" (60).

27. Maslow maintained that new humanistic psychologies give "promise of developing into the life-philosophy, the religion-surrogate, the value system, the life program that these people have been missing" (1968, *Psychology of Being,* iv). Outraged religious believers might denounce Maslow's "secular humanism," but many have adopted a belief in creativity (see Henry Dumery 1968, for example).

28. Increasingly global as this metaphysics has become, it is obviously more strongly adhered to in different parts of the world than others and by some individuals more strongly than others.

29. Several mid-century philosophers, including Paul Weiss, Charles Hartshorne, Gaston Milhaud, John Dewey, Martin Heidegger, Maurice Merleau-Ponty, Hannah Arendt, and others emphasized the importance of growth, initiative, and originality in diverse ways. The Society for Creative Ethics, later named the Society for Philosophy of Creativity, was founded in 1951.

30. W. T. Anderson espouses the view that postmodernism, environmentalism, and the media are pushing us toward more communalism and less individualism. As Robert Bellah has said, however, (1996), global culture is a long way from being a global community. Indeed, in the United States today, fully one quarter of the population lives alone.

31. . . . or perhaps an expression of despair. Strictly speaking, "self-actualization" and "peak experiences" which Maslow discusses do not in themselves directly equate with creativity. Creativity is one route (love and religion are others) toward the kind of "peak experiences" which Maslow relates to self-actualization. However, the weight of Maslow's work is on

individual discovery, achievement, and expression of the "true self." According to Maslow, those who are most self-actualized are spontaneous, inquisitive, and creative. This is echoed by several other humanistic psychologists, like Carl Rogers, Viktor Frankl, and Rollo May, whose book, *The Courage To Create,* treats "creating oneself" as the highest possible achievement. And this is how many laypeople seem to understand the term, "self-actualization."

32. Ironically, even the leading proponents of the postmodern deconstruction of Self, Foucault and Derrida, appear to their admirers as heroic self-inventors and "living works of art." See Simon Schaffer's "deconstruction" of the myth of the individual scientific discoverer. Schaffer notes that Ernst Kris and Otto Kurz similarly noted the myth-making around great artists' lives in their 1934 *Die Legende vom Kunstler.*

33. Even Georgia O'Keefe maintained that works of hers taken as abstractions by others were almost "photographic" portraits (Dillon and Reed 43).

34. For both Jean Clair, the Biennale curator, and William Rubin, the MOMA curator, the focus on portraiture, and particularly on the self-portrait, was the single theme of the century matching, and in a sense, opposing the otherwise dominant idea of abstract minimalism (Bonetti, "The True Face" 1996, c11). In a *New York Times* essay reflecting these same cultural forces, Celia McGee quotes New York Museum director Philip Verre and proclaims the reemergence of portraiture as an art form for our individualistic times: "Portraiture has produced [and reflects] intense debates about formalism and realism, about irony in art, about politics, about tradition and breaking with conventions. . . . The intense examination of sex, ethnicity, sexuality, and class has led naturally to portraiture and the ménage à trois it sets up among artist, subject, and viewer" (1, 35). Of course, next year—or next month—other critics will proclaim a whole new tendency about to take over the art world. That is part of the perpetual search for novelty. On the other hand, the commonality of self-portraiture in the arts is hardly new or necessarily significant: looking in the mirror, one finds the least expensive, most obedient model.

CHAPTER NINE: THE IDEOLOGY OF CREATIVITY IN THE UNITED STATES

1. While many of the newcomers to America were critical of European institutions, all nonetheless obviously came with European cultural assumptions. In other words, even if the land had been a *tabula rasa*, those writing on it were already strongly inclined in what direction they would write.

2. Nonetheless, Melville quickly became disillusioned with this American mythology—see his *Clarel.*

3. This was in part the logical consequence of the fact that many of the earliest immigrants were themselves "protestant dissenters." Furthermore, when some protestant communities tried to force everyone to follow their particular interpretation of the biblical tradition but this proved ineffectual in such open territory. "Rebels," like Roger Williams, would leave and create their own new religious groups.

4. Which echoed British and French views.

5. However, the system of checks and balances makes fundamental change so much more difficult than in some parliamentary democracies, that many have lost interest in politics and others repeatedly call for a new Constitutional convention.

6. Some claim that much credit is due the Iroquois statesman, Canasatego, for influencing Jefferson and Franklin and that in general, American Indian freedom and self-government greatly impressed Locke and other European political theorists, who, in their turn, influenced United States political thinking. See Felix S. Cohen, pp. 18–19.

7. In fact, it may be that a more tragic view of life is more conducive to artistic creativity. Then again, perhaps social-economic-political limitations reinforce a tragic view, and artistic creativity then becomes one of the few outlets possible for the frustration experienced in other realms. In this case, the relative social-economic-political opportunities in the United States might allow for more optimism that problems can actually be solved by inventiveness, lessening somewhat the therapeutic need for artistic expression. However, many Europeans criticize American "optimism" as ridiculously superficial: the most profound existential problems are hardly "solvable" by American ingenuity, and maturity means facing the tragic realities of existence.

8. While business hopes that the techniques employed in creativity training will help employees create new products, services, and new markets, the ultimate goal remains "the bottom line," and it is unclear to what extent the emphasis on creativity in American business leads to creative fulfillment of any kind in the workplace. However, a company's reputation for innovation is both a significant lure for workers and a powerful marketing element.

9. Indeed, much of American society's artistic creativity has been absorbed into the so-called entertainment industry of television, film, and popular music. For some creators, the backing, marketing, and technological resources of this industry have allowed them literally to create "beyond their wildest dreams." Others, however, dream of carrying out more "serious," or "genuine" forms of creativity, and participate in the entertainment industry to provide the financial wherewithal to create as they wish.

10. Tax deductions began in 1952, when the Internal Revenue Service agreed to view the Martha Graham Dance Company as a nonprofit organization. From then on, tax breaks were given for donations to the arts and nonprofit organizations aimed at creativity could depreciate equipment. These changes have allowed countless museums, theaters, painters, and musicians to survive.

11. According to the *United Nations Human Development Report* of 1994, the average American paid 1.4 visits per year to art, science, and historical museums, more than citizens of all other countries, including even those of Austria, Israel, Denmark and Sweden—where government subsidies keep entrance costs much lower than in America.

12. The frontierswoman, on the other hand, is often imagined as the domesticating one, the one trying to get "the boys" to settle down. Occasionally we think of Annie Oakley and other exciting frontier women. When we read a book such as Lillian Schlissel's *Women's Diaries of the Westward Journey*, we are struck, however, by the diversity of the women: some followed their husbands and fathers only with the greatest of reluctance, others reveled in the adventure of the idea.

13. Significantly, Kennedy allowed his words to be used as text accompanying photographs from the Magnum Agency for a 1962 coffee-table book (*Creative America*).

14. Whitman, for example, wrote, "O days of the future, I believe in you" (1881, 187).

15. Disneyland does not encourage people to practice creativity, but it does appeal to their sense of curiosity, their excitement with novelty, and their admiration for Walt Disney's cartoon and film creations. Epcot Center, also created by the Disney Corporation, encourages creativity and invention a bit more directly. As Disney's brother Roy states, "for Walt Disney, innovation was a way of life" (introduction to *Snow White*).

16. Already Whitman had written in his *Poem of the Road* "my call is the call of battle— I nourish active rebellion" (1881, 238). The downside of this, of course, is that the "hero" always needed an enemy, and while bourgeois society was Whitman's and later Kerouac's, in much of the American cultural focus on the frontier, the enemy was the American Indian. An impressive body of American literary, artistic, and musical creativity includes prejudice against, in fact violent hostility toward, Native Americans, a phenomenon declining somewhat today.

17. Even American enthusiasm for outlaws like Jesse James seems to have been based on a belief in their original righteousness. The Superman myth runs directly counter to the rebellious outlaw myth. Superman is a bland, upright, ordinary citizen (Clark Kent) who, in times of need, transforms himself into an extraordinary defender of goodness and justice. Superman is, however, a supernatural creature. He is, in this way, reminiscent of the semi-divine heroes of ancient mythology. While American folk legends, cartoons, and fairy tales are filled with heroes who have supernatural powers or get magical assistance, the westerns are often tales of imperfect humans who gather their strength, skill, wits, and courage to solve a seemingly intractable problem. This connects them, more strongly, I feel, to American ideas about creativity, particularly about problem solving.

18. The image of the cowboy looms large in American society, even though very few individuals hold this job today (more do in South America). The archetypal cowboy hero is a man of deeds, not words, as Clint Eastwood portrays him. However, scores of cowboy poetry readings have taken place each year since the first one in Elko, Nevada in 1985. Isolation, freetime, and a heroic tradition seem to fuel this creativity; sensitive men and women now ride the range and relate to the muses.

19. Or, as R. W. Emerson said in *Society and Solitude*, 1870, "invention breeds invention."

20. About one million scientists and engineers are employed in the United States. According to the UN *Human Development Report* of 1994, this number represents only 55 people per 100,000 in the general population, as compared to 110 in Japan, 174 in Canada, 236 in Ireland, and 262 in Sweden! (188). These statistics have probably not changed in any significant way.

CHAPTER TEN: CONCEPTIONS OF CREATIVITY IN "TRADITIONAL" AND "NON-WESTERN" CULTURES

1. Of course, Europeans rarely thought of themselves as a single group. Superior as they all seem to have felt toward peoples of other continents and religions, they also expressed great condescension and bitterness toward each other. And, of course, chauvinism and ethnic rivalry abounded on other continents as well.

2. Already in 1918, anthropologist Hercules Read attempted to restrict the use of the word "primitive" to prehistoric cave dwellers (Dark, 1978, 32).

3. Heavily "modernized" already at the end of the nineteenth century, Japan as well felt a need to save traditional arts which were in the process of disappearing, and in 1936 the Japan Folk Crafts Museum was founded in Tokyo. While this clearly reflects the kind of thinking James Clifford referred to in which we strive to rescue creations from the world we are destroying, it is obvious that Japanese nationalism had reached a feverish pitch in 1936, and efforts there and in Germany at that time to preserve folk traditions had multiple rationales.

4. Our fascination with the "exotic" character of other cultures is hardly new. Herodotus was intrigued by the Egyptians, Renaissance Italians by Marco Polo's tales of China.

5. In the nineteenth century, for example, when Western collectors wanted to buy wooden *nkisi* sculptures from the Kongo people, they ritualistically removed the powerful "spiritual" elements from the works and handed over what they considered the dead material containers to the "ignorant" Europeans (Tervuren Museum).

6. Even the outstanding University of British Columbia Museum of Anthropology in Vancouver, which is strongly committed to respecting the cultures whose works it collects, explicitly states: "As is true of all great art, totem poles and other expressions of Northwest Indian Indian sculpture can be appreciated without knowledge of their cultural context." In this book, I, too, extract elements from diverse cultural contexts, and I may as a result do injustice to these cultures.

7. These negative portrayals often served political ends, of course. Aside from this, it generally helps a group to define itself by characterizing others as less developed precursors.

8. Inuit (Eskimo) art went through several transitions as a result of climatic changes and contact with the Europeans, and according to Robert McGhee, "Inuit plastic art practically disappeared for a few centuries." After James Houston visited the Arctic in 1948 and collected works which sold well in Montreal, an organized export market developed, and Inuit carving was reborn (McGhee 1988, 20; Blodgett 1988, 21).

9. Despite the recent rise in urban and industrial anthropology, anthropology as a whole continues to focus on groups of people attempting to live in ways that are "traditional."

10. In a rural village of Indonesia where my wife and I were intrigued by the "exotic" cloth designs local women were painstakingly creating on handlooms, we found to our surprise that all the villagers dropped their activities, grabbed their meager savings, and rushed out to the nearby road when a truck brought a supply of Levi's blue jeans.

11. This is precisely what is meant by the anthropological focus on the integrated web of a particular society. The parts are supposed to fit with the whole, and the society maintains a variety of means to encourage and enforce this cohesion. According to Marjorie Shostak's (1993) analysis of the !Kung people, however, the "popular misconception that small-scale communities demand greater conformity in individuality and creative expression than larger-scale societies finds no validation here" (55). Nonetheless, Shostak herself indicates how some of the creators she studied seek to repress their strong, creative personalities—because of social pressure (55–6, 64).

12. In some places, I've ridden on forty-year-old public buses for which no replacement parts existed. Local mechanics and metalworkers had managed to rebuild these vehicles many times over.

13. Hynes puts it this way: "Something about the antics of the trickster causes this figure to be enjoyed worldwide. The heartiest laughter within belief systems seems to be reserved for those mythic and ritual occasions when tricksters profane the most sacred beliefs and practices—be they occasioned by Hermes in Greece, Maui in Hawaii, Loki in Scandanavia, or Agu Tomba in Tibet. Systems normally busy generating firm adherence to their constitutive values are discovered to be simultaneously and contradictorily maintaining a raft of tricksters who perpetually counter, upend, and loosen adherence to these same values" (1993, 202). While this clearly shows that "traditional cultures" are not absolute in their commitment to traditions, it is significant that the trickster figures (a) have traditional names and roles, and (b) appear, as Hynes says, on certain "mythic and ritual occasions." Most likely, the tension released by the parody on those occasions allows members of the community to maintain their reverence for the traditions the rest of the time.

14. The fact that we have to use the qualifier, "Orthodox" Jews is indicative of the fact that so many other Jews—the majority, in fact—are far from appearing as traditional, even though large numbers of them might maintain certain elements of their traditional culture by celebrating holidays.

15. Thus, while the West uses the word "culture" less and less to refer to "high culture" and more and more in the anthropological sense of a society's practices and beliefs, it appears that almost every individual culture maintains some distinction between "high" and "low" culture. This probably corresponds to some degree to the distinction between sacred and profane, but it also expresses degrees of appreciation of quality for various creations. Marjorie Shostak points out that the Kung people consider it bad taste to impose standards of judgment on creators or their creations: everyone is supposed to be equal. Nonetheless, Shostak imposes her assessments of qualitative differences among the !Kung creators and shows how the !Kung themselves subtly but inevitably grant more recognition to certain creators rather than others.

16. On the other hand, however, writing frees us from memorizing the story's content, so that a literate culture can have millions of lengthy works, a situation that allows for far greater thematic diversity than might exist in an oral culture.

17. In traditional Hinduism, "the number of arts is unlimited; their very names cannot be counted. But among them, sixty-four are more prominent." These arts include such things as painting, singing, and dance, but also cock-fighting, massage, knowledge of omens, helping children play. (Tripathi 1990, 14–17).

18. The Japanese film director, Akira Kurosawa, is an example of someone who took modern technology and a modern art form and combined classical Western and traditional Japanese motifs to produce outstanding creations.

19. Sponsored by the Smithsonian, these fifteen individuals spent two years seeking out indigenous groups throughout the hemisphere which were attempting to maintain traditional cultural patterns. The resulting collaboration of videotapes, sculptures, paintings, installations, and narratives explicitly confront the issues of tradition and change, power and resistance, art, technology, and society.

20. Compare with Maslow's emphasis on "peak experiences" and creativity.

21. And many other twentieth-century Westerners not associated with these religious groupings might react similarly.

22. The cyclical aspects of Judaism and Christianity can be seen in the myth of the return to paradise, the Second Coming of Jesus, and the liturgical cycle. Even though the secular West abandoned the hard and fast line between divine "creating" and human "doing," which held sway from biblical times to the late Renaissance, the West continues to accept the principle that humans are finite and imperfect, as opposed to divine perfection. Somehow this has not hindered the West's reverence for individual human creators. In contrast, some Hindu and Buddhist texts often speak of the attainment of perfection—which on the surface would support human creativity as well—except for the fact that the individual pursuit of perfection leads to the transcendence of the individual Self, hence the rejection of the belief in the individual creator.

23. See, however, the recent discovery of individually named craftsmen's tombs near the Great Pyramid in Egypt. Interestingly, despite the Communist proclamations of the late Soviet Union, the names of individual creators continued to be recognized in many cases—because the society was in fact, "modern" and secular, and not religious or "traditional."

24. As we have seen, however, the West's interest in the creations of traditional cultures has helped break down the West's own tradition of categorizing art, craft, technology, or form and function as completely separate.

25. According to Leonard Burkat, the Western "tradition" of classical music did not begin until Handel's *Messiah* (1742) generated so much enthusiasm that conductors felt driven to perform it again and again. Until this time, and even a bit later, Western "musical life depended principally on novelty, on the newest, latest works," even though they adhered to traditional forms. Since then, of course, large groups of musicians have dedicated themselves to reinterpreting classical masterpieces.

26. Among the countless examples of Western "borrowing" from traditional cultures, I think of the explicit African influences in Paul Simon's music, the American Indian influences on painter Jackson Pollock, the Japanese tradition on musician Tony Scott, and, as mentioned earlier, the African sculptural tradition on the painting of Braque and Picasso.

27. This has been emphasized by Kuhn in his studies of the history of science, by T. S. Eliot regarding poetry, and by Shils regarding traditional institutions in general.

28. Indeed, those analyzing creativity often presume such differences. When creativity tests, devised in the "modern" West were carried out among different groups in the Sudan, "the study showed that there were significant differences between traditional and modern education with regard to creativity." Even though the researchers were sensitive to the need to respect traditional cultures, they concluded rather bluntly that "it is as if traditional education castrates the creativity of its individuals" (Khaleefa, et al 1997, 206). This certainly makes sense if we define creativity in modern cultural terms as bringing something new into being rather than as reinterpreting traditional paradigms, and such a definition very likely structured the tests. Class differences and rural/urban differences may also have played roles in this otherwise very interesting study. The potential importance of the study is, I think, that no matter how much we respect "traditional" cultures and how much we condition the distinctions between them and "modern" ones, we see that the kind of divergent thinking and risk taking we consider hallmarks of creativity are dampened by the obedience and conformity which are too often hallmarks of traditionalism.

29. In a multicultural society such as the United States, the intentional merging of cultural traditions is a realm of considerable creativity and sometimes of considerable humor: as Ric Salinas of the Chicano comedy group "Culture Clash" says, "we've always embraced a kind of Catskills humor—a burrito belt counterpart to the borscht belt . . . (Hamlin 1996, B1)."

CHAPTER ELEVEN: CHINA FROM TRADITIONAL CULTURE THROUGH REVOLUTION TO . . . ?

1. For Westerners, China was long viewed as "inscrutable" rather than as "primitive," because of the many impressive achievements of the society. Difficult as it is for me as a Westerner (who is not a China scholar) to give a fair appraisal of the culture, the task is made a bit easier to the extent that I am examining China here in regard to the Western-dominated "global culture." Indeed, I understand that "American discourse about China has long been as much about ourselves as about China" (Madsen, 55).

2. India, Egypt and other countries might compare in this respect.

3. Needham says: "By the time of the Thang [Tang] (seventh to tenth centuries C.E.), the patterns of Chinese and European thinking had become so fixed that the acceptance of any new element from outside was quite difficult if not impossible . . . " (1954, I:239).

4. This focus on memorizing and revering past text was, of course, paralleled in medieval Christian Europe.

5. Ray Huang refers these ideas to Chancellor Shi-huang-di (1990, 31).

6. Records indicate that already Marcus Aurelius sent ships from Rome to the China, and the "Silk Route" was a continuous source of East-West commerce.

7. See Akiyama, Tregear, vol. I, reproduction no. 287 for the storyteller figure; see *The Freer Gallery of Art* I: China, reproduction no. 38, for Kuo Hsi's painting.

8. Perhaps, however, the Chinese admiration for the Maitreya Buddha (the Buddha of the Future) shows a different, more activist, more "Western" approach to Buddhism. Certainly, northern Mahayana Buddhism is usually perceived as more "worldly" than the Theravada Buddhism of India and Southeast Asia.

9. This parallels the Chinese scientific conception "that the celestial bodies floated freely in a vast inane [*sic*], or were driven by winds along their course in empty space," something so inconceivable to Western thinkers of the late Middle Ages, fixated as they were on "solid, concentric, crystalline spheres," that "when the Jesuits first heard of these old Chinese theories of emptiness of the heavens, they set them down as yet another of the absurdities of the Mandarins and bonzes" (Needham 1954, I:240).

10. This is how the sanskrit *samatha* was translated through the Chinese *chih*, according to Wing-Tsit Chan (1963, 389–99).

11. And, as Boorstin has mentioned, since education in the classics was usually considered the prerequisite to sageliness as well as to civil service, many of the artist-poets were also government officials (419–422).

12. This image seems like the nineteenth- and twentieth-century Western focus on the bohemian artist, and Chan's words read like a Romantic poet's manifesto.

13. I thank my friend, Lei Ching Chou, for helping me better understand this.

14. Okazaki cites Lu Yu's assessment of quality of porcelain from different regions (1968, 69).

15. ". . . the freedom of the calligrapher is essentially in his mastery of the brush, in the beauty and energy of the strokes he produces, and in the compositional sensitivity he develops. Within the limitations of the conventions, the aesthetic potentials are infinite" (Fu 1977, xi).

16. The Mongols took over in 1279 and established the largest land empire of world history. Under the *Pax Mongoliana* of Kublai Khan 1215–1294, Rabban Bar Sauma, the Turkic ascetic monk traveled from northern China to Rome; and Marco Polo traveled with father and uncle, traders, from Venice to China. Captured in 1298 in a war with Genoa, Polo told his story to Rustichello of Pisa, who wrote his travels in what became a very popular book.

17. Chinese exports to Britain had become so substantial, that the British began to sell opium from India in an attempt to rectify the trade imbalance. A number of Chinese government bans on opium imports proved impotent, but after the Chinese destroyed twenty thousand chests of opium, the British sent troops to demand restitution. Holding superior firepower, the British imposed their will on China through the Treaty of Nanking (1842), which called for indemnities, trade privileges, free movement for Christian missionaries, and the transfer of Hong Kong. Through subsequent pressure, privileges were granted to France, the United States, Japan, and Russia.

18. The ongoing character of the revolution for Mao seems to echo Thomas Jefferson's idea of continuous generational change at least as much as Marx's idea of a revolution which leads to a seemingly complete and "content" Communist society.

19. Mao further indicated his frustration with ideologically meritorious but crude efforts: "Politics cannot be equated with art, nor can a general world outlook be equated with a method of artistic creation and criticism. . . . Therefore, we oppose both works of art with a wrong political viewpoint and the tendency towards the 'poster and slogan style' which is correct in political viewpoint but lacking in artistic power" (302).

20. For many Chinese critics, including the leaders who succeeded Mao, the Cultural Revolution which he unleashed in 1966 was doctrinal "terrorism."

21. Of course, this applause is directed toward a person as creative only; there are certainly many circumstances in which lack of discipline and lack of commitment to a common cause would be denounced in the West (business and military come to mind).

22. I have seen very divergent statistics on this, with Taiwan having anywhere between five and twenty times the per capita income of the PRC, and with Hong Kong doubling Taiwan. (One clear reason for the per capital income disparity, however, is that a substantial amount of China's gold and other assets were moved out of the mainland when the Communists came to power). Emigrant Chinese communities in the United States, Britain, Thailand, Vietnam, Indonesia, and elsewhere have elicited admiration and sometimes resentment for their extraordinary business successes as well.

23. William H. Overholt interestingly notes that Deng's incremental policy reforms, directed first at one segment of the population, then at others, has won the kind of acceptance

and achieved the kind of success that has escaped the more sweeping reforms made by Gorbachev in Russia (1993, 36–40).

24. It seemed as if "troublemakers" like Harry Wu, Wei Jingsheng, Xu Wenli, and others would be completely ignored and the great cultural discussion had ground to a halt—but the visits of Jiang to the United States in 1997 and of President Clinton to China in 1998 seem to have moved things forward again. However, the CCP is not about to abandon its power monopoly, and to a degree greater than many of the ancient dynastic governments, it surely has the power to prove this. It need not prove this power on a daily basis: occasional crack-downs probably suffice to internalize oppression in the majority.

25. Li Zhun wrote of "excavating the family system, ethics, morality, wisdom and creativity of the peasants" and saw that the power of the peasant family had both sustained China through hardship and imposed obstacles on its growth. For the author, "love is the best mirror of one's personality. Struggling at death's door, Li's characters hoist their lives and their loves together as banners of their existence as true human beings" (Siu 1990, 309).

26. Gardner presents "five points or assumptions that are dominant in China and contrast with the *ideal* situation in the West": (1) life should enfold like a performance, with clearly delineated roles; (2) all art should be beautiful and should lead to good (moral) behavior; (3) control is essential and must emanate from the top; (4) education should take place by careful shaping and molding; (5) basic skills are fundamental and must precede any effort to encourage creativity (1991, 251).

27. Hong Kong's transition from British Colony to part of the People's Republic has been less dramatic than some feared, but the future direction is uncertain, and some degree of political intimidation is obvious. The "One China, two approaches" formula for the reintegration of Hong Kong is creative, but whether the two approaches will modify one another or one will be swept away, is impossible to say.

28. When President Lee Tung-hui recently described relations between Taiwan and the mainland as "state to state," he infuriated Beijing as well as many Taiwanese who want "One China."

29. Many Taiwanese youngsters also know Japanese comics and motorcycles better than traditional Chinese culture. Of course, American youth also know movie stars and sports heroes better than then know writers, artists, and political leaders—but the stars and heroes they know are for the most part Americans.

30. Other Chinese economic practices which disturb the United States and some other countries include China's export of goods produced by prison labor and direct exports from the Chinese military. To a certain extent, the United States is hypocritical in its criticism of the Chinese here, since a limited amount of prison labor products are bought and sold in the United States and since America exports more military goods than any other country.

31. Beijing also maintains that their efforts at political decentralization have made it more difficult for them to control piracy in the provinces (particularly when individual, corrupt provincial officials benefit from payoffs by the pirates). Still, when Beijing wants to impose national control—as it has regarding political dissidents—it can achieve its purposes. Another area of contention regards Western concern with Chinese "oppression" in Tibet. For

the Chinese government, however, Tibetan nationalism is separatism and primitivism. The Tibetan Buddhist social structure, for Beijing, is traditional hierarchical power which needs to be swept aside in the name of modernism and the collective good. For Tibetans, China is simply oppressing their ethnic, national, religious, civil and human rights.

32. And precisely because "the Chinese government recognizes that the internet is a global thing," as Peter Yip has said, his government-backed China Internet Corporation seems to have been developed explicitly to maintain some degree of governmental controls on the material reaching China's increasing millions of Internet users (Landler 1998, C1, C4).

33. As a recent Chinese Internet post claimed, "The 21st century will be China's century (Pomret 1999, A12).

CHAPTER TWELVE: EVERYDAY OBSTACLES TO CREATIVITY IN OUR SOCIETY

1. Teresa Amabile twice cites the words of Charles Dickens: " 'It is only half-an-hour'—'It is only an afternoon'—'It is only an evening,' people say to me over and over again; but they don't know that it is impossible to command one's self sometimes to any stipulated and set disposal of five minutes—or that the mere consciousness of an engagement will sometimes worry a whole day. These are the penalties for writing books" (1985, 8; original in Allen, 1949, p.230).

2. The separation of professional creators from "passive" audiences today may be no more extreme than in the past. While class structures in medieval Europe, for example, were more fixed—preventing many from exercising creativity outside very circumscribed borders—the relatively low level of commercial activity and division of labor required everyone to be more inventive than in a society where necessities can be easily purchased from specialists. On the other hand, the relative social democratization and availability of materials in our society allow millions to write, paint, dance, sing, and invent avocationally.

3. For most people, creative expression usually brings more joy and fulfillment than suffering; and that is why Troisi and others continued their efforts.

4. So widespread is this belief that Avis Rent-A-Car advertised its services for years under the slogan, We're number 2; we try harder.

5. According to Autumn Stanley, "European peasant women bound moldy bread over wounds centuries before Alexander Fleming 'discovered' that a *Penicillium* mold killed bacteria." (1990, 314).

6. See Whitney Chadwick, *Women, Art, and Society*, and Linda Nochlin, "Why have there been no great women artists?" According to Chadwick, it took centuries for the art world to recognize that the highly regarded 1630 painting, *The Happy Couple*, was not by the famed Frans Hals, but rather by Judith Leyster; when this fact was discovered, it did not increase respect for Leyster as much as it reduced the value of the work (see Joan Smith, 1990, 13–18).

7. Perhaps these groups are allowed this role by the Anglo-male power structure, which keeps its creativity in the areas that maintain their power: economics and politics.

8. Marcel Meth carried out the statistical work analyzed by Arieti. They determined that between 1900 and 1970—and despite Nazi persecution—Jews won the Nobel Prize in

a ratio of twenty-eight times their population. The other group which won Nobel Prizes above statistical average was the French, with a ratio of two times their population (325–335). Long term oppression or discrimination frequently gives rise to creative forms of resistance, such as the invention of new words and the transformation of standard grammar (so that the dominant group won't understand), underground economies, or guerilla revolutionary movements.

9. I do not know whether Mary Shelley knew of the story of the *golem*, but the 1915 German silent film of that name apparently inspired the subsequent American horror films on the Frankenstein theme.

10. On a more humorous note, George Bernard Shaw was so impressed by a violin performance of Jascha Heifetz, that he wrote him a letter, saying, "My wife and I were overwhelmed by your concert. If you continue to play with such beauty, you will certainly die young. No one can play with such perfection without provoking the jealousy of the gods. I earnestly implore you to play something badly every night before going to bed . . ." (in May 1975, 21).

11. It was not until 1947 that Ives received a Pulitzer Prize for his 1911 Third Symphony. Unappreciated as a composer, he turned to insurance and invented "estate planning."

12. Paulo Freire called this the "banking system" of education. (See also George Stoddard 1959).

13. That is why unhindered brainstorming is a fundamental exercise in all creativity workshops and programs.

14. Recognizing these problems, hundreds of educators have written about creativity in the classroom. Indeed the continually changing curricula of our schools express not only the globalization and multiculturalism of society, but also the intense efforts of educators to creatively improve the way we learn. That half the efforts lead to naught should not be surprising; but the students who are the guinea pigs of those initiatives may well lose as a result.

15. As Mihaly Csikszentmihaly concluded from his study of creativity "If nothing else, this study should renew our determination that narrow specialization shall not prevail" (1996, 329–330). However, it seems to be taking some time for social structures to reflect this.

16. The "mystic," the eccentric," the "genius," and the "radical" are all perceived to be at the margins of society, but their ideas, unlike those of the "madman," are not rejected out of hand. Socially tolerated "deviance," like that of Saint Francis, may be honored as creative, though he would presumably have taken no credit for being creative, claiming that he did what the divine spirit inspired him to do. On the other hand, the criminal genius of Al Capone might be considered creative, if we overcome our distaste for what he did. It is more difficult to call a seriously mentally ill person "creative," despite his or her departure from "normalcy," because this person does not necessarily intend his or her actions.

17. Thus, while J. Robert Oppenheimer had serious misgivings about the nuclear weapons he had helped create, his collaborator, Edward Teller was convinced that human progress required "discoverers" to push ahead despite others' fears and resistance (see Kipphardt 1968).

CHAPTER THIRTEEN: CREATIVITY AND SOME CONTEMPORARY
POLICY ISSUES IN THE UNITED STATES

1. This works better for business activity than for art, which has traditionally relied
on government, foundation, or religious support. Scientific activity is frequently supported
by the corporate world, but generally for those projects fostering profit.

2. These are open-ended questions and do not easily admit of simple answers. Accord-
ing to Edward Shils, in fact, every society is stabilized by the vagueness of its agreed upon
values: " . . . extreme clarity in the formulation of values can be dangerous to society . . . it
is likely to further conflict in society between beneficiaries of the decision to carry out to the
full a single fundamental value and those who have to pay the price (1988, 51, 54). None-
theless, groups will invariably attempt to define laws in line with their values and beliefs,
and these may be quite absolute. And even when people are willing to compromise, they
often demand precision in laws and regulations which have direct impact on their lives.

3. Depending on inflation and the dollar exchange rate, the capital raised by foreign
biotechnology may seem even higher.

4. Not all religious people or environmentalists are so worried—they may even have
invested in the biotechnology industry. For many people, however, these questions are of the
utmost importance.

5. See Lesser, 1995, 907–909.

6. While some maintain that this cloning of human genes was not a case of genetic
engineering but of the duplication of existing, unaltered embryos through advanced medical
technology, Maclean's *Dictionary of Genetics and Cell Biology* does count cloning as a form of
genetic engineering (1987, 168). In any case, the news media and public figures around the
world latched onto the development as a fateful step for humankind and conflated Hall and
Stillman's cloning work with other genetic engineering developments. As the *New York Times*
front page headline announced: "Scientist Clones Human Embryos, and Creates an Ethical
Challenge" (1 Nov. 1993); *Time Magazine* responded with "Cloning: Where Do We Draw the
Line" (8 Nov 1993).

7. "Bio-informatics" is a broad term for all the ways that computers and biology
might interface. According to Chairman of Microsoft, Bill Gates, this is the "most interest-
ing" material for us to decipher and consider changing; the investment community is there-
fore very active in this field (Rifkin 1998, A25).

8. Indicative of this situation is the fact that while President Clinton has barred the
use of federal funds for human cloning and the state of California, for example, fines indi-
viduals for violating this ban, the $1 million fine might easily pale in significance compared
with the potential billions of dollars a company might profit by pursuing the work.

9. Even before this case, Mapplethorpe was "notorious" as the "prince of darkness and
the angel of light" (S. Weiley 1988, 106–11).

10. July 1998, the United States Congress voted to eliminate the NEA altogether.
Democratic Congresswoman Nancy Pelosi, condemning the Republican Majority, said, "they
delivered for the 'Christian Coalition' instead of for creativity for America" (A3). One month

earlier, the Supreme Court had reaffirmed the 1990 law providing for the NEA, which spoke of "artistic excellence and merit" as well as "general standards of decency and respect for the diverse beliefs and values of the American people" (A3). One need not be a conservative Republican to feel critical of the NEA. In fact, minorities received few grants at first and justifiably complained.

11. As Graham Beal has noted, the whole NEA budget is less than the pentagon's funds for military music (1990, 318).

12. Deviance carried out with great conviction might in fact alter norms. Hitler managed to make his previously and subsequently perceived deviance the "norm" for a whole society. But this also happens in less dramatic ways: creative individuals continuously alter perceptions of what is normal.

13. To the casual observer, the variations in pornography often seem formulaic, but perhaps to a connoisseur, it's a different matter. Is this comparable to the artistic or musical creations of a "traditional" culture, in which an often-repeated piece is varied just slightly?

14. The medium does matter to some degree. "Pornography" on the Internet is more opposed by some because access to it is easier than is access to magazines in an "adults only" pornography shop. Still, even conservative House Speaker Newt Gingrich opposed his own party's efforts to stop obscenity on the Internet, saying, "it is clearly a violation of free speech . . . " (*New York Times* 22 June 95).

15. The museum representatives in the Mapplethorpe court case tried to have the seven "objectionable" photographs viewed as an integral part of the 140 work exhibit; even though the judge disallowed that, the jury was influenced to accept the museum director's perspective.

16. In this light, it is interesting to consider the controversial thesis of John Horgan, whose 1996 work, *The End of Science* emphasized that "the great era of scientific discovery is over," since we've already discovered so much, and finding out more requires such great expense (6).

CONCLUSION: CREATIVITY AND BEYOND

1. In the United States, for some reason, many of the most successful comedians since World War II have been Jews and African-Americans. While one group has been professionally and economically more successful than the other, both have long been "marginal" in the society and have long been targets of hate and persecution. And a sizable number of women (including Jewish and African-American ones) have made their mark on comedy in the United States as well. The gay community, too, is responsible for significant creativity in American society, and among themselves (to a much greater degree than among often hostile "straights"), comedy plays a big role. Are these marginal groups the "tricksters" of our culture?

2. Sometimes this is not possible—other creative responses, including, in the extreme case, armed struggle, may be necessary. And as Paolo Friere has maintained, creativity is itself the opposite of oppression: to choose creativity is to choose liberation. (See also Arieti 1976, 318–336, 17.)

3. This is not to imply that all marginalized people are creative.

4. This is an amazing change, though perhaps implicit in the biblical notion that we are made in the image of God.

5. See also DeGeorge, who says: In actual life . . . most people in most societies do not operate from only one basic principle. In the United States, debate about the morality of practices . . . frequently proceeds by using several approaches—sometimes considering consequences, sometimes justice, sometimes rights, sometimes some second order principles such as the Ten Commandments." (1990, 46–7) These approaches may overlap or contradict, but, according to De George, this does not mean that America is "radically pluralistic." Most of our values are not mutually irreconcilable, and there is in fact much agreement in American society.

6. In these two cases I see that my priority is the safety and well-being of others over my need for self-expression, but I see that helping others may require my creativity. Indeed, saving the neighbor might require great creative problem-solving as well: what strategy should I pursue against someone who is strong and violent? How do I protect myself and my family? But I also know from experience that I will act first on impulse and then worry about my decision. In any case, I do not give a damn about how creative the mugger is.

7. And this, of course, is exactly what our contemporary ideology of creativity asserts and what many well-intentioned teachers, parents, and managers already practice.

8. In these ways, our culture has come within a few steps of traditional cultures, where creativity is often seen primarily in terms of reinterpretation. Still, a very major difference is that a traditional culture will focus its attention on reinterpreting certain primary and sacred texts (written or not); what is primary or sacred in postmodern culture is perhaps the process itself, if anything.

9. For me, Fyodor Dostoyevsky's *Brother's Karamozov* was "just right" the first time I read it, but "almost perfect" the next time; but the length of the work and the details of it were partially a consequence of the fact that the author was paid by the word . . . had that not been so, he might have written a much shorter work.

10. Heidegger made this mistake in his *Ursprung des Kunstwerkes (Origin of the Work of Art)*, in which he compared Van Gogh's painting and the originating effort of founding a state. Heidegger's error no doubt allowed him to glorify Hitler, who seemed to be a forceful creator of a new state; later, when the world could see how Hitler followed through on that creation, Heidegger turned silent.

11. As Amabile puts it, "heuristic" endeavors, where ambiguity reigns and problems are open-ended, is where we should look for the greatest creativity. Indeed, creative individuals throughout history have looked beyond the literal meaning of the Bible and every other "text" to arive at the most diverse metaphors.

12. See also Gardner's *Creating Minds*. Schaffer argues that "both epistemologists and psychologists have been disabled by the demarcation between inspiration and reason, notably because neither side seems able adequately to account for the processes by which discoveries are recognized as such" (17), but it is also because the theory of stages and a readiness to accept dualism has been an entrenched part of Western thought at least since Herder, Kant, and Hegel.

13. Indeed, we could look at much of the steady stream of innovation in the computer industry, for example, as a continuous tinkering with existing products.

14. But even where a well-defined blueprint has been written out beforehand, as in architect's drawings for a building or a composer's score for music, those carrying out the work will transform the piece through their own insights and practice—which is why no two performances of Mozart, for example, are identical.

15. And how will we ever know if the "good" or "bad" student or child is that way because of parenting, teaching, or something else? That is why Amabile says, "given the current state of psychological theory and methodology, a definition of creativity based on process is not feasible . . . products or observable responses must ultimately be the hallmarks of creativity" (1997, 31, 32), because this is really the only way we can assess the thing.

16. However, as Wenk has pointed out, market research works fairly well, and this shows the possibility of prognostication (1986, 39).

17. As Elaine de Kooning said: "That something new in art cannot come into existence despite influence is a ridiculous idea, and it goes hand in hand with an even more ridiculous idea: namely, that something totally new, not subject to any influence, *can* be created" (Selz 1970, 571).

18. For this reason, when we impose restrictions on creativity—and we must do so in some cases—they should be minimal, absolutely necessary, and easily revised.

19. This is perhaps because, as Benjamin Barber has put it, "we are caught between the past of tribalism and race and the future of cosmopolitanism and soul, but neither choice offers us a future that is other than bleak, neither promises a polity that is remotely democratic" (1996, 4).

20. Convinced, as I am, that three quarters of what I've said thus far is true (the rest being a guess), I am still not sure what to conclude—after all, what *can* be concluded about such a vast, multifaceted, global, cultural phenomenon as creativity? Words seem barely adequate—I feel prompted to dance out how I feel.

REFERENCES

Abrams, M. H. *The Mirror and the Lamp*. London: Oxford University Press, 1953.

Abrams, M. H., ed. *The Norton Anthology of English Literature*. Vol. II. New York: W. W. Norton, 1962.

Adams, Henry. *The Education of*. Atlanta: Norman S. Berg, 1975.

Adams, James L. *Conceptual Blockbusting*. 3rd ed. Reading, MA: Addison Wesley, 1986.

Adler, Les. "Politics and the Culture: Hollywood and the Cold War." In *The Spector: Original Essays on the Cold War and the Origins of McCarthyism*. Robert Griffith and Athan Theoharis, eds. New York: Franklin Watts, 1974.

Akiyama, Terukazu, Mary Tregear, et.al. *Arts of China*. Tokyo and Palo Alto: Kodansha Int. Ltd., 1968.

Allard, Alexander Jr. "The Roots of Art." In *Ritual, Play and Performance*. New York: Seabury Press, 1976.

Allen, Jane Addams. "The Sacred and the Profane: A Continuing Story in Western Art." *New Art Examiner*. (Summer 1990): 18–22.

Allport, Gordon. *The Nature of Prejudice*. Cambridge, MA: Addison-Wesley, 1954.

Almond, Brenda and Bryan Wilson. *Values*. Atlantic Highlands, NJ: Humanities Press, 1988.

Alpert, Steven. "Creativity." Fax addressed to author, 18 July 1996.

Amabile, Teresa. *The Social Psychology of Creativity*. New York: Springer-Verlag, 1983.

———. "The Personality of Creativity." *Brandeis Review* 5:1 (1985). In *An Introduction to Creativity*. Michael Joyce, ed. 2nd ed. Acton, MA: Copley, 1997.

Anderson, Harold, ed. *Creativity and Its Cultivation*. New York: Harper and Row, 1959.

Andrea, Alfred J. and James Overfeld. *The Human Record: Sources of Global History*. 2 vols. Boston: Houghton-Mifflin, 1990. 2nd edition 1994.

Andreasen, Nancy. "Creativity and Mental Illness: Prevalence Rates in Writers and Their First-degree Relatives." *American Journal of Psychiatry* 144, No. 10. (Oct. 1987): 1288–92.

Andronicos, M. *National Museum*. Athens, Greece: Ekdotike Athenion SA, 1975.

Angelou, Maya. *All God's Children Need Travelin' Shoes*. New York: Vintage, 1986.

Angier, Natalie. "An Old Idea About Genius Wins New Scientific Support." *New York Times,* 12 Oct. 1993. *Science Times* C 1, 8.

Angus, Ian and Sut Jhally, eds. *Cultural Politics in Contemporary America*. New York: Routledge and Kegan Paul, 1989.

Anselm, Saint. *Monologium/Prologium*. S. N. Deane, tr. Chicago: Open Court Pub., 1903.

Apotolos-Cappadona, Diane. *Art, Creativity, and the Sacred*. 2nd ed. New York: Continuum, 1995.

Arendt, Hannah. *The Human Condition*. Chicago: University Press, 1958.

———. *The Origins of Totalitarianism*. New York: Harcourt, Brace, 1951.

Arieti, Silvano. *Creativity: The Magic Synthesis*. New York: Basic Books, 1976.

Aristophanes, The Complete Plays. Moses Hadas, ed. New York: Bantam Books, 1962.

Aristotle, The Basic Works. Richard McKeon, ed. New York: Random House, 1941.

Arnaldez, R. "Khalk." In E. van Donzel, B. Lewis, and Ch. Pellat. *The Encyclopedia of Islam*. Leiden: E. J. Brill, 1978.

Artaud, Antonin: Works on Paper. Margit Rowell, ed. New York: Museum of Modern Art, 1996.

"Artists' Session at Studio One." In *Theories of Modern Art*. Herschell Chipp, ed. Berkeley: University of California Press, 1970, pp. 564—568.

Athanasius. *Contra Gentiles*. E. P. Meijering, tr. and intro. Leiden: Brill, 1984.

Augustine, Saint. *Confessions*. R. S. Pine-Coffin, tr. Harmondsworth, England: Penguin, 1961.

Babcock, Barbara. "At Home, No Womens Are Storytellers: Ceramic Creativity and the Politics of Discourse in Cochiti Pueblo." In *Creativity/Anthropology*. Smadar Lavie, Kirin Narayan, and Renato Rosaldo, eds. Ithaca: Cornell University Press, 1993.

Bacon, Francis. *New Atlantis*. Jerry Weinberger, ed. Wheeling, WY: Harlan-Davidson, 1989.

———. *Novum Organum*. John Sibson and Peter Urbach, eds. Chicago: Open-Court, 1994.

Baldwin, James. *Notes of a Native Son*. 2nd ed., Boston: Beacon, 1984.

Barber, Benjamin. *Jihad vs. McWorld*. 2nd ed. New York: Ballentine, 1996.

Barron, Frank. *Creativity and Personal Freedom*. 2nd ed. Princeton: Van Nostrand Co., 1968.

———. *Creative Person and Creative Process*. New York: Holt, Rinehart and Winston, 1969.

Barron, Frank and David Harrington. "Creativity, Intelligence, and Personality." *Annual Review of Psychology* 32 (1981): 439–76.

Barron, Stephanie. "Modern Art and Politics in Pre-War Germany." In *Degenerate Art: The Fate of the Avante-Garde in Nazi Germany*. S. Barron, Peter Guenther, and others. Los Angeles County Museum of Art. New York: Harry Abrams, Inc., 1991.

Barzun, Jacques. "The Paradoxes of Creativity." In *Creativity: Paradoxes and Reflections*. Harry Wilmer, ed. Wilmette, Il: Chiron, 1991.

———. *The Use and Abuse of Art*. Bolligen Series 35. Princeton: Princeton University Press, 1975.

Bateson, Gregory. *A Sacred Unity: Further Steps to an Ecology of Mind*. Rodney Donaldson, ed. New York: Cornelia and Michael Bessie, 1991.

Bateson, Gregory and Margaret Mead. *Balinese Character, A Photographic Analysis*. New York: New York Academy of Sciences, 1942.

Baudelaire, Charles. *Les Fleurs Du Mal*. Pierre Dufay, intro. Paris: Librarie des Bibliophiles Parisiens, 1921.

Bauer, E. E. *China Takes Off: Technology Transfer and Modernization*. Seattle: University of Washington Press, 1986.

Bauman, Zygmunt. "Semiotics and the Function of Culture." In *Essays in Semiotics*. Julia Kristeva, Josette Rey-Debove, and Donna Jean Umiker, eds. The Hague: Mouton, 1971, pp. 279–91.

Bazin, Germain. *The History of World Sculpture*. Jay Madelain, tr. 2nd ed. New York: Chartwell, 1976.

Beal, Graham. "But Is It 'Art'?: The Mapplethorpe/Serano Controversy." *Apollo* (Nov. 1990): 317–21.

Beck, James. *Raphael: The Stanza dell Signatura*. New York: George Braziller, 1993.

Begley, Sharon. "The Puzzle of Genius." *Newsweek* (June 28, 1993): 46 ff.

Bellah, Robert. *The Broken Covenant: American Civil Religion on Trial*. New York: Seabury, 1975.

———. On Community, 1996. Lecture at Saint Mary's College, Moraga, CA, January 17.

Bender, Thomas. "Thomas Edison's New York." Lecture, Lemelson Conference on invention. Smithsonian Museum. Washington, DC, Nov. 1994.

Benedict, Ruth. "Configurations of Culture in North America." *American Anthropologist* 34: 1–27.

Benjamin, Walter. *Das Kunstwerk im Zeitalter seiner technischen Reproduzierbarkeit*. 2nd ed. Frankfurt am Main: Suhrkamp Verlag, 1968.

Berdyaev, Nikolai. *The Meaning of the Creative Act*. Donald Lowrie, tr. New York: Harper and Row, 1954.

Berg, John C. "Beyond Creativity." In *Creativity and Liberal Learning: Problems and Possibilities in American Education*. David Tuerck, ed. Norwood, NJ: Ablex Pubs, 1987.

Berger, John, et al. *Ways of Seeing*. London: British Broadcasting Corporation; Harmondsworth: Penguin, 1972.

"Big Uproar Over Plan to Clone People." *San Francisco Chronicle*, Associated Press, 8 Jan. 1998, A8.

"Biotechnology and the Law: Recombinant DNA and the Control of Scientific Research." The Asilomar Conference Symposium. *Southern California Law Review*. 51, No. 6. September 1978.

Blake, William. *The Marriage of Heaven and Hell*. London, Eng.: Oxford University Press, 1975.

Blank, Robert. *The Political Implications of Human Genetic Technology*. Boulder, CO: Westview, 1981.

Blodgett, Jean. "The Historic Period in Canadian Eskimo Art." In *Inuit Art: An Anthology*. Edited by Alma Houston. Winnipeg: Watson and Dwyer, 1988, pp. 21–29.

Blofeld, John. *The Book of Change: A New Translation of the Ancient Chinese I Ching*. London: Allen and Unwin, 1965.

Boden, Margaret, ed. *Dimensions of Creativity*. Cambridge, MA: MIT Press, 1994.

Bonetti, David. "From Temple to Disco: The Museum Redefining Itself." *San Francisco Examiner*. 2 Jan 1994, D2, 7.

―――. "Artistic Reflections of Japan." *San Francisco Chronicle* 28 April 1996, Arts and Ideas.

―――. "The True Face of Modern Art: Reconsidering the Self-Portrait." *San Francisco Chronicle*. 14 July 1996, C11.

Boorstin, Daniel. *The Creators*. 2nd ed. New York: Vintage/Random House, 1993.

Borges, Jorge Luis. *Ficciones*. Anthony Kerrigan, tr. New York: Grove Press, 1962.

Borgmann, Albert. "Technology and Democracy." In *Technology and Politics*. Michael Kraft and Norman Vig, eds. Durham: Duke University Press, 1988.

Brahm, Randolph, ed. *Reflections of the Holocaust in Art and Literature*. New York: Columbia University Press, 1990.

Bramly, Serge. *Leonardo: The Artist and the Man*. Sian Reynolds, tr. London: Penguin, 1991.

Brimm, Michael. "Risky Business: Why Sponsoring Innovations May be Hazardous to Your Health." *Organizational Dynamics*, n.d.

Brinton, Crane. *The Anatomy of Revolution*. 2nd ed. New York: Vintage, 1952.

"A. J. Brodsky—Soviet Emigre, U.S. Poet Laureate." *San Francisco Chronicle*, Associated Press 29 Jan. 1996, p. A20.

Brown, Francis, ed. *The New Brown, Driver, Briggs, Gesenius Hebrew and English Lexicon*. Peabody, MA: Hendrickson Publishers, 1979.

Brownowski, Jacob. "The Creative Process." *Scientific American*. 199, No. 3, (Sept. 1958): 5–12.

Bruen, Hanan, Joseph Schwarcz, Lea Barinbaum. "Examiniming Social Aspects of Creativity—A Multimedia Approach." *Journal of Creative Behavior* 18, No. 1 (1984): 41–44.

Bunch, Bryan and Alexander Hellemans. *The Timetable of Technology*. New York: Simon and Schuster, 1993.

Burckhardt, Jacob. *Die Kultur der Renaissance in Italien: Ein Versuch*. Horst Gunther, ed. Frankfurt am Main: Deutscher Klassiker Verlag, 1989.

Burkat, Leonard. Program Notes to Handel's *Messiah*. Florida Philharmonic, Dec. 1994.

Burns, James MacGregor, J. W. Peltason, and Thomas Cronin. *Government by the People*. 13 alt. ed. Englewood Cliffs, NJ: Prentice Hall, 1989.

Burroughs, Betty, ed. "Commentary" to *Vasari's Lives of the Artists*. New York: Simon and Schuster, 1946.

Cahill, James. "Chinese Painting: Innovation After 'Progress' Ends." In *China: 5000 Years: Innovation and Transformation in The Arts*. Sherman Lee, ed. Exhibit Catalogue. Guggenheim Museum, New York, 1998.

Cameron, Dan. "Self-Determination." *Vogue* (July 1994).

Campbell, Joseph. *The Hero With a Thousand Faces*. 2nd ed. New York: Pantheon, 1953.

Camus, Albert. *The Rebel*. Anthony Bower, tr. 2nd ed. New York: Vintage, 1956.

Cardew, Michael. "Design and Meaning in Preliterate Art." In *Art in Society*. Michael Greenhalgh and Vincent Megan, eds. London: Duckworth, 1978.

Carnegie, Andrew. "A Talk to Young Men." *The Road to Business Success*. In *American Issues*, by Merle Curtis, et al. Philadelphia: Lippincott, 1971.

Cembalest, Robin. "The Obscenity Trial." *Art News* (Dec. 1990): 136–141.

Cervantes, Miguel de. *Don Quixote*. Walter Starkie, tr. 3rd ed. New York: Penguin, 1979.

Chadwick, Whitney. *Women, Art and Society*. 2nd ed. New York: Thames and Hudson, 1997.

Chadwick, Whitney and Isabelle De Courtivron, eds. *Significant Others: Creativity and Intimate Partnership*. London: Thames and Hudson, 1993.

Chai, Chu and Winberg Chai, eds. *The Humanistic Way in Ancient China: Essential Works of Confucius*. New York: Bantam, 1965.

Chan, Wing-Tsit. *A Sourcebook in Chinese Philosophy*. 2nd ed. Princeton: University Press, 1963.

Chaucer, Geoffrey. *The Canterbury Tales*. Howard Donald, intro. New York: Signet, 1969.

Ch'en, Kenneth. *Buddhism in China*. 2nd ed. Princeton, NJ: Princeton University Press, 1972.

Chipp, Herschl B. with Peter Selz, and Joshua Taylor, eds. *Theories of Modern Art: A Source Book By Artists and Critics*. Berkeley: University of California Press, 1970.

Chou, Lei Ching. Interview by Robert Paul Weiner, Orinda, CA. 15 May 1996.

Cicero. *Selected Works*. Michael Grant, intro. and tr. 3rd ed. Harmondsworth: Penguin, 1974.

Clemens, Robert J. *Michelangelo's Theory of Art*. New York: New York University Press, 1961.

Clifford, Geraldine. "A Culture-Bound Concept of Creativity." in *Educational Theory* (1964) 14: 133–43; reprint. In *Creativity: Theory and Research*. Edited by Morton Bloomberg. New Haven: College and University Press, 1973.

Clifford, James. *The Predicament of Culture*. Cambridge, MA: Harvard University Press, 1988.

Cochrane, Linda Ray. "How to Manage Creative People." *Public Relations Quarterly* (Winter 1984): 6–14.

Cohen, Felix. "Indian Self Government." In *Red Power*, by Alvin Josephy, Jr. New York: McGraw Hill, 1971.

Coleridge, Samuel Taylor. "Biographia Literaria." In *Norton Anthology of English Literature*. M. H. Abrams, ed. 2nd ed. New York: W. W. Norton, 1968.

Coles, Robert. *Dorothy Day: A Radical Devotion*. New York: Harper and Row, 1987.

Columbus, Christopher. "Letter to Lord Gabriel Sanchez," 14 March 1493. In "Renaissance, 17th and 18th Century Thought Reader," Saint Mary's College Collegiate Seminar Program, Moraga, CA, 1996.

Coming To Our Senses: The Significance of the Arts for American Education. The Arts, Education, and Americans Panel. New York: McGraw-Hill, 1977.

Cook, Harold J. "The Cutting Edge of a Revolution? Medicine and Natural History Near the Shores of the North Sea." In *Renaissance and Revolution: Humanists, Scholars, Craftsmen, and Natural Philosophers in Early Modern Europe*. J. V. Field and Frank Jones, eds. Cambridge: University Press, 1993.

Creative America. Text: John F. Kennedy, photography: Magnum. National Cultural Works. New York: Ridge Press, 1962.

Creativity: A Comprehensive Bibliography on Creativity in Science, Engineering, Business, and the Arts. New York: Industrial Relations News, 1958.

Crèvecoeur, Michel-Guillaume-Jean de (Pseudonym J. Hector St. John). *Letters From an American Farmer.* London: Dent, 1971.

Csikszentmihalyi, Mihaly. *Creativity: Flow and the Psychology of Discovery and Invention.* New York: Harper Collins, 1996.

Dante. *The Comedy of Danta Alighieri, the Florentine: Hell (L'Inferno).* Dorothy Sayers, tr. Harmondsworth: Penguin, 1949.

Dark, P. J. C. "What Is Art for Anthropologists?" Michael Greenhalgh and Vincent Megan, eds. *Art in Society.* London: Duckworth, 1978.

Davies, John of Hereford, The Complete Works. New York: AMS Press, 1967.

De Bono, Edward. *New Think: the Use of Lateral Thinking in the Generation of Ideas.* New York: Avon, 1971.

Decartes, Rene. *Discourse on Method and the Meditations.* F. E. Sutcliffe, tr. London: Penguin Books. 1968.

DeGeorge, Richard. "Ethics in Coherence" *Proceedings and Addresses of the American Philosophical Association.* Vol. 64, No. 3 (Nov. 1990).

De Jesus, Carolina Maria. *Child of the Dark.* David St. Clair, tr. New York: E. P. Dutton, 1962.

de Kooning, Elaine. "Subject: What, How, or Who?" *Art News.* 54, No. 4. (April 1955): 26–29. In *Theories of Modern Art.* Herschel Chipp, ed. Berkeley: University of California Press, 1970.

Deleuze, Gilles. "Literature and Life." Daniel Smith and Michael Greco, trs. *Critical Inquiry.* 23:2, Winter 1997.

Deloria, Vine, Jr. *God is Red: A Native View of Religion.* 2nd ed. Golden, CO: North American Press, 1992.

Dembart, Lee. "The Mystery of Creativity," *San Francisco Examiner*, 29 April 1990, D–16.

de Pizan, Christine. *The Book of The City of Ladies.* E. J. Richards, tr. New York: Persea Books, 1982.

Devaraja, N. D. *Freedom, Creativity and Value.* New Delhi: Indus Publishing, 1988.

Dewey, John. "Science and Society." In Larry Hickman, ed. *Technology as a Human Affair.* New York: McGraw-Hill, 1990.

Didion, Joan. "Georgia O'Keefe." In *Women's Voices.* Pat Hoy, Esther Schor, Robert DiYanni, eds. New York: McGraw Hill, 1990.

Diebold, John. *The Innovators: The Discoveries, Inventions, and Breakthroughs of Our Time.* New York: E. P. Dutton, 1990.

Dillon, Diane, and Christopher Reed. "Looking and Difference in the Abstract Portraits of Charles Demuth and Duncan Grant." *Yale Journal of Criticism.* 11:1. Spring 1998.

Dimock, Wai Chee. "A Theory of Resource." *Publications of The Modern Language Asociation.* 112, No. 5 (Oct. 1997): 1060–1071.

Drenkhahn, Rosemarie. "Artisans and Artists in Pharaonic Egypt." In *Civilizations of the Ancient Near East*. Jack Sasson, ed. Vol. I. New York: Simon and Schuster Macmillan, 1995.

Drexler, K. Eric. *Engines of Creation*. New York: Doubleday, 1986.

Drucker, Peter F. *Innovation and Entrepreneurship*. New York: Harper and Row, 1985

———. "New Technology: Predicting Its Impact." In *Technology and the Future*. Albert H. Teich, ed. 5th ed. New York: Saint Martin's Press, 1990.

Dryden, John. "Preface" to *Troilus and Cressida*. In *Works*. Maxmillian Novack, ed. Berkeley: University of California Press, 1984.

Duméry, Henry. *Faith & Reflection*. 4th ed. Intro by Louis Dupre. Translated by Stephen McNierney and M. Benedict Murphy. New York: Herder and Herder, 1968.

Dunne, J. B. "African Art." Michael Greenhalgh and Vincent Megan, eds. *Art in Society*. London: Duckworth, 1978.

Dupré, Louis. *Passage To Modernity*. New Haven: Yale University Press, 1993.

———. "Postmodernity or Modernity: Ambiguities in Richard Rorty's Thought." *Review of Metaphysics* 47 (Dec. 1993).

Dürer, Albrecht. "Outline of A General Treatise on Painting." In *Artists on Art*, by Robert Goldwater and Marc Treves. New York: Pantheon, 1945. In *Art and Human Values*, by Melvin Rader and Bertam Jessup. Englewood Cliffs, NJ: Prentice Hall, 1976.

Eckholm, Erik. "China Cracks Down on Dissent in Cyberspace." *New York Times,* 21 Dec. 1997.

Eco, Umberto. *The Aesthetics of Thomas Aquinas*. Hugo Bredin, tr. 2nd ed., Cambridge, MA: Harvard University Press, 1988.

Edel, L. "The Madness of Art." *The American Journal of Psychiatry*, 132 (1975): 1005–1012.

Edwards, Betty. *Drawing on the Right Side of the Brain*. Los Angeles: J. P. Tarcher, 1979.

Edwards, Jonathan. *Basic Writings*. O. L. Winslow, ed. New York: New American Library, 1966.

Edwards, J. M. B. "Creativity: Social Aspects." *International Encyclopedia of the Social Sciences*. Vol. 3. David L. Sills, ed. 442–457. Detroit: McMillan and Free Press, 1968.

Edwards, Morris O. "Creativity Solves Management Problems." *Journal of Systems Management* (June 1975).

The Eerdmans Analytical Concordance to the Revised Standard Version of the Bible. 6th ed. Grand Rapids, MI: William B. Eerdmans Co., 1977.

Ehrenreich, Barbara and Deidre English. *Witches, Midwives, and Murses: A History of Women*, 2nd ed. Old Westbury, New York: Feminist Press, 1973.

Einstein, David. "Growing Computers One Atom at a Time." *San Francisco Chronicle,* June 21, 1999, B1, B6.

Eliade, Mircea. *Cosmos and History*. Willard Trask, tr. 2nd ed. New York: Harper and Row, 1959.

Eliot, J. E. "Paradigms Retained: Cultural Theory, Critical Practice." *Comparative Literature*. 50:1, Winter 1998.

Eliot, T. S. *Selected Essays*. 1917–1932. London: Faber and Faber, 1937.

Ellis, Havelock. *A Study of British Genius*. London: Hurst and Blackett, 1904.

Ellul, Jacques. *The Technological Society*. 3rd ed. New York: Vintage, 1964.

Elmer-DeWitt, Philip. "Cloning: Where Do We Draw the Line?" *Time Magazine* (Nov. 8, 1993).

Emerson, Ralph Waldo. Lewis Mumford, introduction. *Essays and Journals*. Garden City, NJ: Doubleday, 1968.

Emmerich, Andre. "We All Inhabit a Time-Frame in Which Tastes Are Shared." *Art International*. (Autumn, 1990).

Encyclopedia of Creativity. Mark Runco and Steven Pritzker, eds. Orlando, FL: Academic Press, 1999.

Engell, James. *The Creative Imagination: Enlightenment to Romanticism*. Cambridge, MA: Harvard University Press. 1981.

Eysenck, H. J. "The Measurement of Creativity." In *Dimensions of Creativity*. Margaret Boden, ed. Cambridge, MA: MIT Press, 1994.

Faison, Seth. "Hot-Selling Book Lights a Fire Under Chinese." *New York Times*, 6 Nov., 1998, p. A4.

The Fine Arts Museums of San Francisco. *Teotihuacan: City of the Gods*. Hong Kong: 1993.

Fineborg, Jonathan. *Art Since 1940*. New York: Harry N. Adams, 1995.

Fitzgerald, Frances. *Cities on a Hill*. 3rd ed. New York: Simon and Schuster, 1986.

Flatow, Ira. *And They All Laughed*. 2nd ed. New York: Harper Collins, 1993.

Flon, Christine and Mitchell Beazley, ed. *The World Atlas of Architecture*. 4th ed. Christopher Dutton, et.al, trans. New York: Portland House, 1988.

Florman, Samuel. *The Existential Pleasures of Engineering*. New York: St. Martin's Press. 1976.

Foote, Carol A. "Designing Better Humans." *Science Digest* (Oct. 1982): 44.

Foucault, Michel. *Discipline and Punish: The Birth of the Prison*. 2nd ed. Alan Sheridan, transl. New York: Pantheon, 1977.

Fox, Dennis and Andrea Coron. "Selling Art, Respecting Tradition." *Tribal College* 5, No. 1, (Summer 1993): 24–27.

Fox, Mathew, ed. *Breakthrough: Creation Spirituality in New Translation*. Garden City, NY: Doubleday, 1980.

Fox, Nichols. "Helms Ups the Ante." *New Art Examiner* (October 1989): 20–27.

Frankl, Viktor. *Man's Search for Meaning*. 3rd ed. Boston, MA: Beacon Press, 1984.

Franklin, Benjamin. *The Autobiography of and Selections from His Other Writings*. Nathan Goodman, ed. New York: Modern Library, 1932.

Freedberg, David. "The Power of Images." *Art in America* (January, 1991).

Freedberg, Louis. "House Votes on NEA." *San Francisco Chronicle*. 26 June 1996, A3.

The Freer Gallery of Art. Vol I: *China*. Washington, DC and Tokyo: Kodansha Ltd., 1972.

Freire, Paulo. *Pedagogy of the Oppressed*. Myra Bergman Ramos, tr. New York: Herder and Herder, 1970.

Freud, Sigmund. *Civilization and Its Discontents*. James Strachey, tr. New York: W. W. Norton, 1961.

———. *On Creativity and the Unconscious*. Benjamin Nelson, ed. New York: Harper, 1958.

Friedan, Betty. "The Feminine Mystique." In *America Since 1945*. Robert Marcus and David Burner, eds. 4th Edition. 123–139. New York: St. Martin's Press, 1985.

Fritz, Robert. *The Path of Least Resistance*. Woburn: Butterworth-Heinemann, 1995.

Fromm, Erich. "The Creative Attitude." In *Creativity and Its Cultivation*. Harold Anderson, ed. New York: Harper and Row, 1959.

Fu, Shen C. Y., with Marilyn W. Fu, Mary McNeill, Mary Jane Clark. *Traces of the Brush*. New Haven: Yale, 1977.

Gabor, Andrea. *Einstein's Wife*. New York: Penguin, 1995.

Galilei, Galileo. *Dialogue Concerning The Two Chief World Systems, Ptolemaic and Copernican*. Stillman Drake, tr. Berkeley: University of California, 1967.

Galton, Francis. *Hereditary Genius*. London: Julian Freidmann, 1978.

Gardner, Howard. *Creating Minds*. New York: Harper Collins/Basic, 1993.

———. *To Open Minds: Chinese Clues to the Dilemma of Contemporary Education*. New York: Harper-Collins/Basic Books, 1991.

Gauguin, Paul. *Noa Noa: The Tahitian Journal*. O. F. Theis, tr. New York: Dover, 1985.

Gawain, Shakti. *Creative Visualisation*. Berkeley, CA: Whatever Pub, 1978.

Geertz, Clifford. "Deep Play: Notes on the Balinese Cockfight." *Interpretation of Cultures*, Selected Essays. New York: Basic Books, 1973.

Gell, Alfred. "Technological Enchantment and the Enchantment of Technology." In *Anthropology, Art and Aesthetics*. Jeremy Coote and Anthony Shelton, eds. Oxford: Clarendon Press, 1992.

Gernsheim, Helmut and Alison. *A Concise History of Photography*. New York: Grosset and Dunlap, 1965.

Ghiselin, Brewster, ed. *The Creative Process*. New York: New American Library, 1952.

Gilligan, Carol. *In a Different Voice*. Cambridge, MA: Harvard, 1985.

Ginsberg, Robert. "Creativity and Culture." In *Creativity in Art, Religion, Culture*. Michael Mitias, ed. Atlantic Highlands, NJ: Humanities Press, 1985.

Giovannini, Joseph. "Getty v. Guggenheim: A Paradigm Apart." *Art in America* 186, No. 7 (July 1998): 80–85.

Gleason, Ralph J. "The Education of the Jazz Virtuoso." In *An Introduction to Creativity*. Michael Joyce, ed. 2nd ed. Acton, MA: Copley Publishing, 1997.

Glover, John A., Royce Ronning, and Cecil Reynolds. *Handbook of Creativity*. New York: Plenum Press, 1989.

Goethe, Johann Wolfgang, von. *Faust*. Stuttgart: N.P., 1838.

GoGwilt, Christopher. *The Invention of the West: Joseph Conrad and the Double-Mapping of Europe and Empire*. Stanford, CA: Stanford University Press, 1995.

Goldscheider, Ludwig. *Michelangelo: Paintings, Sculpture, Architecture.* 6th ed. London: Phaidon, 1996.

Gombrich, E. H. *Ideals and Idols: Essays on Values in History and in Art.* London: Phaidon, 1979.

Goodfield, June. *Playing God: Genetic Engineering and the Manipulation of Life.* New York: Random House, 1977.

Gordon, Jack and Ron Zemke. "Making Them More Creative," *Training* (1986): 30–45.

Gossen, Stephen, *School of Abuse.* London: Shakespeare Society, 1841.

Gould, Stephen Jay. "The Human Difference. *New York Times,* 2 July 1999, p. A12.

Gray, Jack. "Development of Kuomintang and Chinese Communist Ideologies." *Encyclopedia Britannica.* 15th ed. Macropedia, Chicago: Vol. 16 (1985). 140–150.

Greenblatt, Stephen. *Marvelous Possessions: The Wonder of the New World.* Chicago: University Press, 1991.

Gruber, H. E., Glenn Terrell, and Michael Wertheimer. *Contemporary Approaches to Creative Thinking.* New York: Atherton Press, 1962.

Grudin, Robert. *The Grace of Great Things.* New York: Ticknor and Fields, 1990.

Guarneri, Carl. *The Utopian Alternative: Fournierism in Nineteenth Century America.* Ithaca: Cornell, 1991.

Guilford, Jay Paul. "Traits of Creativity." In *Creativity and Its Cultivation.* Harold Anderson, ed. New York: Harper and Row, 1959.

Hades, Moses. "Introduction," to *Complete Plays of Aristophanes.* New York: Bantam, 1962.

Haggart, John P. "The Value of Invention." In *Values, A Symposium.* B. Almond and B. Wilson, eds. Atlantic Highlands, NJ: Humanities Press, 1988.

Hall, Stephen S. "James Watson and the Search for Biology's 'Holy Grail.' " *Smithsonian* (Feb. 1990).

Hamlin, Jesse. "Back in the Barrio with 'Radio Mambo.' " *San Francisco Chronicle,* 17 Sept. 1996, B1–2.

Harris, Bruce. *The Collected Drawings of Aubrey Beardsley.* New York: Crown, 1967.

Harman, Willis and Howard Rheingold. *Higher Creativity.* Los Angeles: J. P. Tarcher, 1984.

Hartshorne, Charles. "Creativity as a Value and Creativity as a Transcendental Category." In *Creativity in Art, Religion, and Culture.* Michael Mitias, ed. Atlantic Highlands, NJ: Humanities Press, 1985, pp. 3–11.

———. *Creativity in American Philosophy.* Albany: State University of New York Press, 1984.

Hauschild, Thomas. *Der Böse Blick.* Berlin: 2nd ed. Verlag Mensch und Leben, 1982.

Hausman, Carl. *A Discourse on Novelty and Creation.* The Hague: Martinus Nijhoff, 1975.

———. "Originality as A Criterion of Creativity." In *Creativity in Art, Religion, Culture.* Michael Mitias, ed. Atlantic Highlands NJ: Humanities Press, 1985.

Heald, Gordon. "A Comparison Between American, European, and Japanese Values." In *Values.* Brenda Almond and Bryan Wilson, eds. 75–92. Atlantic Highlands, N.J.: Humanities Press, 1988.

Heidegger, Martin. *Sein und Zeit.* 13th ed. Tubingen: Max Niemeyer. 1976.

———. *Die Ursprung des Kunstwerkes.* Hans George Gadamer, intro. Stuttgart: Reclam, 1960.

Heiss, Paul. 1990. "Roundtable on Creativity." Presentation at Association for Integrative Studies Conference, Nov. 1990, at Manchester NH.

Helmholz, Herman Ludwig von. *Vorlesungen über die theoretische Physik.* Arthur Konig und Carl Runge, Hrsg. Hamburg: L. Voss, 1897.

Helson, Ravenna. "Women Mathematicians and The Creative Personality." In *Journal of Consulting and Clinical Psychology* 36 (1971): 210–11, 217–220.

Herbst, Edward. *Voices in Bali.* Hanover, NH: Wesley University Press, 1997.

Herder, Johann Gottfried. *Abhandlungen uber den Ursprung der Sprache.* John H. Moran, ed. *On the Origin of Language.* (Rousseau and Herder). New York: Ungar, 1967.

Herman, Josef. "The Modern Artist in Modern Society." In *Art in Society.* Michael Greenhalgh and Vincent Megan, eds. London: Duckworth, 1978.

Herodotus. *The Persian Wars.* William Shepherd, tr. New York: Cambridge University Press, 1982.

Hickman, Larry. *Technology as a Human Affair.* New York: McGraw-Hill, 1990.

Ho, Samuel P. S. and Ralph Huenemann. *China's Open Door Policy: the Quest for Foreign Technology and Capital.* Vancouver: University of British Columbia Press, 1984.

Hobbes, Thomas. *Leviathan.* Richard S. Peters, intro. Michael Oakeshott, ed. New York: Collier, 1962.

———. *of Malmesbury, The English Works of.* William Molesworth, ed. 11 vols., Aalen: Scienta Verlag, 1966.

Horgan, John. *The End of Science: Facing the Limits of Knowledge in the Twilight of the Scientific Age.* Reading, MA: Addison-Wesley, 1996.

Horkheimer, Max and Theodor Adorno. *Sociologica II: Reden und Vortrage.* Frankfurt: Europaische Verlagsanstalt, 1962.

Houston, Alma, ed. *Inuit Art: An Anthology.* Winnipeg: Watson and Dwyer, 1988.

Huang, Ray. *China: A Macro History.* 2nd ed. Armond NY: East Gate, 1990.

Hudson, Barbara. "Images Used by African-Americans to Combat Sterotypes." In *Racial and Ethnic Identity: Psychological Development and Creative Expression.* Herbert Harris, Howard Blue, and Ezra Griffith, eds. New York: Reutlidge, 1995.

Hughes, Thomas. *American Genesis.* New York: Viking 1987.

Huizinga, Johan. *Homo Ludens.* Boston, MA: Beacon Press, 1950.

Humanities Research Institute. "Microcosms: Objects of Knowledge." University of California, course description, 1998.

von Humboldt, Wilhelm. *The Sphere and Duties of Government.* Joseph Coultard, tr. London: N.p. 1854.

Hunt, Lynn, ed. *The Invention of Pornography.* Boston: MIT/Zone Books, 1993.

Hutzler, Charles. "China Casts Eye Toward Democracy: Jiang Poring Over Secret Report on U.S., Sources Say." *San Francisco Chronicle,* 28 July 1998, 10.

Huxley, Thomas. "The Method of Scientific Investigation." *Collected Essays*. Reprint. Westport: Greenwood, 1970.

Hynes, William J. "Inconclusive Conclusions: Tricksters—Metaplayers and Revealers." In *Mythical Trickster Figures: Contours, Contexts, and Criticisms*. William J. Hynes and William G. Doty, eds. Tuscaloosa, AL: University of Alabama Press, 1993.

Isaksen, Scott. "Creatology: A Potential Paradigm for an Emerging Discipline." In *Nurturing and Developing Creativity: The Emergence of a Discipline*, by Scott Isaksen, Mary Murdock, Roger Firestein, Donald Treffinger. Center for Studies in Creativity, State University College at Buffalo, 2 vols. Norwood, NJ: Ablex Pubs, 1993.

Issacs, Leonard. "Creation and Responsibility in Science." In *Creativity and the Imagination: Case Studies From the Classical Age to the Twentieth Century: Studies in Science and Culture*. Mark Amsler, ed. Vol. 3. Newark, NJ: University of Delaware Press, 1987.

Jackson, Robert. "NEA Chief Tells Critics That Dollars for Art is Money Well Spent." *San Francisco Chronicle*. 14 Jan. 1995, A6

Jamison, Kay Redfield. "Manic Depressive Illness and Creativity." *Scientific American* (February 1995).

————. *Touched With Fire: Manic Depressive Illness and the Artistic Temperament*. New York: Free Press, 1993.

James, William. *The Principles of Psychology*. Cambridge, MA: Harvard University Press, 1983.

Janson, H. W. *History of Art*. 2nd ed. Englewood Cliffs, NJ: Prentice Hall, 1977.

Jefferson, Thomas, The Life and Selected Wrings of. Adrienne Koch and William Peden, eds. New York: Modern Library, 1944.

Jhanji, Rekha. "Creativity in Traditional Art." *British Journal of Aesthetics* 28, No. 2 (Spring 1988).

Johnson, Ken. "Forbidden Sights." *Art in America* (January 1991): 106–9.

Josephy, Alvin, Jr. *Red Power*. New York: McGraw Hill, 1971.

Joyce, Michael, Scott Isaksen, Fred Davidson, Gerard Puccio, Carol Coppage, and Mary Ann Maruska. *An Introduction to Creativity*. 2nd ed. Acton, MA: Copley Publishing, 1997.

Jung, C. G. *Memories, Dreams, and Reflections*. 4th ed. Aniela Jaffe, ed. Richard and Clara Winston, tr. New York: Vintage, 1965.

————, Marie-Louise von Franz, and others. *Man and His Symbols*. Garden City, NY: Doubleday, 1954.

Kamenetz, Rodger. *The Jew in the Lotus*. San Francisco: Harper-Collins, 1994.

Kant, Immanuel. *Critique of Pure Reason*. Norman Kemp Smith, tr. New York: St. Martin's Press, 1929.

————. *Kritik der Urteilskraft*. Karl Vorlander, ed. Hambrug: F. Meiner, 1963.

Kass, Leon. "The New Biology: What Price Relieving Man's Estate?" *Science* 174, No. 4011 (Nov. 19, 1971): 779–88. In National Council of Churches of Christ/U.S.A. *Genetic Engineering: Social and Ethical Consequences*. New York: Pilgrim Press, 1984.

Katherin S. Gilbert et al., eds. *Treasures of Tutankhamun*. New York: Ballentine Books and Metropolitan Museum of Art, 1976.

Kemp, Martin. "Leonardo da Vinci." Lecture, Lemelson Conference on Invention. Smithsonian Museum, Washington DC. Nov. 1995.

Kemp, Martin and Jane Roberts. *Leonardo da Vinci* (Exhibition Catalog). London: Yale University Press, 1989.

Khallefa, Omar, George Erdoes, and Ikhlas Ashria. "Traditional Education and Creativity in an Afro-Arab Islamic Culture: The Hope of Sudan." *Journal of Creative Behavior* 31, No. 3 (3rd Qrtr, 1997): 201–211.

King, Jonathan. "New Genetic Technology: Prospects and Hazards." *Technology Review.* (1980): 57–65.

King, Martin Luther, *The Papers of.* Clayborn Carson, Ralph Luker, and Penny Russell, eds. Berkeley: University of California Press, 1972.

————. *Why We Can't Wait.* New York: Harper and Row, 1964.

Kingston, Maxine Hong. *The Woman Warrior.* 2nd. ed. New York: Vintage, 1976.

Kipphardt, Heinar. *In the Matter of J. Robert Oppenheimer.* New York: Hill and Wang, 1968.

Klein, Ernest. *A Comprehensive Etymological Dictionary of The English Language.* New York: Elseview-Science, 1971.

Kleiner, Diana E. E. *Roman Sculpture.* New Haven: Yale, 1992

Kline, Stephen. "Limits to the Imagination: Marketing and Children's Culture." In *Cultural Politics in Contemporary America.* I. Angus and S. Shelly, eds. 299–316. New York: Routledge and Kegan Paul, 1989.

Knox, Bernard. "Introduction." *Three Theban Plays.* Robert Fagles, tr. 2nd ed. Hammondsworth: Penguin, 1984.

Koenigsberger, Leo. *Hermann Von Helmholtz.* Frances Welby, tr. New York: Dover, 1965.

Koestler, Arthur. *The Act of Creation.* New York: Dell, 1964.

Kris, Ernst, and Otto Kurz. *Die Legende vom Künstler.* Franfurt am Main: Suhrkamp, 1980.

Kristof, Nicolas. "1492: The Prequel." *New York Times Magazine.* 6 June 1999, pp. 80–86.

Kristof, Nicholas and Cheryl Wudunn. *China Awakes.* New York: Vintage/Random, 1994.

Kubie, Lawrence. *The Neurotic Distortion of the Creative Process.* Lawrence, Kansas: Kansas University Press, 1958.

Kuhn, Thomas. *The Structure of Scientific Revolutions.* 2nd. Chicago: Chicago University Press, 1970.

Kurtenbach, Elaine. "Long Secret Tale of Tibet's Agony Under China's 'Great Leap,' " *San Francisco Chronicle,* 12 Feb. 1998, A12.

Kuspit, Donald. "We No Longer Expect Art to Ripen Into Immortality." *Art International,* "Special Issue on How We Value Art," (Autumn 1990).

LaFramboise, Clifford and Watt, Marie. "Mixed Media: Blending the Traditional and Contemporary in Indian Art." In *Tribal College: Journal of American Higher Education* 5, No. 1 (Summer 1993).

Landler, Mark. "Bringing China On Line (With Official Blessing)." *New York Times.* 3 Aug 1998, C1, C4.

Lappe, Marc, and Robert Morison, eds. *Ethical and Scientific Issues Posed by Human Uses of Molecular Genetics*. New York: New York Academy of Sciences, 1976.

Lasswell, Harold. "The Social Setting of Creativity." In *Creativity and its Cultivation*. Harold Anderson, ed. 203–221. New York: 1959.

Lavie, Smadar, Kirin Narayan, and Renato Rosaldo, eds. *Creativity/Anthropology*. Ithaca: Cornell University Press, 1993.

Layton, Robert. *The Anthropology of Art*. 2nd ed. Cambridge, Eng.: Cambridge University Press, 1991.

Leeming, David Adams, with Margaret Adams Leeming. *Encyclopedia of Creation Myths*. Santa Barbara, CA: ABC-Clio, 1994, pp.202–208.

Lelut, Louis-François. *Du Demon de Socrate*. Paris: Tringuart, 1836.

Leonardo da Vinci, The Literary Works of. Jan Paul Richter, ed., 3rd ed. London: Phaidon, 1970.

Lesser, W. "Transgenic Animal Patents." In *Molecular Biology and Biotechnology: A Comprehensive Desk Reference*. Robert Myers, ed. New York: VCH Press, 1995.

Levine, Lawrence. *Black Culture and Black Consciousness*. New York: Oxford University Press, 1978.

Levinson, Paul. "Toy, Mirror, and Art: The Metamorphosis of Technological Culture."*Etcetera* 34 (1977): 151–167.

Levy, Steven. *Hackers: Heroes of the Computer Revolution*. Garden City, NY: Doubleday, 1984.

Lewis and Short. *A Latin Dictionary*. Oxford: Clarendon, 1969.

Liddell, H. G. and Scott, Robert. *A Greek-English Dictionary*. Oxford.

Light, Ken and Suzanne Donovan. *Texas Death Row*. Singapore: University Press of Mississippi, 1997.

Lobo, Susan. "The Fabric of Life." *Cultural Survival Quarterly* (Summer 1991): 40–46.

Locke, John. *Two Treatises of Government*. New York: Dutton. 1924.

Lombroso, Cesare. *Genio e Degeneratione*. 2nd. Milano: Remo Sandron, 1907.

Lowell, Amy. "The Process of Making Poetry." In *The Creative Process*. Brewster Ghiselin, ed. New York: New American Library, 1952.

Lucretius. *On The Nature of the Universe*. R. E. Latham, tr. and intro. London: Penguin, 1951.

Lyotard, Jean-François. *The Post-Modern Condition*. Geoff Bennington and Brian Massumi, tr. Minneapolis: University of Minnesota, 1984.

Machiavelli, Niccolo. *The Prince*. George Bull, tr. 3rd Edition. Middlesex, Eng.: Penguin Books, 1981.

MacKichan, Margaret. "When Art and Business Don't Mix." *Tribal College. Journal of American Indian Higher Education* 5, No. 1 (Summer 1993): 20–23.

MacKinnon, Donald. "Creativity: Psychological Aspects." *International Encyclopedia of the Social Sciences*. Vol. 3. David L. Sills, ed. 435–442. Detroit: MacMillan & Free Press, 1968.

Maclean, Norman. *Dictionary of Genetics and Cell Biology*. New York: New York University Press, 1987.

Madsen, Richard. "China in the American Imagination." *Dissent.* Winter, 1998.

Magyari-Beck, Istvan. "An Introduction to the Framework of Creatology." In *Journal of Creative Behavior* 3, No. 3 (1990).

Madrigal, Alix. "Unblocking the Artist Inside All of Us." Author Interview of Julia Cameron, *San Francisco Examiner Book Review*, 3 Nov. 1996, 6.

Malcolm X, The Autobiography of. With Alex Haley. 2nd. New York: Ballantine, 1965.

Mancini, Piero. "Our Fathers the Greeks—a Renaissance Myth?" Lecture. Saint Mary's College. Moraga California, Sept. 25, 1996.

Mao Tzsedong. *Quotations From Chairman Mao Tsetung.* Beijing: Foreign Language Press, 1972.

Maritain, Jacques. *Creative Intuition in Art and Poetry.* New York: Pantheon, 1952.

Marinetti, Filippo Tommaso. *The Futurist Cookbook.* Suzanne Brill, tr. San Francisco: Bedford Arts Publishers, 1989.

Martindale, Colin. "How Can We Measure a Society's Creativity?" In *Dimensions of Creativity.* Margaret Boden, ed. 159–197. Cambridge, MA: MIT Press, 1994.

———. "Personality, Situation, and Creativity." In *Handbook of Creativity.* J. A. Glover, ed. New York: Plenum, 1989.

Marx, Karl and Friederich Engels. *Marx-Engles Werke (MEW).* Berlin: Dietz, 1974.

Maslow, Abraham. "Creativity in Self-Actualizing People." In *Creativity and Its Cultivation.* H. Anderson, ed. New York, 1959.

———. *Motivation and Personality.* New York: Harper and Row, 1954.

———. *Psychology of Being.* 2nd ed. New York: Van Nostrand Reinhold Co. 1968.

Mathews, Donald. "Artisans and Artists in Ancient Western Asia." In *Civilizations of the Ancient Near East.* Jack Sasson, ed. Vol I. New York: Simon and Schuster MacMillan, 1995.

Matt, Daniel. *The Essential Kabbalah.* San Francisco: Harper, 1995.

May, Rollo. *The Courage to Create.* Toronto: Bantam, 1975.

McCain, Garvin, and Erwin Segal. *The Game of Science.* 5th ed. Pacific Grove: Cole Publishing, 1987.

McCaslin, Nellie. *Creative Dramatics in the Classroom.* New York: McKay, 1968.

McClung, William Alexander. *The Architecture of Paradise: Survivals of Eden and Jerusalem.* Berkeley: University California Press, 1983.

McGee, Celia. "Portraiture is Back, But, My, It's Changed." *New York Times* 1 Jan. 1995, Sec. 2, 1 and 35.

McGhee, Robert. "The Prehistory and Prehistoric Art of the Canadian Inuit." In *Inuit Art: An Anthology.* Alma Houston, ed. Winnipeg: Watson and Dwyer, 1988, pp. 12–20.

McKim, Robert. *Experiences in Visual Thinking.* Monterey, CA: Brooks/Cole, 1972.

McLuhan, Marshall. *The Gutenberg Galaxy.* Toronto: University Press, 1962.

McNickle, D'Arcy. "American Indians Who Never Were." In *The American Indian Reader: Anthropology.* Jeannette Henry, ed. Washington DC: Library of Congress, Indian Historian Press, Inc., 1972.

McPherson, C.B. *The Political Theory of Possessive Individualism*. London: Oxford University Press, 1962.

Mead, Margaret. "Creativity in Cross-Cultural Perspective." In *Creativity and Its Cultivation*. Harold Anderson, ed. New York: Harper and Row, 1959.

————. "Note From New Guinea." *American Anthropologist* n.s. 34 (1932): 740. In James Clifford. *The Predicament of Culture*. Cambridge: Cambridge University Press, 1988, p. 230.

Medicine, Bea. "The Anthropologist as the Indian's Image Maker." In *The American Indian Reader: Anthropology*. Jeannette Henry, ed. Washington DC: Library of Congress, Indian Historian Press, 1972.

Melville, Herman. *Clarel: A Poem and Pilgrimage in the Holy Land*. New York: Hendricks, 1960.

————. *White Jacket*. London: Putnam, 1892.

Mesthene, Emmanuel. "The Role of Technology in Society." In *Technology and the Future*. Albert Teich, ed. 5th ed. New York: Saint Martin's Press, 1990.

Meyer, Leonard B. "Universalism and Relativism in the Study of Ethnic Music." In *Readings in Ethnomusicology*. David P. McAllester, ed. 277–292. New York: Johnson, 1971.

Michelangelo, The Poetry of. James M. Saslow, annotated translation. New Haven: Yale University Press, 1991.

Miles, James. *The Legacy of Tiananmen*. Ann Arbor, MI: University of Michigan Press, 1996.

Mill, John Stuart. *On Liberty*. New York: Liberal Arts Press, 1956.

Miller, Carolyn. Novelty, Decorum, and the Commodification of Invention in the Renaissance. 1996. Paper presented at Modern Language Association National Conference, Washington, DC, Dec. 27–30.

Miller, David Lee. *Philosophy of Creativity*. New York: Peter Lang, 1989.

Miller, Louallen. "Creativity's Contribution to a Liberal Education." *Journal of Creative Behavior*. 20, No. 4 (1986): 248ff.

Milton, Sybil. "Art of the Holocaust." In *Reflections on The Holocaust in Art and Literature*. Randolph Brahm, ed. New York: Columbia University Press, 1990.

Milunski, Aubrey, and George Annas, eds. *Genetics and the Law II*. New York: Plenum Press, 1980.

Miyamoto, Masao. *Straitjacket Society*. Tokyo and Canada: Kodansna, 1994.

Mokyr, Joel. *The Lever of Riches: Technological Creativity and Economic Progress*. New York: Oxford University Press, 1990.

Moments of Rising Mist: A Collection of Sung Landscape Painting. Amitendranath Tagore, tr. New York and Tokyo: Mushinsha/Grossman, 1973.

de Montaigne, Michel. *Essays*. J. M. Cohen, tr. London: Penguin, 1958.

Montefiore, Alan. "Value." In *Values*. B. Almond and B. Wilson, eds. Atlantic Highlands, NJ: Humanities, 1988.

Mooney, Ross Lawles and Taher Razik, eds. *Explorations in Creativity*. New York: Harper and Row, 1967.

Morison, Samuel E. and Henry Steele Commager. *The Growth of the American Republic*. 5th ed. New York: Oxford University Press, 1962.

Morrison, Toni. "Memory, Creation and Writing." *Thought: A Journal of Culture and Ideas* 59, No. 235 (Dec. 1984). In *The Anatomy of Memory*. James McCorkey, ed. New York: Oxford University Press, 1996.

Mosse, George, Rondo Cameron, Henry B. Hill, Michael Petrovich. *Europe in Review*. 2nd ed. Chicago: Rand McNally, 1964.

Muller-Mehlis. *Die Kunst im dritten Reich*. 2 Auflage. Munchen: Wilheim HeyreVerlag, 1976.

Mumford, Michael and Dean Keith Simonton. "Creativity in the Workplace: People, Problems and Structures." *Journal of Creative Behavior*. 39, No. 1 (First Qrtr, 1997): 1–6.

Murray, Peter. "A New Vision." In *The Age of the Renaissance*. Dennis Hays, ed. New York: McGraw Hill, 1967.

Myers, Robert A., ed. *Molecular Biology and Biotechnology: A Comprehensive Desk Reference*. New York: VCH Press, 1995.

Nash, Roderick. *Wilderness and the American Mind*. New Haven: Yale University Press, 1967.

National Council of Churches of Christ/U.S.A. *Genetic Engineering: Social and Ethical Consequences*. New York: Pilgrim Press, 1984.

Nahm, Milton. *The Artist as Creator*. Baltimore: The Johns Hopkins Press, 1956.

———. *Presocratic Greek Thought*. 3rd ed. New York: Appleton-Century-Crafts, 1967.

Needham, Joseph. *Science and Civilization in China*. 5 vols. Cambridge, Eng.: Cambridge University Press, 1954–85.

Nerlich Michael. *Kritik der Abenteur—Ideologie: Beitrag zur Erforschung der burgerlichen Bewusstseinsbildung*, 1100–1750. Berlin: Akademie Verlag, 1977.

Neumann, Erich. *Art and the Creative Unconsciousness*. Ralph Mannheim, tr. New York: Pantheon, 1959.

Neusner, Jacob. *First Century Judaism in Crisis: Yohannan ben Zakkai and the Renaissance of Torah*. Nashville, TN: Abingdon Press, 1975.

———. *The Mishnah: An Introduction*. Northvale, NJ: Jason Aronson Inc., 1989.

———. *Self-Fulfilling Prophecy: Exile and Return in the History of Judaism*. Boston, MA: Beacon Press, 1987.

Nietzsche, Friedrich. *Also Sprach Zarathustra*. Stuttgart: Reclam, 1975.

———. *Basic Writings of*. Walter Kaufmann, tr. and ed. 3rd ed. New York: Modern Library, 1968.

———. *The Will to Power*. Walter Kaufmann and R. J. Hollingdale, trs. New York: Vintage, 1967.

Nin, Anais. *Anais Nin Reader*. Philip Jason, ed. Chicago: Swallow Press, 1973.

Nisbet, J. F. *The Insanity of Genius*. 4th. London: Grant Richards, 1900.

Nochlin, Linda. "Why Have There Been No Great Women Artists?" *S.F. Chronicle: Image Magazine*, 25 Feb. 1990, p. 13–18.

Oech, Roger von. *A Whack on the Side of the Head*. New York: Warner, 1983.

Okazuki, Takashi. In *Art of China*. Akiyama, Terukazu, Mary Tregear, et al. Tokyo and Palo Alto: Kodansha Int. Ltd., 1968.

Organization for Economic Co-operation and Development. *Recombinant DNA Safety Considerations*. Paris: OECD 1986.

Ornstein Robert. *The Psychology of Consciousness*. San Francisco: W. H. Freeman, 1972.

Ortiz, Alfonso. "An Indian Anthropologist's Perspective on Anthropology." In *The American Indian Reader: Anthropology*. Jeannette Henry, ed. Washington DC: Library of Congress, Indian Historian Press, 1972.

Orwell, George. "Benefit of Clergy: Some Notes on Salvador Dali." In *Dickins, Dali, and Others*. New York: Reynal and Hitchock, 1948. In Melvin Rader and Betram Jessup. *Art and Human Values*. Englewood Cliffs, NJ: Prentice-Hall, 1976.

Osborn, Alex F. 2nd ed. *Your Creative Power*. New York: Simon and Schuster, 1977.

Overholt, William H. *The Rise of China: How Economic Reform is Creating a New Superpower*. New York: W. W. Norton, 1993.

Pacey, Arnold. *The Culture of Technology*. Cambridge, MA: MIT Press, 1983.

Paine, Thomas. *Common Sense and Other Political Writings*. Adkins, Nelson, ed. Indianapolis: Bobbs-Merrill, 1953.

Parnes, Sidney, Ruth Noller, and Angelo Biondi. *Guide to Creative Action*. 2nd ed. New York: Charles Scribner's Sons, 1977.

Parnes, Sidney and Harold Harding. *A Source Book for Creative Thinking*. New York: Clark Scribner and Sons, 1962.

Papanek, Victor. *Design for the Real World*. 3rd ed. London: Granada Publishing, 1974.

Pascal, Blaise. *Pensées*. J. M. Cohen, tr. Baltimore: Penguin, 1961.

Peters, Thomas J. and Robert H. Watterman, Jr. *In Search of Excellence*. New York: Harper and Row, 1982.

Pickering, G. *Creative Malady*. New York: Oxford University Press, 1974.

Pineda, Cecile. *Face*. New York: Viking, 1985.

"Plagiarism Is Rampant, a Survey Finds." *New York Times*, 1 Apr. 1990, pp.1, 36:6.

Plato, The Collective Dialogues of. 3rd ed. Hamilton, Edith and Huntington Cairns. Princeton, NJ: Princeton University Press, 1961.

Plutarch. *Makers of Rome*. Ian Scott-Kilvert, intro. and tr. Harmondsworth: Penguin, 1965.

Poincaré, Henri. "Mathematical Creation." In *The Creative Process*. B. Ghiselin, ed. New York, New American Library, 1952.

Pomfret, John. "Chinese Raise Voices Silently in Internet Political Chat." *San Francisco Chronicle*, June 23, 1999, p. A.12.

Potok, Chiam. *My Name is Asher Lev*. New York: Knopf, 1972.

Prentsky, Robert. "Creativity and Psychopathology: Gamboling at the Seat of Madness." In *Handbook of Creativity*. John A. Glover, Ronning Royce, and Cecil Reynolds, eds. *Handbook of Creativity*. New York: Plenum Press, 1989.

Puccio, Gerald. "Why Study Creativity." *Creativity and Innovation Yearbook*. Vol. 2, 1989. Tudor Richards and Susan Moger, eds., Manchester: Manchester Business School, Publisher.

Puttenham, George. *The Arte of English Poesie.* In *Elizabethan Critical Essays.* G. G. Smith, ed. Cambridge: Cambridge Press, 1936.

Quispel, Gilles. "Faust: Symbol of Western Man." In *Schopfung und Gestalt.* Adolf Portmann, ed. Eranos Jahrbuch 36. Zurich: Rheinverlag, 1967.

Raab, Theodore. *Renaissance Lives: Portraits of an Age.* 55–71. New York: Pantheon Books, 1993.

Rader, Melvin, and Bertram Jessup. *Art and Human Values.* Englewood Cliffs, NJ: Prentice Hall, 1976.

Raffel, Burton. *Artists All: Creativity, the University and the World.* University Park, PA: Pennsylvania State University Press, 1991.

Ray, Michael, and Rochelle Myers. *Creativity in Business.* New York: Doubleday, 1986.

Razik, Taher, *Bibliography of Creativity Studies and Related Areas.* Creative Education Foundation. Buffalo, NY: State University of New York Press, 1965.

Redner, Harry. *The Ends of Science: An Essay in Scientific Authority.* Boulder, CO: Westview Press, 1987.

Regis, Edward. *Nano: The Emerging Science of Nanotechnology: Remaking the World—Molecule By Molecule.* Boston: Little Brown and Co., 1995.

Reich, Robert. *The Next American Frontier.* New York: Penguin, 1983.

———. "Why the Rich Are Getting Richer and the Poor Poorer." *New Republic* (May 1, 1989).

Reston, James. *Galileo: A Life.* New York: Harper Collins, 1994.

Rhodes, Mel. "An Analysis of Creativity." *Phi Delta Kappa.* 42 (1961). In *An Introduction to Creativity.* Michael Joyce, ed. 2nd ed. Acton, MA: Copley Publishing, 1997.

Rifkin, Jeremy. "Genes and Chips Bring A New Era." *San Francisco Chronicle,* 15 May 1998, p. A25.

Riggs, Marlon. "Ethnic Notions: Images of Black People in White Minds." Berkeley, CA. Film. 1980.

Robbins, Lois. *Waking Up in the Age of Creativity.* Santa Fe, New Mexico: Bear and Co., 1985.

Rogers, Carl. "Toward a Theory of Creativity." In *Creativity and Its Cultivation.* Harold Anderson, ed. New York: Harper and Row, 1959.

Roosevelt, Franklin Delano. *The Public Papers and Addresses of.* New York, Random House, 1938.

Root-Bernstein, Robert Scott. *Discovering.* Cambridge, MA: Harvard University Press, 1989.

Rosenberg, Charles. Book review of *The Court Artist: On The Ancestry of the Modern Artist,* by Martin Warnke. David McLintock, tr. Cambridge, Eng.: Cambridge University Press, 1993. In *Comparative Studies in Society and History.* (40, No. 1 (Jan. 1998): 189–90.

Rosenthal, Donna. "The Master Builder." *San Francisco Examiner Image.* 17 Oct. 1993, pp. 20–29.

Rosenthal, Scott. "Internet Revolution is On-line an Growing." *San Francisco Chronicle.* 2 Jul 1995.

Rothenberg, Albert and Carl Hausman. *The Creativity Question.* Durham, North Carolina: Kuke, 1976.

Rousseau, Jean-Jacques. *A Discourse on Inequality*. Maurice Cranston, tr. London: Penguin, 1984.

Sagan, Carl. *The Dragons of Eden*. 2nd ed. New York: Ballentine, 1978.

Sappho—A New Translation. Mary Barnard, tr. and ed. Berkeley: University of California Press, 1958.

Saslow, James J, tr., annotation to *The Poetry of Michelangelo*. New Haven: Yale University Press, 1991.

Sayers, Dorothy. "Introduction" to *The Comedy of Danta Alighieri: Hell (L'Inferno)*. Dorothy Sayers, tr. Harmondsworth: Penguin, 1949.

Schaer, Roland. *L'invention des Musées*. Paris: 1993.

Schaffer, Simon. "Making Up Discovery." In *Dimensions of Creativity*. Margaret Boden, ed. Cambridge: MIT Press, 1994.

Schama, Simon. *Landscape and Memory*. New York: Alfred Knapf, 1995.

Schell, Orville. *Mandate of Heaven*. New York: Simon and Schuster, 1994.

Schiff, Bennett. "Out of Egypt: Art in the Age of the Pyramids." *Smithsonian* 30, No. 6 (September, 1999): 108–119.

Schiller, Friedrich. *Über die ästhetische Erziehung des Menschen*. Stuttgart: Reclam, 1972.

Schlesinger, Arthur M. *A Thousand Days: John F. Kennedy in the White House*. Boston, MA: Houghton Mifflin Co., 1965.

Schlissel, Lillian. *Women's Diaries of the Westward Journey*. New York: Schocken, 1982.

Scholem, Gershom. *Major Trends in Jewish Mysticism*. 3rd ed. New York: Schoken Books, 1961.

Schopenhauer, Arthur. *The World as Will and Representation*. E. F. J. Payne, tr. New York: Dover, 1966.

Schopfung und Gestalt. Eranos Jahrbuch 1966, Band 35. Zurich: Rheinverlag, 1967.

Scott, Katie. "Authorship, the Academic, and the Market in Early Modern France." *Oxford Art Journal* 21, No. 1 (1998): 27–41.

Scott, Randall. "Creative Employees: A Challenge to Managers." *Journal of Creative Behavior* 29, No. 1 (First Qrtr, 1995): 64–ff.

Seeger, Anthony. "Singing Other People's Songs." *Cultural Survival Quarterly* (Summer, 1991): 36–39.

Selz, Peter. "Art and Politics: The Artist and the Social Order: Introduction." In *Theories of Modern Art*. Chip Hershel, ed. 456–461. Berkeley: University of California, 1970.

Serr, Ronnie. "The End of History *vs.* All Is History." *Issues in Integrative Studies* (1991).

Shaftsbury, Anthony, Earl of. *Characteristics of Men, Manners, Opinions, Times, etc*. John Robertson, ed. Vol I: 36. London: Grant Richards, 1900.

Shakespeare, William: *The Tragedy of Macbeth*. E. K. Chambers and Edward Allen, eds. Boston: D.C. Heath and Co., 1915.

———. *Comedy of Errors*. London: T. H. Lacy, 1850.

———. *A Midsummer Night's Dream*. Henry Norman Hudson, intro. and notes, 3rd ed. Boston: Ginn and Co., 1910.

Shankar, Ravi. *My Music, My Life.* New York: Simon and Schuster, 1968.

"Sheep Clone Was Born Old, Study Finds." *San Francisco Chronicle,* May 27, 1999, pp. A1, 17.

Shelley, Mary. *Frankenstein.* New York: Airmont, 1963.

Shelley, Percy Bysshe. *The Complete Poetical Works.* Boston: Houghton Mifflin, 1901.

Shelley's Defense of Poetry. Brett-Smith, H. F. B., ed. (Shelley, Peacock and Browning Essays). Oxford: Blackwell, 1929.

Shils, Edward. *Tradition.* Chicago: Chicago University Press, 1981.

———. "Values and Tradition." In *Values.* Brenda Almond and Bryan Wilson, eds. Atlantic Highlands, NJ: Humanities Press, 1988.

Shostak, Marjorie. "The Creative Individual in the World of the !Kung San." In *Creativity/ Anthropology.* Smadar Lavie, Kirin Narayan, and Renato Rosaldo, eds. Ithaca: Cornell University Press, 1993. pp. 54–69.

Silko, Leslie Marmon. "Landscape, History, and the Pueblo Imagination." In *Women's Voices.* Pat C. Hoy II, Esther Schor, and Robert DiYanni, eds. New York: McGraw Hill, 1990.

Simon, Julian. *The Ultimate Resource.* Reprint. Ann Arbor, Mich.: Books on Demand, 1981.

Siu, Helen F, ed. *Furrows: Peasants, Intellectuals, and the State: Stories and Histories from Modern China.* Stanford: Stanford University Press, 1990.

Smith, Adam. *An Inquiry Into the Nature and Causes of the Wealth of Nations.* Chicago: Encyclopedia Britannica, 1952.

Smith, George. *The New Biology: Law, Ethics, and Biotechnology.* New York: Plenum, 1989.

Smith, Joan. "Going Ape: Women Artists Go Underground to Fight Sexism in the Art World." *San Francisco Examiner: Image Magazine.* 25 Feb. 1990, pp. 13–18.

Soloman, Robert. "Creating Normal Narcissism." *Journal of Creative Behavior.* 19, No. 1 (1985): 47–66.

Solzhenitsyn, Aleksandr. "Beauty Will Save the World" (Nobel Prize Acceptance Speech). Pelikan, Jaroslav. *The World Treasury of Modern Religious Thought.* Boston, MA: Little, Brown, and Co., 1990.

Sontag, Susan. "In Plato's Cave." In *Women's Voices.* Pat C. Hoy, Esther Seror, and Robert DiVanni, eds. New York: McGraw Hill, 1990.

Sophocles. *Three Theban Plays.* Robert Fagles, tr., Bernard Knox, intro., 2nd ed. Hammondsworth: Penguin, 1984.

Speiser, E. A. "Akkadian Myths and Epics: The Creation Epic." In *The Ancient Near East.* James B. Pritchard, ed. 2nd ed. 31–39. Princeton: Princeton University Press, 1958.

Sprat, Thomas. *The History of the Royal Society of London, for the Improving of Natural Knowledge.* London: n.p., 1734.

Stanley, Autumn. "Women Hold Up Two-Thirds of the Sky: Notes For a Revised History of Technology." In *Technology as a Human Affair.* Larry Hickman, ed. New York: McGraw-Hill, 1990.

Steinkraus, Warren. "Artistic Creativity and Pain." In *Creativity in Art, Religion, and Culture.* Michael Mitias, ed. Atlantic Highlands, NJ: Humanities Press, 1985.

Stoddard, George D. "Creativity in Education." In *Creativity and Its Cultivation*. Harold Anderson, ed. New York: Harper and Row, 1959.

Stone, Irving. *The Agony and the Ecstasy*. New York: New American Library/Dutton, 1978.

Subbiondo, Joseph. "Francis Bacon's *New Atlantis* and John Wilkins' Essay." In *Linguists and Their Diversions*. Vivien Law and Werner Hüllen, eds. 123–139. Münster: Nodus, 1996.

Suzuki, David, and Peter Knudtson. *Genethics: The Ethics of Engineering Life*. 2nd. ed. Cambridge, MA: Harvard University Press, 1989.

Sydney, Sir Phillip. *Defense of Poesy*. Louis Soens, ed. Lincoln, Nebraska: University of Nebraska Press, 1970.

Swift, Jonathan. *Gulliver's Travels and Other Writings*. Miriam Kosh Starkman, ed. New York: Bantam, 1962.

Taplin, Oliver. "Emotion and Meaning in Greek Tragedy." In *Greek Tragedy: Modern Essays in Criticism*. Erich Segal, ed. New York: Harper and Row, 1983.

Tao te Ching. (See Whaley, The Way).

Tatsuno, Sheridan. *Created in Japan: From Imitators to World-Class Innovators*. New York: Harper and Row, 1991.

Taylor, Calvin W. and Frank Barron, eds. *Scientific Creativity*. New York: Wiley, 1963.

Teich, Albert. *Technology and The Future*. 5th ed. New York: Saint Martin's Press, 1990.

Terman, Lewis, et al. *Terman Life Cycle Study of Children With High Ability, 1922–1982*. Ann Arbor, MI: Inter-university Consortium for Political and Social Research, 1983.

"Tervuren Museum, Treasures From." Exhibit at *San Francisco Palace of the Legion of Honor*, March 1998.

Thomas, Lewis. *The Lives of A Cell*. Hammondsworth: Penguin, 1974.

———. "Notes of A Biology Watcher: The Hazards of Science." *New England Journal of Medicine*. 296, No. 6 (Feb. 10, 1977): 324–28.

Thomeer, Jan. "Innovation in Higher Education: The Dutch Way." *Journal of Business and Society*. 8, No. 1 (1995): 17–19.

Thucydides. *The Peloponnesian War*. Rex Warner, tr. Hammondsworth: Penguin, 1954.

Tillich, Paul. *Biblical Religion and the Search for Ultimate Reality*. Chicago: Chicago University Press, 1955.

———. *Religionsphilosophie*. 2nd. Stuttgart: Kohlhammer Verlag, 1962.

Tonay, Charles de. *Michelangelo: Sculptor, Painter, Architect*. Princeton: Princeton University Press, 1975.

Torrance, Paul E., et al. *Cumulative Bibliography on the Torrance Tests of Creative Thinking*. Athens, GA: Universit of Georgia, 1981.

Toynbee, Arnold J. *A Study of History*. Vols I–IV. Abridged. New York: Oxford University Press, 1947.

Trachtenberg, Alan. *Classic Essays on Photography*. New Haven: Leete's Island Books, 1980.

Tripathi, Durgadatta. "The 32 Sciences and the 64 Arts." In *Studies in Indian Music and Allied Arts*. Leela Omchery and Deepti Omcherly Bhalla, eds. 1–26. New Delhi: Sundeep Pakastan, 1990.

Trotsky, Leon. *Literature and Revolution.* New York: Russell and Russell, 1957. In *Theories of Modern Art.* Hirschel Chipp, ed. *Theories of Modern Art.* Berkeley: University of California Press, 1970), pp. 462–466.

Tucker, Robert, ed. *The Marx-Engels Reader.* 2nd ed. New York: W. W. Norton, 1978.

Tuerck, David, ed. *Creativity and Liberal Learning: Problems and Possibilities in American Education.* Norwood NJ: Ablex Publishers, 1987.

Tupitsyn, Margarita. "Gustav Klutsis: Between Art and Politics." *Art in America* (January 1991).

Turner, A. Richard. *Inventing Leonardo.* 2nd ed. Berkeley: University of California, 1993.

Turner, Frederick Jackson. *The Frontier in American History.* New York: Holt and Co., 1920/ 1947.

Turner, Victor. "Betwixt and Between: The Liminal Period in Rites of Passage." In *The Forest of Symbols.* 93–111. Ithaca: Cornell University Press, 1967.

Tylor, Edward B. *Anthropology: An Introduction to the Study of Man and Civilization.* New York: Appleton and Co., 1881.

———. *Primitive Culture.* (1871). New York: Harper, 1958.

Ueland, Brenda. *If You Want to Write.* 2nd ed. St. Paul, MN: Gray Wolf Press, 1987.

United Nations. 1994. Human Development Report. New York.

U.S. Congress. "Commercial Biotechnology: An International Analysis." (1984). Office of Technology Assessment. In *Technology and the Future.* Albert Teich, ed. 4th ed. New York: St. Martin's Press, 1986.

U.S. Congress. *Editorial Research Reports on Advances in Science.* Washington, DC: Congressional Quarterly, 1979.

Untermeyer, Louis. *The Lives of the Poets.* New York: Simon and Schuster, 1959.

van Oech, Roger. *A Whack on The Side of the Head.* Atherton: Creative-Think, 1973.

van Over, Raymond. *Sun Songs: Creation Myths from Around the World.* New York: New American Library/Dutton, 1980.

Vasari, Giorgio. *Lives of the Artists.* Abridged. Betty Burroughs, ed. New York: Simon and Schuster, 1946.

Vare, Ethlie Ann, and Greg Ptacek. *The Mothers of Invention: From the Bra to the Bomb, Forgotten Women and Their Unforgettable Ideas.* New York: Morrow, 1988.

Veblen, Thorstein. *The Theory of the Leisure Class.* New York: Macmillan, 1899.

Vernon, P. E. "The Nature-Nurture Problem in Creativity." In *Handbook of Creativity.* John A. Glover, ed. New York: Plenum, 1989.

Viviano, Frank. "Taiwan Waits and Worries; An Island Searching for Its Identity." *San Francisco Chronicle,* 9 June 1997.

Vollrath, Ernest. "Die Kategorie des Sinnlichen bei Marx." In *Philosophisches Jahrbuch,* Bd. 78 (1971).

Voltaire, the Portable. 2nd ed. Ben Ray Redman, ed. New York: Viking, 1968.

Wade, Nicholas. "Scientists Cultivate Cells at Root of Human Life." *New York Times.* 6 Nov. 1998, pp 1 and 21.

Wakefield, Dan. *Creating From the Spirit.* New York: Ballentine, 1997.

Walker, Paul E. "Heresy: Islamic." In *Dictionary of the Middle Ages.* Joseph Srayer, ed. New York: American Council of Learned Socities, 1985.

Walker, Williston. *A History of the Christian Church.* 3rd ed. New York: Charles Scribner's Sons, 1970.

Wallace, Graham. *The Art of Thought.* London, 1926.

Wang, Jing. *High Culture Fever: Politics, Aesthetics, and Ideology in Deng's China.* Berkeley: University of California Press, 1996.

Ward, Adolfus William. *A History of English Dramatic Literature: To the Death of Queen Anne.* 3 vols. London: MacMillan, 1975.

Webb, Robert. "Creativity: The Need for a Definition." In *Creativity and Liberal Learning.* Donald Tuerck, ed. Norwood, NJ: Ablex, 1987.

Weiley, S. "Prince of Darkness and Angel of Light." *Art News* 87 (Dec. 1988): 106–11.

Weiner, Robert. *Das Amerikabild von Karl Marx.* Bonn: Bouvier, 1982.

———. "Western and Contemporary Global Conceptions of Creativity in Relief Against Approaches from So-Called 'Traditional' Cultures.'" *Issues in Integrative Studies,* No. 15 (1997): 1–48.

Weisberg, Robert. *Creativity: Beyond the Myth of Genius.* New York: W. H. Freeman and Co., 1993.

Wenk, Edward, Jr. *Tradeoffs: Imperatives of Choice in a High-Tech World.* Baltimore, MD: Johns Hopkins University Press, 1986.

West, M. L., ed. and commentary. *Hesiod: Theogony.* Oxford: Clarendon, 1966.

Whaley, Arthur. *The Way and Its Power: A Study of the Tao te Ching and Its Place in Chinese Thought.* New York: Grove, 1958.

———. *The Book of Songs.* Boston, MA: Houghton Miffin Co., 1937.

White, Lynn. "The Act of Invention." In *The Technological Order: Proceedings of the Encyclopedia Britannica Conference.* Carl Stover, ed. Detroit: Wayne State University Press, 1963.

Whitehead, Alfred North. *Process and Reality: An Essay in Cosmology.* Gifford Lectures Delivered at University of Edinburgh. New York: MacMillan Co.; Cambridge: Cambridge University Press, 1929.

———. *Science and the Modern World.* New York: MacMillan Co., 1925.

Whitman, Walt. *Leaves of Grass.* 2nd ed., Philadelphia: Rees Walsh and Co., 1881.

Wiesel, Elie. *Night.* Stella Rodway, tr. Toronto: Bantam, 1960.

Wilford, John Noble. "When No One Read, Who Started to Write? *New York Times,* "Science," April 6, 1999, D1–2.

Williams, William Appleman. *History as a Way of Learning.* New York: Granslin Watts, 1973.

Williams, Raymond. *Culture and Society.* 2nd ed. New York: Columbia University Press, 1983.

Wilmer, Harry, ed. *Creativity: Paradoxes and Reflections.* Wilmette, Il: Chiron, 1991.

Wilson, Bryan. "Values and Society," In *Values*. Brenda Almond and Bryan Wilson, eds. Atlantic Highlands, NJ: Humanities Press, 1988.

Winthrop, John. *Winthrop Papers*. Vol. III. Boston: Massachusetts Historical Society, 1931, pp. 294–295.

Wolfson, Harry A. *Philo*. 2 vols. Cambridge, MA: Harvard University Press, 1947.

———. "Philo on Free Will." *Harvard Theological Review* 35.

Wong, Edward. "Film Makers Fear Final Cut." *San Francisco Chronicle*, 16 June 1997.

Wood, Michael. *China: The Mandate of Heaven* (*Legacy* series). Maryland Public Television, 1991.

Woolf, Virginia. *A Room of One's Own*. 2nd ed. San Diego, CA: Harcourt Brace Jovanovich, 1957.

Wordsworth, William. "Lines Composed a Few Miles Above Tintern Abbey. . . ." In *Norton Anthology of English Literature*. M. H. Abrams, ed. 2nd ed. New York. W. W. Norton and Co., 1968.

———. *Preface to Lyrical Ballads* in *Norton Anthology*.

Wu, Harry. 1998. Human Rights. Lecture at Saint Mary's College, Moraga, CA. March 12.

Yeats, William Butler. "The Second Coming." In *Norton Anthology of English Literature*. M. H. Abrams, ed. 2nd ed. New York. W. W. Norton and Co., 1968.

Zdanek, Marilee. *Right Brain Experience*. Santa Barbara, CA: Two-Roads Publishing, 1996.

Zervos, Christian. "Conversation With Picasso." In *The Creative Process*. Brewster Ghiselin, ed. Berkeley: University Press and New American Library, 1952.

Ziman, John M. "Information, Communication, and Knowledge." *Nature* 224 (1969): 318–24.

———. *The Force of Knowledge*. Cambridge, Eng.: Cambridge University Press, 1976.

MUSEUMS VISITED IN CONJUNCTION WITH THIS BOOK

Asian Art Museum, San Francisco, California
Chaing Mai University Anthropology Museum, Thailand
De Young Museum, San Francisco, California
The Exploratorium, San Francisco, California
Foundation Meght, St. Paul de Vence
Freer Gallery of Art, Smithsonian, Washington, D.C.
Heard Museum, Phoenix, AZ
L'Accademia, Firenze, Italy
Le Louvre, Paris, France
Los Angeles County Museum of Art, Los Angeles, California
The Mexican Museum, San Francisco, California
Musée d'Orsay, Paris, France
Museum of Anthropology of the University of British Columbia, Vancouver Canada
Museum of the American Indian, New York, NY

Museum of Modern Art, New York, NY
Museum of Modern Art, San Francisco, California
Metropolitan Museum of Art, New York, NY
National Museum of Archeology, Athens, Greece
Norton Gallery of Art, West Palm Beach, FL
Oakland Museum of California, Oakland, California
Phoebe Hearst Museum of Anthropology, University of California Berkeley, CA
Schnutgen Museum, Koln, Germany
Smithsonian Museums, Washington, D.C.
Vatican Museum, Vatican, Rome, Italy
Walters Art Gallery, Baltimore, Maryland
Ubud Museum, Bali, Indonesia
Uffizi, Firenze, Italy

INDEX

Find Acacia Wood